"Our Own Country Canada"

"Of this
magnificent
National
inheritance
we
purpose
to give
a concise
description,
with
copious
pictorial
illustrations."

Rev. William H. Withrow,
Our Own Country Canada
(Toronto, 1889), p. 17

"Our Own Country Canada"

Being an Account
of the
National Aspirations
of the
Principal Landscape Artists
in
Montreal and Toronto
1860–1890
by
Dennis Reid

NATIONAL GALLERY OF CANADA

NATIONAL MUSEUMS OF CANADA

1979

Design: Frank Newfeld

Printing: Southam Murray Printing

Obtainable from your
local bookstore;
The National Gallery Bookstore;
or National Museums of Canada
Mail Order
Ottawa, Canada
K1A 0M8

PRINTED IN CANADA

Photograph Credits

COLOUR:

Front Cover:
National Gallery of Canada, Ottawa.

Back Cover:
Notman Photographic Archives,
McCord Museum, Montreal.

BLACK AND WHITE:
The National Gallery of Canada,
Ottawa, except for the following:
Archives of Ontario, Toronto, Nos 103,
166; Art Gallery of Hamilton, Ontario,
Nos 69, 160; Art Gallery of Ontario,
Toronto, Nos 29, 93, 123; Beaverbrook
Art Gallery, Fredericton, No. 159; Glen-
bow Alberta Institute, Nos 80, 101,
171; Tod Greenaway, Vancouver, Nos
121, 133, 161; Her Majesty the Queen,
No. 128; A. Kilbertus, Montreal, Nos
65, 66, 67, 106; McCord Museum,
Montreal, Nos 71, 72, 73, 140, 141,
142; Metropolitan Toronto Library,
No. 137; David Mirvish Gallery,
Toronto, No. 175; Montreal Museum of
Fine Arts Nos 37, 43, 70, 85, 136,
163; Musée du Quebec, Nos 23, 32, 47,
102, 147; Museum of Fine Arts, Boston,
No. 129; New Brunswick Museum, St
John, No. 76; Notman Photographic
Archives, McCord Museum, Montreal,
Nos 1, 2, 3, 4, 5, 6, 9, 17, 18, 26, 27, 38,
39, 49, 51, 53, 54, 77, 78, 82, 112, 113,
139, 144, 148, 149, 150, 151, 152, 153,
154, 155, 156, 179; Provincial Archives
of British Columbia, Victoria, Nos 96,
172; Public Archives of Canada,
Ottawa, Nos 19, 20, 21, 22, 41, 42, 55,
56, 57, 58, 59, 60, 61, 62, 63, 64, 83, 84,
109, 110, 111, 114, 115, 134, 167,
168; Gabor Szilasi, Montreal, Nos 127,
157; Vancouver Art Gallery, No.
50; Ron Vickers, Toronto, Nos 8, 46,
89, 90, 91, 92, 119, 165, 169; Peter
Vogel, Ottawa, No. 33; Winnipeg Art
Gallery, No. 100; source unknown No. 95.

Contents

Foreword

In 1967, the centennial year of Confederation, J. Russell Harper's *Painting in Canada; A History* terminated a succession of increasingly dense surveys of Canadian art that had begun in the 1920s. It will be another decade before any single author will attempt, or I might say should attempt a similar synthesis.

In the meantime provincial histories will be written, the biographies of individual artists will be produced, and period cross-sections and thematic investigations will be undertaken. There is a new generation of young researchers to do this work. Each has his own special interests, and most are directors and curators of art galleries (many once or still on the staff of the National Gallery of Canada). This new generation, by inclination as well as by obligation, are concerned to combine the care of works of Canadian art, their public display, and the further ordering of their research through special exhibitions and their accompanying catalogues, and other pertinent publications.

These exhibition-catalogues-turned monographs will be the literature of the present generation of researchers. In former times, the monograph was the province of the private scholar or university professor; in future it will be more the tool, and the product, of the curator. Although there are risks in this – there are limits to what can be organized into an exhibition – there are, by way of compensation, a broader, more immediate exposure in the gallery attendance at the exhibition, and a solid body of readers of the catalogue after the exhibition has closed.

The exhibition *"Our Own Country Canada,"* which opened in Ottawa in November 1978 and has since been travelling to various centres across the country, is the very model of this new kind of research. (It incidentally satisfies the National Gallery's policy of enhancing "the understanding of Canada's present and past achievements in the arts." However, the work that sprang from it is in no way a catalogue and is, indeed, much closer to being a textbook.

In the book, as in the exhibition, Mr Reid has chosen to explore a parcel of territory hardly more than surveyed by Russell Harper. It is a wilderness made up of some good artists, many, and most, little-known; of pictures in degrees of quality right down to rather scrubby stuff; and of whole swamps of conflicts between individuals and among groups. This territory is a kind of social equivalent to those daunting lands across which the railways were then pushing their way.

By choosing the theme of landscape the author has taken the only firm and continuous passage through the period. The many portraits and the occasional genre pictures of the time are, for the most part, ignored: by and large they were, and remain, phenomena peripheral to the Canadian scene.

The generation that has been singled out in this exhibition would have agreed with Mr Reid: landscape painting and photography did provide the evidence of a major expansionist drive toward the frontier. Moreover, these were the artists most active in forming the societies, academies, and galleries nationally to institutionalize the arts. I believe Mr Reid is quite right in claiming that the obsessive regard for landscape as the national theme was formed in public consciousness at this time.

So also is Mr Reid discerning to stress the special role of photography in this process. The central position of William Notman, photographer-entrepreneur, and the turbulence of artists and photographers about him, constitute the key to the dynamics of the period. It is so patently clear that one wonders why more has not been made of it before this. Not only does Mr Reid cite instances of outright borrowing, he also points out the acceptance of the peculiarities of the camera: lens distortion, for example, marginal loss of detail. However, though insisting on "influence," Mr Reid stops short of "surrender": his judgement is more tentative than final. The whole matter should evoke a later exhibition.

Finally, the atmosphere created by entrepreneurial pressures, cabals of contending groups and individuals, places landscape squarely in the context of Canadian political and business life. And the long litanies of children born and children dead, of residences changed with the winds of fortune, though at first seemingly irrelevant, locate each artist in the rhythm of contemporary life far more firmly than a mere chronology of works.

Happily, this exhibition leads to other exhibitions: it does not smother furthur examination of the relation between landscape painting in Canada and abroad – to cite only one theme for future consideration. *"Our Own Country Canada,"* is a first, firm probe: it will not inhibit further research.

G. STEPHEN VICKERS

Preface

The images that capture an artist's attention, the vision through which he is able to interpret them – these are the factors that create art and which art historians are concerned to recognize and define. In *"Our Own Country Canada"* Dennis Reid has not only given us the opportunity to see this country through the eyes of the landscape artists and artist-photographers of the time but has also shown us how both images and vision interacted to produce a sharply focused picture of Canada during thirty definitive years.

As Curator of Post-Confederation Art at the Gallery, Mr Reid has given much time and thought to discovering his own images and defining his own vision, and our collections have greatly aided him in his work.

Central to Mr Reid's thesis is the recognition that today the word "art" encompasses a much broader spectrum than was recognized in earlier years. Coincidentally, about ten years ago, the National Gallery itself recognized photography as "an image-making process" and a creative art form. Our collection in this field is now one of the best in the world, and the impact that the photography collection has made upon the visual awareness of our curators is well demonstrated in the present book.

A review of Dennis Reid's acquisitions over the past five years makes it clear that as his own vision widened in scope so our national collections grew deeper and richer in content. The names of Lucius O'Brien, F.M. Bell-Smith, Allan Edson, John A. Fraser, Otto Jacobi and Fredrick A. Verner have become familiar to us all at the Gallery.

While doing research for this book and bringing to light new acquisitions for the national collections, Mr Reid also did much to reveal the importance of what already existed in various public and private collections. The final result, as contained within these pages, is a highly original work filled with new facts and fresh approaches, providing us with a socio-economic portrait of one of the most colourful eras in Canada's history. Meetings with descendants of the artists, and the exploration of collections across this land as well as in England and the United States, have aided Mr Reid in his research and contributed to the dimensions of his understanding. We should all be grateful to Dennis Reid and to those who have helped him in the research and writing of this book.

HSIO-YEN SHIH
Director

Author's
Acknowledgements
and
Bibliography

Writing my *A Concise History of Canadian Painting* (Toronto: Oxford University Press, 1973), I devoted one chapter to the landscape artists who so dominated the years around Confederation, and who now are the subject of this study. It was clear that they constituted a vital link in the developement of our art, even though we then knew relatively little about them. There were a few general sources upon which to draw:

Bourassa, Anne. *Un artiste canadien-français, Napoléon Bourassa.* Montreal: privately published, 1968.

Bourassa, Napoléon. *Lettres d'un artiste canadien.* Bruges, Paris: Desclée de Brouwer, 1928.

Colgate, William. *Canadian Art, its Origin and Developement.* Toronto: Ryerson, 1943.

Collard, Elizabeth. "Eastern Townships Artist, Allan Edson." *Canadian Antiques Collector,* vol. v, no. 1, January 1970, pp. 13-15.

Dyonnet, Edmond. "Memoirs of a Canadian Artist." Montreal, typescript, 1951 (published as *Mémoires d'un artiste canadien.* Ottawa: Université d'Ottawa, 1968).

Gagen, Robert F. "Ontario Art Chronicle." Toronto, typescript [c. 1919].

Harper, J. Russell. *Painting in Canada; a History.* Toronto: University of Toronto, 1966.

~ · *Early Painters and Engravers in Canada.* Toronto: University of Toronto, 1970.

Hendricks, Gordon. *Albert Bierstadt, Painter of the American West.* New York: Abrams, 1973.

Hubbard, R.H. *The Development of Canadian Art.* Ottawa: National Gallery of Canada, 1963.

~ · "The Early Years of the National Gallery of Canada." *Transactions of the Royal Society of Canada,* vol. III, series IV, section II, June 1965, pp. 121-129.

Leduc, Father Pierre. "Les origines et le développement de l'*Art Association* de Montréal (1860–1912)." Thesis, Maître ès Arts, Université de Montréal, 1963.

MacTavish, Newton. *The Fine Arts in Canada.* Toronto: Macmillan, 1925.

McElroy, Guy. *Robert S. Duncanson: A Centennial Exhibition.* (Exhibition catalogue) Cincinnati Art Museum, 1972.

I began to seek further in disparate sources, determined to form a more complete impression of the artists and of their period. While I worked at this, a number of new studies appeared which contributed information:

Annett, Margaret. "Paintings, Watercolours, Drawings: Frederick Arthur Verner." *Journal* no. 20, Ottawa: National Gallery of Canada, 1976.

LeMoine, Roger. *Napoléon Bourassa, l'homme et l'artiste.* Ottawa: Université d'Ottawa, 1974.

Nelles, Charles M. *Selections from Picturesque Canada, An Affectionate Look Back.* Victoria: Pandora, 1975.

Thomas, Ann. "The Role of Photography in Canadian Painting 1860–1900: Relationships Between the Photographic Image and a Style of Realism in Painting." Thesis, Master of Fine Arts, Concordia University, Montreal, 1976.

Vézina, Raymond. *Napoléon Bourassa, Introduction à l'étude de son art.* Montreal: Editions Elysée, 1976.

As work progressed, the central rôle of the photographers of the period became apparent. I was aided in my investigation of this kind of activity by a few pioneering publications:

Birrell, Andrew J. "Fortunes of a Misfit; Charles Horetzky." *Alberta Historical Revue,* vol. XIX, no. I, winter 1971, pp. 9-25.

~ · *Into the Silent Land, Survey Photography in the Canadian West,* 1858–

1900. (Exhibition catalogue) Ottawa, Public Archives of Canada, 1975.

Greenhill, Ralph. *Early Photography in Canada.* Toronto: Oxford University Press, 1965.

Harper, J. Russell and Triggs, Stanley G. *Portrait of a Period, A Collection of Notman Photographs 1856 to 1915.* Montreal: McGill University Press, 1967.

Triggs, Stanley G. "Alexander Henderson: Nineteenth-Century Landscape Photographer." *Archivaria,* no. v, winter 1977–78, pp. 45-59.

All of this suggested the broad outlines, and indeed some of the framework, of the structure I should build. Then came the lengthy, systematic research that is the real substance of this book. I examined all of the exhibition records, and combed the contemporary periodical literature and newspapers for reviews and general commentary on the art of the time. I was assisted in this work by Karen Love and Andrée Lemieux, who, in 1973, while engaged as summer students at the National Gallery of Canada, compiled art indexes of the principal nineteenth-century Canadian periodicals.

I was aided at a later stage by Charles Hill, Assistant Curator of Post-Confederation Art at the National Gallery of Canada, Maija Vilcins, Reference Librarian at the same institution, and Edward Phillips, a research assistant who worked with me during part of 1978. Charles Hill was essential. He searched futher in periodical runs, examined the papers of the Ontario Society of Artists in the Archives of the Province of Ontario in Toronto, the papers of the Royal Canadian Academy of Arts in the Public Archives of Canada in Ottawa, and the records of the Art Association of Montreal, preserved in the library of the Montreal Museum of Fine Arts, its successor. In the final stages of synthesizing all this nineteenth-century material, Edward Phillips and Maija Vilcins were indispensable.

My search for works of art of the period and for futher documentary material led me from St John, New Brunswick to Victoria, British Columbia, to England, and into the United States. I was helped in some significant way by virtually every art museum and gallery in this country, and by all whom I contacted abroad. I would like to acknowledge in particular the assistance of the following individuals:

Jerry Mossop, Art Curator, Provincial Archives, Victoria, B.C.; Jeremy Adamson, then Curator of Historical Canadian Art, Art Gallery of Ontario, Toronto; Sybil Pantazzi, Librarian, Art Gallery of Ontario, Toronto; Richard Huyda, Chief, Andrew J. Birrell, Head, Acquisitions and Research Section, and Duncan Cameron, Head, Photo Control Section, all of the National Photography Collection, Public Archives of Canada, Ottawa; Stanley Triggs and his staff of the Notman Photographic Archives, McCord Museum, Montreal; Conrad Graham, Registrar, McCord Museum; Micheline Moisan, Curator of Prints and Drawings, The Montreal Museum of Fine Arts; Sandra Paikowsky, Division of Visual Arts, Concordia University, Montreal; Claude Thibault, Conservateur de l'art ancien du Québec, Musée du Québec, Québec; Sir Oliver Millar, Surveyor of the Queen's Pictures, London.

Blair Laing of Laing Galleries. P.G. McCready of McCready Galleries Inc. and Geoffrey P. Joiner of Sotheby Parke Bernet (Canada) Limited, all of Toronto, Walter Klinkhoff of Walter Klinkhoff Gallery Inc., Bernard Desroches of Galerie Bernard Desroches, Warda Drummond, and William P. Wolfe, all of Montreal, each led me to important material. Elizabeth and Edgar Collard also helped on particular details concerning Otto Jacobi, Allan Edson, and the city of Montreal itself.

Much valuable information, and a great deal of stimulating assistance, came from the descendants of our artists. These include: Mrs Louise M. Davison, Portland, Oregon; A.M. Edson, Chesterville, Ontario; Don D. Fraser, Victoria; J.A. Grant, Shanty Bay, Ontario; John J. Grant, Vancouver; Mrs Joan S. Muller, Bakersfield, California; Murrough O'Brien, London, Ontario; Mrs Gordon A. Potter, Montreal; Mrs Jacob H. Wener, Montreal.

A work of such scale would have been inconceivable without the support of Jean Sutherland Boggs, the Director of the National Gallery of Canada at the time that the project was commenced, and of Hsio-Yen Shih, who became Director at the beginning of my most intense period of application. Both J. Russell Harper and Robert H. Hubbard kindly read the manuscript upon its completion and made many useful suggestions. Gordon Day read the portions dealing with Allan Edson, and Sharon Goelman, who is completing a master's thesis at Concordia University on the artist, read those parts concerning William Raphael.

The Publications Department of the National Gallery of Canada, directed by Peter Smith, supported my final decision to turn what had

been planned as an exhibition catalogue into a real book, and my editors, Pamela Fry, of the English version, and Louis J. Arial, of the French translation, have been indispensable in accomplishing this transformation. That it indeed is a book is due to Frank Newfeld.

The owners and custodians of the works of art that constitute the primary documents have been, by and large, exemplary in their support of this project. And the staff of the National Gallery of Canada each turned her or his skills to a thoroughly professional – in fact creative – public presentation of the exhibition that was the core of this study. Their counterparts in Winnipeg, Vancouver, Toronto, and Montreal have maintained that standard.

But as I near the end of the work, I realize that it never could have been accomplished without the constant support of Charles Hill, who assumed the routine responsibilities of my office at the National Gallery of Canada during the months of writing, and the dedication of my secretary, Francyne Edgar, who had a hand in every stage. I also appreciate that none of this would have been possible without the understanding and encouragement of my wife, Kog, and my daughters, Jessica and Naomi, each a steady rock in the sea of my life.

*Let me recite
what
history teaches.
History teaches.*

GERTRUDE STEIN

*This is not
the* absolute *truth –
don't believe*
everything *I say.*

JEAN-LUC PEPIN,
when co-chairman of the
Task Force on National
Unity; a note suggested
to precede all Canadian
history texts

Introduction

"Our Own Country Canada" is the title of a book by the Rev. William H. Withrow of Toronto, published in that city in 1889. I have used it as part of the title of this one because its smug exclusivity – evidencing not only the needs of pride but of possession – strikes the exact note of jingoistic nationalism, of straining materialism, typical of the period of Canada's artistic history which ended at about the time of its publication.

It was the period during which a culture based on the English language, and in large part on British political and institutional models, was being firmly established in Central Canada. The immigrants who accomplished this believed that they were establishing the Canadian nation. That they did so while remaining largely in ignorance of those other cultural values – based on the French language and the Catholic religion – that had already existed in Canada for some two centuries, has resulted in their separateness from that older Canadian community. Indeed, the landscape art that will be described in some detail in the following pages, and which so vividly reflects the growth and change of the country, was of little interest to French-Canadians.

Although so prominent a francophone politician as Sir George Étienne Cartier finally placed the full weight of his support behind the concomitant ideas of a Canadian railroad to the Pacific and western growth, and although in the seventies a few French Quebeckers did homestead in Manitoba, the idea of continental expansion was most often expressed in English during these years. French Canadians were pioneering in the Saguenay and Lake St John region, along the St Maurice River, in Gaspé, the Eastern Townships, and along the Ottawa River and its northern tributaries. An active colonization programme, led by the Church, and encouraged by provincial legislation, caused

the establishment in the latter half of the nineteenth century of thousands of families in these frontier areas of Quebec. It was expansion, but it was also more of a consolidation of particular linguistic, social, and cultural values that have persisted to this day.

In the eighteen-sixties the aspirations of English-speaking Canadians were also limited to the development and exploitation of the Montreal-Quebec City hinterlands. The inauguration of the Intercolonial Railway in the mid-seventies, which opened eastern Quebec and northern New Brunswick to settlement, as well as offering a route for commercial traffic from Montreal through to Halifax, was consistent with such immediate goals, and was welcomed by all. But the more ambitious effort, which was to run rail through to the Pacific, and in so doing effectively appropriate the vast western territories of British North America, was more specifically a response to the impetus of British Imperial growth, further quickened by a mixture of fear and the desire to emulate the spectacular western expansion of the United States. It was the British and American business interests of Montreal and south-western Quebec, of Ontario, and to some degree of the Maritimes, that sought their main chance in that direction, and it was in these communities that the excitement, the dream, caught hold.

We would be right to maintain a certain scepticism as to the spiritual depth of this Victorian vision of a newly broad, strong, and wealthy Canada, for it reveals the fundamental materialism of the age. An implicit belief in the goodness of growth, in the heaven-sent inevitability of progress as the reward of concentrated effort, fuelled their ambitions. Symbolic agreements cast in quasi-legalistic terminology removed the native inhabitants from the farmland in the West. The establishment of a federal mounted police force assured peaceful settlement, and safe traffic across the continent.

After that, Central Canada, which gave its own name to the whole country, could speak of it as "our" land, "our own country," our own country Canada. As an expression of proprietary pride, such a phrase conjured up a future of limitless potential, open to those with the strength to take hold, and the fortitude to hang on. Although he tended to promote them like a "property," when William Cornelius Van Horne of the Canadian Pacific once referred in a letter to the Rockies as "our mountains," he perhaps did not mean they belonged only to the company, but to all Canadians.

This capacity for self-interest and personal ambition, enlarged to embrace an expression of communal goals and values, was also responded to by Canadian artists during the years of Canada's rapid territorial growth. Their national aspirations, as we will see in the pages that follow, were, like Van Horne's, tied to personal ambition, to a sense of advancement and self-improvement. That they found the most effective expression of these goals to be romantic and naturalistic images of the noble adversary, the strong and resistant land itself – therein lay the poetry of their vision, and the force their work carries to this day.

It seemed so natural to Victoria's Canadians, this ambition to appropriate and enlarge; like an urge that had to be answered. Tractable land was squared into townships, sections, and lots. The wilderness barriers, these became monuments, natural monuments to the ability of man to dream of even grander appropriations, or before which to thrill with the fear of faltering, of being denied that ultimate power the prize held out. It was all so clear, the way order ruled. What a strong and true foundation this was, they believed, for a new nation. Although we live today with much that they built, we can see now that their optimistic belief in the inherent correctness of their position was often narrow and limiting, and that their sense of nationalism itself was always complicated and sometimes confused.

And as we look closely at the lives of the principal artists of the period, the confusion of their national aspirations also becomes apparent. They aspired to national status, to be accepted in a larger than local forum. But they found that they had to define the extent and nature of the nation this new platform was meant to address. They could only grope – meanly, it seems at times – feeling their way out from their local base, be it Montreal or Toronto.

The artistic community in Canada was small, much smaller, of course, even than now. That part of North America that was known as Canada before 1867 was the portion of what we call Quebec and Ontario that lies south of the watershed, where the rivers begin to flow north into Hudson's Bay. With few exceptions, all of the artists of European descent lived in Montreal, the commercial centre of the country; in Quebec City, the capital; or in Toronto, the local centre in the west. It was Montreal, however, where in the sixties there was a significant congregation of younger artists.

Most were recent immigrants, from England, the United States, Germany, and frequently Scotland. As do all immigrants, they brought with them the instruments of their culture, or in the cases of the more elaborate or otherwise untransportable structures, attempted to recreate them in the New World. Although their activities had far-reaching consequences – they were the foundations of all that will be examined in this book – in the eighteen-sixties their impact was local. At their centre was the Scottish photographer William Notman, perhaps the most important artist then working in Canada.

The eighteen-seventies brought the promise of western expansion with the establishment of the province of Manitoba, the purchase of the vast Hudson's Bay Company domains, and the entry of British Columbia into Confederation. Toronto came into real prominence, already thriving in the happy circumstance of its location, where the hinterlands of New York and Montreal overlapped. As early as the late sixties we can see the beginnings of a shift in the cultural centre of English-speaking Canada from Montreal to what was then called the "Western Metropolis." This artistic shift is nicely typified in the move to Toronto in 1868 of the painter, John A. Fraser, to establish a branch of the Notman photographic firm.

In the fall of 1873 a great depression settled upon Canada, which was felt most severely in Montreal. Artistic activity in that city diminished to a fraction of what it had been in the previous decade, and the artistic importance of Toronto grew in consequence. The nationalist "Canada First" political movement, which had been started in Ottawa in 1868, found its natural base in Toronto in the seventies, and the notorious "Pacific Scandal" also left that city feeling ambitiously self-righteous. The artists organized to concentrate the meagre artistic support that had hitherto existed, and during the decade a few painters of ability developed. John Fraser and Lucius O'Brien were thought to be the best. Attesting to how small the spoils of such recognition still were, these two were to fight over them steadily, for more than a decade.

By the late seventies, Montreal had regained its economic footing, and the Pacific railway was soon underway again, headed by a Montreal-based syndicate. An art gallery was built, embodying the city's reassumption of the central role in the artistic life of the country. Before competition between Toronto and Montreal for that claim

could begin to succour divisiveness, the federal government, through the institution of the Governor-General, moved for the first time into the area of culture.

Within a period of less than two years, through the agency of vice-regal patronage, the idea of a "truly national" point of view – beyond the local concerns of any one region – was introduced. It was precisely patronage that was employed – a series of small supports. There were a few commissions given, and an honourific exhibiting association was established, conceived in conjunction with which was a national gallery at the federal capital. Artists were also encouraged to find in the environment a supportive "spirit" for the new federal ideal of a nation linked in common purpose from sea to sea. All of these steps were in part expedient and artificial, but they had the effect of broadening the scope of the aspirations of many artists. It meant a great deal, as we will see, to both Fraser and O'Brien.

In the mid-eighties this romantic involvement with the land found concrete manifestation in the ribbon of steel that sought to physically bind the nation together. The promoters of the CPR understood the force of images, and they encouraged the associations artists made between their road and the picturesque wonders it opened. If they saw themselves as nation-builders, they were also eager to be seen as enriching the cultural life of the nation. And mountains, they knew, sold tickets. The remarkable success of the CPR programme in promoting interest in artistic views of the Rockies and the West Coast, represents the first significant instance of a widespread acceptance in Canada of the myth of the land as the basis of a national art. It is a theme that has attracted many Canadian artists since.

The organization of an exhibition brought me to undertake the close investigation of these landscape artists who worked in Montreal and Toronto in the three decades between 1860 and 1890. This exhibition has provided the first opportunity in almost ninety years to see the work of these largely-forgotten painters and photographers assembled together. They brought the form of their art, like their institutions, from abroad. The roots of this landscape art lie in England, Scotland, Germany, and the United States. Often living within their own ethnic communities in Canada, and sometimes returning to their native land (or to the land of their forefathers, for some were born in Canada, although the sons of

immigrants), connections with British art in particular were fairly constant, or at least regular.

There are many links with the United States, in spite of the fact that during the sixties Canadians took up arms in defense of their country against the threat of American invasion. The development of railroads and western expansion occured earlier, faster, and more spectacularly in the United States, and it served as a model for many Canadian responses. The American landscape painters of the middle decades of the century, known as "Luminists," responded to the idea of expansive nature before that awareness had arisen in Canada, and so they became examples for some Canadians. The famous German-American painter of the far west, Albert Bierstadt, played a direct role, we will see, in the development of particular landscape images in Canada.

Photography was widespread in the American west at an early stage, and Canadians worked with some conciousness of those images as well. It was also the period when wood-engraving was widely used in popular illustration, and a number of Canadian landscape artists worked in this medium. It brought them within the sphere of the British, and particularly of the American, world of magazine illustration.

What is most important to an understanding of the landscape art of these decades, however, is to be aware of photography's role in it all. The relationship between photographers and painters – all potential artists – is complex and fascinating. Photographs were often composed according to pictorial conventions. There is evidence of paintings being based directly upon photographs. It is known that portrait painters worked on photo-sensitive supports (usually thin paper glued to canvas), upon which the required image had previously been printed. I have as yet found no evidence of this practice among landscape painters, although it would have been consistent with their intentions in the eighteen-sixties in particular. Mainly, photographs were used by painters as sketches were, to capture momentary effects or complicated detail for later incorporation in a studio composition. This close association with photography underlines a fundamental change that occurred in Canadian landscape painting during the years under examination.

The landscapes of the earlier painters – Joseph Légaré, Paul Kane, Cornelius Krieghoff, for instance – are conceptual. They arise from a

developed, formal landscape convention, and the individual elements –
trees, rocks, water, clouds, etc. – follow generalized conventions as
well. They would represent more the idea of a tree, for instance, than
any particular tree. The painters of the sixties, and particularly in the
seventies and eighties, produced landscapes that are perceptual. That
is, they are based on the retinal image of things and places. Convention
plays its part, but prominent in their work is evidence of the close
observation of the way a form can be perceived only because it reflects
or absorbs light. The best artists, both photographers and painters,
perceived landscape as moving light made still.

This is a book about artists as well as about art. I have accumulated
much new material on the lives and associations of these people, and
have sought to present it in a straightforward manner, much as it was
found in the records and documents. The texture of their lives, the
mark of their times, I believe, comes through. This has encouraged me
to resist the urge to interpret their motives, to draw lessons from their
actions, even though in writing of them I have felt that we often walk in
deep paths they first wore bare. Their country Canada, we must
remember, is but a small, distant part of our own.

1860–1873:
Montreal

The British Community and the Foundation of the Art Association of Montreal

Canada and Montreal in 1860
the "Great Exhibition"
the Art Association of Montreal, 1860
AAM *revived, 1863; Napoléon Bourassa and the* AAM
Art Union established, 1864; AAM *lottery and show, 1865*
further comments from Bourassa.

CANADA AND MONTREAL IN 1860

Canada was known as the Province of Canada in 1860, the two previous British colonies of Upper and Lower Canada having been combined under one local government twenty years earlier. In area, this United Canada, as it was sometimes called, effectively comprised that region of British North America which lay east of Lake Huron; north of the lower Great Lakes, and north of a line running just south of the St. Lawrence River; west of the coast of Labrador; and south of the watershed that marked the limits of the Hudson's Bay Company domains.

The region was divided at the Ottawa River into Canada West, which was predominantly English-speaking, and Canada East, where the majority spoke French. The total population was about 2,500,000 people, most of whom lived on farms, never very far from one of the large rivers or lakes which had always been the principal highways. The capital was then Quebec City, although facilities already were under construction in Ottawa, the controversial choice for the new seat of government.

The most important city was Montreal, situated on a large island in the St Lawrence, downstream from the confluence of that great river with the Ottawa. Its position, straddling the east-west flow, had made it the centre of the fur trade. And as the timber trade grew in the early nineteenth century, much of it also passed through Montreal. Massive

British immigration in the first half of the century settled Upper Canada to the west, and the Eastern Townships to the south-east, and Montreal, as the major commercial centre of the Province, grew and prospered even more. Virtually all traffic in and out passed through the hands of Montrealers.

This central position made the city attractive to British immigrants and to French-Canadians from rural areas of Canada East, and the continual influx of both groups caused constant growth. British immigration was so great that their numbers increased more quickly, and by 1840 the population was about one-half English-speaking. The English reached a majority of fifty-seven per cent in 1844, then began gradually to dwindle in proportion to the French. But in 1860 they still constituted a slight majority of the total population of about 90,000.

The English of Montreal – most of whom were in fact Scottish or Irish, and some American – brought with them clear concepts of social organization: economic, political, and cultural. During the two decades of their numerical dominance at mid-century the foundations of this order were set. It was an order that very evidently rested upon Montreal's position at the centre of the country, a position whose only weakness was that the city had only a three-season port. The possibility of overcoming this major restriction increased as the technology of transportation changed, and Montrealers made every effort to remain abreast of the new developments.

The government of the Province of Canada had only just completed an extensive and impressive system of commercial canals when it became apparent that the railway was a faster, and perhaps a more efficient mode of transport. It was also evident that the rapidly proliferating American railroads threatened to syphon off traffic from the recently improved St Lawrence-Great Lakes route. The first Canadian railway had commenced operation in 1836; a portage road from Laprairie, opposite Montreal, south-east to St John's on the Richelieu River, which in turn connected with Lake Champlain and ultimately New York or Boston. Then in 1847 another portage route had been opened, the Montreal and Lachine, skirting the up-river rapids.

However, the main concern soon became to gain for Montreal direct access to a winter port on the Atlantic, and all-season connections with its hinterlands. To this end, the Grand Trunk Railway was incorporated in 1852. By that time, two lines that would fulfil one of

these goals were already under construction. The Atlantic and St Lawrence Railway was to run from Portland, Maine (the closest sea-port), through New Hampshire to the Canadian border, where it would meet the St Lawrence and Atlantic, which was being built from Longueuil, across the river from Montreal. The Grand Trunk leased these lines (for 999 years), and the same month that they were opened through to Portland – in July 1853 – began the construction of a bridge designed to span the St Lawrence and link Montreal with Longueuil. It was to be the first large bridge with a metal superstructure built in North America, and it was named in honour of the Queen: Victoria.

The Grand Trunk Railway, while continuing the construction of the Victoria Bridge, also pursued its other aim of linking Montreal with its hinterlands, and in November 1854 a line was opened to Lévis, opposite Quebec City. In October 1856 the line to Toronto was put into operation, and over the following years a series of small existing railways were acquired in Canada West that when linked together resulted in a true trunk line. By late 1859 the eastern end of the Grand Trunk was open as far as Rivière du Loup on the south shore of the St Lawrence River, 200 km below Quebec City, and the western end ran through to Lake Huron at Goderich, and the American border at Sarnia. The final step – assuring Montreal's continuing position as the main link in the commercial route between the expanding markets of Canada West and the year-round ports of the American north-east – was accomplished 17 December 1859, when the Victoria Bridge first opened to regular train traffic.

The official opening of the bridge was delayed some eight months, however. Victoria's eldest son, Edward Albert, the Prince of Wales, was to conduct a Royal Tour of British North America the following summer, and it seemed appropriate that such a wonder of modern engineering, dedicated to his mother, should be inaugurated by him. It was the first official royal tour of the continent, and Montreal was fit to shine as Her Majesty's proudest Canadian possession.

THE "GREAT EXHIBITION"

In Montreal, the visit of the Prince of Wales centered on two main functions, the inauguration of the Victoria Bridge, and the opening of the "Great Exhibition," a spruced-up version of an annual regional

exhibition, organized under the auspices of the Board of Arts and Manufactures. A large Crystal Palace had been erected for the occasion, and among the displays contained therein was a Gallery of Fine Arts, situated on one of the upper stories. No catalogue of the exhibition has come to light, but most of the newspapers gave reports of varying lengths. The *Daily Witness* devoted some space to a description of "The Picture Gallery." It is not much, so we can repeat it all here:

> On making the tour of the upper stories of the Crystal Palace, the chief point of attraction is the Gallery of Fine Arts. Entering this by one door, we find high up on one side several first-class photographs, in the centre of which looks forth the aristocratic countenance of Mayor Rodier. Immediately beneath him are several water-color pieces by C. Jones Way, among which is a scene in the White Mountains, another on the Saguenay, another represents the Royal squadron ascending Gaspé Bay, which was selected by the Prince of Wales, and presented to him by the Board of Arts. The varied talent of this artist is visible in many parts of the room. Krieghoff gives a number of peculiarly happy Canadian Scenes. We find here, indeed, perhaps, as fine and varied a collection of originals and copies as has ever been shown in the city; and the selections from Mr Notman's gallery, hardly behind oil painting in art and finish, are a most important portion of it. Among the pieces that more particularly engaged our admiration were 'The Sealing of the Letter' and 'Luther leading his Bride, Catharine Bora, from the Nunnery' (1 September 1860).

Cornelius Krieghoff was living in Quebec City in 1860. He was then probably the most widely-known artist working in Canada, except for perhaps Antoine Plamondon, who had retired in 1851 to a farm at Neuville, east of Quebec City; and the portraitist Théophile Hamel, who was, like Krieghoff, established in Quebec City. C.J. Way was a young English painter, recently arrived in Montreal. William Notman, the photographer, was a Scot, also not too long established in Montreal, although by 1860 already an artist of considerable reputation, as we can gather from this article.

There is little other information concerning art in Montreal in 1860 that can be gleaned from the *Daily Witness* article. We should note that photographs were featured, and on par with the paintings. On the other hand, the paintings – except for the productions of Krieghoff and Way – are of questionable origin and nature. The only other information we have concerning the exhibition is not contemporary.

In the report of the General Meeting of the Art Association of Montreal (AAM) for 1865, preserved by its successor, the Montreal Museum of Fine Arts, we can read that the Art Department of the Provincial Exhibition was organized in August, 1860, under the auspices of the Art Association. The Art Association of Montreal had been established earlier in the year, a manifestation of the cultural aspirations of the large English-speaking population of the city.

THE ART ASSOCIATION OF MONTREAL

The AAM was commented upon in the London *Art Journal* soon after its organization:

> An active movement has been made in Canada to establish in that populous and important colony an institution for the promotion of the Fine Arts. The necessity of such a society has long been felt by the colonists, for the progress of the country in wealth and political power has had the effect of directing the minds of the people towards Art as an evidence of their improved social position, and as a means of increasing those engagements which result from a high state of civilization. It was only right, then, that some efforts should be made for the purpose of organizing an institution which would have the effect of cultivating taste and gratifying those who desire that the Arts and sciences should be recognised among them.

The motivation for such an effort seems to have been understood. What were the stated intentions of the Association? The article goes on:

> To carry out the project a large and influential meeting was held at Montreal on January 25th, when the following resolutions, framed by a committee appointed at a previous meeting, were agreed to unanimously:–

'That after a careful consideration of the subject, the Committee are encouraged to believe that there is sufficient appreciation of its benefits to warrant the formation of such an Association.

'That, in carrying out the organization of the Association, they would propose that it be called 'The Art Association of Montreal,' and that it have for its objects:

'1st. The establishment of an Annual Exhibition of Works of Art.

'2nd. The promotion of sound judgement in Art, by means of lectures, conversazioni, etc.

'3rd. The establishment of a Library and Reading-room, devoted to publications on the subject of Art.

'4th. The establishment of a Gallery of Sculpture, including casts, etc.

'5th. The formation of a permanent Gallery of Paintings.

'6th. The foundation of a School of Art and Design.

'They would recommend to the meeting also that a committee be appointed to canvass the city for the purpose of obtaining a list of subscribers to the Association upon the basis of the above suggestions, as upon the amount of support afforded to it by the public the extent and nature of its operations must be dependent; and that a meeting of such subscribers be called at the earliest date practicable to organize the Association and carry out its objects' (New Series VI, 1860, p. 208).

A meeting of two hundred subscribers was held 25 February, and shortly after, a private bill was proposed in the Canadian Legislature in Quebec City, "An Act to incorporate the Art Association of Montreal" (23 Victoria cap. 13). It received second reading 21 March 1860, and 23 April it was given assent. The Petitioners – the members of the founding committee – were the Right Reverend Francis Fulford, Lord Bishop of Montreal, the Reverend William T. Leach, William H.A. Davies, Thomas D. King, and John Leeming. Their first corporate act was to hold a Fine Arts Conversazione; a social evening, with music, for the purpose of viewing and discussing assembled works of art. It was held the evening of 10 May 1860. Here, is the report of it from the *Gazette:*

This event in the social history of Montreal, marking, as it does, we hope, a new era, in the development of a taste for the fine arts, came off on Thursday evening, and was a decided success. The Music Hall was well, comfortably, filled with a most respectable assemblage of the lovers of art in Montreal. Among them we were glad to notice his Excellency the Commander of the Forces and Staff, the Anglican Lord Bishop (President of the Association), Sir William Logan, and others of the more distinguished residents of the city. There was a good collection of paintings, photographs and objects of vertu, with some fine stereoscopes and microscopes. A portion of the Band of the R.C. Rifles, by the kind permission of Lieut-Col. Bradford, was present, furnishing sweet music, to which Mr. Sabatier furnished a most excellent complement at the piano. Altogether the soiree was a most pleasant and profitable one, and we feel we may congratulate the Council of the Art Association on the success of their debut, a success in very great part due to the unwearied zeal and diligence of the Secretary, Mr. King, to whom the chief meed of praise is due. There can be no doubt, after the interest evinced, that there is a love of the fine arts, which has taken a pretty strong root here in Montreal, and it promises a healthy development (12 May 1860).

The Music Hall was in the Mechanics' Insitute, centrally located on Great St James Street. We don't know who contributed what, by way of works of art ("paintings; photographs and objects of vertu, with some fine stereoscopes and microscopes"). Three things, however, are quite clear. It aspired to be no more than a local affair – for the Montreal community only. It involved the very core of the British establishment of the city. And, it seems, it did *not* involve in an organizational sense, or even much in a social way, any artists. Later in the year, as we have noticed, the AAM organized the art display in the Crystal Palace, and then there was silence for more than three years.

THE AAM IS REVIVED

On 8 December 1863 Bishop Fulford approached the long-dormant Council of the AAM demanding that they "consider the propriety of

holding an Art Conversazione during the present winter." The Council met 26 January 1864, at which time it established a set of Regulations, which was then published. A copy has been preserved by the Montreal Museum of Fine Arts. It contains seven resolutions, which can be summarised:

> 1. "An Exhibition of Works of Art, upon Canadian subjects, or executed by Artists resident in British North America, shall be held (if practicable) in each year... in the month of May...." A sum not to exceed $200 could be spent each year in prizes or purchases from this exhibition.
> 2. An Exhibition open to "all Artists desirous of competing" was to be held each November, up to $200 again to be spent on prizes or purchases.
> 3. An art lottery would be organized to encourage subscriptions and raise money.
> 4. Six Standing Committees were to be appointed: a Finance Committee, a Building Committee, an Exhibition Committee, an Art Union Committee (to organize the lottery), an Art Collection Committee, and a School of Art and Design Committee.
> 5. Each Committee was to determine its own necessary composition.
> 6. A Secretary was to be appointed, and a Curator hired upon occasion as required.
> 7. The Council was to meet once a month; the Committees as they found necessary.

There appears to have been a determination among its supporters to finally establish the operations of the AAM on a firm, well-organized basis. However, during that first year of their renewed effort, all they were able to manage was the staging of another conversazione.

This second conversazione was held 11 February 1864, again in the Mechanics' Hall on Great St James Street. The *Gazette* of 13 February 1864 found this to be a far more successful effort than the one held four years earlier. Even so, we can assume that its general character was nonetheless very similar. The emphasis was on the ownership of the works, most of the exhibition consisting of portions of certain collections held by members of the British and American community.

Andrew Wilson, a prominent businessman and publisher of the *Montreal Herald*, lent twelve objects, for instance. G.W. Frothingham, whose family arrived from Boston in the first decades of the century, and which had made its money first in hardware and then in banking, lent five.

A certain W.A. Townsend lent fifteen works, including what were supposed to be a Carracci and a Canaletto. W.B. Lambe, of another American family, lent a Greuze, and G.D. Ferrier, Jr, lent what was described as a Cranach portrait. The prominent photographer, William Notman, lent eleven works from his art collection, and the local dealers also contributed. A.J. Pell lent two, William Scott ten, including six by the local topographer, James Duncan. And Dawson Brothers, publishers, stationers and art dealers, lent eleven works, including the only three Krieghoffs in the show, and three watercolours by C.J. Way, who seems to have figured so largely in the 1860 "Great Exhibition." The local professional artists again appear not to have been directly involved. Only five contributed any of their own work (and in some cases, works by others which they owned). These were Herbert Hancock, an architect and painter who would soon move to Toronto; William Sawyer, a portraitist who was born in Montreal, but who finally settled in Kingston, Ontario; Otto Jacobi, William Raphael, and Robert Duncanson. These last three will figure prominently in the pages that follow.

There were no French-Canadian artists included, nor any French-Canadian collectors. The show did not go unnoticed in that community, however. The most prominent French-Canadian painter resident in Montreal at the time was Napoléon Bourassa. He is a fascinating figure. Born at L'Acadie, just south-east of Montreal, 10 October 1827, he received a classical education at the Petit Séminaire de St Sulpice in Montreal, and thereafter prepared for the law. He soon abandoned this in favour of art, taking lessons from Théophile Hamel – who had recently established a studio in Montreal – during the winter of 1849–1850. He then worked as Hamel's assistant until the early summer of 1852, travelling to Toronto, Hamilton, Kingston, and into the United States with him, following portrait commissions.

Hamel then settled in Quebec City, and at the end of June 1852, Bourassa left for Europe. He first spent time in Florence, but afterwards moved to Rome, where he was greatly impressed by the religious

mural work being done there by those Germans who called themselves
the Nazarenes. Moving on to France, he studied in Paris with the well-
known muralist Paul-Hippolyte Flandrin. He returned to Montreal at
the beginning of December 1855, but the following year found him in
Ottawa (then called Bytown), where, among other things, he worked
on a series of portraits for the Oblate Order until September 1857.

That month he married Azélie, the eldest daughter of the great
politician and *Patriote,* Louis-Joseph Papineau. In December 1858
Bourassa established a studio in Montreal, at 12 Bonsecours Street. He
worked mainly as a portraitist, but he had returned from Europe con-
vinced that the noblest form of art was the great public mural, devoted
to themes of spiritual import. By 1860 he had his own vast mural pro-
ject underway, an *Apothéose de Christophe Colomb* that would celebrate the
European mission to the New World.

NAPOLÉON BOURASSA AND THE AAM

Bourassa was a man of refined culture. He played music well, and
wrote with much more than average ability. Early in 1864 he was
engaged by the Collège Sainte-Marie in Montreal as professor of draw-
ing and painting, and was then also deeply involved in the effort to
launch a new French periodical in Montreal, *La Revue canadienne.* He
believed strongly in the need for a school of art in Montreal, a library
and a museum, and so quite naturally had become a member of the
AAM (although he was neither exhibitor nor lender to the 1864 conver-
sazione). A keen and interested observer, he wrote a lengthy commen-
tary on the occasion of the February show in *La Revue canadienne* (I,
March 1864, pp. 170 – 182) entitled "Quelques réflexions critiques à
propos de l'Art Association de Montréal."

Although lengthy, it is light and relaxed. He felt that his readers
required an extensive explanation of this new phenomenon on the
Montreal scene, and so most of the article is devoted to background.
He first explains what a "conversazione" is, although decrying the use
of the word, as the English pronounced it in such a ridiculous manner.
He then felt that it was necessary to explain why the Art Association
was an English affair:

> This spirit of association exists at a high level among our Eng-
> lish compatriots. It is a quality so deeply entrenched in them

by their upbringing that it is today part of their characters. No matter where he goes to settle, the Englishman takes it with him and maintains it, for there is no doubt that it is his most precious piece of luggage. It is this quality that contributes most vigourously to his success, and that secures wealth and unquestioned political dominance for him wherever he goes – with no great effort, without disputes or internal wars.

We, whose origins are French, spend a long time arguing at the beginning of any new venture. We spend more time arguing in the middle and we almost always argue when it comes to the end. How many fine ideas, how many patriotic plans have we not smothered in the cradle by arguing so childishly! We have learned nothing from past experience; on the contrary, we have never been more disposed to squabbling (p.171, trans.).

It is difficult to imagine how such an explanation could have satisfied very many of his readers. He then goes on to state his belief that all great art of the past has rested upon religious themes. The English were deficient in this area. They were perhaps the greatest collectors of all, but English art had not as yet reached the level achieved by the other countries of Europe. English art was small in scale, and concerned only with small things. It was not grand and spiritual.

All of this was by way of preparation for his consideration of the AAM exhibition. Or more precisely, so that he would *not* have to give much space to the consideration of it. "The way I have described English art will give a clear idea of what there is in this exhibition, and will release me from talking about it at greater length" (p.203, trans.). He explains that the show was made up almost entirely of works from small private collections and that obviously one should not expect much. Slight as it all was, there were some diverting pieces lent by Andrew Wilson, G.W. Frothingham, and one or two others. Otto Jacobi is the only painter then working in Montreal whom he mentions. He concludes, finally, with a long appeal to Benaiah Gibb – the Vice-President of the Association and, in Bourassa's opinion, the most serious collector in Montreal – to consider leaving his collection to the AAM. It is a bold suggestion, but one, as it finally turned out, that paid off.

THE ART UNION IS ESTABLISHED

In the firm belief that some sort of extra incentive was required to draw public attention to the activities of the AAM, the Council soon after the 1864 conversazione sought special permission of the Canadian Parliament to organize a lottery or Art Union in connection with their exhibitions. This was to involve the selling of chances on a draw for works of art, the tickets also admitting the bearer to the exhibition, and entitling him to some sort of small work of art. The scheme, which was widely practiced in England and Scotland, and also had become very popular in the United States, was, of course, a form of gambling, and as such was condemned by a certain portion of the population, and was prohibited by law.

However, the Lord Bishop of Montreal felt that the benefits of such an operation far outweighed any dangers. Subscribers would be attracted to the AAM, swelling its membership and consequently its resources; artists would benefit by having works of art purchased for distribution in this fashion, and the populace would benefit from thus having the opportunity of taking works of art into their homes. A private member's bill was put before the Canadian Parliament in Quebec City in the spring, and 30 June 1864 an act was given assent that enabled the AAM to establish an Art Union (27 Victoria cap. 142).

THE AAM LOTTERY AND SHOW

On the evening of 27 February 1865, the AAM held its third exhibition, which again opened in the Mechanics' Institute with a conversazione. In many ways, it was more ambitious than either of the preceding two. The Art Union had attracted over four hundred subscribers. Each subscriber is supposed to have been given two photographs by Alexander Henderson, an important amateur in the city, of whom we will hear more later. The draw itself was for forty other works of art, the chief prize being a large watercolour, *Headland, Spanish River,* painted by W.N. Cresswell, an English artist who had settled near Seaforth, on the shores of Lake Huron in Canada West.

The Exhibition Committee had, indeed, gone much farther afield than previously in its search for appropriate works. Artists in both Canada East and Canada West had been approached, and arrangements were made for a large group of pictures to be sent up from New

York, and another from Boston. The Boston pictures were lent by two collectors, and most of the pictures from New York were also owned by two collectors, but some New York artists were themselves induced to send paintings, including George Innes, J.F. Cropsey, and Albert Bierstadt. William Armstrong of Toronto joined Cresswell to form the contingent from Canada West. And that year, the Montreal painters also made a greater effort. Hancock, Duncanson, Raphael, and Jacobi all showed again; and Adolph Vogt and Napoléon Bourassa contributed work for the first time. There was also a separate section for photographs, and a selection of reproductive engravings of famous European paintings.

It was advertised that the exhibition would be open to the general public for ten days after the conversazione (it in fact remained open almost a month), and the catalogue contained a long introductory text explaining in detail the technique of an oil painting, a watercolour painting, and an engraving. Reprinted from the catalogue of the Fine Arts Collection of the International Exhibition held in London in 1862, in the course of describing the various media, the introduction also undertook a vigorous historical explanation of the strength and merits of English art. It was chosen, doubtless, as a kind of reply to Bourassa's criticisms of the year before. The English-language press in Montreal hailed the whole effort with enthusiasm.

FURTHER COMMENTS FROM BOURASSA

Napoléon Bourassa exhibited three oils – a *Fishing Scene,* which is probably *Les petits pêcheurs* of 1860 now in the Musée du Québec, a *Christ in the Garden,* and a picture called *Misery* – and had two crayon portraits contributed by others. Although still out of sympathy with the sort of art that was generally shown, he nonetheless found the public success of the exhibition laudable. What it was achieving for the development of Canadian art, however, was open to some question:

> Glancing around at the various small pictures gathered here, one quickly apprehends that no national work of any great importance has come to light this year. This exhibition is less a demonstration of the progress of our Art than a manifestation of the growing efforts on the part of the Association to breathe some life into it. For in a city like ours, where a few

despairing lovers of painting look in vain for something to appear on the artistic horizon, we should not expect to be suddenly blinded by flashes of genius or see the splendours of the 17th century appear overnight (*La Revue canadienne*, II, March 1865, p.17, trans.).

His view of what might constitute the basis of a national art was very particular, and it had nothing to do with landscape. As we will see, the artists who were introduced to the Montreal audience through these exhibitions of the sixties, largely chose to work with landscape images. Bourassa, and for that matter, the largest part of the French-Canadian community of Montreal, never appreciated what they did.

Nor did Bourassa value the contributions of the photographers.

We live in an age ruled by machines, in a time when fortune smiles on all those who follow Daguerre, on all those found-lings of Art born of progress in chemistry and a few rays of light. Truly, the sun must shine for everyone (p. 173, trans.).

Again, as we will see, it was photographic images of the expanding nation that were often most prominent during these and the following years: images that attracted the painters, and that they found they had to accommodate to their own art.

Bourassa did approve, on the other hand, of the inclusion of paintings from Boston and New York:

First of all, it demonstrates that the work of the Art Association is already being felt at some distance; that a dialogue has begun between the art associations of these two great cities and our own; that the core of an intelligentsia is forming amongst us, beside the commercial one, a core that should aim to enrich and improve our social lot, and grant us a more lasting importance, a more durable fame. The more we can attract into our midst remarkable works from other lands, the more we will give those who are sensitive to beauty the means to compare and learn; and to our artists a chance to establish their reputations on firmer ground (p.175, trans.).

It is against the background of this attempt of the Art Association of Montreal to establish a formal support for art in Montreal that we must now examine the activities of the principal artists.

II

Landscape, Photography and Painting: 1860–1867

William Notman: his influence and his art
Charles J. Way
Robert S. Duncanson
John A. Fraser
William Notman and Photographic Selections....
Alexander Henderson
painting and photography: changing opinions

WILLIAM NOTMAN

The artist most involved in the foundation of the Art Association of Montreal was William Notman (see pl. 1). He first appears in a Montreal city directory in 1858, already established as a photographer in a studio at 11 Bleury Street. As the directories were generally published in the spring, it is possible that he had set up his business as early as April or May of 1857.

We learn from Notman's obituary, which appeared in *The Dominion Illustrated* of 5 December 1891, that he was born in Paisley, Scotland, 8 March 1826. As a young man in Scotland he wanted to be a painter (there is a competent oil landscape in the Notman Photographic Archives at the McCord Museum in Montreal). However, his family had other ideas, and persuaded him to enter the wholesale dry goods business. It was with the intent of pursuing this trade that he emigrated to Montreal at the age of thirty in 1856. He was first employed by the dry goods merchants, Ogilvy, Lewis & Company, as was his brother, Robert. But apparently the appeal of art was still great, because after less than a year at Ogilvy's an earlier fascination with photography took hold again, and he shifted his business interest accordingly.

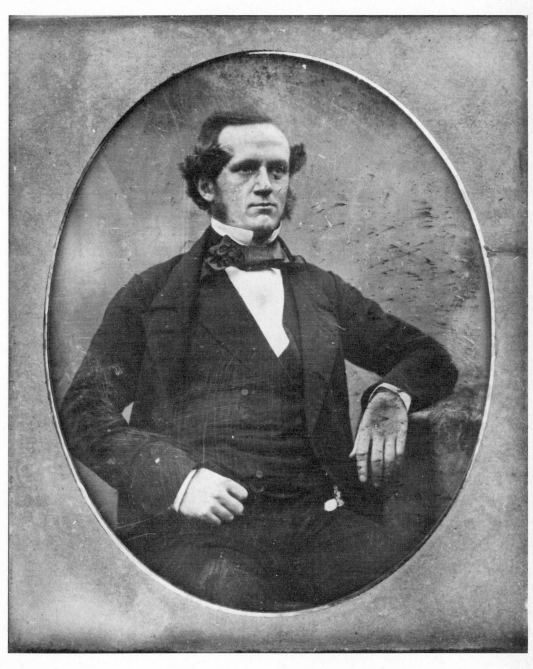

1

Photographer unknown
William Notman probably 1853
Daguerreotype, quarter-plate
Notman Photographic Archives,
McCord Museum, Montreal

By this time he already had a family. He had met Alice Merry Woodwark, an Englishwoman from near Stroud, and they had married on 15 June 1853. William came out to Canada ahead of her, but she was able to join him a few months later. They and their two children, Francis Elizabeth (Fanny), who was three, and William McFarlane, born in Canada the previous November, were now all living at 143 St Urbain, with brother Robert, who was still employed by Ogilvy, Lewis & Company.

With regard to much of the information concerning these early years we are indebted to Russell Harper, who devoted a magnificent volume to Notman and his art, which he prepared with Stanley Triggs (*Portrait of a Period*, Montreal, 1967). When Notman opened his studio on Bleury there were more than a few photographers working in Montreal, mainly portraitists. But he was good, and his new business flourished from the start. "Constant experimentation was one of the secrets of William Notman's success" says Harper. "No new development was overlooked, and he was always ready to enlarge upon any idea which seemed practical."

Notman was one of the first in America to take so-called "instantaneous" landscape photographs: the shorter exposures achieved through a reduction of the negative size. And at about the same time he began to produce stereographic views in large numbers. Stereography during the eighteen-fifties attracted a very great deal of public interest with its startling illusion of space. Many households possessed a stereoscope, the instrument that held the stereo card for viewing and unified its double image.

We cannot identify which are the first among Notman's stereo views, but we do know that soon after he had established his business he became engaged in chronicling the progress in the construction of the great Victoria Bridge. He continued to photograph the bridge after its completion, quite evidently drawn to the power of its stark beauty, and in August 1860 when the Prince of Wales officially opened the structure, Notman of course was there. He photographed other events during the Prince's visit, and although there is no evidence that he was then working under commission – the Prince had brought the painter G.H. Andrews from London to record his progress – Notman did receive an order from the Governor-General, Sir Edmund Head, to prepare an elaborate set of stereo views and other photographs for

later presentation to the Prince of Wales as a memento of his Canadian visit.

Head did not necessarily arrange for this in advance of the tour. Notman had on hand a great variety of views, and actively promoted their sale through catalogues, one of which he sent to the *Art Journal* in London in the fall of 1860. The notice that appeared in response is of considerable interest not only because of what it reveals regarding current attitudes towards stereography, but also because it shows the extent of Notman's achievement in this field. I repeat it here in full:

> A publisher in Canada, Mr. Notman, of Montreal, has issued a mass of views for the stereoscope, of which he has sent us some specimens, together with his list, containing the names of no fewer than five hundred and twenty places thus pictured. Judging from those before us, the productions are of great merit; skilfully manipulated, and arranged with much artistic skill, the subjects being judiciously selected. They give us, indeed, almost a perfect idea of the interesting country which is just now attracting special attention in England – the ties that bind us to our valuable colony having been drawn closer and closer by recent events. It is impossible for us to convey an idea of the extent of country embraced in this large series: of the Victoria Bridge alone there are forty views; of Montreal, and its neighbourhood, sixty; of Quebec, and its vicinity, forty; while of Niagara, there are, perhaps, one hundred. The publication is a large boon to Art: the views cannot fail to be acceptable to all who take delight in the stereoscope (New Series VI, p. 351).

The grandest tribute to Notman's stereoscopic art, however, he prepared himself: an elaborately bound and cased set of some 600 photographs that was delivered to the Prince of Wales in June 1861. A duplicate that he retained for himself (it lacks the views actually taken during the tour) is now in the Notman Photographic Archives at the McCord Museum (see pl. 2). The stereos are mounted nine to a page in two volumes (along with other photos), one depicting scenes in Canada East, the other in Canada West. Beautifully bound, these two volumes are contained with their own viewer in a finely-crafted box of bird's-eye maple, fitted with silver mounts.

The stereo views themselves display a similar elegance and attention to craftsmanship. Because of the small size of the double negatives – which were exposed simultaneously, focused on the same scene but from slightly separated points of view – there is some loss of detail and a tendency to high contrast. Notman fully exploited the dramatic mood that results. In the numerous scenes of waterfalls, white water gleams against black rock, and in the majority of the landscapes, unmodulated light skies form a backdrop to the ominous density of the forests (see pls 3 and 4). There is an iron-like solidity to all of this early work.

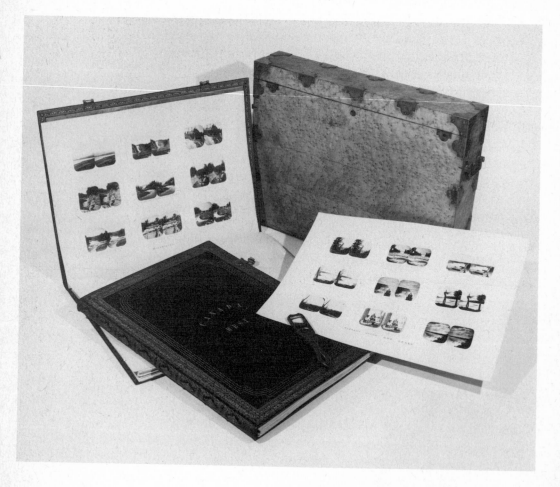

2

William Notman
Prince of Wales Presentation Portfolios 1860
Two leather-bound portfolios of photographs in a maple box
Notman Photographic Archives, McCord Museum, Montreal

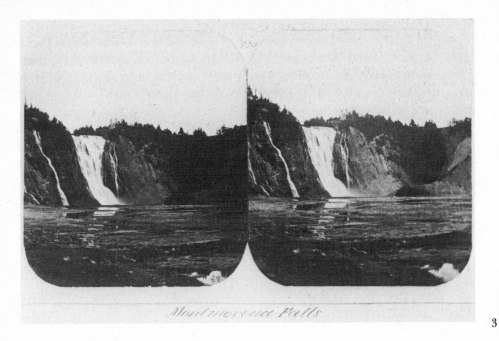

Montmorency Falls

3

4

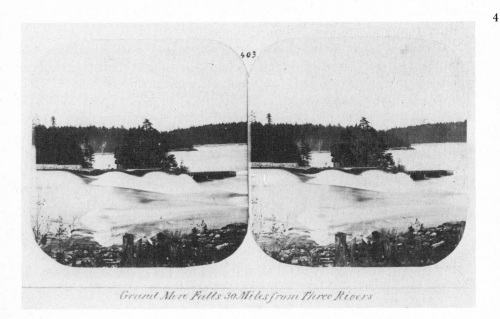

Grand Mere Falls 30 Miles from Three Rivers

3
William Notman
Montmorency Falls, Quebec
before 1860
Stereograph, 7.5 x 14.2 cm
Notman Photographic Archives,
McCord Museum, Montreal (7520 view)

4
William Notman
Grand-Mère Falls, 30 Miles
from Three Rivers before 1860
Stereograph, 7.5 x 14.2 cm
Notman Photographic Archives,
McCord Museum, Montreal (7403 view)

The compositions are always striking. Carefully contrived, with a foreground of varied texture and interesting detail, each image inevitably has a clear middle plane, a backdrop, and often as well some form that recedes sharply into the deep space. For of course stereography was devised in order more effectively to give the illusion of space, and all of these pictorial devices aided the mechanical effect of binocular photography. In some of his stereos of the Victoria Bridge, however, Notman laid aside these essentially painter's devices, shooting the simple, stark form straight-on as it soared overhead (see pl. 5). Relying thus solely on the inherent optical effect of his medium, the resulting image is, in its directness, startlingly modern.

Between spring 1859 and the late winter of 1860 Notman expanded his business to include 9 Bleury, and moved his home to Lagauchetière. The household had grown with the addition of another daughter, Jessie Sloan (born 9 December 1859), but he was no longer sharing living space with his brother Robert, who does not appear in the 1860 city directory, although he is back again by early 1861 with another brother, John, and their father, William Sr, freshly arrived from Scotland with their mother, their sister, Margaret, and a young brother, James. All six are resident at 148 St Urbain, up the street a couple of doors from the place William and Robert had shared when they first arrived from Scotland about four years before.

The new-comers must have been impressed with William's success. By early 1862 he had moved his home to 7 Bleury, which gave him three doors in a row on that fashionable street. Business continued to expand, and at the beginning of 1865 he had consolidated his shop in larger quarters near the corner of Craig at 17 Bleury (where he would remain until his death), and had taken a suburban house, Clydeside Cottage, on the Lower Lachine Road. The Notman family also continued to grow, increased by a third daughter, Alice Richenda (born 12 April 1863), and soon a fourth, Emily Mary (7 August 1865). His two brothers, Robert and John, were both probably working for him by then. The former is listed in that year's directory as a photographer, and the latter as an artist, neither with an independent business address.

Certainly by 1865 William Notman had in his employ a number of camera operators and, as has so often been noted elsewhere, many of the prominent painters of the city. The firm's wage books that are pre-

served in the Notman Archives begin only with the summer of 1864. But we know that about a year earlier the firm was assembling a publication that demonstrates a close involvement with those whose interest in art centered on painting, and also reveals some direct association with three painters then in the city: C.J. Way, Robert Duncanson, and John A. Fraser.

This publication, which bears the date December 1863, is *Photographic Selections by William Notman*. We shall return to it later to explore what it and a companion volume of 1865 reveal of taste in Canada just prior to Confederation. At the moment it is useful from the viewpoint of our consideration of William Notman's involvement with Montreal's painters. The "Photographic Selections" of the title are almost all photographic reproductions of paintings (there are only two photographs "from nature" among the forty-six items in the book). There is among these one by Fraser, who was Notman's art director and later a partner in the firm. There are two by Duncanson, an American then resident in Montreal. And there is one by Way, an Englishman who arrived in Montreal about 1859. Let us turn to him first.

5
William Notman
Bottom of Centre Tube,
Victoria Bridge 1859

Stereograph, 7.5 x 14.2 cm
Notman Photographic Archives,
McCord Museum, Montreal (7014 view)

CHARLES J. WAY

Charles Jones Way was born in Dartmouth, Devonshire, 23 July 1834. This is according to information he supplied, while living in Lausanne, to a Swiss dictionary of artists, published in 1913. (Shortly after that, he filled out an information form for the files of the National Gallery of Canada in which he gives his date of birth simply as "1835.") We know nothing of Way's youth. He noted on the information form that he studied art at the South Kensington School in London (for only one year apparently, 1855), and that he arrived in Canada in 1858 and settled in Montreal. He was then twenty-three or twenty-four years of age. He first appears in the Montreal city directory in 1860, as "artist, Bonaventure Bldg, Commissioners Square" (see pl. 6).

He remained in the same quarters on Victoria Square (the new name for Commissioners Square after 1860) until at least the spring of 1862. Although Way is not listed in the 1863 directory, he gave his address as Montreal when exhibiting at the National Academy of Design in New York that year. And in 1864 William Notman published a volume of twelve photographic reproductions, *North American Scenery, being selections from C.J. Way's studies, 1863–64.*

North American Scenery...., the second of Notman's large-format publications, contains photos of monochromatic watercolour paintings executed by Way in Maine, Gaspé, at Quebec City and the mouth of the Saguenay, in New Hampshire and at Niagara. There is also a view of Montreal dated 1864. Some time during that year he returned to England, where he arranged for his Montreal dealer the production of two chromolithographs of Canadian scenes. As reported in the *Art Journal*, they tantalize us by the English reaction to their "strangeness":

> Messrs Day and Son have executed for Messrs Dawson Brothers, of Montreal, a pair of small chromolithographs of Canadian river-scenery, from sketches made by Mr Way, an English artist temporarily resident in that country. The views are striking, and appear singular, to those who are ignorant of the peculiar atmospheric effects and vegetation of Canada, from their intense vividness of colour. One of the pictures, where the banks of the river are lined with large blocks of ice, whose whiteness contrasts strangely with the deep red purple of the distant line of hills and the glowing crimson and yellow of a

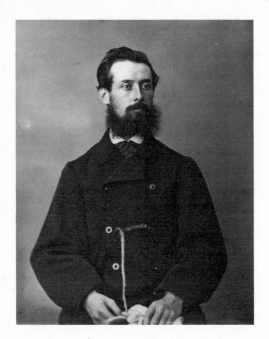

6
William Notman Studio
C.J. Way 1864
Albumen print, 8.0 x 5.5 cm
Notman Photographic Archives,
McCord Museum, Montreal (9522-I)

sunset sky, presents a most remarkable appearance (New Series III, 1864, p. 251).

Back in England, and, it would seem, really established for the first time, Way had watercolours accepted for exhibition in 1865 at both the Royal Academy (RA), and the Royal Society of British Artists (RSBA).

Way's career then was, effectively, launched in Montreal. And judging by the text to his *Falls of the Shawenegan* (pl. 7) published in the 1863 *Photographic Selections by William Notman*, he quickly rose to prominence in that city. It reads in part:

The productions of this artist are so well known and appreciated in Montreal, that little need be said in his behalf. His great aim and object was to be truthful, and to faithfully represent what he saw. Perhaps there has been no artist, certainly no water colour painter, resident in Canada, who has given to us so much variety of subject, from the grandeur of our mountain solitude, to the quiet dell and babbling brook – and has so happily caught the peculiarities of our Canadian landscape, and given so much expression to our beautiful skies.

It is possible, of course, that the enthusiastic praise expressed here by Thomas King, the author of the letter-press portion of the 1863 *Photographic Selections....*, was motivated by his knowledge that the work of C.J. Way was to be the subject of the next Notman volume. And in the catalogue of the 1865 exhibition of the AAM we see that Notman himself had bought all twelve of the sepia drawings that were photographed for the 1864 *North American Scenery.... Notman's Photographic Selections* of 1865 (about which more later), included twelve photos of British scenes by Way, mostly of Wales. Notman exhibited four of the sepia originals – again his own property – in the 1867 AAM exhibition. By this time, Way had been absent from Montreal about four years.

It is clear that he sold quite a bit of work during this first stint in Montreal, roughly from 1859 through 1863 (he held a large exhibition at Dawson Brothers late in 1863), and that this work appealed to people who were at that time among the leading collectors and the principal supporters of the AAM, such individuals as Thomas Rimmer, S.E. Dawson, W.F. Kay, C.H. Frothingham and John Popham. During the royal visit of 1860, the Prince of Wales was presented with a painting of Way's depicting the arrival of the Prince's squadron in Canadian waters off Gaspé. And, of course, it is clear that he enjoyed the committed support of William Notman.

What was the great appeal of Way's work? One cannot say with much degree of certainty, as few of his early works have, as yet, come into public collections. But from the evidence of the Notman photos it was chiefly, at this point in his career, a quality of drama. There is a large watercolour in the Loeb Collection in Toronto, *Niagara in the Time of the Red Man* of 1864, in which the sky, in the fiery colours of the great English Romantic, Turner, races as fiercely as the plummeting waters (pl. 8). Way has observed closely, and displays an evident concern to describe the water in an exact, naturalistic way. But the force of his imagery lies in the great, broad movements of the composition. It is equally so with the Notman photos of his sepias. Way is an impressive craftsman, who controls tone and texture expertly, orchestrating each image like a small symphony in tribute to nature's power and energy. That would certainly have appealed.

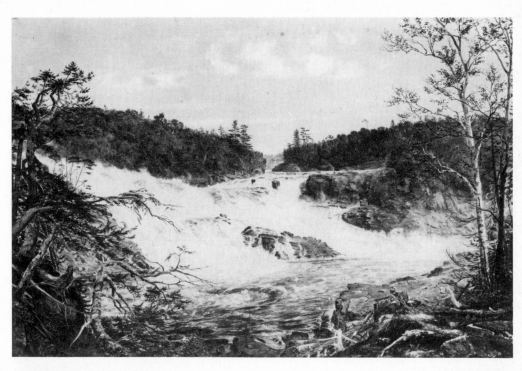

7

8

7
William Notman Studio
C.J. Way's Falls of the Shawenegan,
in *Photographic Selections....* 1863
Albumen print, 17.5 x 26.5 cm
The National Gallery of Canada,
Ottawa, purchased 1968

8
C.J. Way
Niagara in the Time of the Red Man
1864
Watercolour, 71.0 x 119.4 cm
Mr and Mrs Jules Loeb, Toronto

ROBERT S. DUNCANSON

Robert Scott Duncanson, the second local painter featured in the 1863 *Photographic Selections....*, had arrived in Montreal probably during the summer of that year. Although quite a bit of work has been done in the United States to reveal the intricacies of his career, much remains to be explained. In particular, Duncanson's numerous connections with Canada remain obscure. He was born in 1821, somewhere in New York State, his father a Canadian of Scottish descent, his mother a black, and although she had been free-born, slavery loomed as an ever-present threat to Duncanson during his maturing years prior to the American Civil War. There is no precise information concerning his activities before 1842, when he first exhibited paintings in Cincinnati, Ohio. It has been handed down from fairly early sources that he was educated partly abroad, probably in Canada, and possibly also in Scotland. A recent writer has suggested that his father took him as a boy to Wilberforce, the community near London in Upper Canada that had been established in the 1830s as a haven for slaves.

By 1842, nonetheless, Duncanson was living with his mother at Mount Healthy, outside of Cincinnati, and over the next ten years he seems to have worked as a painter in that city, and also in Detroit, and to have established himself latterly as a "daguerreotype artist." He is listed as such in the Cincinnati city directory of 1851. In 1853 the Anti-Slavery League sponsored him on a trip to Europe, and he travelled to Italy with another Cincinnati artist, the landscape painter, William Sonntag. He is for the first time listed simply as an "artist" in the 1855 Cincinnati directory. In 1858 he purchased land in Detroit, and so seems to have re-established, after his European trip, the pattern of working between those two cities.

As he approached the age of forty Duncanson enjoyed a considerable reputation in the Ohio area, but he quite naturally sought broader horizons. With the outbreak of the Civil War he must also have felt some desire to remove himself from the conflict, a conflict that revolved so much on questions of racial prejudice. For whatever reasons, sometime late in 1860 he commenced a vast, ambitious work. We can read the following in the *Cincinnati Gazette*:

R.S. Duncanson, Esq., has just completed and placed on

exhibition his painting, the Lotus Eaters – from Tennyson's poem of that name. Mr Duncanson has long enjoyed the enviable reputation of being the best landscape painter in the West, and his latest effort cannot fail to raise him still higher in the estimation of the art loving public.... His vivid portrait of the poet laureate's composition, presents to the eye a scene of almost unequalled beauty, of detail, as well as configuration. The mountains, tinted with the crimson glory of the setting sun, the soft, mellow and unclouded sky, and tableland and valleys, rich in the luxuriance of a tropical clime, are rendered with a faithfulness truly wonderful.

Mr Duncanson has been engaged upon this picture about six months. He had just commenced another, which will develop his talent as a delineator of nature in a state altogether different from tropical mildness and beauty. He purposes to paint a 'Western Tornado,' and we doubt not will fully realize the expectations of his most sanguine friends in its production. The Lotus Eaters will be on exhibition at the extreme east store of Pike's Building, on Fourth street, for eight days, after which it will be taken to Canada and exhibited there. In about six months, it and the Western Tornado will be sent to London and disposed of (30 May 1861).

It stayed on view until almost the middle of June (*Cincinnati Gazette*, 4 June 1861).

Duncanson was apparently unable to fulfill his travel plans, and he is still listed as a resident in the Cincinnati city directory of 1863. He may have made a short visit to Montreal earlier, because many of his paintings of 1862 were done in nearby Vermont and New Hampshire. But it is clear in a letter from a friend, which was sent to the London *Art Journal* early in 1864, that the plans went somehow awry:

He [Duncanson] painted the 'Lotos-Eaters' in 1861; after exhibiting it in companionship with 'The Tornado'; the two were sent to Canada for view, *en route* for this country. By an accidental circumstance he was unable to carry out his intentions, and the two paintings have remained in Toronto, Canada West, till, I believe, the present time....Besides these

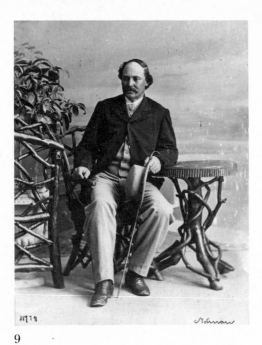

9

9
William Notman Studio
R.S. Duncanson 1864
Albumen print, 8.0 x 5.5 cm
Notman Photographic Archives,
McCord Museum, Montreal
(11,978-I)

10
William Notman Studio
R.S. Duncanson's The Lotus Eaters,
in *Photographic Selections....* 1863
Albumen print, 19.0 x 33.0 cm
The National Gallery of Canada,
Ottawa, purchased 1968

he has lately – within these two or three years – painted a rep-
lica of the 'Lotos-Eaters,' a view of Niagara, 'The Prairie on
Fire,' and 'Œnone,' an ideal view of the Vale of Ida, Mount
Gargarus, and the Trojan city in the far distance.... All these
paintings are of nearly the same dimensions as the 'Lotos-Eat-
ers'.... When I left Cincinnati in last May [1863], he then fully
intended coming to this country for a home, bringing his large
paintings with him for exhibition (New Series III, 1864, p.
113).

No other evidence has turned up of either Duncanson, or his
paintings, appearing in Toronto, but sometime during the summer of
1863 he did establish himself in Montreal (see pl. 9). He soon made the
acquaintance of William Notman, who photographed *The Lotus Eaters*
(pl. 10) and another impressive painting, *City and Harbour of Quebec.*
Both of these appeared late in 1863 in *Photographic Selections....* The text
accompanying the latter asserts that "Mr Duncanson has been for some
time resident in Montreal; where he has met with that success and

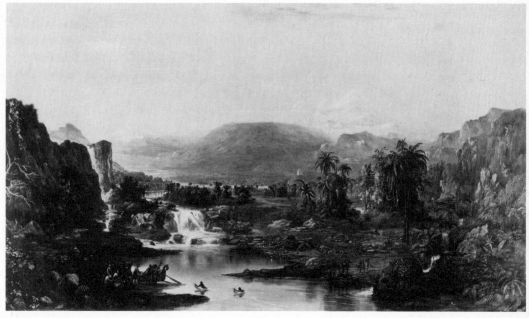

10

encouragement in his profession as a landscape painter, which he was entitled to expect as the painter of the Lotus Eaters."

Although he may have been able to exhibit *The Lotus Eaters* in his rooms or with a dealer in the fall of 1863, Duncanson arranged for its public display in the February 1864 exhibition of the AAM along with the *Prairie on Fire* mentioned by the *Art Journal* correspondent. This new painting, almost as large as *The Lotus Eaters* was already in the hands of one of the Montreal picture dealers, the previously mentioned A.J. Pell. A year later Duncanson was still in Montreal, and at the end of February 1865 he was represented at the AAM exhibition by seven oils and one watercolour. The oils were of the Eastern Townships, the Quebec City region and the Ottawa River, as well as *Recollections of the Tropics*, and *The Vale of Cashmere*. This last and the two views on the Ottawa had already been sold.

Duncanson had not abandoned his plan of going to Britain, however. He managed to have work included in the Canadian representation at the Dublin Exhibition of 1865 (address given as Montreal), showing *The Lotus Eaters*, of course, and a *Chaudière Falls near Quebec*.

Some time that year – probably in late spring or early summer – he finally did get to Britain, and late in the year a Presbyterian minister wrote back to Cincinnati describing the great interest Duncanson's work had aroused there (*Cincinnati Gazette*, 24 November 1865). He apparently exhibited in Glasgow, and presumably in London. A lengthy notice in the *Art Journal* early in 1866, although praising *The Lotus Eaters* most extravagantly, fails to mention where the painting could be seen. Canadian pictures by Duncanson are mentioned in passing (New Series v, 1866, p. 93). He is listed again in the Cincinnati city directory for 1867, and so most likely left Britain in the fall of 1866.

Duncanson's stay in Montreal of one and a half to two years duration does not, perhaps, count for a great deal. But the spectacular *The Lotus Eaters* would certainly have been remembered for some time, and he sold a number of paintings before he left. There are a *Lake St Charles, Near Quebec* of 1864 and a *Lake Beauport* of 1865 in the Musée du Québec, both medium-sized canvases. The Montreal Museum of Fine Arts has a small oil sketch of 1863 which we will mention again later, and also possessed a second, which was sold in the late nineteen-forties. There is a watercolour *View on the St Anne River* of 1864 in a private collection in Montreal that is as large as the Quebec City canvases. And the National Gallery of Canada now has four works: a large 1864 watercolour study of trees entitled *Mount Royal*, mounted on canvas; a small oil, *Montmorency Falls* of 1865; a larger oil of 1864, *The Owl's Head Mountain*; and an even larger canvas of 1868, *Wet Day on the Chaudière Falls*, that was painted after his return to Cincinnati, yet was sold in Canada. There doubtless are more in private collections.

The most interesting of all of these is *The Owl's Head Mountain* (pl. 11). It and *View on the St Anne River* Duncanson sold in January 1865 to a certain J.C. Baker, a banker at Stanbridge in the Eastern Townships whose interests brought him frequently to Montreal. It is not a very realistic picture of Lake Memphremagog, and certainly the Owl Head has been exaggerated in shape – it is not so cone-like. The painting in fact is a romantic poem, a little bit of the Land of the Lotus Eaters transferred rather incongruously to a Canadian setting. Its ethereal light is remarkable, even memorable, and as we later look at other paintings of Lake Memphremagog by younger men in Montreal, we will have particular reason to remember that light.

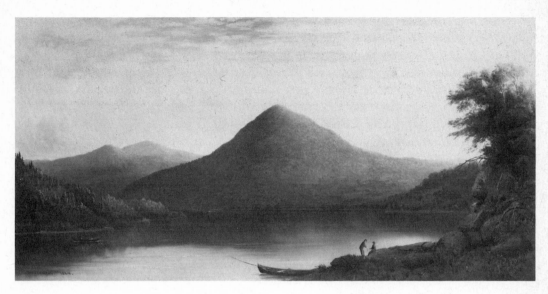

11

R.S. Duncanson
The Owl's Head Mountain 1864
Oil on canvas, 45.7 x 91.4 cm
The National Gallery of Canada, Ottawa,
purchased 1978 (18,982)

JOHN A. FRASER

John Arthur Fraser, the third local painter included in the 1863 *Photo-graphic Selections....*, was of all three, the most closely related to Not-man's enterprises. Fraser was born of Scottish parents in London, 9 January 1838, and family tradition has it that he set out on his own at the age of fourteen to become an artist, working during the day to pay for evening classes at the Royal Academy. His father, also called John, and a native of Banff (Scotland), was a Moral Force Chartist, an extreme liberal very rigid in his ideals. Again according to family tradi-tion, John Fraser's business collapsed in 1858 (he was a tailor), in part, at least, as a consequence of his political stance. The decision was then taken for the whole family to emigrate to Canada.

Be that as it may, family records show that John Arthur married Anne Maria Sayer of Herne Bay, Kent, 4 April 1858, and that five days

later they sailed for Quebec. They settled in the Eastern Townships with his parents, two brothers, and two sisters, and their first child, John Arthur Jr, was born at Stanstead on 12 March 1859. They soon moved to Montreal, and Fraser first appears in the Montreal city directory in 1860 as "artist" on Balmoral Street, one block east of Bleury above St Catherine. Their second child, Augustine George, was born 11 January 1861. Fraser must have begun working for William Notman almost immediately upon his arrival in Montreal, tinting photographic portraits. He was living at 386 Lagauchetière, the same street as Notman, by 1861 and in the Notman Archives at the McCord Museum there is a tinted photo of T.M. Taylor and family, signed by John Fraser and dated 1861. By the spring of 1863 Fraser had moved again, to 136 St Urbain, at that time also a Notman neighbourhood, and by October 1864, when he first appears in the Notman wage book (which only records back to the summer of 1864), he is drawing $61.50 every other week as the "Art Director," the highest-paid employee of the firm.

Fraser's tinting work is of the highest order. There are a number of examples in the Notman Archives, and all are delicately painted in order to bring out the photograph's own tone. His sense of colour is true and balanced, and his colour arrangements are always pleasing. A portrait of his wife which is still in the family is as striking, as clean and intense as a miniature on ivory. Did he work at landscape painting too, during these early years? It would seem not very much. The text accompanying his picture in *Photographic Selections....* is quite explicit:

> This is one of the few landscapes that the artist has produced since his residence in Canada. His practice is to paint in the open air, direct from Nature, and many of his sketches are faithfully transcribed from particular spots. There is a freshness and natural tone about them that makes us regret he has not had more opportunity of following a branch of art in which he would be successful.

Judging from the old photo of *Sunshine and Shower* (pl. 12), Fraser was in 1863 an accomplished painter. He of course handled paints daily at Notman's, and so we should expect an adept hand and a good sense of how the paint would respond. He has given us a feeling of the space over the pond with the careful placement of trees, and their foliage is handled in such a way as to emphasize texture. It is all well-exec-

uted, it would appear, but forgettable; about as typical a mid-century English landscape painting as one could find.

He exhibited only two works in the 1864 AAM show, both oils. One was lent by A.J. Pell, the other by William Notman. Again in February 1865 he exhibited only oils, and all were lent by others. There was a sketch of Owl Head Mountain in the Eastern Townships; a copy after a *Portrait of Lord Metcalfe*; and a *Portrait of the Bishop of Montreal*, who was also the president of the AAM. This last was presented to the AAM for their permanent collection by William Notman. Then there was one tinted photographic portrait, also lent by Notman. John Fraser's artistic activity quite clearly centered on the photograph during his first years in Canada.

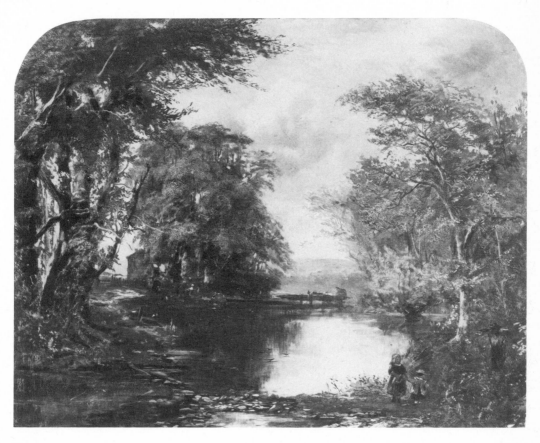

12

William Notman Studio
John A. Fraser's Sunshine and Shower,
in *Photographic Selections....* 1863
Albumen print, 14.5 x 18.8 cm
The National Gallery of Canada, Ottawa,
purchased 1968

Should we be surprised? It would seem at this remove that the most original art being produced in Montreal in the mid-sixties was coming out of William Notman's studio on Bleury. And many, if not most, of his contemporaries would have agreed. A new Montreal magazine, *Les Beaux-Arts*, inaugurated a column in its second year, which was devoted to "Les arts et les artistes en Canada," and the first artist so presented was "M. Notman, le célèbre artiste photographe de Montréal." They were extravagant in their praise. Photography itself was an

> art that has become a rich source for all the arts. Mr Notman's photographs are true masterpieces. The skill, which is a characteristic of this artist, is incontestable.... But what raises Notman to the rank of first-class artist-photographer is the magnificent publication which he is publishing by subscription, in monthly installments. (ii, 25 February 1864, p. 20) (trans.).

His portrait work was also highly valued, as is indicated by the following notice, which appeared in the London *Art Journal* at about the same time:

> There must be something in the atmosphere of Canada very favourable to the development of photographic art, judging from a number of specimens recently sent us by Mr Notman, of Montreal, which are certainly among the most brilliant *carte-de-visite* portraits we have ever examined (New Series IV, 1865, p. 95).

And the next year the *Art Journal* yet again singled him out for praise:

> Mr Notman, the Prince of Canadian photographers, has again appeared in the field of Art. His last production is a beautifully executed photographic view of a scene on the Champ de Mars, Montreal, on Saturday afternoon, June 23rd, during the delivery of an address of welcome to the volunteers and regulars, after their return from the late Fenian campaign (New Series V, 1866, p. 306).

PHOTOGRAPHIC SELECTIONS....

The handsome volume, *Photographic Selections by William Notman*, represented an ambitious effort on the photographer's part to embody current art interests in Montreal. Dedicated to the Governor-General of British North America, Lord Stanley, fourth Viscount Monck, it was published, according to the Preface, "in order to foster the increasingly growing taste for works of art in Canada...." It appeared in December 1863, precisely at the moment that the Art Association of Montreal began to stir again to life. Its extensive text was written by Thomas D. King, the first Secretary of the AAM and the principal organizer of the 1860 conversazione. Among the numerous subscribers were most of the prominent collectors of Montreal, as well as some from other parts of Canada, such as James Gibb and John Budden of Quebec City, and Thomas Fuller and Allan Gilmour of Ottawa.

There are forty-six photos in the book, and all but two are of engravings or paintings. Those taken of the paintings of Way, Duncanson, and Fraser, we have already looked at. The others give a broader sense of the taste and aspirations of Canadians at the time. The first photo in the book is of an engraving which had been made from the sensational work, *The Heart of the Andes*, painted by the American, Frederick Edwin Church in 1859. Next is of an engraving after an *Adoration of the Shepherds* by the seventeenth-century Italian, Luca Giordano, followed by a photo of an engraving after a painting by the celebrated Swiss painter of heroic mountain landscape (a sort of European counterpart to Church), Alexandre Calame. The fifth is of the Englishman, W.P. Frith's huge canvas, *The Derby Day*. The seventh is Raphael's *School of Athens*. The ninth is Holman Hunt's *The Light of the World*.

There is another Calame, *The Alpine Torrent*, and some more well-known Italian Renaissance paintings, in the form of photos of reproductive engravings. There is a photo of Rosa Bonheur's *The Ploughed Field*, and photos of three engravings of Paul Delaroche's *Hemicycle du Palais des Beaux-Arts*, "lent to the publishers by the Institut Canadien ...one of the large series of engravings presented to the Institute by Prince Napoleon in remembrance of his visit to Canada." Watts's portrait of Alfred Lord Tennyson is included, and a painting by George Moreland, an engraving after Turner, two Faeds, and Landseer's *Stag at Bay*. Seventeenth-century Holland is represented by Teniers' *The*

Card Players, and by the last image in the volume, the Rembrandt etching of *The Supper at Emmaus*. Photography allowed each subscriber to possess at reasonable cost a veritable dream collection of great art.

Integral to this collection are the two photographs "from nature" by William Notman. The first, *Fort Chambly*, was chosen, the text tells us, "for its historic importance, and on account of its beauty as a composition." It is indeed beautiful. But the other Notman photo surpasses it. *Road Scene, Lake of Two Mountains* is found at the centre of the volume (pl. 13). Notman rises to the challenge presented by the painted images that surround his picture. It depicts a deep country lane, picturesquely bathed in sunlight: one of the most conventional landscape types of British or European art of the mid-nineteenth century. He employs every device common to such scenes, and even "vignettes" it, softly fading the edges to give the image a long, roughly oval shape, as seen so frequently at the time in lithographs and steel engravings.

In his work, however, Notman achieves a wonderful quality of deep space and atmosphere. His practice with stereography has brought him to catch just the right rise and fall in the running fence at the right-hand side of the road, to introduce a penetrating gentle rhythm that is captivating. The combination of textural variety, of tonal range, and absorbing space in the photo achieves a forceful wholeness.

And the "vignetting," rather than reinforcing the pictorial aspects of the work, reads instead as though it were a hole in the sheet, eaten away by chemicals, through which the viewer peers to discover a revelation of true nature. In spite of all of the care with composition and presentation, the candid quality of the image predominates, and its strength lies primarily in this very sense of startling and immediate actuality. We react with urgency. Is this a glimpse of a never-to-be-repeated moment?

Notman's individual landscape photos, often arched and mounted on heavy card for sale, invariably display this great concern for composition and presentation. A strong view, *Citadel, Quebec from Point Lévis* of 1864 again shows how he skilfully combines painting conventions with the experience of stereography. And this print also has the dark, contrasting masses of the stereos. It is a fascinating image, with its fanciful stage-set tree framing a view of Quebec City that is starkly realistic. It was to be published in 1865, in yet another volume of Notman's photographs (see pl. 14).

13

William Notman
Road Scene, Lake of Two Mountains,
in *Photographic Selections....* 1863
Albumen print, 25.2 x 20.3 cm
The National Gallery of Canada, Ottawa,
purchased 1968

14

William Notman
Citadel Quebec from Point Lévis,
plate 18 in *Notman's Photographic
Selections* 1865
Albumen print, 16.2 x 23.2 cm
The National Gallery of Canada, Ottawa,
purchased 1966

The successful 1863 edition of *Photographic Selections....* had been followed in 1864 by *North American Scenery*, which, as was previously mentioned, consisted entirely of photographs of C.J. Way's paintings. The volume published in 1865, however, was more catholic in content, and was called *Notman's Photographic Selections*.

Although it does not contain a text, it does have printed captions, in the manner of lithographs or steel engravings. This book is more tightly concentrated than the one which appeared in 1863. There are photos of eleven British and European works in the collections of Montrealers, and two from engravings after famous recent works by the Englishmen, Danby and Wilkie. There are only two photos of reproductive engravings after Old Masters, both Raphaels. There are photos of twelve sepias painted in Wales by C.J. Way, seven paintings by Cornelius Krieghoff owned by John Budden of Quebec City, and photos after a work by each of two Montreal painters, Henry Sandham and Otto Jacobi. The other pieces are twelve Notman photos "from nature."

Lorette Falls, Near Quebec is one of the finest of these (pl. 15). In composition the least pictorially conventional, its tone and texture are rich and most varied. The tonal range in particular is totally engaging, resulting, as it does, from the various depths of water differently reflecting light as it runs over the rocks. *St Anne Falls Near Quebec* is also a magnificent picture (pl. 16). Here the contrasts are more marked, and it becomes in effect a study in light and dark. The dark areas form great masses, and the white of the water is so dense that it, too, takes on mass. In both photos the texture draws our attention, closer and closer, as we perceive that it results from incredibly clear detail.

Notman by the later sixties had created literally hundreds of such forceful landscape images, collected on trips that had taken him to the Saguenay, up the St Maurice and the Ottawa, and as far west as Niagara. In 1867 he spent some time in the neighbourhood of Lake Memphremagog in the Eastern Townships, near the American border. All of these areas were popular with the painters, and Notman never lost sight of the fact that he was working, in a sense, in competition with them.

The mood he created in works like *Mount Orford and Lake* (pl. 17), or *Mount Orford from the Channel* (pl. 18), established a standard not easy for the painters to reach. He was relying more and more upon inherent

15
William Notman
Lorette Falls, Near Quebec,
plate 13 in *Notman's
Photographic Selections*
1865
Albumen print, 18.9 x 23.1 cm
The National Gallery of
Canada, Ottawa, purchased
1966

17
William Notman
Mount Orford and Lake 1867
Albumen print, 9.5 x 23.2 cm
Notman Photographic
Archives,
McCord Museum,
Montreal (29,001A-I)

15

17

294

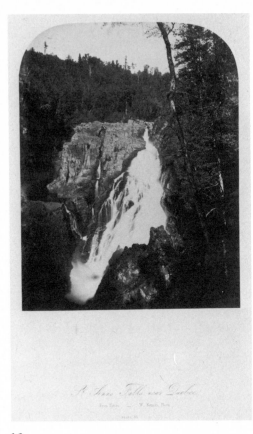

St Anne Falls near Quebec.

16
William Notman
*St Anne Falls Near
Quebec,* plate 33 in
*Notman's
Photographic
Selections* 1865
Albumen print,
22.4 x 16.9 cm
The National
Gallery of Canada,
Ottawa,
purchased 1966

18
William Notman
*Mount Orford from
the Channel* 1867
Albumen print,
10.2 x 14.0 cm
Notman
Photographic
Archives,
McCord Museum,
Montreal (29,002)

16

18

qualities of the photograph, and consequently less on a painter's compositional means. His framing devices became less obvious, and a steady, clear light – picking out detail, bringing texture to life, producing elegant, timeless reflections – had, by that time, become almost as important to him as the massing of forms. His images were still weighty and substantial, but were not so hard and iron-dense as they had been.

ALEXANDER HENDERSON

The only other very prominent photographer in Montreal in the mid-sixties was Alexander Henderson. In 1865 when photographs were listed as a category in the catalogue of the AAM exhibition, Henderson contributed as many as all the others combined, and prints of eight of his views of Canadian scenery were offered as incentive gifts to new subscribers to Art Association membership. For the following exhibition (1867), three volumes of his entitled *Canadian Views* were offered, along with three volumes of Notman's called *Canadian Sports*, and another group of three Notman photos, as prizes in the Art Union draw. A number of copies of Henderson's album, titled variously *Canadian Views and Studies by an Amateur*, *Canadian Views and Studies Photographed from Nature*, and *Photographic Views and Studies of Canadian Scenery*, are in public collections.

Little was known of Henderson's life and career until the publication recently of a fine and sensitive article by Stanley Triggs (*Archiveria*, 5, 1977–1978, pp. 45-59). Henderson was a Scot, like Notman. Born in 1831 at Press Castle, the family estate south-east of Edinburgh, his childhood was everything that wealth could make it. Although he showed some inclination towards the creative arts – encouraged probably by an uncle, James Mack, who was something of a painter – he was trained to be an accountant. Henderson worked at that profession in Edinburgh until late in 1855. Then in October of that year he married Agnes Robertson and emigrated with her to Canada a few days later. They settled in Montreal that winter, and their first child – a girl – was born the following year. Eight more children arrived during the subsequent decade; only two boys and three of the girls were to grow to maturity.

Henderson first appears in the Montreal city directory in 1859, described as a "commission merchant," and resident at 3 Inkerman

Terrace, in a fashionable new part of Drummond Street. We have no idea what goods he sold. Later that year he is the only North American in a list published in *The Photographic News* of London of the members of a "Stereoscopic Exchange Club" that had been established earlier that year (III, 9 September 1859, p. 12).

Triggs points out that although there is, in the Notman Archives, a stereo-half of Belœil Mountain inscribed on the back in Henderson's hand "Taken about 1858," the earliest securely-dated photograph to survive is from 1859. For the next few years Henderson often carefully ascribed his considerable photographic output to "an amateur." But he was a very serious amateur, travelling out about Montreal, and up and down the St Lawrence, seeking forceful landscape views. In 1865 he showed, at the AAM exhibition, scenes taken around Pau in the French Pyrénées, and in Scotland, as well as in Canada. And certainly the publication of his volumes of *Canadian Views....* in 1865 was an act of self-assured commitment. In 1866 he finally took the natural step, and established himself in a studio at 10 Phillips Square, advertising his services as a portrait and landscape photographer. Triggs remarks that there are few portraits known, and that landscape continued to hold the greatest interest for Henderson. This is born out by the contents of the *Canadian Views....*

Looking through one of his albums, one gains a strong impression of a particular vision of landscape. It is what we might call "pastoral wilderness." *Inlet to Lake Inchbrakie, North of the Ottawa River* is an example (pl. 19). It is a romantic view of nature, and of man's place in it, but it is the opposite of dramatic. There is, rather, an intense awareness of actuality, even though it is a work in which, as in the contemporary photographs of Notman, contrasts are played against one another. In *Bark Canoe, Lake Commandeau* there is a feeling of serenity that is unique to Henderson (pl. 20). But still and quiet as they are, we yet do not feel that these pictures record moments frozen in time. Rather, we have a sense of the sustaining essence of a place, of a mood or aura that could always be found there. Henderson was a genuine landscape artist, responding to his subjects with deep sensitivity and awareness.

The main elements in his art were, from the beginning, texture and light, always perceived in unity. His images consequently are homogeneous, unlike Notman's pictures which are often built up of dynamic contrasts. Henderson's light is scattered, flickering across

19

Alexander Henderson
Inlet to Lake Inchbrakie,
North of the Ottawa River before 1865
Albumen print, 11.5 x 19.2 cm
National Photography Collection,
Public Archives of Canada, Ottawa,
Sir Sandford Fleming Collection (1936-
272)

20

Alexander Henderson
Bark Canoe, Lake Commandeau, in
*Photographic Views and Studies of
Canadian Scenery* 1865
Albumen print, 16.3 x 21.5 cm
National Photography Collection,
Public Archives of Canada, Ottawa
(1968-108)

21

Alexander Henderson
Untitled Landscape *c.*1865
Albumen print, 14.4 x 21.0 cm
National Photography Collection,
Public Archives of Canada, Ottawa,
Sir Sandford Fleming Collection (1936-
272)

rich, fine screens of foliage (see pl. 21). The textures are delicate, but firm, and – characteristically – pervasive. There is a sense of atmosphere, but during this period his photos are never "atmospheric." Above all, they are intimate.

Although a photograph such as *Edge of the Bush in Winter* does not seem in any sense contrived, nor even formal, neither does it appear candid (pl. 22). So transient an effect as freshly fallen snow has in Henderson's vision a permanency. There is, by his understanding, nothing momentary about it. It is through composition that he convincingly achieves this, composition that doubtless results from the greatest care

22

Alexander Henderson
Edge of the Bush in Winter before 1865
Albumen print, 16.4 x 27.0 cm
National Photography Collection,
Public Archives of Canada, Ottawa,
Sir Sandford Fleming Collection (1936-272)

and attention to effect. The fact that his pictures seem so free of this very contrivance is because he seldom composes – again, as does Notman – by relating forms in space, but almost wholly by his framing. Henderson heightens the mood he has caught by excluding everything extraneous to it. He is indeed a committed, skilled artist of great originality and force.

Although Alexander Henderson's work differs in many ways from that of William Notman, the two shared one concern: an attention to detail. An inherent characteristic of the photograph, it was, in the decades following photography's introduction just before mid-century, the principal fascination that the new medium of expression held. We have become so accustomed to the mechanical reproduction of photographic images (hundreds confront us every day), that it requires a considerable effort of imagination to appreciate the wonder with which early photographs were received. Here was a drawing, a picture that one could hold in the hands, that depicted clearly every leaf of a tree, every pebble of a beach, the slightest nuance of expression in a face. For a traveller it meant that he could take a speaking likeness of loved ones along, and return with exact depictions of scenes of the journey to share with those at home. The basic functions of portraiture and of topographical painting were almost immediately appropriated by this new medium.

PAINTING AND PHOTOGRAPHY: CHANGING OPINIONS

Artists whose work engaged them in more complex issues of reality and perception than did the trade of the work-a-day portraitist or topographer also saw in photography a significant turning-point. Debate raged as to how significant. Some incorrectly dismissed the photographic image as a mechanical production, independent of human intelligence, and thus devoid of any other than passing interest. Others rashly saw in it perfect verisimilitude, absolute truth to nature, and through this the satisfaction of the highest purposes of art. John Ruskin, a man who in the second half of the nineteenth century virtually moulded the attitudes and expectations of the English-speaking world concerning art, himself first saw it so.

Ruskin was an English critic moved by a passionate commitment to right thinking about art, and throughout the years of his long career,

what constituted right thinking constantly changed for him. Nonetheless, his views – which he often proclaimed in the form of principles – became codified in the public mind at an early stage as embracing these two principal ideas: that great art resulted from the closest observation of the facts of nature, and that this capacity for "truth to nature" was a moral force. From this, his readers came to view his writings almost as though the canons of a new religion. Here is what the Lord Bishop of Montreal, the Right Reverend Francis Fulford, was able to make of Ruskin's ideas, and of his words, in an address to the AAM in 1865. The fact that Fulford was President of the Association, underlines the then near-fusion of religious and art values:

> Much has been said...of the power of art to refine men, to soften their manners, and make them less of wild beasts.... But apart from direct spiritual worship and self-dedication to the Supreme, I do not know any form of ideal thought and feeling which may be made more truly to subserve, not only magnanimity, but the purest devotion and Godly fear; by fear, meaning that mixture of love and awe, which is specific of the realization of our relation to God. And apart from religious pictures in the usual sense, if the painter is himself religious...then will he paint religious pictures and impress men religiously, and thus make good men better, and possibly make bad men less bad. This is the true moral use of Art, to quicken and deepen, and enlarge our sense of God (*Montreal Herald*, 28 February 1865).

Such attitudes brought a certain social purpose to art, justifying its support. This was compatible with Ruskin's intention, though more meagre.

Ruskin often addressed artists directly, and it was statements like the following that led to a dogmatic interpretation of the concept that "truth to nature" was the foundation of great art.

> It will be the duty, – the imperative duty, – of the landscape painter, to descend to the lowest details with undiminished attention. Every herb and flower of the field has its specific, distinct, and perfect beauty, it has its peculiar habitation, expression, and function. The highest art is that which seizes

this specific character, which develops and illustrates it, which assigns to it its proper position in the landscape, and which, by means of it, enhances and enforces the great impression which the picture is intended to convey. Nor is it of herbs and flowers alone that such scientific representation is required. Every class of rock, every kind of earth, every form of cloud, must be studied with equal industry, and rendered with equal precision (Preface to the Second Edition, *Modern Painters*, London 1848, VOL. I, p. XXX).

It is only from the closest attention to the small parts that the great patterns will emerge. Such a mixture of materialism and religious idealization, so close in spirit and method to the great contemporary feats of scientific classification, appealed to that sense of progress, of increasing knowledge, and at the same time, that belief in the growing capacity for knowledge, so central to the Victorian age. The photograph seemed a marvel. It was like a mirror upon which the face of nature could be fixed, studied, and known.

Historians have only in recent years begun to understand the dramatic impact of the photograph upon the visual arts at mid-century. It is a complex issue. There is much evidence that wherever they came into contact with it, artists embraced photography. The world it reflected coincided closely with that perceived by the painters (and by critics like Ruskin). But many people, including Ruskin, soon understood that the photograph was not a perfect mirror, that it often seemed to distort or obscure. And the world, as perceived by painters and critics, was also changing. The careful depiction of minutiae, it was endlessly demonstrated, did not in itself make art. What is unfortunate is that very few people, in these earliest decades of photography, realized that the complexity of the procedures involved in securing a photographic image made it as rich and varied a medium of artistic interpretation as painting itself. Not a mechanical mirror, the sensitized plate was in fact a recording instrument of great expressive potential. It required men like William Notman and Alexander Henderson to reveal that fact, and they did so, time and time again.

In the general critical confusion concerning the nature and function of photography that then surrounded the art, the relationship it

held to painting was the least clearly understood. Basically, although "truth to nature" was a recognized prerequisite of art, and the photograph – as it was at first felt – perfectly mirrored nature, to copy a photograph in painting nonetheless seemed an act lacking in the proper moral force. It seems now a picky point, but it aroused deep feelings, feelings that at the time reflected poorly, and unfairly, on photography as well as on painting. For example, here is a critic in Montreal in 1871, commenting on a case in point, a painting by a young man named Frederic Marlett Bell-Smith, *Skating Rink*, exhibited with the Society of Canadian Artists:

> We believe there is a standing order to the effect that no photographs are to be exhibited by this Society. We can understand how such a thing may have in the hurry of business passed the committee, [but what] are we to think of the individual who has passed this off for a picture. Some of the figures are painted from a photograph and others are plastered on from the same source. It is usual to take photographs from pictures, but in no case for pictures to be taken from photographs, and to be claimed as artistic productions which this Society professes to give to the world (*Montreal Herald*, 7 March 1871).

But here is how someone else reacted to that same object.

> There is a picture by F.M. Bell-Smith, which may be characterized as full of work, full of color, and full of spirit. It represents a carnival at the Victoria Skating Rink, and will be found amongst the water colors (*Daily Witness*, 6 March 1871).

Two years later, the recently established Ontario Society of Artists passed a by-law prohibiting the exhibition of copies, "of photographs or otherwise." Yet, as we will see, the principal mover behind the founding of the osa, a man who lived most of his life by photography, would continue until the late eighties to use photographs in making his paintings. They are no less works of art because of it.

This antagonism concerning photography in its relationship to painting also affected how people looked at photographs. As a painting had to be a "hand made" object, photography was deemed to be mechanical. Otto Jacobi, a painter who for ten years repeatedly used

photographs to increase the naturalness of his painted landscape images, in later life made this fatuous remark: "The camera has no soul, and it has only one eye." It was a widespread misconception, that the human agency was somehow absent from the photographic image. Up until at least 1865, when there was a special photography section in the AAM exhibition, photographers in Canada (no doubt reflecting a widespread attitude), were considered to be artists. But already, hesitations had been expressed. The initial *Canadian Illustrated News*, published in Hamilton, Canada West, reprinted an article from the *London Review*, "Photography's Approach to Art," of which the following are excerpts:

> We confess that the pleasure we derive from an exhibition of photographs, however excellent, is never wholly unalloyed by a lurking, undefined feeling of dissatisfaction. They are so near perfection, and yet so far from it.... After the first blush of admiration at the marvellous accuracy of the imitation has passed away, we look for something more – something deeper and more lasting than mere reflection – for something of the poetry and sentiment with which nature clothes herself – and of course we fail to discover it.... A score of men who sucked in art with their mother's milk – real, true-born artists, mind – would treat the self-same subject under the same effects, and you would have a score of pictures, each as widely differing from the others as black from white, and yet each a grand and perfect work. With photography, it is, of course, precisely the reverse. Two photographs are as like to one another as possible; they are, in fact, mere impressions of natural objects, just as they might be seen in a looking-glass; and however perfect and wonderful, they are only capable of inspiring a very limited kind of admiration (I, 7 February 1863, p. 152).

But critics do not make works of art. In Canada during the years we are examining – from 1860 to 1890 – photographers did, and painters did, and the two, as a consequence, found themselves constantly in association.

III

Landscape Painters in the German Community: 1860–1865

Otto Jacobi
Adolph Vogt
William Raphael

OTTO JACOBI

There is in the Musée du Québec a large canvas of startling clarity, depicting the Lake of Two Mountains, where the Ottawa River meets the St Lawrence west of Montreal (see pl. 23). As arresting as is the sparkling atmosphere, it is the lateral, streaming quality of the composition that is memorable. Unlike most landscape paintings of the period, this displays no "staginess"; no set-like wings intrude to frame the scene. It appears a slice of reality; a stopped moment in the stream of time. It has the informal directness of a documentary photograph, and if we look closely, we will see that it resembles a photo in other ways.

There is throughout a fine and consistent attention to detail, and yet this detail is unified by the even cast of light that suffuses the whole. Within this are many closely observed optical effects. The floating branches in the left foreground in particular present a striking instance of multiple reflection, revealing by its textures a complex form in open space. It is evident that a painter could not in a sketch have recorded so many momentary effects in such detail while retaining this pervasive sense of unity. This is a painting of a photograph.

There are two smaller pictures, painted in 1860, by the same artist. Now in the Musée du Québec, they are also paintings of photographs. Both show different sections of the Montmorency: one is a view of its rapids (see pl. 24) and the other of another section of the river (see pl.

23

Otto Jacobi
Lake of Two Mountains 1860
Oil on canvas, 69.2 x 107.5 cm
Musée du Québec, Québec
(A 40 101 P)

25). This pair reveal, even more immediately than does the large can-
vas, their dependence upon the agency of photographs. The rushing
water in *Rapids, Montmorency River* is blurred because the photographic
plate was too slow to stop very quick movement. The contrast in tones
in both is exaggerated, even though they are painted all in shades of
brown. High-lights are intense and shadows are dark, with little inter-
nal modelling of any subtlety.

And in this case, the source photos are available for direct compar-
ison (see pls 26, 27). They are stereographs taken by William Notman's
firm about 1860, and the painter has followed them closely, deviating

24

26

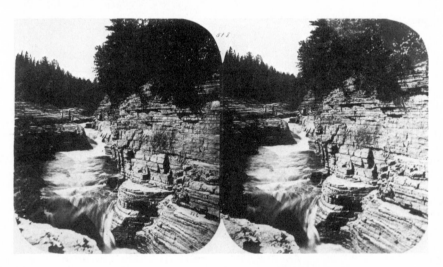

24
Otto Jacobi
Rapids, Montmorency River
1860
Oil on canvas, 41.0 x 48.6 cm
Musée du Québec, Québec
(A 36 34 P)

26
William Notman
Natural Steps, Montmorency Falls,
Quebec c.1860
Stereograph, 7.5 x 14.2 cm
Notman Photographic Archives,
McCord Museum, Montreal (7515 view)

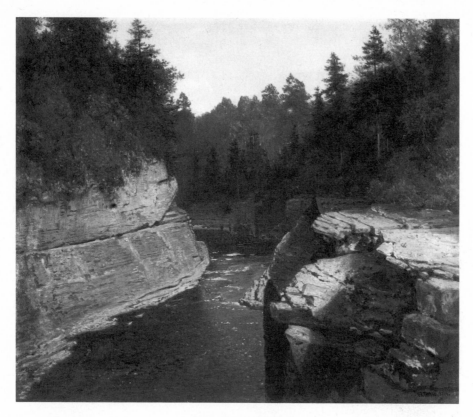

25

27

25
Otto Jacobi
Montmorency River 1860
Oil on canvas, 41.4 x 48.6 cm
Musée du Québec, Québec
(A 36 39 P)

27
William Notman
Natural Steps, Montmorency Falls,
Quebec c.1860
Stereograph, 7.5 x 14.2 cm
Notman Photographic Archives,
McCord Museum, Montreal (7516 view)

only in order to take advantage of certain painterly short cuts in the description of texture. He has also suppressed the tiny figures that appear in the photographs. The painter of these direct, immediate images of the Canadian landscape is Otto Jacobi who, during the eighteen-sixties and seventies, was one of the most highly respected artists in the country.

Jacobi commanded such respect because, of all the painters working in Montreal at the time, he had the most thorough professional training. In Montreal in the 1860s, he must have seemed like a living old master. He was born Otto Reinhard (or more likely, Reinhold) Jacobi, 27 February 1812 (1814 in some German sources), in Königsberg, Prussia (now Kaliningrad, USSR). His father, Ehlert Reinhold Jacobi, was a malt-brewer, but Otto showed an early interest in art and was given drawing lessons by C.E. Rauschke until he was old enough to enrol in the provincial art school in Königsberg.

In the 1880s he told a biographer that he subsequently taught art at the Königsberg school for the deaf and dumb. He was in Berlin by 1830, however, for he first exhibited in the Königliche Akademie der Kunste that year (a watercolour drawing). In later life he reported that he also enrolled in the Academy courses, which occupied him for two years. A prize is then supposed to have taken him to Düsseldorf Academy – right at the peak period of its influence – where he studied under the landscape painter Johann Wilhelm Schirmer. (In 1870 in Berlin a *Winter Landscape* by Jacobi was sold from Schirmer's estate.)

Jacobi exhibited in Berlin again in 1834 (two landscape paintings), in 1836 (eight landscapes, two owned by the Rheinischer-Westphalischer Kunstverein, and a drawing or sketch owned by a certain Dr Woringen), and in 1839 (a landscape drawing or sketch owned by the Rheinischer-Westphalischer Kunstverein, and four landscape paintings). Throughout these years he remained resident in Düsseldorf, and in later years in Canada he reported that he taught there, though this was probably as a private tutor. He contributed a decorative border etching to a book of poems (R. Reinick's *Leidern eines Malers....*, Düsseldorf, 1838), and in 1839 produced five more etchings, all seemingly ambitious landscapes with figures (listed in G.K. Nagler, *Die Monogrammisten....*). He of course exhibited in other centres, notably at Halberstadt in 1836 and at Leipzig in 1841. In 1838, his home town of Königsberg acquired a painting depicting the Lake Geneva region.

Jacobi had married Sibille Renter in 1837, and they soon had the first of their three children, a son. Around 1840 Jacobi was appointed court painter at Wiesbaden, in the Duchy of Nassau (now Hesse). He spent the next twenty years fulfilling the obligations of that office, which seemed to involve the teaching of art to the children of the court, as well as repairing pictures and painting landscapes. He was able to travel, as a trip to Rome the summer of 1855 has been recorded (Friedrick Noack, *Deutsches Leben in Rome, 1700 bis 1900*, Stuttgart, 1907).

Jacobi's European painting is not well known today. There is a small landscape in oil on panel of 1845, presently with the Raydon Gallery in New York, that is very much like the highly detailed but moody, almost melodramatic landscapes of Jacobi's Düsseldorf teacher, Schirmer. His better-known and somewhat larger canvas, *The Splugen Pass* of 1855 (Montreal Museum of Fine Arts, where it has been since 1879), although emphasizing anecdotal incident, in its detailed, almost meticulous treatment of foliage, its dramatic sky and pervasive moodiness, is still close to Schirmer. And there is a slightly wider canvas of 1858 in the Art Gallery of Ontario, Toronto, that features darkly massed trees against a dramatic sky, which shows that Jacobi followed Schirmer's formula to the end of his years at Wiesbaden.

We can only guess the reason why Jacobi and his family turned up in Montreal in 1860. Certainly there is no evidence at all to support the oft-told story that he was invited to come to paint Shawinigan Falls for the Prince of Wales, liked the place, and stayed. One suspects that this story grew in response to the fact that C.J. Way actually did have a painting presented to the Prince. It is more likely that it was a general search for new opportunity that brought Jacobi to America at the age of forty-eight, although family tradition holds that the second of two Jacobi sons was escaping military draft. (The first son died in his youth, after falling from a tree.)

There is also a strange, large canvas of 1854, called *Indian Encampment* (presently with the Dominion Gallery in Montreal). It is the usual Schirmer landscape, even to the dead branches against heavy, meticulously rendered foliage, but peopled with story-book Indians.

It is clear that Jacobi was, like so many Germans at that time, already thinking of the New World. He would have known many American students at Düsseldorf, and possibly the Canadian-born Henry Ritter, who was then living there. There were thousands of Germans,

including artists, emigrating to America. And there was even, during these years, a considerable interest in German art in the United States. The Düsseldorf Gallery in New York was a famous commercial institution throughout the eighteen-fifties.

Jacobi, having arrived in Montreal some time during 1860, appears first in the 1861 city directory, as "artist, 28 St Lawrence," north-west of the Champ de Mars. The following year he was at the corner of St François Xavier and Fortification Lane, three blocks west and south, with a house at 275 St Catherine, both house and shop shared with his son, who was working as a lithographer and engraver. He was still on St François Xavier in 1863, but had let the house go, and was alone again, and by 1865 he had moved to Place d'Armes Hill on the corner of Craig. There is no directory listing for him again until 1869, and we have no other reason to believe that he was in Montreal after September 1865, even though that city is given as his address in the Upper Canada Provincial Exhibition prize list. The exhibition had been held in London that year, and Jacobi had won second prize for an oil in the professional category, "landscape or marine painting, not Canadian subject."

The annual exhibition of the AAM was not held in 1866 because of the fear of Fenian raids from the United States, following the mass demobilization of soldiers at the close of the Civil War. (In June, Fenian forces had crossed the Niagara River at Fort Erie, but were repulsed, with the loss of six Canadian lives.) However, a more mundane reason, which also contributed to the postponement, was disappointment over the Jacobi picture that was to have been chromolithographed for use as the incentive prize for the Art Union. This is mentioned in an article, "Conversazione of the Art Association of Montreal" in the *Montreal Herald* the following year (6 February 1867).

We know from a circular, produced prior to the planned exhibition of February 1866, that this picture was a view of the new Parliament Buildings in Ottawa. Two similar watercolour versions survive; a relatively sketchy one in the Montreal Museum of Fine Arts, and a highly finished one in the National Gallery of Canada. Both are pedestrian, and it is no surprise that the Art Union Committee decided not to proceed with the manufacture of the prints.

Among the proposed lottery prizes for the 1866 Art Union were to

have been at least five watercolours by Jacobi; including three views around Ottawa and two idealized landscapes. When the draw was finally held the following February, all five – purchased the preceding year by the AAM for this use – were offered. The twenty-three Jacobis in the actual exhibition were all contributed by others. In fact, he himself was not to contribute another work to an exhibition in Montreal until February 1870. He is listed in the city directory again in 1869, living at 298 German, and in the summer or fall of 1870 he established a separate studio at 319 Notre Dame. In January of that year he had won the second annual purchase award of the AAM, although, following some dispute, the prize was shared with the Kingston-area watercolourist, Daniel Fowler.

There is a story that has been handed down in the Jacobi family that Otto and his wife homesteaded in Canada, carrying to their wilderness cabin on a certain Malcolm Lake a rosewood square-grand piano, "which they had to ferry across the lake in two Indian war canoes." Had he really been seized, just before Confederation, with this comic-opera ideal of pioneering? We recall that his fantasy of unspoiled American aboriginal life had found form in a painting done not too long before he actually left for America. And, in February 1865, the one painting he himself contributed to the AAM exhibition was another large fantasy picture. It is entitled in the catalogue *Emigrants Going West*. The reviewer for the *Montreal Herald* found it one of the more remarkable works in an exhibition that boasted loans from many prominent New York and Boston painters:

> This is a work of surpassing excellence and would in any country possess vast historic interest, but in this Canada of ours must have more than elsewhere. The artist has here thrown his whole heart and soul into his work. He had something to say and he has said it with a power and feeling, which no other local artist could touch, and we believe there is not one of them but will endorse the remark. To our mind this picture is a perfect poem. It represents a party of emigrants in search of a new home in the unproved forests of the far West, coming to a halt in the way intercepted by a vast expanse of water. The pioneer of the party is in consultation with the Indian guide, who with outstretched arm points across the

water plain towards the setting sun. One of the party in patriarchal mood intently peruses a map of the outlying country, while the rest are arranged in groups such as the imagination can conceive though few hands can depict (28 February 1865).

The painting has been lost, but a photograph of it was published in *Notman's Photographic Selections* of 1865, where it was called *Emigrants Pioneering West* (pl. 28). A poem it was, perhaps; an exotic dream, certainly. In its scale, in the sweep of its composition, and most particularly in the quality of its light, it was inspired by Robert Duncanson's *Lotus Eaters*, which had been exhibited at the AAM the year before and reproduced in Notman's 1863 *Photographic Selections....*

Although one cannot judge on the basis of Notman's print alone, the colour of the atmosphere must also have approached the pink-and-blue-tinged golds of Duncanson's great work; or perhaps more the saturated "gold and crimson" of Albert Bierstadt's *Sunset*, sent up to the exhibition from New York by that German-American painter who then was first attracting an enthusiastic public to his vast operatic landscapes of the American west.

We have no way of knowing whether the exhibiting of *Emigrants Pioneering West* did, in fact, presage Jacobi's own first attempt at pioneering. It is probably more likely that the two years or so that he was away from Montreal were spent travelling along the St Lawrence and up the Ottawa River, seldom really far from "civilization," although he may first have visited Malcolm Lake at that time. It is well north and west of Kingston, in what was then thick bush. (He would settle there only some ten years later.)

We also do not know how much painting he was doing during the two-year period he was away from Montreal, although it is certain that only one Canadian subject was exhibited before 1867. It was a watercolour, called *River Montmorenci*, that was lent by William Notman to the 1864 exhibition of the AAM. (Was it related to a Notman photo, as were the Montmorency oils of Jacobi's early years in Montreal?) In the 1867 exhibition, on the other hand, virtually all of the specifically located scenes are Canadian: the Montmorency again, the St Anne Falls, Murray Bay, and Lake of Two Mountains. The watercolours acquired by the AAM in 1866 for the Art Union draw were all, if identi-

Emigrants Pioneering West

28

William Notman Studio
Otto Jacobi's Emigrants Pioneering West,
plate 27 in *Notman's Photographic
Selections* 1865
Albumen print, 13.6 x 27.2 cm
The National Gallery of Canada, Ottawa,
purchased 1966

fied, of the region around Ottawa. Scenes along the St Lawrence, up
the Ottawa, and on the Mississippi River – which joins the Ottawa just
above the national capital – appear regularly from then on.

What seems clear from the surviving works of the eighteen-sixties
is that the pictures of specific Canadian locations are all, to varying

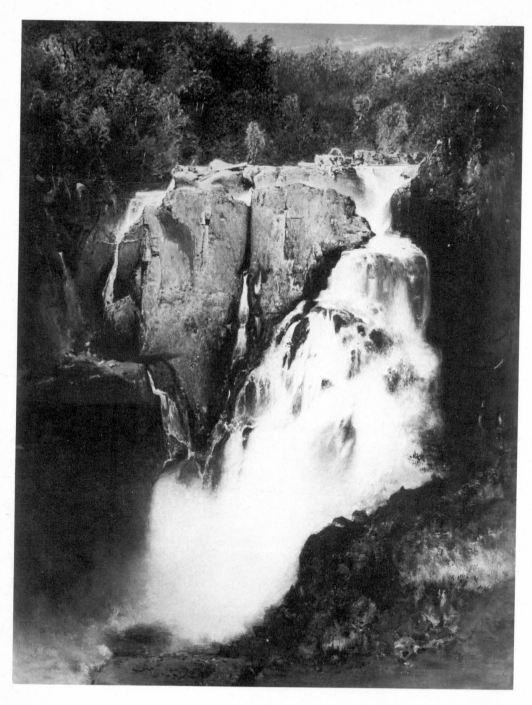

29

Otto Jacobi
Falls of St Anne, Quebec 1865
Oil on canvas, 76.2 x 58.4 cm
Art Gallery of Ontario, Toronto,
gift of Thomas Jenkins, 1927 (884)

degrees, dependent on photographs. That they be truthful and actual in appearance, was of primary importance. As the decade advanced, however, the demands of verisimilitude diminished, and the foreground of the *Falls of St Anne, Quebec* of 1865 (pl. 29), now in the Art Gallery of Ontario, for instance, could be handled in a loose, painterly fashion. Such "blurring" on the corners is often a phenomenon of nineteenth-century photos, but not, it should be added, of the series of Notman photos of the falls of that same year, which Jacobi seems to have used as his model (see pl. 16).

A large canvas of 1867 in the Art Gallery of Windsor, *On the Gatineau* (pl. 30), is one of the most painterly and atmospheric of the specifically located Canadian scenes (the Gatineau River enters the Ottawa just below the capital). It is virtually devoid of that shock of immediacy we feel before a painting like *Lake of Two Mountains*. It also lacks the

30

Otto Jacobi
On the Gatineau 1867
Oil on canvas, 66.0 x 104.1 cm
The Art Gallery of Windsor, Windsor,
gift of the Jr Women's Committee,
1972 (72.76)

convincing unity of the latter, although there is another kind of attraction in the way the elaborate brushwork describes in an almost abstracting, and certainly in a generalizing way, the painter's large and varied repertoire of forms and textures. That harks back to Schirmer in Düsseldorf, as does the dramatic contrast of dark masses against light that is used in *On the Gatineau*.

It is from here but a short step to an utterly idealized work like the *Landscape* of 1870 (pl. 31), in the National Gallery of Canada. This is but one typical example of the many studio-pieces Jacobi produced throughout his years in Canada, in which conventionalized landscape elements are combined for painterly effect alone. Any topographical reference is evidently quite beside the point. With such a generalizing tendency in one direction, and the obvious reference to photography in another, one might well suspect that Jacobi never travelled beyond his studio. Yet the fact that he loved to travel and, indeed, periodically needed to do so, will be confirmed time and again as the years pass.

There was, during the eighteen-fifties and sixties, a growing German community in Montreal. It was part of the massive emigration to America which had resulted from the unstable and often violent conditions in west-central Europe, following the widespread, and largely

31

Otto Jacobi
Landscape 1870
Oil on canvas, 64.2 x 102.3 cm
The National Gallery of Canada, Ottawa,
purchased 1977 (18,887)

unsuccessful, revolutions of 1848, and the subsequent struggle to find some basis for the unification of the German states. Jacobi quite naturally participated in this community, and between 1868 and 1873 lived on German Street (now Hôtel de Ville Avenue), in the area of Montreal favoured by recent immigrants. He would have been particularly drawn to Germans who shared his interest in art and, in fact, in 1866 he collaborated with a fellow-artist in painting *View on the Mississippi River – Ottawa Valley* (pl. 32), now in the Musée du Québec. One of Jacobi's idealized landscapes – there are no particular topographical features to associate it with the location of its title – the foreground, dominated by two large goats, was vigorously painted by a man who also signed the picture: "Vogt."

32

Otto Jacobi and
Adolph Vogt
*View on the Mississippi
River – Ottawa Valley*
1866 Oil on panel
68.4 x 58.8 cm
Musée du Québec,
Québec (A 51 164 P)

ADOLPH VOGT

Adolph Vogt probably arrived in Montreal in January 1865. According to an obituary published in the *Canadian Illustrated News* (III, 11 March 1871, p. 148), he was born 29 November 1842. However, the great German dictionary of artists, compiled by Thieme and Becker, says 1843, and Robert Harris writing in 1898 says 1842 or 1843 – at Libenstein, in the Duchy of Saxe-Meiningen (now Thuringia). He was taken to America by his family at the age of eleven or twelve, to Philadelphia. His father, George, is listed in the Philadelphia city directory from 1855 through 1860, as a piano-maker. His small shop moved every year, and the family home nearly as often, although they always lived on Arch Street.

Adolph, having shown some interest in art, was duly enrolled with the drawing master and music teacher, Matthew Schmitz. (Adolph's father was also a music teacher.) The *Canadian Illustrated News* notes that Adolph also studied with Peter Kramer, a painter and lithographer in Philadelphia. Vogt could not have studied long with Kramer, for that painter returned to Germany in 1858. So, reportedly, did Vogt in 1861, travelling first to Munich, and then to Zurich, Switzerland, where he studied with a certain M. Koller – or Kohler, as reported in the *Art Journal* (New Series x, 1871, p. 139). He is surely the Rudolph Koller, born in Zurich, who was working there between 1851 and 1871. Both of the above sources agree that he was an eminent animal painter. According to the *Canadian Illustrated News*, Vogt studied with Koller until 1865, at which time he settled in Montreal, his parents having moved there from Philadelphia while he was in Europe. In fact, he may have been in Europe only a little more than a year, as an Adolph Vogt appears twice in the Philadelphia directory: in 1861 ("wines, 1300 Marshall Street"), and in 1863 ("batter, 418 Buttonwood Street"). That would leave gaps for travel during 1862, or after the directory listings were made in 1863.

In the Montreal city directory of 1862 two Vogts appear. They are both pianoforte-makers, established in a small business on Craig. One is Joseph, who appeared during the previous year in the Philadelphia directory, and following the same trade. In 1863, two more Vogts are listed, and both are also pianoforte-makers, although they have no apparent connection with the first arrivals. Adolph's father is not listed

until 1866 ("George Vogt, professor of music, 149 St Dominique"), so we can assume that he arrived some time during the previous year. If he were related to the afore-mentioned piano-makers, he may even have visited, or, in fact, settled in Montreal, before Adolph.

We first hear of Adolph himself at the end of February 1865, when he showed two works at the AAM exhibition – both of which were animal pictures. His obituary in the *Canadian Illustrated News* states that he stayed only a short time in Montreal, leaving for Paris – where his Zurich teacher, Koller, had strong connections – in April 1866. Did his collaboration with Jacobi take place in the first quarter of the year, then? Perhaps. Another of his works from that period survives, and as it was reported in the London *Art Journal* part-way through the year, it would also have been produced before April. Called *Pastoral Scene with View of Montreal* (pl. 33; in a private collection, Ottawa), it is similar in conception to the *View on the Mississippi River*, although much larger.

33

Adolph Vogt
Pastoral Scene with View of Montreal
1866
Oil on canvas, 101.6 x 152.4 cm
Mr Peter Vogel, Ottawa

In its high-keyed colour, in the broad, almost coarse application of the paint, and indeed in its very composition and subject, it reflects the work of Rudolph Koller. Vigorously-painted animals dominate the foreground, and, even more than with the Jacobi landscape, what lies behind them exists only as a back-drop; attractive, but of secondary concern. Both pictures quite unintentionally manage to look like scenes in central Europe; the background in the Vogt seems particularly romantic in a Germanic way, with its light-filled atmosphere, and the solitary figure set apart on the brink of the hill to the right – of course traditionally identified as a depiction of the artist himself. The *Art Journal* reviewer did not sense an anomaly, however, and simply described the picture as "a view from Mount Royal: in the foreground... a group of sheep; while in the distance we get a glimpse of Montreal, and the shining river St Lawrence" (New Series v, 1866, p. 240). For him it was a work "of real merit."

In fact, Montreal seems almost immediately to have taken Vogt to its heart. Later in the year he is called "the 'Canadian Landseer,' " and a "very promising young artist," whose talents suggest the possibility of real achievement in Canadian painting (*Art Journal*, New Series v, 1866, p. 330). This notice refers to Vogt as though he were still in Montreal, so it is difficult to be certain whether, as previously suggested, he did get to Paris as early as April, although he was definitely there later that year.

He was sending back pictures to his dealer, A.J. Pell, who placed six of his new oils in the AAM exhibition in February 1867. He also arranged for the sale of two more oils to the AAM, as draw prizes for the Art Union. Two of the exhibited paintings were copies, one after Rosa Bonheur, the famous French animal painter. The rest but one were also animal pictures.

Vogt stayed in Paris until late summer, taking plenty of time to view the paintings at the Exposition International. The *Canadian Illustrated News* offers the opinion that after his return in September his work evidenced "very high artistic merit, in a bold, dashing manner, which is the favourite style of the present French school" (III, 11 March 1871, p. 148). The following year he appears in the Montreal city directory for the first time, because he has established a studio in the Merchants' Bank Building on Notre Dame Street. He is living with his parents at 149 St Dominique, above St Catherine.

Early in the year he is noticed yet again in the *Art Journal*.

> The clever Montreal artist A. Vogt, still continues to progress
> in the Art he loves. One of his latest productions entitled the
> 'Morning Bath' is specially deserving of commendation. This
> picture, which is of large dimensions, represents a cow,
> attended by a dog, performing her ablutions on the bank of a
> gently-flowing stream. The subject is simple enough, but has
> had ample justice done it by Mr Vogt's pencil (New Series VII,
> 1868, p. 159).

Late that February he was represented at the annual AAM exhib-
ition by three more broadly-painted cattle pictures.

WILLIAM RAPHAEL

Another German painter Jacobi would have known in Montreal was
William Raphael. There is little information concerning his life before
he settled in Canada. A Jew (he was a member of the Reform congrega-
tion of Temple Emanu-El in Montreal), he was born, according to an
information sheet he filled out for the National Gallery of Canada just
before his death, somewhere in Prussia in 1833. There are six sketch-
books, which are also in the National Gallery, that contain material
from 1850 through the turn of the twentieth century, and we can trace
his movements through these.

The earliest sketches were done in Nakel, which lies north-west of
Berlin, about a quarter of the way to Hamburg. This was perhaps
Raphael's hometown, as he returned there frequently during his
remaining years in Prussia. By 1851, at the age of eighteen he was in
Berlin, and there are sketches of casts from antique sculpture dating
from 1853 until 1856, presumably school-work. A notice in the *Art Jour-
nal* later makes the statement that he "studied for eight years in the
Royal Academy of Berlin" (New Series V, 1866, p. 306) – an inordinate
length of time. And an obituary in the London *Art News* states that he
studied there "under Wolf, Begas, and others" (II, 21 March 1914, p.
4).

The Begas referred to would be Karl-Joseph, who studied with
Gros in Paris in 1813 and, by the time Raphael was a student in Berlin,
was an old and venerated teacher. In his prime, Begas was mainly

known as a portraitist, although he also undertook paintings of history. He died in November 1854. The other teacher associated with Raphael's Berlin years was probably Johan Edward Wolff, who also studied in Paris with Gros. He too would likely have been somewhat apart from students by the eighteen-fifties, and seems from the entry in the Thieme and Becker dictionary to have been deeply involved in cultural administration and direction.

Raphael quit Berlin 28 November 1856 and, according to a note in one of the sketch-books, he first set foot in New York 22 December. He began painting portraits immediately (there is a list of his New York sitters), and that profession took him to Montreal for the first time in April 1857. Subsequently, there were short trips down the river as far as Quebec City, and at one point he returned to New York, but he appears to have stayed in Montreal pretty steadily until February 1858. There is a note that he was in Quebec again that May, but then he returned to Montreal, and there are lists of portraits completed in both cities.

In the summer and fall of 1859 he was working for William Notman; the photographer's name appears in an account in one of the books. Raphael continued to travel to outlying towns periodically – there is a note on expenses incurred on a trip to Three Rivers in July 1861 – but he was firmly settled in Montreal by October of the following year, when he married Ernestine Danzigar. Their first child, a son, Rudolph, was born a year later. Raphael first appears in the city directory in 1865, listed as "artist, 98 German."

Two other sketch-books are in the McCord Museum in Montreal, and one of them was used on a trip to Scotland. A drawing of Strathaven, a village south-east of Glasgow, is dated 2 August 1865. He could not have been away more than a few months, for he is again listed in the city directory the following year, as "artist & teacher of figure & landscape painting" with a studio at 147 Great St James Street, and a new residence at 303 German, which was changed to 302 in subsequent listings. This remained his home until 1880, and from 1868 until 1872 Otto Jacobi lived two doors down.

We must assume that Raphael managed to earn a living largely through his portraiture, for although he exhibited paintings regularly, he never exhibited many. Until the seventies they are all genre scenes. Usually – as in the *Royal Mail, New Brunswick* of 1861 in the Beaver-

34

William Raphael
Behind Bonsecours Market, Montreal
1866
Oil on canvas, 67.3 x 109.2 cm
The National Gallery of Canada, Ottawa,
purchased 1957 (6673)

brook Art Gallery in Fredericton, N.B. – they are set in perfunctory
landscapes.

One, however, is very ambitious and was, indeed, his major work
of the sixties. It depicts a specific setting: life on the wharf behind
Montreal's famous Bonsecours Market (see pl. 34). It is possible that
he began working on the idea as early as his first trip to Montreal in
1857, for preliminary drawings of the buildings are found in a sketch-
book in which all the dated notations fall between 1853 and 1857. In
February 1864 Raphael showed a *Bonsecours Market* at the AAM exhib-
ition. According to a review in the *Montreal Herald*, it was a "characteris-
tic street scene *in front* of Bonsecours Market in the height of the winter

time" (12 February 1864). In September of the following year presumably while he was in Scotland, another *Bonsecours Market* was shown at the Provincial Exhibition in Montreal.

> ... a very small canvas of the Bonsecours market by the riverside. It has atmosphere; it is alive, vibrant. The group of peasants is successful, although some of the figures, especially the people listening to the travelling fiddler, do border on caricature. But it is a unified composition (*Journal de Québec*, 28 September 1865, p. 3, trans.).

Could it have been a small version of the picture we now know in the collection of the National Gallery of Canada which is clearly dated 1866? First mention of it was made in the *Art Journal* in the fall of 1866.

> Mr William Raphael, ... who is now a resident of Montreal, evidently possesses some of the spirit of the immortal Hogarth. Into a large picture recently painted by him, he has introduced a graphic full-length caricature of a noted *blind Art-critic*, who is a stumbling-block in the way of every artist visiting Montreal (New Series v, 1866, p. 306).

Is the above reference to the man behind the fiddler whose eyes are shaded, the old fellow on the saw-horse, or the fiddler himself? Whatever the answer may be, the picture is again referred to in another issue of the *Art Journal*:

> Mr W. Raphael's painting, of which mention was made in the *Art Journal* for October, has been sent to Glasgow; if not disposed of in that city, it will be forwarded to London. Lovers of the Fine Arts will thereby have an opportunity of seeing a good Canadian production, and, at the same time, a graphic representation of a scene in the rear of the Bonsecour Market and Church, Montreal, together with the St Lawrence River, and part of St Helen's Island (New Series v, 1866, p. 330).

The picture was back in Montreal by February 1867, Raphael's only contribution to that year's exhibition of the AAM. His Scottish connections, presumably established during his trip late in the summer of 1865, had not paid off.

Just as are Vogt's *Pastoral Scene with View of Montreal* and Jacobi's

idealized landscapes, *Bonsecours Market* is a very Germanic work. There is the light-filled background landscape with its pastel tones, so reminiscent of Vogt's, and so obviously harking back to German Romantic painting of the early nineteenth century. The generalized but nonetheless effective massing of shadow and light areas derives from the same source. It must also be remembered that Düsseldorf was but one of many German academies in the nineteenth century that encouraged the depiction of elaborate scenes of "low-life," compounded of numerous anecdotes, all brought to a high, professional finish. There is an underlying sense of complex order to the picture, of an, at times, startling symmetry, that lifts it above the illustrative. The light in it is also special, bringing separate life to each individual form. Raphael has placed himself squarely in the centre, with his sketch-pads under his arm, curiously grasping an elaborate five-pronged candlestick. While observing the crowd from its outer edge, he presents himself as an integral part of this vital, growing city.

IV

The
Response
to Immigration
and the
Founding of
the Society
of
Canadian
Artists

Two Canadian artists:
Henry Sandham and A. Allan Edson
the first artists' societies: 1834–1847
the Society of Canadian Artists: 1867–1873
further developments: boom and bust

The presence of these European-trained artists in Montreal naturally attracted young Canadians to the calling, and two in particular followed their inclinations with good results: Henry Sandham and Allan Edson. Let us turn to Sandham first, for he was closely tied to the scene that centered on the Notman studio.

HENRY SANDHAM

Because Henry Sandham later achieved some fame as an illustrator in Boston, numerous short descriptions of his career were published during his lifetime, and all agree on the basic facts concerning his beginnings. He was born in Montreal 24 May 1842, the last of four children of John Sandham and Elizabeth Tait. His parents were both born in Yorkshire in 1804, and emigrated to Canada at about the age of thirty, settling in the Griffintown section of Montreal, north of the Lachine Canal where it joins Montreal Harbour. They already had one child, Elizabeth. A son, Frederick, was born in Montreal in 1834, and another, Alfred, arrived in 1838, four years before Henry. By the mid-fifties John and his eldest son were both working as house-painters, with their respective homes and shared shop all within a block on Nazareth Street in Griffintown. Alfred Sandham

appears first in the Montreal city directory in 1859, also working as a house-painter in the family's Nazareth Street business.

Most of the later biographical sketches tell the story of John Sandham insisting that his youngest son take over a family farm, even though Henry had already expressed a desire to become an artist. The second son, Alfred, had been living on the farm in question for some time prior to 1859. It was at Covey Hill, due south of Montreal in the Eastern Townships, near the American border, and Alfred's son, John, was born there 6 October 1858. Shortly after this event Alfred returned to Montreal and the family painting business. Neither John nor Fred Sandham appear in the city directory that year. Had the rest of the family taken Alfred's place at Covey Hill? Henry would then have been seventeen, just ripe for pressing into farm life. The point of the story is, of course, that it didn't work, and the 1861 city directory lists John Sandham back on Nazareth Street again. And with his whole family, it would seem, for Alfred had to move out, taking a house at 51 Wellington, closer to the docks.

Henry Sandham first appears in the Montreal directory in 1863, listed as a photographer, situated in a small location at the rear of 42 St Simon Street. Whether it was residence or shop, we do not know. He was then twenty. By 1865 he had moved to 216 St George, and is described as an artist. We do know that by then he was working for William Notman, because he first appears in the Notman wage books in August 1864, which are the earliest surviving records. Later biographies say that he began there as a delivery boy after leaving the family farm. It is therefore quite possible that the young photographer listed as on St Simon early in 1863, could have already been working for Notman for more than a year.

In the Notman studio Henry naturally met John A. Fraser, and by March 1865 John's brother, William Lewis Fraser, when he too joined the firm. On 23 May of that year, Henry married their sister, Agnes Amelia. Finally, drawing the interests of the two families even more closely together, Alfred Sandham joined the Notman firm that August. (He had been made secretary of the Montreal YMCA in 1864, but that probably did not sufficiently fill either his time, or his pocket.) However, he only worked at Notman's for eight months. Later that year Henry and Agnes Sandham moved to 62 City Councillors, north of St Catherine, just east of Phillips' Square, and then within the year to 62

Aylmer, one block west, where they were to remain until 1866. Henry John Fraser, their first child, was born about a year after they were married, but died a year later, in March 1867.

Evidence of Henry Sandham's creative work in the sixties is scant. He first exhibited publicly in the 1865 conversazione: illustrations for Longfellow's "Phantom Ship" that have been lost. His first real showing, however, was in February 1867, when he exhibited two watercolours and sold a third to the AAM to be used as an Art Union prize. All were marines – scenes of shipping. None is known today. One, a sepia entitled *A Stiff Breeze* (the other two were watercolours), was lent by A.J. Pell. It probably closely resembled another lost picture, which we now know through a photo in the 1865 volume of *Notman's Photographic Selections* (pl. 35). There titled as *A Squall from the North-East on the St Lawrence Near Montreal*, it was probably also executed in sepia, as were all of C.J. Way's paintings reproduced in the 1864 *North American Scenery....*, and in fact all those Way included in the 1865 volume. Working in monochrome gave the artist more control of the tonal balance in the final photographic print.

It is those very paintings of Way's that spring to mind when looking at the Notman photo of the Henry Sandham painting. The composition, with its low foreground of choppy water and its high sky is typical of Way. And the sky itself could almost have been copied from one of the great storm-bursts in Way's *North American Scenery....* In later years, Sandham took pains to credit his early art education to Way, John A. Fraser, Jacobi and Vogt. However, it would seem that, at the middle of the decade, C.J. Way held sway.

A. ALLAN EDSON

Aaron Allan Edson was born at Stanbridge Ridge in the Eastern Townships, close to the Vermont border south-east of Montreal, 18 December 1846. There are two main sources of information concerning his life: a lengthy and elaborate obituary that appeared in *The Dominion Illustrated* 11 August 1888 (I, p. 94), and a few pages in a book, *In Old Missisquoi* (Montreal 1910, Chapter x), co-authored by a woman who knew Edson, Theodora Cornell Moore. Both of Allan's parents, Hiram Edson and Elmira Gilmore, were from New Hampshire. They first settled on a farm, where Allan was born, but a few years later

moved in to the nearby village of Stanbridge East to run a hotel, the American House.

The Dominion Illustrated obituary contains reminiscences of some of Edson's teachers and school chums, and is rife with contradictions concerning his formal education. It seems that he entered Stanbridge Academy, a small private school up the street from his parents' hotel, in September 1857, and stayed there for about four years. A prospectus published in 1860 lists Allan and his two brothers, Marcellus and Walter, as pupils. Their father was then a director of the school. Subsequently, Allan studied at Verchères College where he received a "commercial education."

35

William Notman Studio
*Henry Sandham's A Squall from
the North-East on the St Lawrence Near
Montreal,* plate 38 in *Notman's
Photographic Selections* 1865
Albumen print, 12.7 x 23.6 cm
The National Gallery of Canada, Ottawa,
purchased 1966

His parents moved to Montreal about 1860, and Hiram Edson appears in the 1861 city directory as the proprietor of the American House at 31 St Henry. It is said that Allan took his first brief job as a clerk in a dry goods store run by James Morrison on Notre Dame Street, and is then said to have moved on to a wholesale establishment, run by James Stevenson on St Helen. It is also recorded that he worked as a book-keeper with the framer and art dealer, A.J. Pell, whom we already know as an active member of the Montreal art scene. Pell had moved from a small shop in his home to a regular store at 36 Great St James Street, late in 1862 or early 1863. The following year he moved into even grander quarters in two adjacent stores at 76 and 78 Great St James. It must have been during these years after 1863 that he employed Allan Edson. Pell was at that time showing the work of Otto Jacobi, John A. Fraser, and Robert Duncanson, and young Allan must surely have met them all.

In Old Missisquoi quotes at length from an unlocated obituary that asserts that Edson studied first under Duncanson. (Robert Harris writes in 1898 that he studied with "Duncan," but Harris would have remembered James Duncan, and would not have known Robert Duncanson at all.) This period of working with Duncanson must have occurred sometime between the summer of 1863 and the spring of 1865, precisely when Edson was also working for Pell. There is a very early work of Edson's in the National Gallery of Canada, that he gave to Theodora Cornell Moore, as a souvenir, and that has since been known as *The Pike River, Near Stanbridge* (pl. 36). It is a lush, exotic thing, with a brilliant sunset and strange palm-like trees – like a miniature variation on Duncanson's *Lotus Eaters*. Even more to the point is a Duncanson in the Montreal Museum of Fine Arts (*Sunset Study*, dated 1863; pl. 37). It is smaller than the Edson, and although generally somewhat more broadly handled, in certain passages, particularly in the foliage, is remarkably close. The fact that the two are also similar in mood, atmosphere, and even colouring, further reinforces the suggestion that Robert Duncanson was indeed Edson's first teacher.

We can assume, then, that *The Pike River, Near Stanbridge* was probably painted in 1864, and possibly under the direct tutelage of Duncanson. (One wonders if he did not even have a hand in it. An Edson watercolour, *The Owl's Head, Lake Memphremagog* dated 1866, in a private collection in Ottawa, has none of its assurance of finish.)

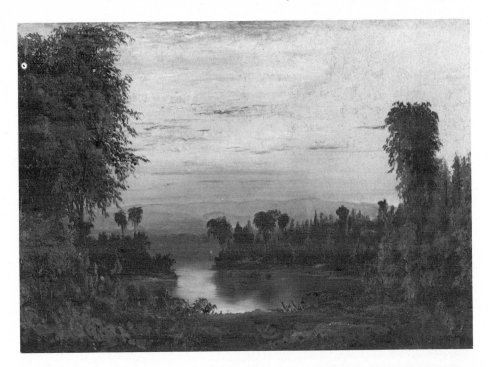

36

37

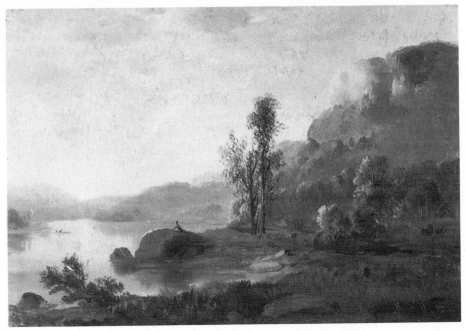

36
Allan Edson
The Pike River, Near Stanbridge *c.* 1864
Oil on panel, 23.7 x 32.2 cm
The National Gallery of Canada, Ottawa,
gift of Elizabeth and Edgar Collard,
Montreal, 1977 (18,938)

37
R.S. Duncanson
Sunset Study 1863
Oil on canvas, 17.8 x 25.7 cm
The Montreal Museum of Fine Arts,
gift of Miss C. Burroughs, 1943
(943.781)

The following year, in September, Edson is first recorded in exhibition. He and Otto Jacobi both won prizes at the Upper Canada Provincial Exhibition at London. Was Pell responsible for sending the works? Edson won second prize in the amateur list, oil landscape, Canadian subject. He was then eighteen years old.

Most of the early biographic sources report that it was about this time Edson made his first trip to England. The visit was made possible by the partial assistance of J.C. Baker, who was related to the young artist by marriage, and who was also the richest and most influential man in Stanbridge, indeed in the whole of Missisquoi. Also a collector of paintings, he owned two Duncansons, which he had bought in January 1865.

According to *The Dominion Illustrated*, Allan also worked for a broker for a time, to help raise the money for his fare. Years later, Robert Harris was to report that when he got to England Edson "studied at Kensington," and various other sources mention that he studied with William Holyoake. But the latter is unlikely, since Holyoake only began exhibiting with the Royal Academy in 1865, and his famous years as curator of the schools came later.

But this first trip was apparently a short one, as Alan appears to have been back in Montreal early in 1866. Before February of that year one of his oil paintings, *Ayers Flats, Eastern Townships* was bought by the AAM as an Art Union prize. However, the exhibition was postponed and by the following February he again submitted an oil, *A Scene near Ottawa*, and was singled out for attention in the *Montreal Herald* review:

> A couple of pictures, one bought for a prize by the Association, have been painted by Edson, who we understand is quite a lad. We mention them, not on account of any special excellence, which is not to be expected from a beginner, but to show that taste for art is being cultivated by many of our young men. This one will no doubt hereafter paint much better pictures than those exhibited yesterday (6 February 1867).

It is unlikely that Edson could have taken encouragement from such remarks, but he had definitely made his final choice of career. That year he appears for the first time in the Montreal city directory, boarding at his parents' new establishment, the Eagle Hotel on College Street, and listed under his new profession of "artist" (see pl. 38).

38
William Notman Studio
Allan Edson 1870
Albumen print, 8.0 x 5.5 cm
Notman Photographic Archives,
McCord Museum, Montreal (60,026-1)

THE FIRST ARTISTS' SOCIETIES: 1834–1847

The year 1867 was to bring the realization of Confederation, with the Parliament of the new Dominion of Canada sitting for the first time in the new Parliament Buildings in Ottawa (although they actually had been occupied by the Legislature of the United Canadas the year before). No doubt this may have caused some swelling of pride among the artists of Montreal. However, it was the fundamental need to stimulate a market, to draw attention to the quality and quantity of work available, rather than the stirrings of patriotism, that led them to band together late in the same year, to form some sort of artists' exhibiting society.

Did not the annual AAM exhibition satisfy this need? Quite clearly not. A glance at the AAM catalogues of 1864, 1865 and 1867 tells the story. Most of the pictures were lent by collectors, and the contributor of each picture is given as much prominence in the listing as is the painter; perhaps more. A good number of the pictures, both old and

modern, were foreign. The President, Vice-President, Treasurer, two Honorary Secretaries and twelve members of the governing Council were always collectors. There was never an artist among them. Such a body, quite naturally, would seek to serve the interests of collectors, and only when such interests coincided with those of the local artists were the interests of the artists themselves served. The fact that the idea of founding a Society of Canadian Artists coincided with the time of Confederation was only because there were then a sufficient number of artists concentrated in one place to recognize their common needs.

It had periodically happened in Canada before. In 1834, the year Toronto was incorporated as a city, the Society of Artists and Amateurs was formed there, but died after one exhibition. Another attempt was made in 1847, when the Toronto Society of Arts held an exhibition limited to professional work. There is a catalogue of that show, and some evidence that two more exhibitions were staged the following year. But the Upper Canada Provincial Exhibition offered prizes in various divisions of art, beginning in 1846, and from 1852 introduced a professional category as well. These large fall fairs rotated annually among the major cities, and were well suited to the dispersed cultural activity of that province before Confederation.

Montreal had become the capital of the Province of Canada in 1844, and in 1847 a small number of professional artists then resident in the city had formed the Montreal Society of Artists. The Society established a picture gallery in the Mechanics' Institute early in the year (*Montreal Transcript*, 11 February 1847), but no catalogue, or other evidence of a formally selected exhibition has survived. The Society seems to have shown only the work of members.

These were the well-known Cornelius Krieghoff, who had arrived in the Montreal area about a year before; James Duncan, an Irishman who had settled in the city about 1830, and who would keep the topographical tradition of landscape painting alive there for fifty years (he was Treasurer of the Society); a portraitist, William Sawyer, the only native Montrealer in the group, who was born in 1820, and in 1851 would leave for New York and Europe; Martin Somerville, an Englishman, who had settled about 1839; William F. Wilson, another Englishman, who had arrived in Montreal in November 1842, and who would leave for Quebec City later in 1847, and then retire to Boston.

The President was Andrew Morris, a Scottish painter who was

active in Montreal by 1844, and who left for New York in 1848; the Sec-
retary was Robert T. Howden, who had set up drawing classes in 1839,
but of whom nothing is heard after 1847. In fact, of the seven members
of the Montreal Society of Artists, only Duncan and Somerville were to
remain for some time in the city after the government moved, alternat-
ing between Toronto and Quebec City, following the riots and burning
of the Parliament Building in Montreal in April 1849.

Eventually, in 1860, there came the AAM, which at the time of its
inception set itself high goals. Its members pledged to form themselves
into "an Association for the encouragement of the Fine Arts by means
of the establishment and maintenance, in so far as may be found practi-
cable, of a Gallery or Galleries of Art, and the establishment of a
School of Design, in the City of Montreal, and otherwise...." (23 Victo-
ria cap. 13).

Again, at the time of its first rejuvenation in January 1864 it had
declared in its formal "Regulations" the intention to hold an exhibition
every May "of Works of Art, upon Canadian subjects or executed by
Artists resident in British North America," as well as in November an
"Exhibition of Works of Art of all Artists desirous of competing." But
the over-riding concern of the AAM at that juncture was the establish-
ment of an Art Union, so as to foster broader public support for their
exhibitions – exhibitions that continued to be primarily show-cases for
local private collections. The gallery and school fared no better, even
though among the six Standing Committees of the AAM, established in
1864, was a Building Committee and a School of Art-Design Com-
mittee.

THE SOCIETY OF CANADIAN ARTISTS: 1867–1873

With the clear evidence, early in 1867, of the inability of the AAM to
accomplish these fundamental goals, the artists realized that they had
to try to take matters into their own hands, and the Society of Canadian
Artists (SCA) came into being.

Such artists' exhibiting societies had a relatively long history in
Europe, in Britain, and even in the United States (the National Aca-
demy of Design in New York, founded in 1825, was familiar to all Mon-
trealers with an interest in art, as was the Pennsylvania Academy of
Fine Arts in Philadelphia, whose annual exhibitions began as early as

1812). The first President of the Society of Canadian Artists, the portraitist John Bell-Smith, brought to his position direct experience of such an organization in England. For fourteen years he had been Secretary and Trustee to the National Institution of Fine Arts, Portland Gallery, London, before settling in Montreal in 1866 (*Art Journal*, New Series VI, 1867, p. 52). At the age of fifty-seven he would have been, after the Secretary-Treasurer, James Duncan, senior artist in the city.

It is interesting to note that in forming the Society the artists acted virtually upon the invitation of the AAM. In February of 1867, that organization held its annual exhibition, which was for the first time held in two special exhibition rooms of the new Mercantile Library on Bonaventure Street. In his opening speech the AAM Vice-President, Peter Redpath, declared that the building of the much-needed gallery and school required a scheme that was "national in its character, for in no other place in either United Canada, as it now is, or in Confederated Canada, as it is about to be, could such an institution be founded. I throw out the suggestion," he went on, "in the hope that it will be taken up by others whose time and tastes qualify them for the work..." (*Daily Witness*, 7 February 1867).

In March of the following year, by which time the SCA had been formed (although its first exhibition was still some ten months off), a public meeting was called by the AAM to press again for the support required to achieve the gallery and school. At this meeting Thomas Rimmer, a collector and member of the Council of the AAM, among other suggestions, and perhaps echoing Redpath's remarks of the year before, called upon the Montreal artists to form themselves into a society to work for the creation of an art gallery.

At the same meeting, John Bell-Smith sought to encourage the foundation of a school by offering his services and those of his son, the previously mentioned F.M. Bell-Smith, as teachers (*Gazette*, 2 March 1868). Someone took him up on it, and by 7 April he had thirty pupils in a new School of Design in the Building of the Mercantile Library Association. Space was probably supplied by the AAM, which now held its exhibitions in the same place, and Peter Redpath (by then President of the AAM) sought a grant from the Provincial Board of Arts and Manufactures on behalf of the school. Thus it was that the SCA started upon the path that would lead it to ultimately achieve the original aims of the AAM.

The Society's first exhibition was held late in 1868 in the galleries of the AAM, in the Building of the Mercantile Library Association. Among the thirty-three participants were Duncan and William Sawyer, the latter having settled in Kingston after his return from Europe, the only remaining veterans of the Montreal Society of Artists. A few of the others were amateurs, and some were itinerants who would soon disappear from the scene.

There were three who had first exhibited in Montreal earlier that year: Ida Braubach, a friend of Adolph Vogt; a portraitist and photographer, Alfred Boisseau, who was born in Paris in 1823, spent some years in the United States, and ended up in Montreal about 1863, where he worked as a secretary and superintendent at the Institut Canadien; W.L. Fraser, John A. Fraser's brother, and his employee at the Notman Studio, who showed sculpture. There seems to have been some attempt to make the society truly national by recruiting artists in Ontario. Daniel Fowler of Amherst Island, off Kingston, wrote to his dealer in Toronto, 3 January 1868, that he

> had lately an invitation to join a Society of Artists forming at
> Montreal in terms so flattering that I will not repeat them. But
> I fear that it is yet, in our Dominion, a doubtful experiment
> and, if it means a rivalry with the Art Association, then I think
> it will not stand (Spooner correspondence, Colgate papers,
> Archives of Ontario, Toronto).

He joined, however, in spite of his fears. And there were perhaps two others from Ontario. A certain J. Cresswell might have been Wm Nichol Cresswell, a painter who lived in the far west of Ontario on the shore of Lake Huron. A Jas Forbes and a W.L. Forbes, who appear to be the same person, J.C. Forbes of Toronto, since both are listed separately, but showing the same work, a *Toronto Bay*. (An undated *Toronto Bay* by J.C. Forbes is in the collection of the National Club, Toronto.) However, the foundation of the Society's existence was that strong core of serious, ambitious painters, who had been working in Montreal for some years: Jacobi, Way, Fraser, Raphael, and the younger Sandham, Edson and Vogt. And it is they who received the greatest attention in the press.

What were the expressed aims of the Society? Above all, to show for sale the work of exclusively Canadian artists. It was this that set

them apart from the AAM. The reporter for the *Montreal Herald* placed the greatest importance on this aspect:

> Yesterday evening the first exhibition of Canadian Art took place in the Arts Hall of the Mercantile Library Association. The attempt to get up an exhibition of this kind, depending exclusively on artists living in Canada, was looked upon as chimerical, and the result was considered as anything but hopeful. So few opportunities were afforded to the public of seeing what the productions of many of our younger artists really were, that they were scarcely known to exist, although established favourites, like Jacobi, Way, Duncan, Vogt and others who might easily be mentioned, had made for themselves a reputation (23 December 1868).

The reporter was pleased, however, to announce that "the present exhibition is a triumphant answer to the doubters and to those who were willing to help forward art, yet who had not the slightest idea in the help being of much use." The *Gazette* review began on a similar note:

> Last night the first exhibition of the Society of Canadian Artists opened in the Hall of the Mercantile Library Association. The exhibition, though comparatively not a very large one, certainly made up in quality what it might lack in quantity, and must be considered a very good step in the right direction. Compared with Canadian Art a few short years ago, the change is marvellous, and we venture to say, there are artists in Montreal who have been scarcely recognized as yet, but of whom, not only the city, but the country may well feel proud, and that ere long the talents of a Vogt, a Fraser, a Sandham, or a Raphael and others in their various departments, will demand that appreciation for which they now only venture with diffidence to ask (23 December 1868).

A large attendance meant that the Art Union held in conjunction with the exhibition was a success too.

A little more than a year later, in February 1870, the SCA held their second show, once again in the Mercantile Library building. C.J. Way, who had reappeared in Montreal just before their first exhibition, was

39
William Notman Studio
W.L. Fraser 1871
Albumen print, 8.0 x 5.5 cm
Notman Photographic Archives,
McCord Museum, Montreal (64,898-1)

now the President, John Bell-Smith having retired. And W.L. Fraser had taken over as Secretary-Treasurer from the sixty-four-year-old Duncan (see pl. 39). Although not listed as a member, Thomas Mower Martin of Toronto showed three works that year. Napoléon Bourassa had become a member, and showed two portraits. But still most prominent in the exhibition were Vogt, Way, Raphael, Jacobi, and more than ever, Edson and Sandham. John Fraser, on the other hand, showed only one picture, an Eastern Townships oil.

The reviewer for the *Canadian Illustrated News* was particularly encouraging:

Taken as a whole this exhibition has been a great success, and leads us to entertain great hopes of the speedy development of Canadian art – as yet but in its infancy. Great credit is due to the Society by whose energetic efforts such a fine show of paintings has been obtained. They have proved themselves well worthy of the patronage extended to them, and if we may judge by the immense crowds who visited their exhibition this

week, there is no cause to fear any diminution either in the interest felt in their labours, or the support which has been so readily accorded them (I, 12 February 1870, p. 231).

Soon after this second exhibition an act was passed in the Federal Parliament incorporating the Society of Canadian Artists (assent given 12 May 1870). The Montreal painters expressed their ambitions in national terms:

> Whereas Charles J. Way, O.R. Jacobi, A. Vogt, Allan Edson and other Artists, members of an Association of Canadian Artists ... have during the last two years existed as an association known as 'The Society of Canadian Artists,' having for their object the advancement of the Fine Arts in the Dominion of Canada by elevating the standard of art, training artists throughout this Dominion and inciting them to emulation in the production of works of art for public exhibition and disposal in the manner practiced by the Art Unions of Great Britain, France and other European Powers, and for these purposes to establish and maintain schools of Art and Design, Art Libraries, Picture Galleries and Art Unions, at the same time providing for the relief of indigent artists, their widows and children ... they are desirous of being enabled to carry out the objects of such association, by legislative enactment incorporating them under the name of 'The Society of Canadian Artists'.... (33 Victoria cap. 59).

FURTHER DEVELOPMENTS: BOOM AND BUST

These aims far exceeded those originally established by the AAM. However, the Society, although pushing hard, was avoiding any appearance of the kind of "rivalry with the Art Association" that Daniel Fowler had feared. As had already been noted, both its exhibitions had been held in the galleries of the AAM, which suggests an atmosphere of mutual cooperation and cordiality. And, at the general meeting of the AAM – held, coincidentally, just after the Society's second, all-Canadian show – a new Council was elected which for the first time included artists: C.J. Way, O.R. Jacobi and John Bell-Smith.

That must have aided their self-esteem, as had the AAM's purchase in January of a Jacobi watercolour and a Fowler. This policy of annual purchases of Canadian paintings, first promised in 1864, had only been inaugurated in 1869, with the acquisition of a C.J. Way watercolour, *Scene Near Monte Rotundo, Corsica*. It was selected from among entries which had been submitted in response to a general invitation to all Canadian artists.

There had been no AAM exhibition that year (as apparently all effort was bent to the raising of a building), but the March 1870 exhibition was opened in the presence of the young Prince Arthur. He was visiting Montreal as part of a royal tour of Canada (the first since that of his brother, the Prince of Wales, ten years before). The moderate pomp and ceremony attendant upon the occasion naturally enhanced it in the eyes of Montreal society, and the opening had the best attendance it had seen in years. The usual appeal was made for financial support for an art gallery, but no wealthy benefactor came forward. The annual exhibition was again missed the following year.

However, in March 1871, the SCA held its third exhibition in the AAM galleries and drew very large crowds. It is possible they may have been indulging in morbid curiosity of a particularly Victorian sort, as a crepe-hung portrait of Adolph Vogt – who had died suddenly of small-pox about two weeks before – was the central feature of the show. But there was also a genuine interest in the latest productions of Montreal's prominent artists (*Canadian Illustrated News*, III, 11 March 1871, p. 151).

It is difficult to understand the failure of the AAM to consolidate support for a building and a more active programme at this time. Montreal, as its inhabitants were fond of declaring, was the commercial capital of the country, no matter where the political capital lay. Always aware of the great benefits of their location just downstream from the confluence of the Ottawa and the St Lawrence, they were, by 1871, anticipating even greater profits from the opening of the Northwest. Manitoba had become the fifth province of the Dominion 12 May 1870, and on 15 July of that year the vast Hudson's Bay Company domain was formally annexed to Canada. British Columbia had agreed to enter Confederation if a railroad were built to join her to the East, and by 1871 even that massive project seemed to be under way.

Money appeared to be everywhere, and the prospect of even

greater commercial opportunity for Canadians, and particularly for Montrealers, was touted constantly, in the schemes of businessmen, in the speeches of politicians, and of course incessantly in the press. Right beside the review of the third exhibition of the SCA in the *Canadian Illustrated News* there appeared a piece that was a typical expression of the sort of heady optimism which was then rampant:

> The new railway projects, mooted, and on foot, are almost beyond computation. Canada never before presented a more prosperous aspect.... The Dominion Government is reported to have a large surplus from the last financial year, and a still larger one accruing during the present. Ontario is so far embarrassed with its plethora of funds that the chief political issue appears to be, which political party is honest enough to be permitted to manage them; and the other Provinces have all more or less of a balance in their strong boxes. [And in the future yet lies] the North-West trade, the bulk of which will inevitably seek its market through the valley of the Ottawa; and ought, if Canadians are wise, to pursue the rest of its journey, to and from the Atlantic, by the St Lawrence.
>
> These great undertakings for the further development of the country's resources ought to be pushed forward with zeal. They are the legitimate consequences of Confederation,... (III, 11 March 1871, p. 150).

And George-Etienne Cartier was fond of promising his readers in *La Minerve* that "Montreal," as the economic centre of this grand new nation, "will be the imperial city, the glory of confederation" (trans.).

In April 1872, in apparent recognition of the fact that it was the Montreal artists who were responsible for focusing the art interests of the community, the seventh exhibition of the AAM was held in conjunction with the fourth exhibition of the SCA. It was also the occasion for the involvement of Canadian artists in the Art Union on an unprecedented scale.

The Union had had an uneven history. In 1865 – the first year in which it was held – each subscriber had received two Henderson photographs. The incentive prize in 1866 was to have been a chromolithograph of a view by Otto Jacobi of the new Parliament Buildings in Ottawa. But the painting was found to be unsuitable (as was mentioned

in Chapter III, it was a very pedestrian effort). By 1867, when the exhibition and second Art Union were held, the committee was again unable to supply a prize to each subscriber. It promised that "if practicable, a picture of some kind" would be given at a later date (*Montreal Herald*, 16 February 1867), but there is no evidence that the subscribers ever received this bounty.

In 1868 no Art Union was held in connection with the AAM exhibition, although the Society of Canadian Artists ran one at the time of its first exhibition in December 1868, which offered original sketches by its members as draw prizes. In January 1869, the AAM had hoped to make a chromolithograph of the first Canadian work purchased with the newly established annual acquisition award money. But it seems that the winning picture, by C.J. Way, was never reproduced as a chromo, and there was again no Art Union connected with the AAM exhibition in 1870. That year, the SCA held its draw for sketches but, as before, did not bother with a subscription prize. We can assume that they did the same in 1871.

So it was the SCA that kept the Art Union concept alive, and it was probably the Society that fostered, in 1872, the idea of engaging a number of Canadian artists in the production of subscription prizes. Certainly it is clear, from a letter now in the Montreal Museum of Fine Arts, that Henry Sandham arranged the printing. A competition of sorts was held, with some Canadian artists being encouraged to submit works suitable for reproduction. Four were chosen (all by members of the Society), and prints were made, each subscriber then being able to select one.

The four were listed in the *Gazette* prior to the show (19 March 1872): *Young Canada*, a winter genre scene by James Weston (a painter then working for William Notman); *Old Ferryman at Rye Harbour* by Daniel Fowler; *Among the Wharves, Quebec*, by Henry Sandham (who was also still at Notman's); *All Alone*, by Edson. There is a print of the Sandham in the Musée du Québec, and the Edson is known from a reproduction in *The Dominion Illustrated* (I, 28 July 1888, p. 64). Called etchings at the time, they were more likely to be reproductions of etchings, or even perhaps of pen-and-ink drawings, which were made in the new Leggotype process developed by William Leggo, who was George E. Desbarats's engraver at the *Canadian Illustrated News*. Three hundred of each were produced.

Canadian artists also intended to be the principal focus of the exhibition. Two sides of the gallery room were hung with European pictures, lent by the members of the AAM, the other two sides were hung with the work of members of the SCA, and other Canadian painters. Comparison was invited, although no one seems to have made much of it. The *Gazette* thought that "to the Canadians is certainly due the credit of boldness and originality of design, a keen eye to the beauties of nature in their own country, and very considerable artistic skill and feeling in depicting them" (9 April 1872).

The *Daily Witness* was even more cautious. "The exhibition as a whole is, perhaps, not so large as we have seen it, but the paintings by Canadian Artists show steady improvement, whilst the European collection was, probably, never so choice" (8 April 1872).

The Journal, in an article promoting the Art Union, even went so far as to imply that one should be grateful for any evidence of new Canadian production. "Up to a late date those who had a wish to encourage Native Art had to fall back upon the multiplied crudities of Krieghoff" (30 March 1872). Nevertheless, the Montreal artists must have felt that they had reached a new stage in their struggle for acceptance and support, a stage from which they could subsequently press their case with renewed force.

That next occasion never came. There was no exhibition the following spring, and then in September 1873 the remarkable economic boom of the early seventies ended in an equally remarkable and devastating crash. Wall street collapsed, banks and railroads failed all over the United States, and economic depression set in. By the late fall its effects were strongly felt in Canada, and particularly in Montreal. Both the AAM and the SCA ceased to function. One of the last acts of the Secretary of the AAM was to settle the account with the printer of the four Art Union prizes of the year before. Burland L'Africain Co. – who was then in the process of taking over the Desbarats firm – wrote 23 October 1873 suggesting that they take back the remaining stock in settlement, and on 8 November the AAM agreed to give it up.

V

The Major Landscape Painters and Photographers to 1873

Henry Sandham; Allan Edson
Adolph Vogt; C.J. Way; John A. Fraser; William Notman
the move westward
Benjamin F. Baltzly; Charles Horetzky
Alexander Henderson

What of the progress of the individual art-
ists during those boom years? Sandham and Edson in particular bene-
fited from association with the sca: both came to maturity during the
Society years. Henry Sandham showed his first oil paintings at the Feb-
ruary 1868 exhibition of the aam; two views on Lake Memphremagog,
one of which was lent by John A. Fraser. We know nothing of these,
although Fraser that year showed seven watercolour field-sketches
done around Lake Memphremagog, all lent by William Notman. Had
they all been there together when Notman took those stunning photos
of the Owl Head and Mount Orford the year before?

HENRY SANDHAM

In December, Sandham was represented in the first exhibition of the
sca by two oils and five watercolours. One of the oils, *Evening on the
Wharf, Montreal*, is possibly a painting which is now in a Montreal col-
lection, and called *Montreal Harbour*, the date of which has been
recorded as 1865, although it is more likely 1868. The other oil and
some of the watercolours also dealt with maritime life around and
about Montreal, a subject that was becoming Sandham's specialty. All
seven of the pictures he showed at the second exhibition of the Society
in February 1870 (two oils and five watercolours again), were scenes

112

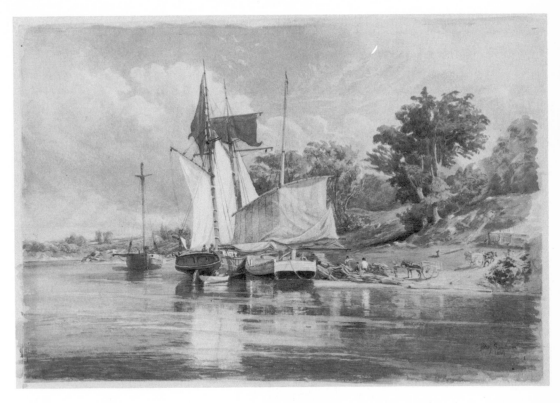

40

Henry Sandham
Landing, St Helen's Island 1869
Watercolour, 21.6 x 34.3 cm
The National Gallery of Canada, Ottawa,
purchased 1978 (18,942)

along the St Lawrence or around Lake Memphremagog. Judging by
one of the watercolours, *Landing, St Helen's Island* (1869), now in the
National Gallery of Canada (pl. 40), he had by that date achieved a high
level of competence and self-assurance in handling this medium. Its
transparency is exploited, and his wash technique is fully controlled. It
is perhaps not as adventurous as his slightly earlier work appears to
have been, and which was done more directly under the influence of
C.J. Way.

It is difficult to know just how seriously Sandham took his painting
at this stage. He did not participate in the sixth AAM exhibition in 1870,

held the month following the SCA show. Certainly his work at Notman's took up his weekdays, and there are signs that his position there was improving. He and his wife moved again in late 1868, or early 1869, to 226 St Urbain. And in June 1870 they had a second child, a girl, who died twelve days later. He spent some time in Toronto that year, probably in connection with the establishment of a Notman branch by his brother-in-law, John A. Fraser.

Three of the works he exhibited at the third exhibition of the SCA in March 1871 were marine scenes around that city. None is known today, although we can reconstruct something of the appearance of one of them, *Toronto Markets from the Bay* (pl. 41), as it was reproduced in the *Canadian Illustrated News* (III, 18 March 1871, pp. 168-169). Only *something* of its appearance, for although the painting was a watercolour, it is, of necessity, reproduced in line, like any relief-engraving. It is one of his by-now familiar scenes of bustling waterfront industry. And in this instance it is so opulent, with its gracefully draped sails and proud civic architecture that the reviewer for the *Montreal Herald* had to remark that "although we know it to be a faithful picture of that part of the Western Metropolis, we must say it is very Venetian in all" (7 March 1871).

This Italianate touch may have been a consequence of the lingering influence of C.J. Way who, as we will shortly see, brought to Canada numerous scenes of Venice when he returned in the late sixties. Our reviewer also has left us the bit of information that Sandham had effectively represented "the green Ontario water."

The reproduction is in itself an impressive thing, spreading across two pages. It is more open and finely textured than a wood-engraving – what the publishers of the magazine called a Leggotype. Its use for the Art Union was described in Chapter IV. The *Canadian Illustrated News* had been launched in October 1869, with a half-tone reproduction of a Notman photo of Prince Arthur on the cover, certainly the first of its kind in Canada, and apparently the first to be employed commercially anywhere.

It represented a crude state of the craft, and was soon abandoned in favour of the more attractive and "tasteful" Leggotype, which used fine lines, similar to those employed by the wood-block cutters of the day, instead of half-tone dots, to describe tonal variation. In fact, the technique was most successful when used to reproduce the sort of pen-

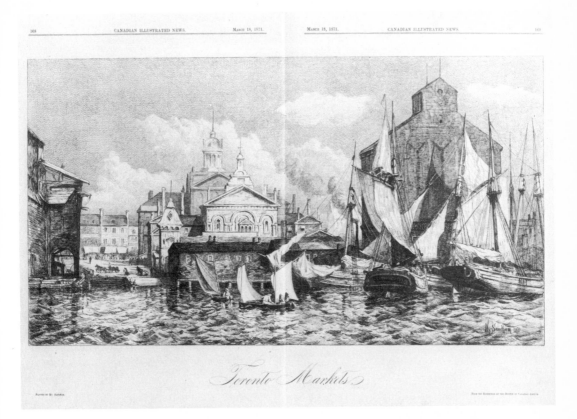

41

Henry Sandham
Toronto Markets from the Bay 1871
Leggotype, reproduced in the
Canadian Illustrated News, III,
18 March 1871, pp. 168-169

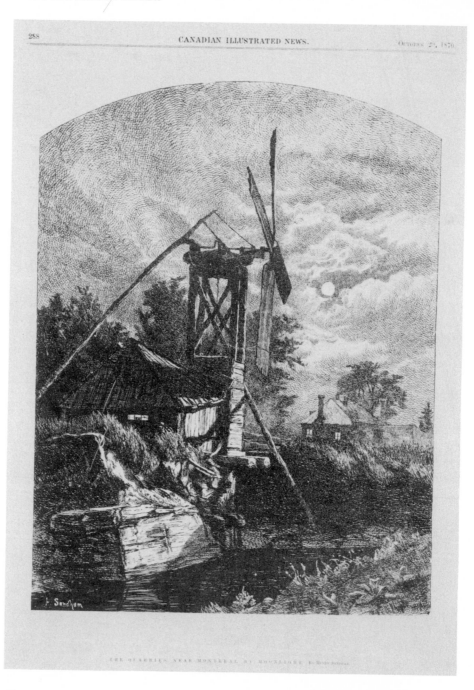

Henry Sandham
The Quarries Near Montreal,
by Moonlight 1870
Leggotype, reproduced in the
Canadian Illustrated News, II,
29 October 1870, p. 288

and-ink drawings that wood-engravings were based upon. It is possible that Henry Sandham himself made a pen-and-ink drawing, after his watercolour, for Mr Leggo's camera. His· first work to appear in the *Canadian Illustrated News* was *The Quarries Near Montreal, by Moonlight* (pl. 42), an etching made directly on a "photographic plate" by Sandham himself (II, 29 October 1870, pp. 279, 288). It is somewhat heavier in handling than the *Toronto Markets* print, but is also more expressive.

Sandham soon carried over these experiments into a "fine art" use, and in the March 1871 exhibition of the SCA he showed an *Old Mill at Côte St Louis*, which was described as a "Leggotype after an etching" (*Gazette*, 6 March 1871). Sandham arranged for the printing of the four Canadian prints for the Art Union which was held in conjunction with the joint exhibition of April 1872, and it is very likely that they were all Leggotypes as well. This process was an interesting introduction to magazine illustration for Henry Sandham, art prints via photography – revealing much about his attitude to the making of images and to their dissemination.

His very first experience of illustration work had been part of a joint effort by members of the SCA. This was *A Tale of the Sea and other Poems* by John Fraser, who was Sandham's father-in-law, and who, as "Cousin Sandy" wrote satirical and political pieces for the *Montreal Herald*. It had been published in 1870 by Dawson Brothers. A primitive little book, it contains twelve illustrations by Jacobi, Sandham, Vogt and W.L. Fraser. Sandham supplied five of these, the largest number, and engraved the wood-blocks for three, only one of which was based upon his own drawing. He doubtless welcomed the relief from such chores that Leggo's process afforded.

ALLAN EDSON

Allan Edson also hit his stride in the years immediately following Confederation. Although he is not listed in the Montreal city directory for 1868, neither is the family hotel, and the following year his father appears as the proprietor of a grocery store at 285 St. Bonaventure. Perhaps they all were missed in 1868 because of the move, for certainly Edson remained close to Montreal, exhibiting at both the fifth AAM show in February, and the first exhibition of the SCA later that December. He displayed only oils on both occasions, and the rapid progress of the young artist was noted in every review.

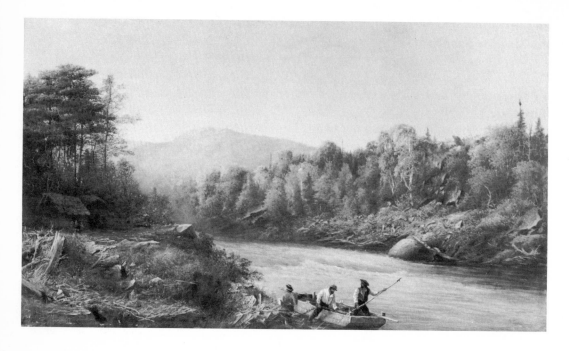

43

Allan Edson
Lumbermen on the St Maurice 1868
Oil on canvas, 58.5 x 101.6 cm
The Montreal Museum of Fine Arts,
gift of Miss Marian Ives, 1940 (940.719)

One work, in the Society exhibition in December, is singled out for particular praise. The *Gazette* liked its elaborate finish (23 December 1868), and the *Montreal Herald* its "beautiful effects of light and shade" as well as the careful study evident in its trees (23 December 1868). This painting, called *Lumbermen on the St Maurice* in the catalogue, and *Lumberers' Camp on the St Maurice* or *Camping Scene on the St Maurice* in the reviews, is now in the collection of the Montreal Museum of Fine Arts (pl. 43). It is the elaborately detailed finish that is striking, a finish that is reminiscent of the technique of Cornelius Krieghoff.

As in Krieghoff's best work, this detail is saved from appearing too brittle by the broad orchestration of the intense, warm colours of the Canadian bush. Although there is much evidence of close observation,

44

Allan Edson
Sheep in Landscape 1869
Oil on canvas, 61.0 x 91.5 cm
The National Gallery of Canada, Ottawa,
purchased 1973 (17,556)

of a concern for truth to nature, it is far from obsessive. The execution
was probably assisted by the examination of photographs, as the rock-
face to the right, particularly, on the far bank of the river, shows the
characteristically exaggerated contrast of light and shade of the photo-
graphic print.

Again, there is a unifying atmosphere within which broad sweeps
of bright sunlight play against the luminous haze on the far hills, and
the subtly rising mist up-river. As in Jacobi's Canadian scenes of the
time, there is in Edson's picture a directness, a sense of the raw imme-
diacy of nature, which is further enhanced by the fact that it depicts a
typical scene of Canadian industry.

Edson was on hand again for the next exhibitions of the sca in

February 1870, and of the AAM in March. He showed his first watercolours with the SCA, four of them with five oils, but only an oil with the AAM. And again he was cited for his steady advancement. A *Shawinigan Falls* was exhibited with the Society, and if it is the canvas now owned by Hydro-Québec, it shows a tendency toward more dramatic contrasts of areas of sun and shade, and an increased attention to particular light effects.

The reviewer for the *Gazette* noted that one of Edson's pictures that year depicted the Burnham Beeches outside London (8 February 1870), and it is likely that more of the canvases shown with the Society were also based on Burnham scenes. We have no trace of his activities in 1869, and so it is possible that he returned to London during that year. Certainly something intervened to markedly change the direction his work was taking. There is a canvas in the National Gallery, dated 1869, and called *Sheep in Landscape* (pl. 44) which can be associated with the English subjects Edson exhibited at the SCA in February 1870. It is most likely a painting which was then called *In the Woods*. Here, the study of light is revealed as a kind of poetry. A strong mood of quietism, of simple, easeful pleasure, arises from random spots of sunlight in sparkling pools upon the thick moss, and in white, momentary flashes on the back of one sheep, or the head of another.

We cannot at this point identify the first watercolours he showed with the SCA. A *Landscape, Eastern Townships* that was in the first Society exhibition, is described in a review as having "a slight Jacobi touch about it, which is sometimes seen in the latter works of this young artist, and not without benefit" (*Gazette*, 23 December 1868). An oil painting in the Montreal Museum of Fine Arts, an unusual one, painted on a large piece of fibre-board, *Landscape: Willows and Sheep*, is dated 1869, the same year as the National Gallery picture just mentioned.

The subject is similar as well: sheep in an open wood of large trees, the sunlight falling through the branches to describe a random pattern on the ground. All similarity ends there, for in the handling of the foliage this painting reveals more than a touch of Jacobi. The leaves have been individually dabbed on, producing a busy and varied texture that almost buzzes, all in a fashion reminiscent of Jacobi's idealized scenes. Edson's signature in this one case even slopes to the left in imitation of Jacobi's. There are no presently-known Edson watercolours that display a similar quality. A group that will be discussed later rela-

tes to some degree, but it is unlikely that they could be so early. Rather, they evidence the lingering influence of Jacobi.

Edson was an unqualified success in the third exhibition of the SCA in March 1871, and his work is described in detail in each review, and often with touches of literary inspiration. For instance, the *Daily Witness* has this to say about *Primeval Forest*, an unlocated but obviously typical Edson of the period:

> It shows the interior of the forest, with a trunk fallen and broken, not by the settler's axe, but from natural decay. All the lines are singularly easy. The fallen trunk, in the last stage of rottenness and death, is partially covered with thick moss of the brightest living green, on which patches of light fall, and seem almost to sparkle in the midst of the general gloom (6 March 1871).

The *Montreal Herald* noted that in *Woodland Scene* "the moss is so beautiful that one could almost imagine one's foot-prints marking the springy vegetation" (6 March 1871). A big work, *Sunshine and Shadow*, reminded the reviewer for the *Daily Witness* of Jacobi again. A large oil study for it is in the National Gallery of Canada, and – particularly in the foliage – it still does hark back to those Jacobi-like works of about a year previously. The eleven or so paintings Edson showed on this occasion – no catalogue of the show has been located – apparently revealed a variety of approaches. Or, as put by the *Daily Witness*, they proved him "capable of considerable versatility of style."

Whatever desire for experimentation Edson still felt at this point (he was only twenty-four), he certainly made an effort that year. There were at least two large canvases in the show, both of Mount Orford in the Eastern Townships. There was the *Sunshine and Shadow* mentioned above, and another entitled *Mount Orford, Morning* (pl. 45), which was the hit of the show. The *Gazette* was almost extravagant in praise of it, and of him:

> He delights in the grotesque – the very Dickens of artists. His forest scenes are wonderful. He seems to take delight in holding the glass to nature when she caricatures herself. Some of his scenes have a weird fascination about them, so that one always wants to have another look at them; and another look

45

Allan Edson
Mount Orford, Morning 1870
Oil on canvas, 91.4 x 152.4 cm
The National Gallery of Canada, Ottawa,
purchased 1917 (1398)

seldom fails to show some new instance of artistic observation
and executive power. Besides his extraordinary sylvan scenes,
he exhibits a 'view of Mount Orford' with the lake stretching
out at the base. The mists of morning give the scene a dreari-
ness and shiveriness which is not pleasant, though quite in
keeping with the subject. Just so may the old mountain have
looked ages before the foot of man had disturbed the silence
of the 'forest primeval,' in the dim dawn when ancient night
and chaos lay a-dying (6 March 1871).

The painting, now in the National Gallery of Canada, does by its
stillness suggest a timeless quality. And although the force of its lower-

ing moodiness brings pleasure to a distant viewing, repeated close examinations, as the *Gazette* remarked, are rewarded too. Edson has turned his developed capacity for observation to the reflections of light on the far shore's foliage, and to the stones and rotting boards on the near shore-line. The frayed wood of the boat's prow seems almost to fluoresce in the sunlight. Such countless details all interconnect, and Edson has perceived the atmosphere, vegetation, earth and water as together held in a cycle of endless change which assures continuance: birth, growth, death, and out of decay rebirth again. It is a classic instance of the underlying metaphysical position that is implied in the catch-phrase of the time, "truth to nature."

It was this belief in very close observation which would reveal the great patterns, that encouraged, or was encouraged by, the consuming interest in photography. We have noted aspects of *Lumbermen on the St Maurice* which seemed to be related to a photographic image; in *Mount Orford, Morning*, in a subtle way, we sense the awareness of the special information a photograph provides. Here we find the tell-tale contrasts of light and shadow which model the stones and boards in the fore-ground, and the marked attention to a consistent source of light.

In all the detail, in fact, we are made aware of how forms are revealed by the intensity and direction of the light reflected from them. There is no known single photograph that Edson has copied, but there is that series of photos of Mount Orford from Lake Memphremagog taken by William Notman in 1867 that Edson could easily have exam-ined (see pls 17 and 18). Their general aspect is similar, but Edson has moved elements about, turned a large exposed root into a boat, added an outcrop of rock on the left, and suppressed all details of human life, save the boat and its rudimentary dock.

The sheer size of such a painting, however, gave it more than an edge on any photograph, and this was an advantage Edson exploited. In the joint exhibition of 1872 he showed four oils, three of them large. Perhaps the fourth one was too, but its size is not suggested in the reviews. *Mount Orford, Morning* was back again, by then the property of Andrew Wilson, a well-known collector, supporter of the AAM and joint-owner of the *Montreal Herald*. There was an oil contributed by the now familiar A.J. Pell; another, *Mountain Torrent*, lent by George Desba-rats, the publisher of the *Canadian Illustrated News*; and the fourth was another large canvas, *Autumn, Mount Orford*, owned by W.F. Kay, like

Wilson a member of the Council of the AAM (pl. 46). It now belongs to a private collector in Toronto. Neither as intense in detail nor as strong in general mood as the National Gallery painting, it is perhaps more pleasingly coloured; the rosy sky harmonizing with the delicate blue mist at its centre. The whole upper portion is lightened to a pastel-like tint with the suffusion of what the *Daily Witness* called "a soft autumnal haze" (8 April 1872).

That year, Edson exhibited eight watercolours, some lent by prominent collectors, such as G.A. Drummond, and one by William Notman. This first really major effort in the field suggested to the *Daily Witness* that he "promises to excell in water colours as well as in oil." Determining which watercolours were included is as difficult this time as when we were looking at his February 1870 showing. He almost never dated works, and particularly in the case of watercolours, the titles are usually lost. His watercolours of the seventies we will discuss later, as a group.

Reproduced in the same issue of the *Canadian Illustrated News* as Henry Sandham's *Toronto Markets* was Edson's *Woodland Scene* (III, 18 March 1871, p. 173). Edson himself was not necessarily involved in the actual making of this reproduction, but the following year, in the same magazine, there appeared a picture, *The Great Bluff on the Thompson River, B.C.*, "etched by Allan Edson" (v, 24 February 1872, p. 116). A note informs us that Edson worked from a photograph, and certainly his understanding of the light qualities transmitted by that medium is immediately evident.

It is a remarkable image he has produced, one that stands out from the other work in the pages of the *Canadian Illustrated News*. Was it etched directly on to a photographic plate by Edson, as Henry Sandham had done with his *Quarries...*. for Desbarats's magazine, back in October 1870? Certainly, in February 1872 Edson was closely involved with both Sandham and Desbarats, and presumably with Desbarats's engraver, William Leggo, for it was then they prepared the set of Art Union prints to which Edson contributed. Three more of his oil paintings were reproduced in the *Canadian Illustrated News* in April and May 1872, but again without Edson's direct involvement, it would seem. There is no evidence that he ever again followed print-making in any form.

These were busy years for him. He was still living with his parents

when the city directory was drawn up early in 1871 (at 34 Scotland, now Argyle Avenue), but he had a studio in the Merchants' Bank Chambers at 319 Notre Dame, where Vogt and Way were, just down the street from both A.J. Pell's and William Scott's shops. There is no evidence that he ever resorted to teaching or commercial work in a photography studio as did so many of the artists. Sometime in the year he married Mary Martha Jackson Stewart of Burnley, Lancashire, England, and the following year they had their first son, Edward. Then they probably moved across the river to Longueuil. From the evidence of paintings that survive, Allan sketched that fall in the Eastern Townships, and worked long hours on canvases back home.

The oil paintings of this year are distinctive. At least three have survived, all large and identical in size (76.0 x 122.0 cm). There is a *Lake Massawippi* now in the Edmonton Art Gallery, an *Autumn on the Yamaska River, Sutton Township* (pl. 47), in the Musée du Québec, and a third in the Vancouver Public Library which has lost its title, but which is probably also a view on the Yamaska. All three are scenes of fishermen in the wilderness. All show traces of the Jacobi-like handling in portions of their foliage.

46

Allan Edson
Autumn, Mount Orford *c.* 1871
Oil on canvas, 72.4 x 148.5 cm
Private collection, Toronto

But what sets them apart from Edson's other work is that all three are painted quite broadly and thinly in areas and with the most intense, high-keyed colours. Some of the sunlit details of *Mount Orford, Morning* are intensely brilliant, and we remarked earlier on the pastel-like hues of sky and mist in *Autumn, Mount Orford*. But these three broad river vistas, particularly in their skies and distant hazy hills, are bathed in startling, whitened tints of pink, baby-blue and citrine yellow. The darker areas – and he is still composing in large sweeps of light and shade – fairly crackle with the intensity of warm autumn hues.

He was then using aniline and coal-tar-derived colours, which had first become commercially available, on any scale, to painters only a few years before. There is a series of articles in the London *Art Journal* of 1865 (New Series IV, pp. 25-26, 102-104, 301-302) which praise the virtues of these new pigments, hailed for their intensity and durability. Highly lightened in Edson's hands, they took on a transparency similar to watercolours.

47

Allan Edson
Autumn on the Yamaska River,
Sutton Township 1872
Oil on canvas, 65.6 x 121.9 cm
Musée du Québec, Québec (A 48 107 P)

ADOLPH VOGT

The other young painter who rose to local fame with the SCA was Adolph Vogt. The eleven oils and single watercolour he contributed to the Society's first show in December 1868 were all, it would seem from the titles and the remarks of reviewers, still very much the work of a student of Rudolph Koller. One wonders if he had met his master again in Paris. Almost all were concerned with such bucolic subjects as *Horses Drinking*, *Donkey and Chicken*, *Study of Sheep*, and everyone was drawn to them.

There were two large pieces, one of which, a *Study of a Cow*, according to the *Gazette* was "a study from life" that could not "fail to arrest attention as it looms on the visitor in all its intense reality" (23 December 1868). But even more of an eye-catcher was his large *Grey Battery Passing Champ-de-Mars on their Morning Exercise* in which "the men and many of the horses are actual portraits"; it is a painting that seems to anticipate the large composite photographs that would soon be so popular. It was last seen publicly at a Toronto auction in 1912.

There were no exhibitions in Montreal in 1869. Vogt, although certainly not using that excuse, displayed at the National Academy of Design in New York that year a *Returning Home at Sunset – Scene in France* (presently in the Loeb collection, Toronto). It is probable that he went to New York for the occasion, but he was soon back in Montreal, and in February 1870 made another strong showing with the SCA: eight oils and one watercolour. His works were again featured, with two large canvases dominating the main room. One, which was huge (124.5 x 223.5 cm), was a Koller subject, *Coming Storm During Harvest*. Now in the Edmonton Art Gallery, it seems a very theatrical piece, with dramatic shadows and heavy sky. Horses and harvesters fill the whole picture in Vogt's usual aggressively bold manner.

The other large canvas was placed in the best location, immediately opposite the door. It was a pure landscape, *Niagara Falls in Summer*. We don't know where it is now, but a large two-page Leggotype reproduction appeared in the *Canadian Illustrated News* in October (five months before Sandham's *Toronto Markets*). It must have been an awesome painting. A study, most likely from nature, is in the National Gallery of Canada (see pl. 48). It is itself quite large, almost a metre wide, but it is painted in the loose, broad manner of a sketch.

As a consequence it is the most spontaneous of Vogt's works to have come down to us, and it is difficult to imagine that he could have transferred its wonderfully fresh sense of atmosphere to a canvas more than twice the size. If we can trust the drawing that was photographed to make the Leggotype – and there is reason to believe that Vogt could have rendered it himself – then the large canvas was indeed formalized. The falls themselves are more tightly framed, a picturesque dead tree has been placed right in the centre foreground, and the rising mist has increased in prominence. His usual bold and broad brushwork is ignored in the Leggotype, of course, but we can only hope that it approached the effectiveness of its use in the National Gallery study.

I suggested that Vogt may have himself prepared the pen-and-ink drawing of his *Niagara Falls in Summer* because, earlier that year, he was employed by the *Canadian Illustrated News* to sketch incidents arising from the new Fenian raids in the Eastern Townships. When the Fenians crossed into the Niagara Peninsula at Fort Erie in the summer of 1866, it was believed that a second force was about to attack Montreal through the Eastern Townships.

This second attack did not come in 1866, but finally occurred late in May 1870. Vogt's sketches of one of the skirmishes and of the volunteers' camp life were creditable work for someone unlikely to have been accustomed to the pen. They appeared in two numbers of the magazine (I, 4 June 1870, pp. 488, 489; II June 1870, pp. 500, 501), and, as did many of the *Canadian Illustrated News* pictures, again five days later in Desbarats's French-language magazine, *L'Opinion Publique*.

Vogt did no other illustration work (although he contributed drawings for four of the wood-engravings that appeared in the elder John Fraser's *A Tale of the Sea....*). He seems to have sold his *Coming Storm During Harvest* soon after the exhibition (he was asking $400, a large amount then), because he sold a second version, painted in 1870, to Edson's early patron, J.C. Baker of Stanbridge, in December. It is now in the Art Gallery of Windsor, a somewhat smaller but otherwise nearly identical copy. Having made a further $100 from that sale he left to establish himself in New York. Almost exactly two months later, 22 December 1871, he died of smallpox.

His friends in the SCA hastily prepared a small memorial display to be included in the third annual exhibition of the Society, which took place only two weeks after his death. A portrait of Vogt by Ida Brau-

baçh, his fiancée and fellow-member of the Society, was "hung draped with crape, over his latest productions" (*Canadian Illustrated News*, III, 11 March 1871, pl. 151).

It was, as the *Montreal Herald* reported in the unconsciously fatuous way of Victorians, "not only a work of art, but an evident labour of love" (6 March 1871). He was by all reports an exceedingly attractive man (there is an amazing Notman portrait of him; see pl. 49), a fine and passionate musician, keenly observant and, Montrealers believed, the most promising painter among them. He had reached the age of twenty-eight.

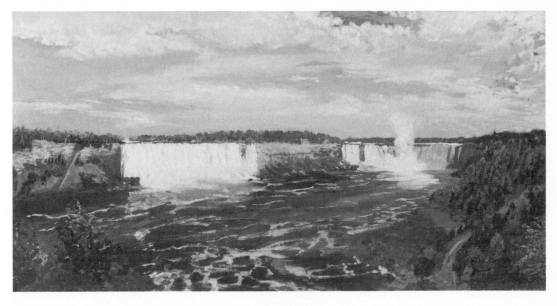

48

Adolph Vogt
Niagara Falls 1869
Oil on canvas, 50.8 x 99.0 cm
The National Gallery of Canada, Ottawa,
purchased 1966 (14,704)

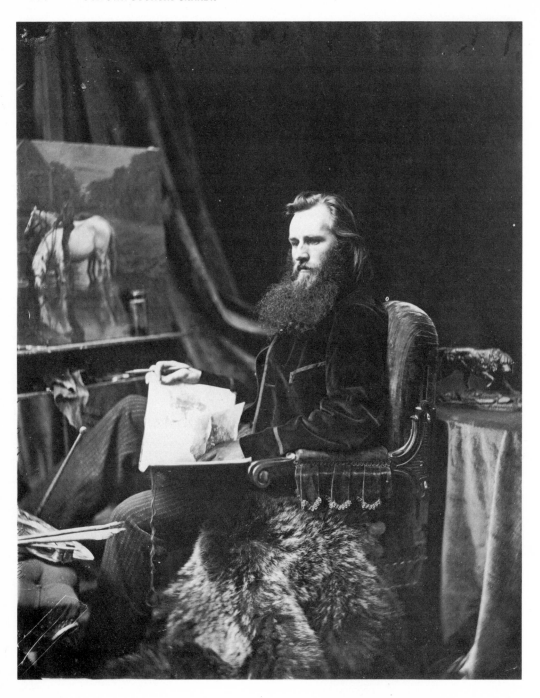

49

William Notman Studio
Adolph Vogt 1868
Recent print from the original negative,
25.4 x 20.2 cm
Notman Photographic Archives,
McCord Museum, Montreal (30,055-1)

C.J. WAY

C.J. Way, who had left Montreal for England in 1864, was back in the "commercial capital" of Canada, just in time to participate in the first exhibition of the SCA in December 1868. He at once took a studio adjacent to Adolph Vogt's in the Merchants' Bank Chambers on Notre Dame Street.

In England he had shown very few of his Canadian paintings. Only one is recorded, *An Autumn Day in the Saguenay....* at the Royal Society of British Artists (RSBA) in 1865 (no. 909). Way also exhibited with the Royal Academy for the first time that year, and again in 1868; in both instances sketches from nature. He contributed to the RSBA from 1865 to 1868, showing watercolours of Swiss scenes the last year, presumably the result of a visit to Europe in 1867.

Throughout this period he also managed to be heavily represented in each of the AAM exhibitions back in Canada. In 1865 William Notman lent all twelve of the original sepias that had been reproduced the previous year in *North American Scenery....* Thomas Rimmer, a member of the Council of the AAM, and a Way supporter from at least 1863 (having contributed two of the works shown in New York that year), lent a watercolour. So did a certain W. Cunningham, and one of the Dawson Brothers lent three.

The pattern repeated in 1867: sepias sent over from England and reproduced in *Notman's Photographic Selections* (mostly views in Wales) were lent by William Notman, the dealers Scott and Pell lent works, and the loans of a whole range of collectors, including Thomas Rimmer, W.F. Kay, and the photographer Alexander Henderson, brought the whole total to twenty-three. Way also continued to sell new work in Montreal, because watercolours that he had painted after his return to England were lent to the February 1868 exhibition of the AAM. They included one that he had shown with the RSBA in 1866, and his first Italian scene, a *Lake Como*. With this local support, Way was as well represented as any of the residents.

He was warmly received upon his return to Montreal, which was very likely late in the fall of 1868. In January it was announced that his watercolour, *Scene Near Monte Rotundu, Corsica*, was to be the first work acquired with the application of the annual Canadian purchase policy that had been established in 1864. (Otto Jacobi's view, *The Parliament*

Buildings, Ottawa, which had been commissioned late in 1865 in order to have it chromolithographed as an Art Union prize, was actually the first work purchased by the AAM, although not with the intention of building up a collection.) Then later in the year when John Bell-Smith retired from the presidency of the SCA, C.J. Way was chosen to replace him. Late in February 1870 he became one of three Society members elected to the Council of the AAM.

Way showed no Canadian works again in the second SCA show, and only one was included in the AAM exhibition the following month in March 1870, a *Sketch of the Wharf, Montreal* which was lent by a collector, and could easily have been done during his first sojourn there. It was only in March 1871 that new Canadian works began to appear, and they constituted no more than half of his contribution to the Society exhibition that month. However, the vast majority of his paintings in the joint exhibition of 1872 were Canadian.

Nevertheless, most of the pictures he showed during these years resulted from the European trip he had taken while in England, probably in 1867, and perhaps on his way back to Montreal in 1868. There are views of the Alps – Swiss and Italian – of Venice, Florence, and Corsica. And there are views of Portland, Maine, and of the Androscoggin River in New Hampshire, both on the line of the Grand Trunk Railway, Montreal's only winter link with the Atlantic Coast.

Although Way continued to enjoy the support of many of the Montreal collectors – as evidenced by the lenders of his works to the AAM shows in 1870 and 1872 – and although he invariably is mentioned in the reviews in the most positive terms, it is generally briefly, and with reference to the "liquidity" of his water, or other of his technical accomplishments. He failed to attract the kind of attention that increasingly was coming to such artists as Sandham, Edson, or Vogt. At times, he is almost not noticed at all.

This, in spite of the fact that in 1870 he began for the first time to exhibit oil paintings, and in 1871 and 1872 showed as many oils as watercolours. In the 1871 SCA show one of his canvases was the largest on view, *An Autumn Afternoon, Lake Magog,* placed in the key position directly opposite the entrance. Although the *Daily Witness* felt it to be the finest work in the exhibition, the tragedy of Adolph Vogt took most of the attention in other reviews, and the reporter for the *Canadian*

Illustrated News mentioned most of Way's contributions, but carefully avoided any word of this, his most prominent picture.

We cannot now judge for ourselves. *An Autumn Afternoon, Lake Magog* has been lost to public view, as has most of Way's production. There is an 1869 watercolour, *Near Portland, Maine*, now in an Ottawa collection, which was shown in the 1870 SCA exhibition. It is rather quieter than the works of his first period seem to have been, with a fine, delicate sky. That he was a skilled technician is borne out by an oil of 1871–1872 that is now in the Vancouver Art Gallery, called *Landscape with Indians* (pl. 50). It is bright and clear in colour, and painted with some evident thought. But we really will have to reserve judgement until we know more of his paintings.

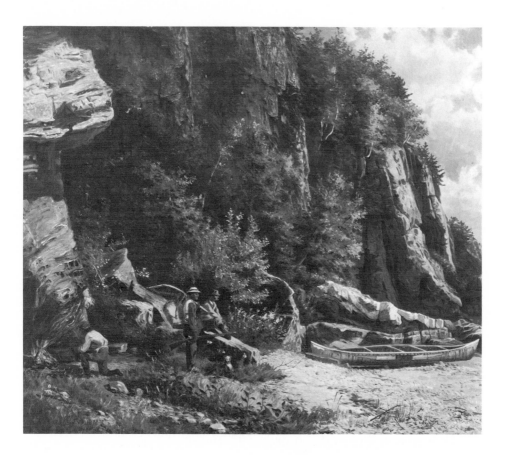

50

C.J. Way
Landscape with Indians 1871–1872
Oil on canvas, 48.5 x 56.2 cm
Vancouver Art Gallery,
purchased with funds from the
Annie M. Mack Bequest, 1964 (64.30)

JOHN A. FRASER

John A. Fraser presents something of a similar problem. We can reconstruct elements of his life and career during the later sixties, but we lack the paintings. For instance, the life-size *Portrait of the Bishop of Montreal*, which was presented to the AAM by William Notman during the opening ceremonies of the exhibition of 1865, has been lost. (It was perhaps later withdrawn from the collection by Notman, as a condition of the gift was that the AAM begin the construction of a building to house its collection within five years.)

That year, the *Montreal Herald* gave more attention to the Bishop Fulford portrait than to any other picture, concluding that "the handling of the whole is bold and masterly; yet the effect of everything is so perfectly natural that the manner does not in any way intrude itself upon our notice" (28 February 1865). We must assume that the strong reaction to this work arose, in part at least, from the skilful showmanship of Notman and Fraser, but without the painting, we cannot judge to what extent.

Fraser was the Notman firm's most important employee, and the demands upon him must have been great (see pl. 51). We know from the wage books that his rewards most certainly were. Late in 1864 or early 1865 he moved his family up the street to 208 St Urbain, and the following year they moved again, into even grander quarters at Monteith Place, 98 Cadieux Street. Upwardly mobile, they were the next year at 25 Plateau. Probably in response to such evident restlessness, Notman had a formal contract of engagement with Fraser drawn up in February 1867.

Fraser had been sketching in the United States the year before, off the line of the Grand Trunk, in the White Mountains of New Hampshire. At the February 1867 exhibition of the AAM he was represented by three watercolour sketches from that trip, lent by A.J. Pell. He had also sold two to the AAM for the Art Union, one of them won by a New Yorker, J.W. Mounford (*Montreal Herald*, 16 February 1867). Fraser had probably visited New York, or was about to, as at the end of the year he was listed as an exhibitor in the first exhibition of the new American Society of Painters in Water Colors, although he did not in fact show that winter. In November his third child, another son, Donald Lovat, was born. Probably as a result of this increase in the size of the family, they moved yet again, this time to 197 Bleury.

51
William Notman Studio
John A. Fraser 1866
Albumen print, 8.0 x 5.5 cm
Notman Photographic Archives,
McCord Museum, Montreal (23,023-1)

The following year was just as frenetic. Notman sent W.J. Topley to Ottawa to manage his first branch, and it is likely that Fraser was there and back a number of times, helping out. (It is frequently stated that Fraser himself established the branch, which was directly opposite Parliament Hill on Wellington Street at Metcalfe, but no evidence has been found to substantiate this. A John Alexander Fraser, photographer, was located on St Patrick's Street near Sussex in 1870, according to the Ottawa city directory, at 104 Sussex in 1874, and at 460 from 1875 to 1877, but this is not our man.) Topley purchased the Ottawa branch from Notman in 1872.

In February Fraser exhibited a small oil in the AAM show, and a watercolour sketch, and seven other of his watercolour sketches done around Lake Memphremagog were lent by William Notman. All were for sale, and possibly were painted on an excursion with Notman, as he had been to Lake Memphremagog, taking photographs, the year before. The whole group is discussed in the *Gazette* of 28 February 1868:

No. 66 to 72 are a series of clever sketches of Canadian scen-
ery by Mr. J.A. Fraser. Some of these have been unfairly criti-
cised as wanting softness of tone and finish, or being hard and
crude. Critics, however, should be able to distinguish between
finished pictures, and mere sketches dashed in on the spot,
and not retouched since. The subjects are scenery in the East-
ern Townships, and in the neighbourhood of Lake Memphre-
magog, and as sketches they are admitted to display great
breadth of treatment, freedom of touch and richness of col-
ouring. If these sketches had been shown as finished watercol-
our drawings, they would undoubtedly have been open to a
charge of crudeness.

In the National Gallery of Canada is a large watercolour sketch of
Mount Orford which was purchased in 1964 in the belief that it was the
study for Fraser's Royal Canadian Academy Diploma piece of 1880,
Laurentian Splendour (pl. 52). It was most likely used as the basis for that
canvas, as there are many similarities, and the general aspect is the
same. But it is not a study for the canvas.

It is a field-sketch, and complete in itself in its own rough way.
During the seventies Fraser did not have the time for regular field-
sketching trips, and there is no evidence of his having returned to
Memphremagog after 1867. The signature, incidentally, is not of a
form seen on any other works. The National Gallery watercolour, then,
is most likely one of that group that was painted in 1867 (the only one
that is presently known), and perhaps even one of those lent by Wil-
liam Notman to the fifth exhibition of the AAM in February 1868. It fits
the general description in the *Gazette* perfectly: it displays "great
breadth of treatment, freedom of touch and richness of colouring."

In May 1868 Fraser was elected to membership in the American
Society of Painters in Water Colors, although he did not exhibit with
that New York body until a decade later. Over the next few years, he
hardly had any time to paint. He drew his final salary from the Notman
firm 31 October 1868, according to the wage books, and shortly there-
after he was established in Toronto, a partner with Notman in the next
stage of the firm's expansion. The earliest advertisement I have so far
found for the new Notman and Fraser business, situated at 120 King
Street East, is 19 November 1868 (*The Globe*).

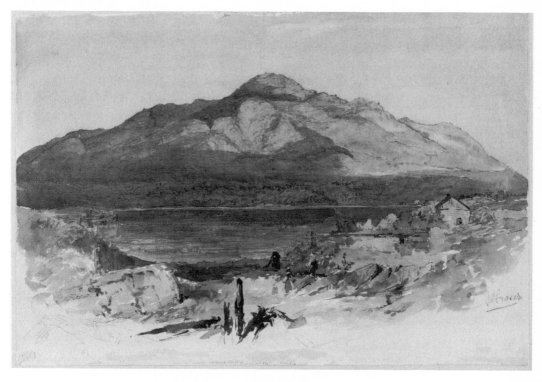

52

John A. Fraser
Laurentian Splendour *c.* 1867
Watercolour, 33.8 x 50.65 cm
The National Gallery of Canada, Ottawa,
purchased 1964 (15,179)

Fraser must have kept up many contacts in Montreal – at the least with his parents (though his father died in 1871, in a fall from the bluff behind the Parliament Buildings in Ottawa); with his brothers and sisters (though again one brother, a rival photographer, followed him to Toronto); and with his business partner – but he settled down to life in Toronto with enthusiasm. His fourth child and first daughter, Nanette Alice Mabel, was born there 25 June 1869. (Mrs William Notman stood as her godmother.) There was no city directory published in Toronto in 1869, but in 1870 we see that the new Notman-Fraser firm is still

established in downtown quarters at 120 King Street East (see pl. 53). The Fraser family is eight blocks north, at Gould and Church streets.

It also seems from the 1870 directory that Fraser had established a separate studio in Toronto, a short block east of his home on Gould Street at Dalhousie. There were then no regular exhibitions in that city (although he sold paintings from the Notman and Fraser shop), and so he sent work to Montreal for two years. In December 1868 he showed two oil paintings with the new SCA, in the formation of which he had

53 Notman & Fraser Studio
 Notman & Fraser, Toronto 1868–1869
 Albumen print, 14.0 x 10.2 cm
 Notman Photographic Archives,
 McCord Museum, Montreal (34,684-BI)

been involved, and a single oil in the Society's second exhibition in February 1870. Then his *Portrait of the Bishop of Montreal* was displayed by the AAM at its March 1870 exhibition, and that was it. When he missed the third showing of the SCA the *Montreal Herald* noticed. "We regret that John A. Fraser, one of the founders of this institution, is not represented in this year's exhibition. We believe his numerous engagements have frustrated the possibility of his exhibiting" (6 March 1871). Ten years would pass before his work would be seen in a public exhibition in Montreal again.

WILLIAM NOTMAN

The Notman expansion into Ottawa and Toronto in 1868 was a manifestation of the persistence of Montreal in reinforcing its cultural and commercial hegemony over the western part of Canada – which then consisted of the Province of Ontario. It was equally a manifestation of the creative energy of William Notman (see pl. 54). *The Dominion Illustrated* remarked upon the occasion of his death that he "paid attention to every detail of the business" (VII, 5 December 1891, p. 531), and it is one of the most remarkable things that no matter how many gifted, creative people he employed to assist that business, his own product, like that of a Renaissance master, continued to carry a personal style. Works of art of singular force and clarity, they were all "Notmans."

In 1866 William Notman again took a house in the city, at 43 Berri Street, a dozen blocks east of Bleury, just beyond St Denis. He apparently retained Clydeside Cottage on the Lower Lachine Road as a summer home. In the 1868 Montreal city directory his house is listed at 34 Berri, and for the following six years, that or Lower Lachine Road are given as his residence. His family continued to grow. Although his eldest daughter, Fanny, died at the age of twelve in 1867, a second son, George, was born in October of the following year. And in December 1870 a third son, their seventh child, Charles Frederick, appeared.

As well as expanding his commercial outlets, to Ottawa and Toronto, and before 1870 to Halifax, Notman also sought to expand the range of his art. As already noted, the first issue of the *Canadian Illustrated News*, on 30 October 1869, had printed on its cover the first half-tone reproduction ever to appear in a news magazine. Although he

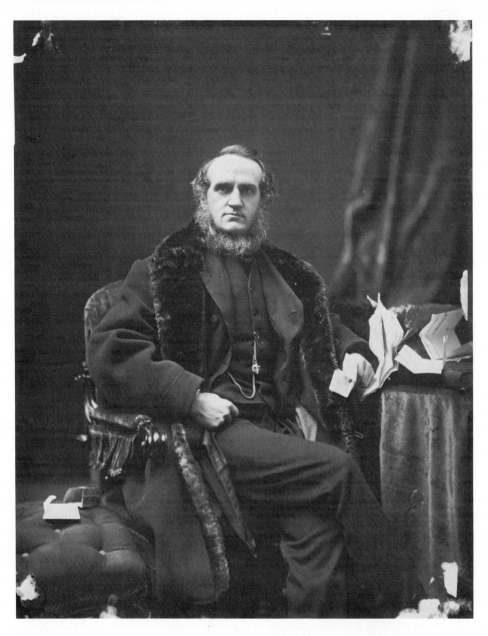

54

William Notman Studio
William Notman 1869
Recent print from the original negative,
25.4 x 20.2 cm
Notman Photographic Archives,
McCord Museum, Montreal (30,283-1)

was not in his lifetime to see the great proliferation of the printed pho-
tographic image which we now take so much for granted, Notman's
involvement in this early experiment reveals his position in the van-
guard of photographers.

Another pioneering venture began in 1870. Extensive group
scenes had always posed problems. A large negative required a lengthy
exposure, and people in a crowd invariably moved, blurring the image.
Early in 1870 in Montreal the "composite photo" was devised as a
solution. Notman's studio rushed on to success with this new tech-
nique. Here is a report included in an article, "Examples of American
Photography," which originally appeared in the London *Photographic
News*, and was reprinted by the *Canadian Illustrated News*:

> From Mr. Notman we have also some of the finest transatlan-
> tic landscape pictures we have seen; two or three large views
> of Niagara, besides being admirable renderings of the mighty
> fall of waters, approach the sublime in the effect of cloud, light
> and shade, and atmospheric effect.
>
> Mr. Notman also sends us perhaps the most perfectly com-
> posed group we have ever seen produced by photography.
> The subject is what is termed a 'skating carnival,' which was
> given in Montreal during the visit of Prince Arthur, whose
> portrait appears pre-eminently in the group. The scene is a
> most animated one, consisting of some hundreds of figures in
> fancy costume engaged in skating in a 'rink,' gaily decorated
> for the occasion. Of these figures nearly two hundred are per-
> fectly made out, and the features perfectly traceable, although
> the picture does not exceed nine by seven inches; and we do
> not remember ever to have seen a more charming looking
> assemblage of pretty girls comprising every style of beauty,
> and of fine-looking men. Such a noble and attractive looking
> assemblage must make Englishmen proud of their kinsfolk in
> the Dominion of Canada. We have no details from Notman of
> the method by which the group was produced, but it seems
> tolerably clear that it has involved enormous labour. The por-
> traits appear to have been taken singly and in groups, accord-
> ing to a pre-devised plan to suit the composition, the whole
> being finally pasted on one large sheet of paper, retouched,

background accessories painted in, and then the whole repro-
duced in a smaller size. The great beauty and the great diffi-
culty of the case is the admirable composition and grouping,
so as to secure harmony, ease, and naturalness. The arrange-
ment of men and women, and the suitable juxtaposition of
costumes, the choice of position and occupation – some
figures skating, some in conversation, some making saluta-
tion, some standing and looking – but all varied and all natu-
ral; the admirable perspective, the perfect definition, and the
perfect light and shade and fine relief, all tend to produce a
group such as we have not before seen produced by photogra-
phy.

Notman was not the first to apply the new technique, however.
The article continues.

Since the receipt of this group, we have received two others of
a similar character, but on a larger scale, by Mr Inglis, of
Montreal. One of these consists of the subject just described,
the carnival of the Victoria Skating Rink, and the other the
opening of the Montreal Curling Rink. The latter was the first
composition of the kind produced, and was the origin, we
understand, both of Mr Inglis's own skating carnival group,
and that of Mr Notman.... (II, 23 July 1870, p. 59).

James Inglis had first appeared in 1864, as a photographer in St
Catharines, near Niagara Falls, Canada West, but he settled in Mont-
real the following year, establishing his studio at 122 Great St James
Street. In 1869 he moved to 199 on the same street, and in 1871 to 195
1/2 St James, finally settling at 51 Bleury, a couple of blocks up from
Notman, in 1874. His first composite, "The formal opening of the Cal-
edonia Curling Rink," was nearing completion 14 February 1870,
according to an item that day in the *Montreal Herald*.

Notman's planned composite of the "Carnival at the Skating Rink"
is first mentioned a few days later, in a notice in the *Canadian Illustrated
News*. It announced that those who wished to be included in the com-
position were being photographed in costume at the studio on Bleury
Street (I, 26 February 1870, p. 262). An advertisement offering the
finished photograph for sale appeared a month later (*Canadian Illus-
trated News*, I, 2 April 1870, p. 351). Seven weeks after that the photo
was reproduced in the same magazine (I, 21 May 1870, p. 460).

The completed art-work – a large painting in colours in which each of the numerous photographed figures has been properly scaled and tinted, and then skilfully integrated into the whole, the background elaborately painted to contain it all – is one of the prized possessions of the Notman Photographic Archives of the McCord Museum in Montreal. It is signed in the lower left corner, "Notman Photo," and in the lower right, "Hy Sandham/Edward Sharpe/Fecit./1870." Edward Sharpe was a young Englishman who had arrived in Canada the previous year, at the age of nineteen, and who was to die suddenly in the fall of 1871. Henry Sandham, of course, we know.

Sandham went on to make the painting of such composites a specialty of the Notman Studio (John Fraser in Toronto, and also in 1870, produced the first painted composites for that branch of the firm, which he duly signed as the artist). They were an important extension of the Notman portrait business, in which the firm had always excelled. Landscape, too, remained important and in 1871 the firm carried that branch of the business, and that aspect of Canadian art, into new areas. Indeed, throughout the sixties William Notman's aspirations were growing apace with the country he had made his own.

THE MOVE WESTWARD

Canada was at that moment experiencing its most extensive territorial expansion. In May 1870 the Manitoba Act was proclaimed, adding a fifth province to the country. (Manitoba was then a fraction of its present size, consisting only of that region immediate to the old Red River Colony.) Then in July the Hudson's Bay Company domains were finally annexed to the Dominion. These Northwest Territories extended west to the Rockies and north to the Arctic Islands, increasing the land mass of the country by more than tenfold. In July of the following year B.C. agreed to enter Confederation, one of the conditions of its entry being the speedy construction of a transcontinental railway, which would link it to the eastern, settled portion of the country. The federal government was by no means certain as to how it would organize such a mammoth project. However, it was anxious to offer evidence of good faith and began the exploration and surveying of possible routes that very summer. This great task was placed in the able hands of Sandford Fleming, a man of much experience in the building of railways.

Fleming had been born in Kirkaldy, Fifeshire, Scotland, 7 January 1827. He emigrated to Canada in 1845, and a few years later entered the service of the Northern Railway of Canada, which was being built to link Toronto with Collingwood, on Georgian Bay. He became the Chief Engineer of the railway in 1857. The promise of a rail-link with Canada had encouraged the entry of the Maritimes into Confederation, and Fleming became the Engineer-in-Chief of the Intercolonial Railway when construction commenced on that government line in 1869. It was only natural that he should expand his office to include the supervision of the new Pacific route as well. The plan was to run the line along the fur routes, from the head of Lake Superior to Lake Winnipeg, along the Saskatchewan River, through one of the low northern passes of the Rockies – the Yellowhead or perhaps the Peace River – and on to Bute Inlet and Vancouver Island.

As early as 1842, there had been established a Geological Survey of Canada. By 1871 it was under the direction of Alfred Selwyn, with headquarters in Montreal. Another of the terms of entry into Confederation by British Columbia was that explorations and geological surveys immediately be undertaken by the federal government. Selwyn and Fleming got together, and it was decided that in certain cases a combined effort could serve the needs of both the Geological Survey and the Pacific Railway Survey. Selwyn himself led a party into British Columbia that first year, and took a photographer with him.

We cannot be certain whose idea this was. Certainly it was Selwyn who sought the proper authorization from the Secretary of State for the Provinces, and who made the actual arrangements to engage suitable men. On the other hand, Sandford Fleming had a life-long interest in art, which certainly included the photographic medium. They of course approached William Notman, who supplied them with two men – an operator and an assistant – and the necessary equipment. It was agreed that Notman would pay their salaries, and retain the negatives and the right to sell prints. The two surveying parties would share the costs of transportation and living expenses.

BENJAMIN F. BALTZLY

The man Notman chose to represent the firm on this first trip into the Rockies was an American, Benjamin F. Baltzly. He was accompanied by

a young Montreal artist, John Hammond, who had joined the Notman staff in August the previous year. Baltzly, we know from an obituary published in *The Cambridge Chronicle* (14 July 1883), was born in Ohio in 1835. He arrived in Montreal in 1866, and found work with the photographer J.G. Parks. The following year he established his own studio (he is listed in the Montreal city directory at 372 Notre Dame), but then in 1870 he joined the Notman firm.

The survey party left Montreal 26 June 1871, travelling by rail to San Francisco, and then by coastal steamer to Victoria. From Victoria they crossed to the Fraser River, and up to Yale, which was as far as the steamboat could go. They then followed the wagon trail to Kamloops Lake, and crossed to Kamloops, at the mouth of the North Thompson River. They proceeded up the North Thompson with pack horses, but just beyond the river valley, near the divide, the trail came to an end.

The plan had been to continue on to the Yellowhead Pass, and through it to Jasper House. But the thick forest, an almost impenetrable jungle, slowed their progress to such an extent that they often advanced but a few kilometres a day. Winter had already begun to close in and finally, having reached the neighbourhood of the pass, they had to give up and return the way they had come. Once back to the North Thompson they hollowed canoes out of huge trees, and after losing one boat (they had to cache the camera equipment), finally made it to Kamloops, and hence on ultimately to Victoria.

Baltzly kept a journal of the trip, and the following summer published a lengthy narrative in the *Gazette* (in nine parts between 18 June and 1 August 1872). The following excerpt gives some idea of the tremendous physical effort and persistence required to move through the wilderness with the heavy and bulky photographic "instruments." It also expresses something of the delight the artist felt in achieving a good view (see pl. 55). The story begins 28 September:

> Another halt for the trail; so the next morning there being some signs of clearing up, I was highly elated with the prospect of getting a few views of Mount Cheadle and the cascade. Thinking the land opposite our camp was the mainland, I got LaRue to take me across in the canoe. Then I started through the willow, alder, and tall cranberry trees and ferns, wet with the last night's rain, to go to the cascade to see

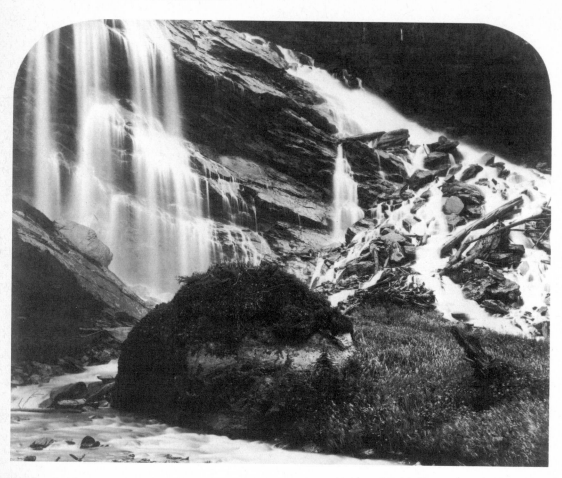

55

Benjamin Baltzly
Lower Falls of Garnet River Cascade,
Near Mount Cheadle, B.C. 1871
Albumen print, 19.0 x 24.0 cm
National Photography Collection,
Public Archives of Canada, Ottawa,
Sir Sandford Fleming Collection (1936-
272)

whether there was any prospect of getting views near the falls. After plodding on about three-fourths of a mile through the above bushes, across bear tracks (one evidently very large judging from the marks of his claws), shooting a grouse, and passing an old deserted Indian hunter's camp and cabin, I found, by coming to a slue or arm of the river, that I was only on a large island. So I returned, deeply chagrined and when I got opposite the camp, Hammond and LaRue came over with the canoe. I told them my mistake, and also that I was determined to go to the falls, this time with the canoe; so away we went down stream. The river flows very rapidly, thus without much paddling it only took us twenty-five minutes to reach the cascade. The cascade, as seen from the foot of the falls, is grand beyond conception. It is by far the boldest scenery of the kind I ever witnessed. It made my heart throb with wonder and amazement as I stood for a few moments and looked upon this beautiful sheet of water as it dashes and tumbles down over the rocks with a deep thundering and roaring noise. The height of the fall is altogether about 400 feet. Far above, it runs down a narrow canyon in angry foaming sheets, and then makes a bold leap over a perpendicular rock for many feet down, and dashes against a rock which turns its course a little to the right, again it makes another fearful leap, but is again arrested by another rock which has a front of about 900 feet. Here the water separates, the most part running over a rocky precipice on the right, and on the left the water flows down over the brow in thin sheets to a distance of 150 feet, and before it reaches the rocks beneath it breaks into a shower of spray, and looks much like a white vail against the dark rocks over which it flows. In the centre the rocks boldly project, and only here and there small streams of water flow over them, looking much like silver threads. The velocity of the falling waters keeps up a continuous hurricane at the brow and foot of the falls, and for many yards around the foliage and trees are kept in continual motion with the wind, and wet with the spray. We did not stay long to admire its beauties, but hastened back to our canoe to return to camp for our instruments; but when we reached camp it began to rain. The cur-

rent was so strong that it took us an hour and a half to get back, and from paddling, pushing, and towing the canoe against the current we got a complete drenching.

The following day being a little more pleasant, Hammond, LaRue and I, accompanied by Selwyn started for the cascade again. Not being able to get near the falls with the canoe, we cut about 40 rods of trail, and carried our instruments near the foot of the falls. After Selwyn took a look at the cascade, and examined the rocks, etc., he left us, Hammond and LaRue taking him across the River Thompson to our trail on the west bank. The day was very cloudy and gloomy, yet I was successful in getting a few good views. The upper rapids we could not get in our view, it being hid by the dense forests of dark green pine and balsam trees. Mr Selwyn named the stream 'Garnet Rivers' and therefore the falls 'Garnet Cascade.'

After taking the above view we carried our instruments back to the canoe, and went up the Thompson about half a mile and stopped on the west bank of the river (trail side.) Here we carried our instruments up a high bank about 200 feet, and then along the trail for a quarter of a mile, to a point where a good view of Mount Cheadle could be obtained. After taking a view of the Mount we repacked the instruments and left them in the woods for the night, thinking it not safe to take them up to camp in the canoe, preferring to bring them the next day on a pack horse (25 July 1872).

Baltzly took 120 photographs on the trip, from which at least three sets were made. One went to the Department of the Interior (for the Geological Survey), a second to the Department of Public Works (for the Pacific Railway Survey), and a third to Sandford Fleming himself, suggesting the degree of his personal interest in the photographic project. Fleming's set was printed directly from the negatives obtained on the trip, whereas, for the other two, second negatives showing cloud effects were often printed simultaneously, in order to add interest to the sky areas (see pl. 56). It was presumably these altered versions that were also available for public purchase. Baltzly was proud of the work he had accomplished, and ended his series of articles with the following modest advertisement:

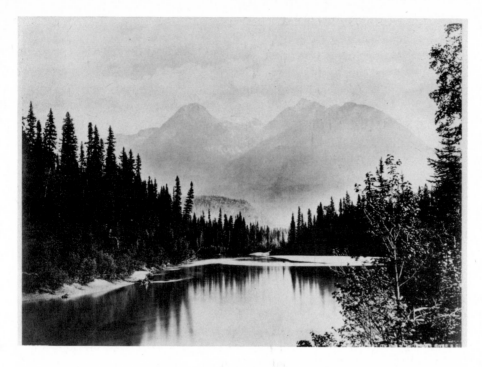

56

Benjamin Baltzly
Glaciers and Mountain Scenery at
Confluence of Muddy and North Thompson
River, B.C. c. 1871
Albumen print, 17.0 x 23.5 cm
National Photography Collection,
Public Archives of Canada, Ottawa,
Geological Survey of Canada Collection
(1970-88)

Photographically speaking our trip was not as successful as I
had anticipated. The season being so late, the difficulty of
travel among the mountains so great, the continuous rains
and winter setting in so early, did much to retard our success.
Yet I took a goodly number of 8 x 10, and stereo negatives of
both geological and general interest. These I was successful in
bringing home, although we had to abandon our photo-
graphic instruments in the mountains.

All who are interested in British Columbia and our travels, would no doubt be further interested and benefited by these photographs, copies of which can be had from Mr. Wm. Notman, Photographer to the Queen, at his studio in Montreal. The photographs are interesting novel and peculiar, and should elicit an inspection (*Gazette*, 1 August 1872).

The documentary intent is evident in Baltzly's photographs. He had accompanied the surveyors in order to record the geological features of the land, and to describe in panoramic views the general terrain of the proposed rail route. He also apparently understood that his role should include the chronicling of the journey, the collecting of full evidence of their struggle in the wilderness. The photographs he produced are works of art as well, still fresh with the dynamic force of that landscape he had come to know so intimately, being a part of it, as he was, for almost six months. They carry a strong mood of containment, with rock and forest always pressing in (see pl. 57).

Baltzly, as did his employer Notman, enjoyed the strength of contrast, and played the smooth-silk quality of falling or rushing water

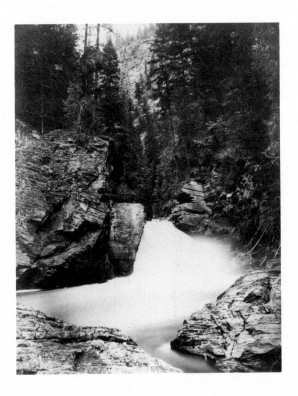

57
Benjamin Baltzly
*Raft River Cascade,
near the Junction of the River,
with the North Thompson, B.C.*
1871 Albumen print,
24.6 x 19.4 cm
National Photography
Collection,
Public Archives of
Canada, Ottawa,
Sir Sandford Fleming
Collection (1936-272)

against blowing grasses or heavily textured rock. He became masterful at drawing to the surface of rock a sense of the forces that had formed it. In one of his most remarkable images, the party tugs anxiously at a log canoe, as even in November the rubble everywhere seems to echo the crushing weight of the spring torrent (see pl. 58).

Benjamin Baltzly continued to work for Notman until about 1878, "becoming well known as a skilful artist, often travelling as agent for the firm to take photographs at various localities" (*The Cambridge Chronicle*, 14 July 1883). He visited Cambridge, Massachusetts, for the first time in 1873 in order to photograph Harvard College groups for Notman, and subsequently specialized in this branch of the art, working most of the eastern schools. In 1879 he moved to Cambridge, where he died suddenly in 1883, leaving his wife and two daughters. Baltzly's Canadian career was short, and his work, other than the 1871 British Columbia photos, has not so far been isolated from the general production of the Notman firm. There can, however, be no question that the images he brought back from the West helped quicken the pulse of adventure in Canadians, as the prospect of the Pacific railway, and the new Canada it would open up, attracted more and more attention.

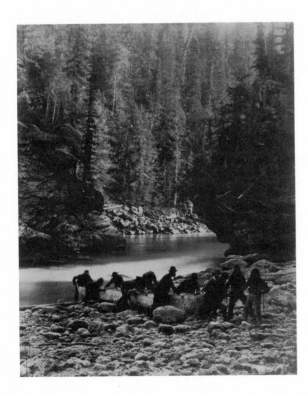

58
Benjamin Baltzly
Making Portage of Canoes Over the Bluff at the Upper Gate of Murchison's Rapids, in the North Thompson River, B.C.
1871 Albumen print, 24.0 x 18.8 cm
National Photography Collection,
Public Archives of Canada,
Ottawa,
Sir Sandford Fleming Collection (1936-272)

Fanning out north and west from the region of the old United Canadas, Sandford Fleming's small army of exploring surveyors sought for the best and the shortest trail across the "Great Lone Land" of the new territories. The summer of 1872 Fleming himself set out to inspect the most likely route. He was accompanied by a Church of Scotland minister from Halifax, George Monro Grant. Grant was born 22 December 1835 at Albion Mines, Nova Scotia, and was educated at Pictou Academy, West River Seminary, and Glasgow University. In 1863 he became the minister of St Matthew's Church in Halifax, a post he still held when he decided to travel across the country with Fleming. His chronicle of the trip he published as *Ocean to Ocean* (Toronto and London, 1873). In the introduction to this work, he put the case directly.

> On the twentieth of July, 1871, British Columbia entered the Dominion. On the same day surveying parties left Victoria for various points of the Rocky Mountains, and from the Upper Ottawa westward, and all along the line surveys were commenced. Their reports were laid before the Canadian House of Commons in April, 1872. In the summer of the same year, Sandford Fleming, the Engineer in chief, considered it necessary to travel overland, to see the main features of the country with his own eyes, and the writer of these pages accompanied him, as Secretary (p. 8).

Fleming and Grant met in Halifax 1 July 1872, but split up immediately, agreeing to meet again in Toronto 15 July. Fleming, or "the Chief," as Grant called him, followed the line along which the Intercolonial Railway was being built. Grant, and a third member of the party, Dr Arthur Moren of Halifax, took two other routes, one went by steamer to Portland, Maine, and then by the Grand Trunk to Montreal and Toronto; and the other by steamer from Pictou, through the Gulf of St Lawrence to Quebec, and then via the South Shore line of the Grand Trunk to Montreal, and on. Having successfully achieved their 15 July rendezvous in Toronto the whole party left the following day, travelling on the Northern Railway to Collingwood, and hence by steamer to Thunder Bay.

While on board the ship Fleming "noticed, among the passengers, a gentleman, out for his holidays on a botanical excursion to Thunder

Bay, and, won by his enthusiasm, had engaged him to accompany the expedition" (*Ocean to Ocean*, p. 21). This was not some soldier-of-fortune ready to act on a dare, but a botanist, John Macoun, a schoolteacher in Belleville, Ontario, who was on a summer holiday. Macoun was presumably able to send word back home to his wife that he had changed his plans. However he certainly could not have given her any real idea of the extent of this adventure, that would see him gone almost six months, and more than once put him in danger of losing his life.

CHARLES HORETZKY

The party left the lakehead 22 July, and followed the "Dawson Route" overland, arriving at Fort Garry ten days later. Here they met another member of the team, Charles Horetzky. Horetzky, as revealed in a fascinating article by Andrew Birrell in the *Alberta Historical Review* (XIX, Winter 1971, pp. 9-25), was a complex, often difficult individual. Of Ukrainian descent, he was born in Scotland in 1838, and was educated there, at least in part at Aberdeen. In 1854 he travelled to Australia seeking gold, but soon returned to Scotland, and then entered the service of the Hudson's Bay Company. In 1858 he was sent as a clerk to the upper Ottawa River. Six years later he was moved to Moose Factory, finally becoming the chief accountant of the Southern Department.

It was during his stay at Moose Factory that he took up photography, at first as a hobby, working with a few other interested amateurs. He had earlier married an Ottawa woman, Mary Ryan, and in 1869 they returned with their daughter to the capital. When the Pacific Railway Survey was being planned Horetzky approached Sir Charles Tupper, a friend of his family, and Tupper asked Fleming to hire Horetzky. Unsure at first, Horetzky had had no engineering experience, Fleming finally agreed to take him on as a photographer, and 4 August 1871 he left Fort Garry with a party. They reached Fort Edmonton 16 October, then passed November and early December in the area of Rocky Mountain House, south-west of Edmonton. Horetzky was then sent further west to Jasper House, where he arrived in early January 1872. He returned to Fort Edmonton, and then Fort Garry, arriving 20 March. He was soon back in Ottawa.

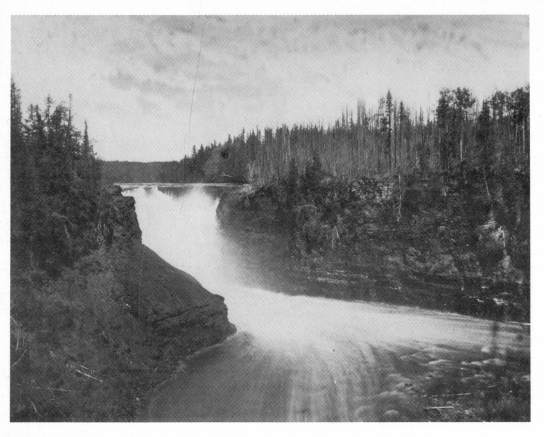

59

C.G. Horetzky
Falls of the Kamanistiquia River,
30 Miles Above Fort William,
Lake Superior, Ontario 1872
Albumen print, 18.2 x 24.3 cm
National Photography Collection,
Public Archives of Canada, Ottawa,
Sir Sandford Fleming Collection (1939-
179)

Fleming must have been impressed with Horetzky's general ability in the field as well as with his photography, for he almost immediately engaged him to arrange the western portion of his trip, and to act as his guide. Horetzky travelled to Fort William a few weeks ahead of Fleming (there is a fine photo of the Falls of the Kaministiquia River that is dated June 1872; see pl. 59), and made all of the preparations for Fleming's reception there before moving on to Fort Garry, where he waited for the party. Because of Horetzky's efficient planning, they were able to leave Fort Garry the day after Fleming's arrival, and set off across the prairies, Horetzky often going ahead to arrange the next stage of the journey. His familiarity with the workings of the Hudson's Bay Company posts proved invaluable. They arrived at Edmonton 27 August.

At Edmonton Fleming decided to split the party, sending Horetzky and the botanist, John Macoun, north and west to explore the Peace River as a possible pass through the mountains for the railway, while he and the rest proceeded west to Jasper House, then through the Yellowhead Pass to the North Thompson, down to Kamloops, on to the Fraser, down to New Westminster, and ultimately to Victoria. They arrived there 9 October. Fleming's party left Victoria 15 October, were in San Francisco four days later, and travelling by American transcontinental train, reached Ottawa 26 October 1872.

Horetzky and Macoun had a much more difficult time. To begin with, they did not get along with each other. Their small party struck out north from Edmonton for Lesser Slave Lake, and then cut west and north to the Peace River, which they crossed below the confluence of the Smoky. They then bore due west to Dunvegan, further up the Peace. Here Horetzky – according to Macoun in an *Autobiography* published many years later (Ottawa, 1922) – tried to talk the botanist into turning back to Edmonton while he proceeded. There is nothing of this in Horetzky's account of the trip, *Canada on the Pacific* (Montreal, 1874).

The two marched on west to Fort St John, where, according to Macoun, Horetzky again tried to get rid of him. But Macoun stuck close as they continued along the Peace, through the mountains, and south along the Parsnip River to Fort McLeod. It was by now mid-October, and in the mountain pass they had encountered the first snow. The cold and slush naturally added greatly to Macoun's discomfort, and to Horetzky's, although he seems to have been unusually hardy.

Horetzky periodically took photographs, even under these trying conditions. He hardly mentions the fact in his book. One photo taken on the Peace River (it is really the Parsnip, which he referred to as the south branch of the Peace) is dated 30 October (see pl. 60). Nor in his chronicle of that day is there any mention of the effort required to employ the bulky and heavy equipment:

> October 30th. – Under way at seven, a.m. Banks low; gravel bottom; poplars very large on banks; current two and a-half miles per hour; ice along the margin; cloudy; rising barometer. At dinner place, river one hundred and twenty yards wide. Water clear as crystal; very rough country on left hand; mountains well back from river (*Canada on the Pacific*, p. 69).

It was all, finally, more than Macoun could endure, however, and when Horetzky made his next attempt to get rid of him, he submitted.

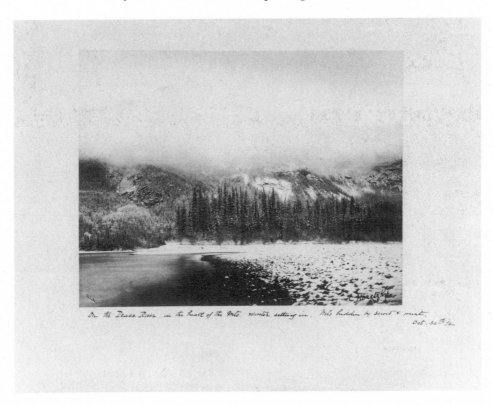

60
C.G. Horetzky
On the Peace River, in the Heart of the Mountains, Winter Setting in, Mountains Hidden by Snow and Mist 1872

Albumen print, altered, 15.3 x 20.2 cm
National Photography Collection,
Public Archives of Canada, Ottawa,
Sir Sandford Fleming Collection (1936-272)

This was at Fort St James, on Stewart Lake, south and west of Fort McLeod. Macoun headed south to Quesnel on the Fraser River, and so down to the sea and Victoria, thankful to have survived the ordeal with his life. Horetzky, after two weeks at Fort McLeod, set out on 2 December by boat along the length of Stewart Lake, crossed to Babine Lake, and then again by boat, ran north up to Fort Babine. From there he took the Susquah River west to the village of Hazelton on the Skeena River, arriving 18 December. Fleming's party was by then almost seven weeks back in Ottawa.

Horetzky stayed in and around the Hazelton area for about two weeks, waiting for Indians who would be willing to travel with him, and exploring the Skeena. Convinced that it offered no route for rail, on 4 January 1873 he set out north and west again for the Nass River, and took it down to Salmon Cove on the Pacific. It was here there occurred one of the very few of his photo-taking sessions that he actually reported later in his book (see pl. 61).

> I now determined to send the canoe round to the Nasoga Inlet, a *détour* of at least twenty miles, while I and a couple of Indians were to camp here, and make the portage the following day. Before the canoe left, we boiled our kettle and lunched on tea and dried salmon. Pending the preparations, I got out my photographic apparatus, and succeeded in getting a negative of the bay, which must be lovely in the summer season, but at this time (21st January) was cold and gloomy, snow lying on the ground to a depth of three feet (*Canada on the Pacific*, p. 140).

Two days later he was in Port Simpson, where he caught a boat to Victoria. He then sailed to San Francisco, and returned to Ottawa by train, arriving in early March, four months after Fleming.

After his return, Horetzky appears to have become fixed upon the idea of the superiority of this northern route through the mountains for the railway – along either the Peace River or the Pine, a little to the south – and to have come into open conflict with Fleming over the issue. He was soon released from service in the Pacific Railway Survey, but then through political connections, was reinstated.

Unpleasantness grew to bitterness, and finally took the form of public attacks upon his enemies, including Sandford Fleming. Finally,

early in 1880, he left the service for good, although continuing to fight over the question of the proper route for the railway through the mountains. What appears to have been uppermost in his mind was his standing as an exploratory engineer. He evidently felt that his photography played but an incidental role in his career, or at least wished to believe that, and after the 1872–1873 trip, he unfortunately chose to diminish that role even more. In 1880 he moved to Toronto to take a job with the Ontario government. He died in 1900.

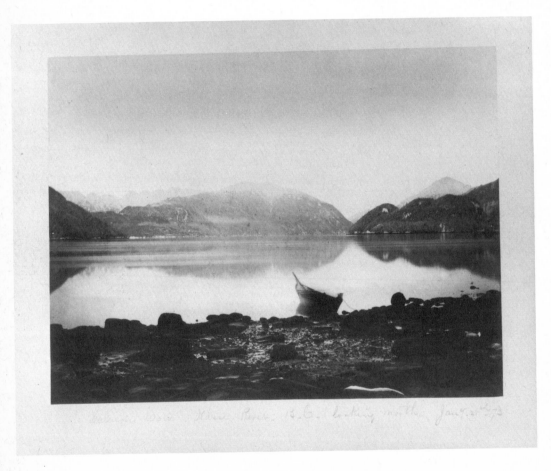

61
C.G. Horetzky
Salmon Cove, Nass River, B.C.,
Looking North 1873

Albumen print, 15.0 x 20.3 cm
National Photography Collection,
Public Archives of Canada, Ottawa,
Sir Sandford Fleming Collection (1936-
272)

However, as Andrew Birrell has pointed out, it is Horetzky's photographs that have kept his memory alive. The largest number of them – Sandford Fleming's personal set – is now in the Public Archives of Canada in Ottawa. They differ considerably from those taken by Baltzly the fall of 1871. Horetzky's landscapes are usually panoramic. There is no evidence of the interest in geological forms that we notice in Baltzly's work. Nor is there any attempt to document the trials of the journey, and Horetzky shows no feeling for his fellow-travellers.

His views are raw, more austere than Baltzly's (which has something to do with the nature of the country through which he was passing), and display a singular concern with the pervasive mood or atmosphere of each place he chose to record. We sense the climate – the cold and the wet – immediately, but the topography often only in a general way. Although detail and texture are important, these are not so pointedly contrasted with smooth or massive forms, but tend to pervade an image, reinforcing its general character and emotional tone, in a fashion that approaches that seen in the work of Alexander Henderson.

ALEXANDER HENDERSON

In fact, Horetzky knew Henderson, and, on occasion, visited him in his Montreal studio. Birrell notes that Horetzky even left his earlier western negatives with Henderson before leaving for the West again in June 1872 (*Alberta Historical Revue*, XIX, Winter 1971, p. 10). He speculates that Henderson may have printed some of them himself. Certainly a number of the Sandford Fleming group have been mounted on cards that bear the blind stamp of Henderson's firm. And Henderson's hand is suggested in the retouching of the negatives – and, it appears, some of the prints – that is evident in more than a few of the Fleming set.

The Horetzky view, *On the Peace River....* (pl. 60), has been heavily re-worked: the top of the mountains is gently outlined, the fall of snow is simulated by spattering the image, and the small twig protruding from the water in the lower left seems an entirely new addition. All of this reinforces the artistic intent of the photograph, as well as clarifying certain aspects of the information Horetzky wished to transmit. Would he have trusted such work to Henderson alone? We cannot say.

Alexander Henderson's reputation as a landscape photographer was steadily increasing. In 1870 he published an album of stereo-halves he called *Photographs of Montreal* (there is a copy in the Public Archives of Canada). He had, indeed, become such a specialist in this branch that in 1874 when he moved his studio from Phillips Square to 237 St James Street, he began to designate himself specifically as "landscape photographer."

Before he left on his cross-Canada journey in July 1872, Fleming arranged for Henderson to take a series of pictures chronicling the construction of the Intercolonial Railway, which he was building to link the end of the Grand Trunk line at Rivière-du-Loup, on the South Shore of the St Lawrence, with Halifax. The line ran along the St Lawrence past Rimouski to a point near the village of Metis, there cutting south-east to meet the Matapedia River. Following the Restigouche River, it proceeded along it to the Bay Chaleur. The railway then continued along the south shore of the Bay (New Brunswick's North Shore), to Bathurst, then cut due south, crossing the Miramichi River (first the North-West-Miramichi, and then the South-West), near the head of Miramichi Bay, and bore on to Moncton and ultimately Halifax.

Henderson worked on the project from late August 1872 until at least 19 September 1874, and perhaps beyond (there is one photo dated "1875"). A portfolio of mounted photographs of the construction entitled *Miramichi Bridges* was published, probably near the date of the official opening of the completed line, 1 July 1876. Sandford Fleming's copy of the portfolio, the photos carefully dated so that the various stages in construction of the bridges can be followed exactly, is in the Public Archives of Canada. According to these dates Henderson was in the field most of the autumn of 1872 (until after 18 November), the spring and summer of 1873 (16 May until 22 September), in January 1874, and again the following September. That is not to say that he was there continuously during these four periods, but frequently.

Fleming probably knew Henderson, or at least knew his work, before 1872. The loose pre-1865 photos that we have already looked at all belonged to him. It is hard not to speculate what role Horetzky played in it all. There are two other large groups of Henderson photos of construction along the line of the Intercolonial in the Public Archives, which also belonged to Fleming. These are unpublished, and

virtually all of one of the groups – taken at early stages of construction on the northern portion of the line – are prints from unsuccessful experiments with dry-plate negatives.

Throughout the sixties and into the seventies photographs were taken by exposing in a large and heavily constructed wooden camera a sheet of glass, covered on one side with collodion (a mixture of guncotton dissolved in ether and alcohol), and then sensitized by immersion in a bath of silver nitrate. This glass plate had to be exposed and developed while it was still wet, so that landscape photographers had to carry a portable dark-room with them. Although this "wet plate" method resulted in sharp, clear, and fast negatives, the weight and bulk of the equipment, and the time-consuming need to prepare each plate immediately before use, and then to develop it immediately afterwards, greatly diminished its attraction.

A dry collodion process was soon invented, but it required an exposure time much greater than that for the wet plate, and so failed to replace the latter method. Further refinements of various sorts were made in the late sixties and early seventies, and finally a prepared glass plate was marketed which used gelatine instead of collodion, that was as fast as the wet plates, and could be developed months after exposure. By 1880, for most purposes, the gelatine dry plate had superseded the wet plate.

In the early seventies collodion dry plates were still in the experimental stage. Henderson made his first major use of them on one of his early trips to the Restigouche for the Intercolonial Railway, and found them to be inadequate. Horetzky had successfully used collodion dry plates on his 1872–1873 trip, although the heavy retouching required for a number of the negatives was one consequence of the shortcomings of the plates. Henderson, however, had had much more trouble. He recorded on the mounts of a number of the prints such remarks as "a dry plate failure," or, "parts of injured dry plate." And many of the prints in the Sandford Fleming collection at the Public Archives show evidence of extensive and sometimes crude re-touching.

The view, *Aleck's Elbow, Near Forks* (pl. 62), taken on the Matapedia River, is an example of one of those dry plate photos that has been extensively worked by hand, and in this case rather effectively. On occasion, Henderson even went so far as to outline the petals of one of the daisies in the foreground, and as we can see in *Aleck's Elbow, Near*

Forks, virtually all the sharp detail in some of the photos was drawn. Henderson reverted to the wet plate method on subsequent trips, and all of the images that were published in the *Miramichi Bridges* portfolio appear to have been from wet plates.

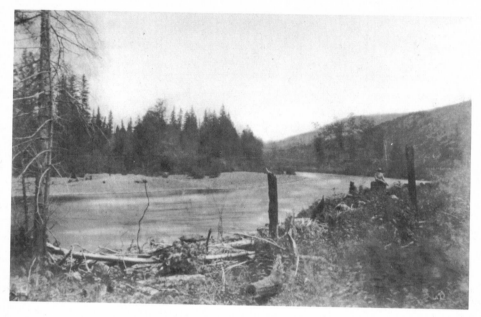

62

Alexander Henderson
Aleck's Elbow, Near Forks *c.* 1872
Albumen print, altered, 11.7 x 19.0 cm
National Photography Collection,
Public Archives of Canada, Ottawa,
Sir Sandford Fleming Collection (1936-272)

Most of Henderson's Intercolonial Railway photographs are of the construction work on the line; the extensive cuttings required for the roadbed, the heavy piers of bridges, the often massive diversion tunnels. These are all documentary in intent, and although a good number are striking photos, many are only serviceable. Periodically, he turned

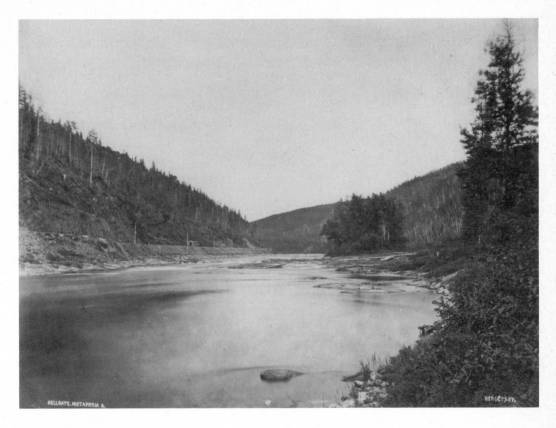

63

Alexander Henderson
Hellgate, Matapedia River *c.* 1873
Albumen print, 14.9 x 20.6 cm
National Photography Collection,
Public Archives of Canada, Ottawa,
Sir Sandford Fleming Collection (1936-
272)

his camera away from the railway works, however, and focused on the landscape through which the line ran. These too have a functional air about them: they are essentially topographical. But they also evince that innate sense of mood that Henderson could not hide if he had wanted to. Although *Hellgate, Matapedia River* (pl. 63), doubtless served

a specific topographical function, it is redolent of the region; a fact that is confirmed in the numerous paintings of the area that began to appear once the line was opened. There are a few photographs among the sets that aspire even less to the minimal documentary use of the topographical view. One of these is a remarkably moving picture, *On Restigouche River* (pl. 64). It is haunting in its gentle stillness, and, as always in Henderson's landscapes, is heavy with the mood of the place. Here, whether inadvertently or not, he left his portable dark-tent in the scene – that large, partly-shrouded box on a tripod, standing close to the bushes of the far beach. It is the hidden pivot of the composition, and by comparison underlines the elegance and economy of shape of the Micmac canoe, around which most of the figures are grouped. That exquisitely crafted form seems to reverberate in the landscape of Henderson's image.

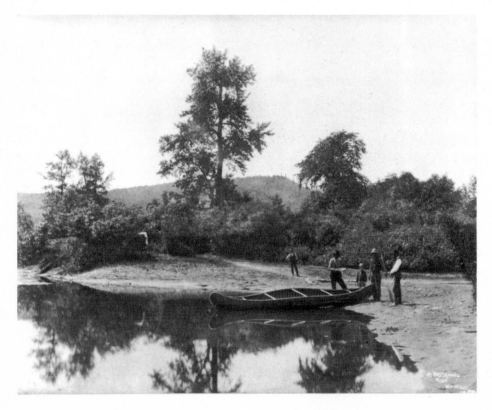

64

Alexander Henderson
On Restigouche River *c.* 1875
Albumen print, 15.0 x 19.0 cm
National Photography Collection,
Public Archives of Canada, Ottawa,
Sir Sandford Fleming Collection (1936-272)

VI

The Depression: 1873–1878

TROUBLE IN MONTREAL

The economic depression of the middle-seventies settled on Montreal with a weight far greater than that borne by most other parts of Canada, and its force was felt for five years following the Wall Street crash of September 1873. The disclosure, that spring, of the Pacific Scandal and the subsequent fall of Macdonald's Conservative government brought to an abrupt and disheartening finish the first attempt to build a railway into the new west of Canada.

There was an understandable disillusionment with the leaders of society, and most especially with Sir Hugh Allan, the most prominent business figure in Montreal. This was the man whose great fleet of ships connected Canada with Britain and Europe; whose associates were to have built the Pacific Railway; and who in 1870, had received Prince Arthur as a house-guest at Belmere, his summer residence on Lake Memphremagog (which looked out upon the Owl Head). Yet unbelievably it was this cornerstone of the community who had been caught buying influence with the federal government, and with American money.

But disenchantment with public figures soon slipped far down on the list of Montrealers' main concerns. Thousands were thrown out of work as the timber trade, the mainstay of the economy, diminished by half. As banks and large businesses began to collapse in the United

States, all facets of life in Montreal were affected. Then in the summer of 1875 a devastating smallpox epidemic hit the city. Hardly a family avoided death. That fall there were "bread riots" at City Hall. The following summer smallpox swept through again. Sectarianism, long held in check, boiled up from the depths of the Depression, with the last stages of the Joseph Guibord incident acted out in mob confrontations. Guibord, before his death a member of the liberal Institut Canadien, had been left unburied for six years because the ultramontane Bishop Bourget refused the body a place in consecrated ground. And the lowest point came in July 1877, in the aftermath of a provocative Orange Parade, when a young Orangeman, John Hackett, was killed in the street.

During the Depression, most institutionalized art activity ceased. Daniel Fowler, the watercolour painter who lived on Amherst Island off Kingston found his principal market closed.

> Montreal seems to be as dull as ditch water. There seems to be absolutely nothing stirring in that way... and no exhibition from the Association, none from the Society, which seems to be defunct. If there is not to be much improvement, I shall take to the plough again as a better thing than the pencil.... (7 January 1875, Spooner Correspondence, Colgate Papers, Archives of Ontario, Toronto).

As the year advanced in 1873, Canadian artists completely disappeared from the pages of the *Canadian Illustrated News*, never to regain the position they had enjoyed during the first three years. Although in 1871 Montreal's population was twice that of Toronto, it was essentially a city of two separate cultures. By that time, there were once again more French-Canadian residents than English (57,000 to 48,000) and, as the decade progressed, this new majority increased markedly.

As landscape painting languished, Napoléon Bourassa was occupied, throughout the whole of the Depression, with the most important work of his career, the architectural design of the church of Notre-Dame de Lourdes and the decoration of its complete interior. Situated on St Catherine Street, just around the corner from his home and studio on St Denis, it was finally completed in 1880.

Another significant artistic activity that persisted through the Depression was a school that had been established in December 1870

by a French priest, Abbé Joseph Chabert. He was born in France, 3 June 1832, and although he entered the order of the Pères de Saint-Croix, he also studied for three years at the École des Beaux-Arts in Paris. Arriving in Canada the spring of 1865, he first worked with the Oblates at Sainte-Thérèse and Terrebonne, near Montreal to the north, then at Ottawa, but by 1870 had settled independently in Montreal where he established an art school which he called "l'Institution nationale." With teaching aids he was able to procure in France, and with numerous fund-raising ventures, he kept the school going for a number of years. In 1872 he initiated free classes for working-men.

The Governor-General of the day, Lord Dufferin, visited the school in February 1874, and gave it his official patronage. He returned in December to award Chabert a medal. The following February l'Institution nationale was incorporated, and received a Provincial subsidy of $1,000. It survived in various locations, and in later years under different guises, until 1888, when Chabert was certified insane and was placed in the Saint-Jean-de-Dieu Hospital. He died there 29 March 1894.

During the later eighties, Chabert taught a number of painters who, at the turn of the century, achieved some status as artists. But during the seventies he had no students seeking such professional training, so that Bourassa remained the only artist of prominence in Montreal who was not working in landscape. The Church, his principal patron, was a bulwark against economic fluctuation. But what of the landscape artists, who daily watched the market for their work shrink until it was almost non-existent?

OTTO JACOBI

Re-established in Montreal after a brief lacuna, Jacobi had, late in 1870, taken a studio in the same building as Vogt, Edson and Way, the Merchants' Bank Chambers at 319 Notre Dame, just down the street from the two principal dealers, A.J. Pell and William Scott. He had been represented by a single watercolour, *Scene, Iron Mine on Rapid River*, in the first exhibition of the SCA in December 1868, a work that seems to have been lent by someone other than the artist, as it was not

for sale. He was probably out of Montreal. (There were iron mines in the Gatineau Hills opposite Ottawa.)

The bulk of his entries in the second exhibition of the SCA in February 1870, although all for sale, were either European subjects or generalized landscapes. The next month, at the sixth AAM exhibition, there appeared a *Shawenegan Falls* of uncertain date, some European subjects, generalized landscapes, two Ottawa Valley watercolours of the sixties, and his *Sunset at the Thousand Islands* which the AAM had purchased earlier that year. All but one, an idealized landscape, were lent by others. Two Canadian landscape oils appeared in the third Society show in March 1871, but again in the joint exhibition of 1872, all but one of the specifically Canadian subjects, which were about two-thirds of his contribution, were lent by others. It would appear that by 1870 or so he had abandoned his practice of painting pictures of specific Canadian locations, usually based on photographs, as we may recall from Chapter III. Instead, he appeared to be concentrating on stylized, idealized landscapes of no particular topographical intent. This is born out by the works that have survived. There is one large, rather heavily-handled canvas of 1870 in the Montreal Museum of Fine Arts, now called *Canadian Autumn*, which has the look of specificity about it. It is, I believe, the last. From that point on the frenetic brush, prominent enough before, took over.

That is not to say that the post-1870 works are of no interest. Certainly, Jacobi continued to be treated in the reviews with the deference due to a skilful, practised artist, and in the early seventies in Montreal he was, undoubtedly, still the most dexterous painter on the scene. His watercolours from this period are often most beautiful. There are three in an Ottawa collection – one of 1870 (see pl. 65), one of 1871 (see pl. 66) and one of 1874 (see pl. 67) – that are particularly fine. They are spontaneous and free, with forms of hills and clouds arising naturally from the flow of colour. And the colours, luscious greens, blues, and reddish-browns, mix richly in their flowing without muddying. They are probably the same new coal-tar colours that Allan Edson was then using, and they have remained intensely fresh and vibrant.

Also in a private collection is another watercolour of this period, of 1872, that is equally fine (see pl. 68). It is closer to those idealized landscapes of the previous decade which, in turn, relate so strongly to the work of Jacobi's Düsseldorf teacher, J.W. Schirmer. In other words,

65

66

65
Otto Jacobi
Landscape 1870
Watercolour, 12.1 x 16.0 cm (sight)
Mr and Mrs Edgar Andrew Collard

66
Otto Jacobi
Blue Hills 1871
Watercolour, 11.5 x 20.4 cm (sight)
Mr and Mrs Edgar Andrew Collard

67

68

67
Otto Jacobi
Landscape 1874
Watercolour, 8.3 x 17.2 cm (sight)
Mr and Mrs Edgar Andrew Collard

68
Otto Jacobi
Clearing in the Forest 1872
Watercolour, 22.2 x 42.7 cm (sight)
Estate of Duncan Macdonald, Toronto

this painting does not depend so much on colour: the jagged silhou-
ettes of trees are played against the sky, and the foliage of those trees is
represented by congregations of tiny dabs. It is also, to some degree,
reminiscent of the mid-century French Barbizon group, particularly
Diaz, whose work is the most decorative of those painters.

Over the years, Jacobi turned out hundreds, perhaps thousands of
these small, expressive works. Inevitably they became, and there is
almost no need to say it, formulary. During the early seventies, how-
ever, the formula was still fresh, and a distinct feeling of creativity
comes through. Some of the watercolours of that period, and there are
virtually no oils, are considerably larger, and often more elaborate, but
the style is the same. This then was what he was producing and, we
must assume, what constituted the basis for his earning a living.

There is one other work that should be mentioned. It is in the Art
Gallery of Hamilton, a huge sepia (61.0 x 125.4 cm) of 1874, entitled
The Arrival of United Empire Loyalists on the St Lawrence (pl. 69). That it is
painted in monochrome on such a scale suggests that it was intended
for photography and reproduction. Perhaps it was intended for
another Notman-type album, like the one in which his *Emigrants Pioneer-
ing West* of ten years before had appeared. Or perhaps it was copied

69

Otto Jacobi
*The Arrival of United Empire Loyalists
on the St Lawrence* 1874
Sepia, 61.0 x 125.4 cm
Art Gallery of Hamilton, presented
in memory of Lt-Col and Mrs John Stephen,
by their family, 1955 (55-74-E)

from a photo, from a sepia-coloured albumen print, for it is identical to that earlier painting in virtually every detail, except that the large trees on the right, and those in the middle-ground at the left edge, have been omitted. The same party of emigrants is depicted, the same Indian points the way, the same figure reads a map, the same glowing sun sets in the West. And this time we know for certain that Jacobi himself set off in the same direction.

The move may not have been entirely due to the Depression. He had given up his house on German Street in 1872, but retained the Notre Dame Street studio. In the 1873 city directory he does not have a residence listing, but his son, Ernest, appears as an engraver at 405 St Dominique. Neither of them appear in the 1874 directory. However, we know that Otto Jacobi went west, although not very far, because at the end of July 1876 he wrote to the Toronto dealer James Spooner from "our little wood cottage" at Ardoch. (T.R. Lee Collection, library, Art Gallery of Ontario, Toronto). This was on the Malcolm Lake of the original pioneering anecdote about him, which was mentioned in Chapter III. It lies north and a bit west of Kingston, well up in the Precambrian shield, just east of Lake Mazinaw, site of the famous native rock-paintings. In 1873 Jacobi was fifty-one years old.

C.J. WAY

C.J. Way also got out right at the beginning of the Depression. He is still listed in his Notre Dame Street studio early in 1873, and later that year is mentioned in the *Art Journal* ("a Montreal artist of repute," New Series XII, 1873, p. 270). But he does not appear in the 1874 directory, in which year he exhibited a single English watercolour with the RSBA. He was then living at 21 Lloyds Square, Pentonville, the same London address he had had before his return to Montreal in 1868. The following year he moved to Lausanne, Switzerland, and although he revisited Canada a number of times, and continued to exhibit here until the end of his life, his main base of operation remained Lausanne.

ALLAN EDSON

How Allan Edson survived those hard years of the Depression is unknown, but he stayed in the Montreal area. Later, in the eighties, as we will see, he was abroad much more than he was home. Shortly after

he married in 1871, he had moved to Longueuil, just across the river from Montreal, and given up his Montreal studio. As was previously mentioned he had, at the joint exhibition of April 1872, shown his largest number of watercolours, eight in all, and later that year had produced those large, shining canvases of the Eastern Townships.

We know from a report in the *Art Journal* that he painted his *White Mountains*, now in the Royal Collection at Windsor Castle, in the summer of 1873 (New Series XII, 1873, p. 270), so he probably was in New Hampshire early that summer. (A second son, William, was born in the same year.) In June 1874 he exhibited with the OSA in Toronto, and gave his address as Longueuil. (There is no Longueuil directory listing until 1876.) That October he had a drawing of a painting, *Evening*, reproduced in the *Canadian Illustrated News* (X, 10 October 1874, p. 237), and in November, *Falls of Montgomery Creek, East Berkshire, Vermont* was reproduced in the same fashion (X, 28 November 1874, p. 344).

He did not show again with the OSA the following June, although he had been elected to full membership the year before. Could he no longer afford to ship his works? A third son, Percy, was born that year. Nor did he participate in the 1878 and 1879 exhibitions of the AAM. He is listed in the Montreal city directory in the Longueuil section in 1876 (Quinn Avenue), 1877 (22 St Jean Street), 1878 and 1879 (65 St Charles Street). Throughout, his profession is described simply and tenaciously as "artist."

There are very few known oil paintings by Edson that could have been done between 1872 and 1880. The picture in the Royal Collection represents a considerable change from the canvases of 1872. It seems in comparison fairly subdued in colouring, not so highly toned. There is still, in certain areas, the marked patterning of the brushstrokes that he got from Jacobi, but no more of that real breadth of handling so evident in portions of the canvases of the year before. It is the only oil between 1872 and 1880 that we can date securely.

We are just as ignorant regarding his watercolours of that decade. There is one dated 1873 in the collection of an Edson descendent in Ottawa. It is the same subject as the three canvases of the year before: a fisherman, but he is working a woodland stream, not a river, and the dappled sunlight that falls through the branches makes the whole scene scintillate in a quiet way. In finish, it is looser than the *White Mountains*.

Another, prominent work of the seventies is *Giant Falls*, the spectacular watercolour in the Montreal Museum of Fine Arts (pl. 70). Some-one once wrote "1872" on a new mount, and that date has been pre-

70

Allan Edson
Giant Falls 1872
Watercolour, 55.7 x 45.0 cm
The Montreal Museum of Fine Arts,
purchased 1963 (63.1434)

sumed accurate. It might well have also been on the original mount. Parts of this radiant painting are broadly handled in the fashion of the canvases of 1872, and the colours are intense, even allowing for the usual transparency of watercolours. Body-colour is used, and the brush-work is fairly descriptive, the large forms clearly blocked in first, the detail added later. There must have been others like it among those eight shown in the April 1872 exhibition of the AAM, and of which we can find no trace.

However, the major group of watercolours of the seventies goes well beyond these two in the rich, elaborate building up of paint to achieve a dazzling, virtuoso display of light effects. There is here no trace of topographical concern. The paintings are linked closely together as a group, and at their heart are four large, vertical forest interiors of amazing freshness, now in the McCord Museum, Montreal

71

72

(see pls 71, 72, 73). These push Edson's work far beyond any real relationship to the manner of Jacobi. They contain just the barest outline drawing. The image is entirely built up with dabs and short strokes of a heavily-loaded brush, describing each small facet by the way it reflects or absorbs light.

The result is a dazzling visual display, rich in constantly shifting values, yet harmonious and convincing as depicted space. The complex juxtaposition of so many varied tones and colours, combined with the liberal use of opaque body-colour, introduces yet another dimension. The final result is an image that, while it avoids the verisimilitude of the photograph, rivals, if not surpasses the photographic image's capacity to present the intense vibrancy of the natural environment. This is mature work, establishing its own limits, and discovering within those limits an infinite range of possibilities.

71
Allan Edson
Autumn Forest I c. 1874
Watercolour, 37.9 x 30.7 cm
McCord Museum, Montreal
(M971.161.1)

72
Allan Edson
Autumn Forest II c. 1874
Watercolour, 38.5 x 27.6 cm
McCord Museum, Montreal
(M971.161.2)

73
Allan Edson
Forest and Sheep c. 1874
Watercolour, 59.5 x 43.4 cm
McCord Museum, Montreal
(M965.145.8)

73

Regarding the dates of these works, there is no sure evidence upon which we can depend. Edson's Academy Diploma picture, the well-known *Trout Stream in the Forest* (pl. 74), relates closely in style. It is probably also the oil which was lent by his old employer, A.J. Pell, to the Canadian section of the International Exhibition in Philadelphia in 1876. (Pell lent three of the seven Edsons in that show, none of which was a recent work.) Then there is a group of fine, highly-finished water-colours that resulted from a trip to Campbellton, New Brunswick, at the mouth of the Restigouche River. They are closer to the 1873 work again, although somewhat tighter.

However, they probably date from about 1876, since it was only then that it first became possible to visit the region around the mouth of the Restigouche by rail from Montreal. During that year the Interco-lonial Railway had opened the final portion of its new "North Shore" line between Rivière-du-Loup and Halifax, the construction of which Alexander Henderson has recorded in his *Miramichi Bridges*.

The whereabouts of four of these paintings of Edson's are now known – two of his grandchildren own one each; one is in the Beaver-brook Art Gallery in Fredericton, N.B.; and another is in the New Brunswick Museum in St John. All are in some respects similar to those unpublished photographs of the area by Henderson, in which he turns his camera away from the railway construction to the landscape. They display opensided compositions. That is, the painter has not placed groups of trees or other large forms at each side in order to create a scene by framing it. We know that what we see is a fragment that the artist has selected from the general environment.

One feels this strongly in the painting presently owned by one of Edson's grandsons (see pl. 75). There is a close attention to texture in all four of the paintings, and particularly evident in the large work in the New Brunswick Museum is an emphasis upon foreground detail, flowers, ferns, twigs, and the like (see pl. 76). This is found in some earlier Edson paintings, but it may be remembered that Henderson even went so far upon occasion as to touch in the petals on his fore-ground daisies with paint, as though driven to reveal every detail. The watercolours are also similar to Henderson's photographs in that they are essentially topographical: primarily concerned with giving an exact image of what that particular landscape looked like. Finally, they resemble the photographs in one other small detail; each is carefully

74

Allan Edson
Trout Stream in the Forest *c.* 1875
Oil on canvas, 59.7 x 46.4 cm
The National Gallery of Canada, Ottawa,
RCA Diploma picture, deposited 1880
(131)

75

76

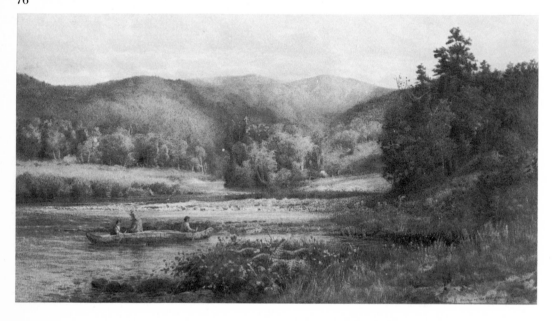

75
Allan Edson
Restigouche River *c.* 1876
Watercolour, 27.9 x 45.7 cm
Mr A.M. Edson, Chesterville, Ontario

76
Allan Edson
Morning on the Restigouche River
c. 1876
Watercolour, 32.4 x 59.1 cm
New Brunswick Museum, Saint John
(54.173)

inscribed as to location, as well as being signed. No other of Edson's paintings is so marked.

That still leaves us with the problem of fitting in that undated group of amazing built-up images, of which the four McCord watercolours are the finest examples. After the Depression hit, Edson last submitted works to an exhibition with the OSA in Toronto in June 1874. Among these five pictures were two watercolours, both harvest scenes. None can presently be identified with known works. The watercolours in particular were admired in most of the reviews, and were also in some instances singled out for their peculiar characteristics. *The Nation* referred to "their thickly laid on body-colour" (I, 25 June 1874, p. 156). *The Canadian Monthly* went on at greater length.

> Allan Edson sends two large and ambitious views of harvest fields, ... whose technical treatment is rather exceptional, the whole surface being solidly covered with colour, while the employment of adventitious aids to effect in finishing off gives a result rather shocking to upholders of the 'pure' school. The *impasto* style is, however, perfectly admissible, and infinitely to be preferred to the 'scratched paper' lights of the old treatment. Effective as his pictures are, Mr Edson is not quite master of his material, as witness his skies, which are smudgy (VI, July 1874, p. 87).

We should then perhaps be safe in dating the McCord and related paintings to around 1874, which means that they came at what was the end, for a while, of his exhibiting. Living in Longueuil, moving frequently during the decade as a result of the steady growth of his family, Allan Edson also, in the depths of the Depression, effectively withdrew from what small art scene remained in Montreal.

WILLIAM RAPHAEL

William Raphael hung on. That he was able to do so was to some degree owing to the fact that as early as 1871 he had stopped relying in any sense upon the group exhibitions. He had by that time organized a means of earning a living through his teaching, his portraiture, and through the sale of popular prints. These latter were chromolithographs, and the first, depicting two old beggars, and entitled *The Early*

Bird Picks up the Worm, he released late in 1868, probably in December, when the canvas upon which it was based was shown at the first exhibition of the SCA. A copy was sent to the *Art Journal*, and a favourable notice was received.

> A chromo-lithograph of a clever picture.... The print certainly does credit to the lithographers, Messrs. Roberts and Reinholmdt: it is a good imitation of an oil-picture, and is specially to be commended as a first attempt in Canada, so we understand, of the chromo process (New Series VIII, 1869, p. 157).

The second of these chromos was based on a canvas Raphael showed in the second exhibition of the SCA in February 1870, *Habitants Attacked by Wolves*. The print was produced later in the year (*Art Journal*, New Series, x, 1871, p. 8).

Raphael had moved his studio down Great St James Street to number 67 in 1866, and there it remained until 1869 when he moved up the street again, to 171. In the 1871 and 1872 city directories his studio is listed at 12 Place d'Armes, after which he did without a separate studio until 1875. At this time, he rented a working space on St James Street again, at 217, but gave it up after two years. By 1878 he was in another studio, 193 St Peter, near Notre Dame, which he retained until 1880.

There is a work by a W. Raphael listed in the catalogue of the 1877 London exhibition of the RSBA, address c/o W.J. Muckley, Royal Institution, Manchester. If this is our man (the work is entitled *Game and Still Life*), then perhaps he visited Britain again. He had not retained a studio in Montreal that year. Or, of course, the painting could have been shipped, as had been his *Bonsecours Market* to Glasgow, late in 1866.

There is not much more to add concerning Raphael during the Depression years. A second child, Pauline, had been born in September 1867, and between March 1870 and the end of November 1878, five more arrived: a girl, Clara, and four boys, Harry, Julius, Samuel and Maurice. As mentioned earlier, he maintained his portrait business, and he is also known to have painted a goodly number of clerics during and around 1875. Such commissions must have been especially welcome during those dark months. A very few landscapes have survived from that period (fewer than genre scenes). There is a pair dated 1876 in the National Gallery of Canada, and of these, one in particular

is reminiscent in subject and general approach to Allan Edson's work of two or three years earlier. In fact the figures in *Two Boys Fishing* could have been lifted directly from an Edson painting. The distant hills and sky, however, go back to German roots, and have the same high-keyed, romantic atmosphere that we have already observed in the landscapes of Adolph Vogt.

ALEXANDER HENDERSON

There is not much, either, to be added to Alexander Henderson's story during the Depression. His work for the Intercolonial Railway extended into 1875, when, in May, he was formally commissioned to run the length of the line "making photographs of the principal structures and natural scenery" (letters from Sandford Fleming in the ICR correspondence, Public Archives of Canada). However, the great bulk of the photographs Fleming owned were taken before the end of September 1874. Henderson moved his studio that year from Phillips' Square to 237 St James Street, and seems to have completely abandoned portraiture by then, for he advertised himself from then on simply as "landscape photographer." Perhaps due to the severe financial situation, in 1876 he moved his studio again, to 387 Notre Dame, about a block up the street from the art dealer, William Scott.

No more commission work has been associated with the years before 1878, but many fine landscapes survive in the Notman Photographic Archives at the McCord Museum from the latter half of the Depression. Stanley Triggs, who believes that Henderson's best work was done when he was free of the demands of a commission, has singled out two photographs from this period.

One is of the *Ice Cone, Montmorency*, of 1876 (pl. 77). It is the absolute final word in the long series of depictions of this remarkable natural monument that stretch back to the late eighteenth century. Henderson sees the cone as a pristine form, set against the hoary back-drop of the frozen falls, its purity enhanced by three tiny human figures, placed precisely equidistant in progression from top to bottom. With its subtle textures, it is a triumph of virtuosity in one of Henderson's favourite fields of specialization, the snow-scene. For work like this he won a silver medal at the 1878 Paris International Exhibition. The other

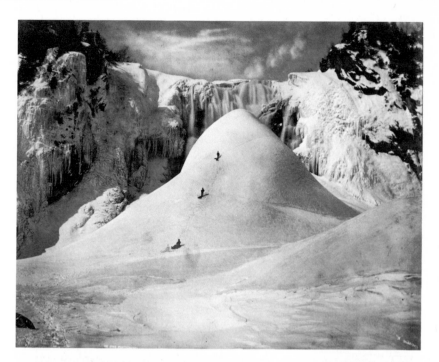

77

78

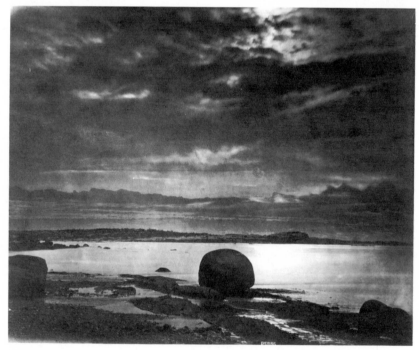

77
Alexander Henderson
Ice Cone, Montmorency 1876
Albumen print, 26.2 x 36.7 cm
Notman Photographic Archives,
McCord Museum, Montreal
(MP 299)

78
Alexander Henderson
"Evening," Metis Beach 1875–1880
Albumen print, 25.6 x 32.5 cm
Notman Photographic Archives,
McCord Museum, Montreal
(MP 104/78)

photograph, entitled *"Evening," Metis Beach*, is a strong study of mood, shot on the primeval tide flats of Metis Beach on the south shore of the St Lawrence, near where the Intercolonial Railway dips south into New Brunswick (pl. 78). Perhaps better than any other of his photographs it demonstrates the intensely personal, intimate, and somewhat romantic side of his vision that sets Henderson's work so distinctly apart from that of the Notman studio.

HENRY SANDHAM

The Notman firm continued to dominate the photographic field in Montreal during the years of the Depression. In fact, even more than in the sixties, it was of major importance to the art scene, or what there was left of the art scene. In actual fact, after about 1875, the artists in Notman's employ were almost the only ones left in Montreal.

From 1870 a steadily increasing portion of Henry Sandham's creative effort was directed to his work with Notman. Prior to that year, his principal occupation there had been the tinting of portraits, and probably some touch-up work on both glass negatives and prints. With the introduction of the composite photograph in 1870, his role expanded to include the painting of the backgrounds behind the pasted-on figures, and the sometimes elaborate work required to blend the figures with that background. It often amounted to painting whole pictures. All of this demanded much more of Sandham's talent than had his work with Notman in the sixties. And it also, of course, involved him much more with the general question of figures.

In the third exhibition of the SCA, in March 1871, Sandham, along with his Toronto area landscapes and his Leggotype print, had shown a watercolour entitled *Scene Suggested by Charles Kingsley's "Three Fishers."* It was his first exhibited figure-piece, and it attracted some notice in the reviews. At the joint exhibition in April of the following year, five of his seven oils were figure-pieces (all Indian subjects lent by a Mrs J. McDougall), although he also contributed six watercolours that seem to have been mostly landscapes with small figures. One, which is now called *Cliff and Boats*, in the Art Gallery of Ontario, is probably his *Low Tide, Indian Cove*, which was exhibited in that show. It is broadly painted, and Sandham has used a great deal of body-colour which has

intensified the hues and lightened the tone. In general handling it is similar to the background of a composite.

The construction of the Intercolonial Railway, especially since it was a government-financed project (active nation-building), attracted a great deal of public attention. As we have seen, Alexander Henderson was drawn into it, and the gradual opening up by rail of the South Shore of the Lower St Lawrence, and the North Shore of New Brunswick below the Bay of Chaleur between 1873 and 1875, drew other artists as well. Allan Edson journeyed down at the middle of the decade, and as early as 1873 Henry Sandham made the trip.

There are three watercolours presently known from that excursion, all depicting Micmac life in summer camp on the Gulf of St Lawrence. The largest of the three is in the National Gallery of Canada (see pl. 79); the others are in the Glenbow-Alberta Institute in Calgary (see pl. 80), and in a private collection in Toronto. They are painted as loosely and broadly as is *Low Tide, Indian Cove*, but without the aid of body-colour, so they are more transparent in appearance. They also feel more immediate, yet somehow fleeting, as though it is a passing moment that has been described.

The next year, at the second exhibition of the OSA in Toronto, Sandham showed a canvas based on these sketches done on the Gulf. And by 1876 he had completed a number more, including some of the Godbout River, one of the famous salmon streams, which had also become accessible as a result of the opening of the Intercolonial Railway. The Godbout is on the North Shore of the St Lawrence, and was then reached by ferry from the point where the railway turned away from the river into New Brunswick.

A canvas depicting one of these eastern salmon streams, the Godbout, or the Restigouche, perhaps, has recently been acquired by the National Gallery of Canada (see pl. 81). It is not as effective a work as are the watercolours. Although Sandham has tried to avoid laboured detail, describing rocks and small shrubs with a relatively light touch, the weight of the oil seems to deny him any real finesse. He does not seem quite capable of the dextrous handling of paint, necessary to describe the variety of interesting textures. Certainly, when it comes thus to competing with the photographic image, Allan Edson is much more successful.

As the decade passed, however, Sandham was more and more

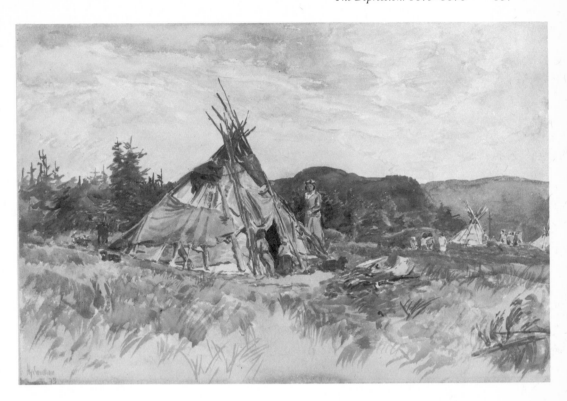

79

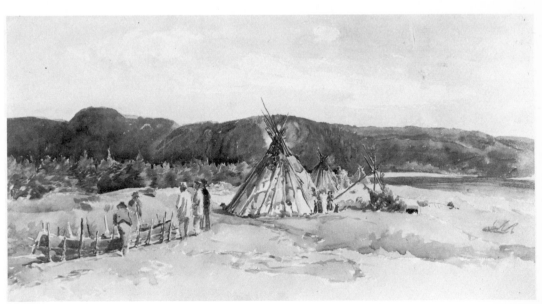

80

79
Henry Sandham
Micmac Indian Camp,
Gulf of St Lawrence 1873
Watercolour, 28.0 x 43.2 cm
The National Gallery of Canada, Ottawa,
purchased 1977 (18,883)

80
Henry Sandham
Indians Building a Canoe 1873
Watercolour, 22.9 x 43.2 cm
Glenbow-Alberta Institute, Calgary
(s.64.12)

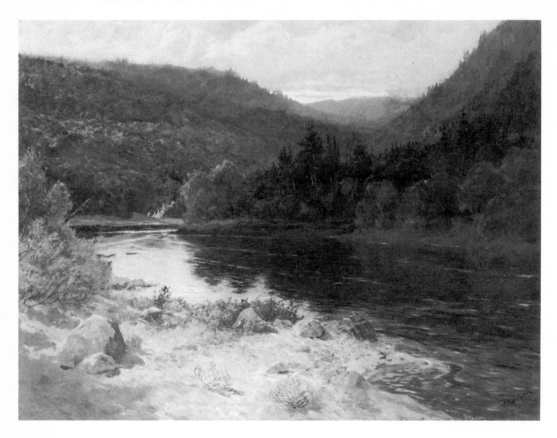

81

Henry Sandham
On An Eastern Salmon Stream c. 1874
Oil on canvas, 76.2 x 99.1 cm
The National Gallery of Canada, Ottawa,
purchased 1977 (18,882)

inclined to leave to the camera what it could do best, and to bend his own efforts to doing what it could not. By the mid-seventies, the painted parts of most of the better Notman composites were his work, duly signed. William Notman came to depend upon his skilful hand, and Sandham's position in the firm improved. He moved his home again late in 1873, to 446 St Dominique, a block east of St Lawrence, and across the road from his brother-in-law, W.L. Fraser. (Prior to that they had lived a block apart on St Urbain.) The following year the Sandhams had their third child, again a daughter, Olivia Isabella (who was to die at the age of seven), and later in the year a son, Arthur, the first of their children who would grow to maturity (although he too died young, at the age of twenty-four). Another daughter, born in 1876, Gwendolyn Winetta, was the only one of their five children who would outlive them. Late that year the family moved across the street into the house that had been occupied by the Frasers until two years before.

Sandham drew his final salary as an employee of the Notman firm 21 September 1877. Five days earlier, articles of co-partnership had been drawn up between himself and William Notman. He had become indispensable, and the firm became Notman & Sandham, in an arrangement identical to that in Toronto between Notman and John A. Fraser, nine years before. Just to keep track of the Frasers, it should be noted that William Lewis Fraser, who had worked for the Notman firm since March of 1865, left in April 1875. The following year he entered into partnership with William Scott. "Scott & Fraser, Dealers in Works of Art" served the public from Scott's old location on Notre Dame Street, as Montreal began to feel the effects of the Depression slowly fading away.

THE NOTMAN STUDIO

William Notman and his associates seem to have felt the effects of the Depression the least of all of the Montreal artists. This was probably because his large and diverse operation gave him many alternatives if certain aspects of the business faltered (see pl. 82). Certainly he must have felt some direct effect of the difficult economic situation.

There are photographic sets of incredibly rich and vital scenes of the lumbering industry, for instance, taken on the Upper Ottawa in 1871, at Quebec City in 1871 and 1872, and in Muskoka, in the bush

country north of Lake Simcoe, in Ontario, in 1873. These would surely have struck a bitter note by the middle of the decade, when the timber trade, a mainstay of the Canadian economy, had dropped by more than half. Could portrait photography also have fallen in popularity during those hard years? There did remain a demand for Notman's composites. Organized outdoor activities continued in the city, and there always seemed to be money enough to make a handsome record of important sports occasions.

The Harvard-McGill football match of 1875 was commemorated in an action scene, and in 1878 Sandham and his photographers put together another remarkable composite, rivalling the great *Fancy Dress Skating Carnival* of eight years before. This was *Curling in Canada* , an effectively naturalistic gathering of many of the more eminent personages in the country – or at least those who were Scots – observing a match on the frozen St Lawrence, with a panorama of Montreal and Mount Royal behind. We can pick out John A. Macdonald (not yet back in power), and the Governor-General, Lord Dufferin, his wife, and their dogs, from among the 135 individual portraits. It was created expressly for showing in the Paris International Exhibition of 1878. But what really got Notman through the Depression unscathed was another major business venture.

In the early years, Notman had drawn some international attention, and particularly among American photographers by the mid-seventies. Somehow he became involved with a Philadelphian, Edward L. Wilson, and the two formed the Centennial Photographic Company, and procured the exclusive concession for all of the official photography for the great International Exhibition at Philadelphia of 1876.

Notman was President of the firm, a certain W. Irving Adams was Vice-President, Wilson was Superintendent and Treasurer, and John A. Fraser was Art Superintendent. They established an office in the city, and a studio in a fairly large building on the exhibition grounds, next to the Juror's Pavilion. Photographs were taken of all of the displays, as well as general scenes, and were printed and prepared by a staff of one hundred. Apparently some 4,000 different images were produced, and many thousands of prints were sold to the general public. The official set is in the possession of the Philadelphia Free Library. Notman and his associates must have made a great deal of money from the venture.

82

William Notman Studio
The Notman Studio, 17 Bleury Street *c.* 1875
Albumen print, 25.4 x 20.4 cm
Notman Photographic Archives,
McCord Museum, Montreal

Notman and Fraser also exhibited a large quantity of their Canadian work in the international photographic display, and Notman won a gold medal. Well paid and well praised, he returned in the fall to a new house he had bought at 557 Sherbrooke Street West just the year before. He had left Berri Street in 1874 (and, it would seem, also Clydeside Cottage on Lower Lachine Road), moving to a large country house in Longueuil. The new house on Sherbrooke was as big, and more imposing in appearance. By the end of the Depression, he was a man of prominence and means, ready to assume an even larger role than before in the reviving artistic life of Montreal.

PART
TWO

1873–1880:
Toronto

VII

National Aspirations and the Foundation of the Ontario Society of Artists

Toronto widens its horizons
the OSA comes into being

TORONTO WIDENS ITS HORIZONS

By the eighteen-seventies both business and culture in Ontario had become institutionally centered upon Toronto, and Torontonians, pridefully aware of their growing richness as the provincial capital, began to see their city as potentially the economic, and increasingly the cultural centre of Canada. There is no denying that in this decade the focus of artistic activity among the English-speaking populace of Canada shifted to the "Western Metropolis."

It was a shift that had much to do with economics, and as much to do with geography. The organized settlement of Upper Canada, or "Canada West" after 1840 had, by mid-century, progressed to the point where the province at once constituted a rich resource and a valuable market. As such, it attracted the commercial interest of both New York and Montreal, each equally desirous of adding the new region to its sphere of economic influence. This overlap gave Toronto the benefit of options, and transformed it into the great trans-shipment point and centre of commerce for the growing hinterlands to the west. The growth of the railroads tells the story.

The Great Western Railway first began running in 1853, and by the following year had a line from the Niagara Falls suspension bridge – where it connected with the American roads that ran the route of the Erie Canal to New York – through Hamilton and London to Windsor

and Detroit. By the end of 1855 a branch-line linked it with Toronto. The Grand Trunk Railway opened its line between Montreal and Toronto in October 1856 (the occasion for a three-day civic festival in Montreal). But as significant was the fact that a year earlier, in 1855, the Ontario, Simcoe and Huron Railway (which became the Northern Railway of Canada in 1858) had completed its line between Toronto, Barrie, and Collingwood, on Georgian Bay. Conceived as a portage route to connect the Upper Lakes with Lake Ontario and the St Lawrence (*or* the American road from Oswego, New York, on the South shore of the lake), it succeeded in placing Toronto squarely in the centre of the western trade in timber, and a little later, wheat.

The resulting prosperity of the city led to encouraging signs of a growing interest in art. There were few institutions to support such an interest, however. The Canadian Educational Museum had been established in the Toronto Normal School in 1857 by Egerton Ryerson, and provided the only continuous public display of paintings in the Province. Unfortunately, however, the pictures shown were hardly a reflection of Canada's national aspirations, since they were all copies Ryerson had either bought or commissioned in Europe. (Some survive to this day in Peterborough and in Stratford, Ontario.) Then there was the Upper Canada Provincial Exhibition, which continued to present an annual forum for professional painters (see pl. 83). By 1868 some pride was being shown in the number of artists who were exhibiting, and in the quality of their work:

> There is perhaps no department of the Exhibition in which greater progress may be observed by those who have regularly attended for some years at the various shows, than in that of the Fine Arts. When these exhibitions were first started, now a considerable number of years ago, the picture gallery was adorned with a few wretched daubs and coarse drawings, such as one now occasionally sees at county or township shows, and to which exulting mothers would proudly point as the splendid achievement of 'our Betsy' or 'Martha Jane.' One or two of these wonderful productions may even yet be seen high up, almost out of sight, and hardly to be noticed among the worthy productions of our true artists, whose numbers, we are glad to find, increase from year to year. Taken as a whole,

the space allotted to the Fine Arts in the western gallery of the Exhibition building is this year very fairly filled, and a large proportion of the works exhibited are of considerable excellence. The Professional List is remarkably well filled by our well-known artists, particularly in the classes of oils (*The Globe*, 24 September 1868).

As in Montreal a few years before, the collectors in Toronto were also organizing displays. In October 1868 there was a particularly large and successful exhibition held in the Mechanics' Institute which was advertised as the "Great Exhibition of Paintings" (*The Globe*, 6 October 1868). Comprising close to a thousand works (including chromolithographs, photographs and statuettes), there were contributions from local artists and dealers as well as the collectors. Even though the newspaper reviews placed the main emphasis on the size of the display and

83

F.M. Bell-Smith
The Picture Gallery,
Provincial Exhibition, Hamilton 1872
Reproduction (probably a Leggotype)
in the *Canadian Illustrated News*, VI,
19 October 1872, p. 244

the supposed value of the paintings, their very response to the show provides evidence of growing aspirations.

By the early seventies almost forty-five per cent of the Canadian population was in Ontario. Strong and growing rapidly, the province enthusiastically welcomed the opening of the West as an opportunity for increased expansion, confident in the potential of its already developed commercial and industrial base. There was concern that the Pacific railway contract would go to a Montreal syndicate (a Toronto group had bid), but that hardly dulled the bright vision Ontario held of a new Canada, a Canada that would be built, it had no doubt, upon the model it had so successfully established. These aspirations found political voice in the Canada First Movement, a group whose aims were expressed in a speech in Toronto in 1871 by W.A. Foster, "Canada First; or, Our New Nationality." Intent upon encouraging cultural development and greater political maturity, as either an independent nation or as part of an Imperial Federation, Foster proclaimed that "all the requirements of a higher national life are here available."

THE ONTARIO SOCIETY OF ARTISTS

It was clearly the right moment for the establishment of some sort of artistic organization in Toronto. John A. Fraser called a meeting at his home 25 June 1872, and six other local painters showed up. One was Robert F. Gagen, a young Englishman who had emigrated from London in 1863 at the age of sixteen, settling with his parents in Seaforth, on Lake Huron. There he had taken painting instruction from W.N. Cresswell. In 1872 he was in Fraser's employ tinting photographs. Another was Marmaduke Matthews, who had arrived from England in 1860, but then had spent four years in New York before re-settling in Toronto in 1869.

Thomas Mower Martin, also an Englishman, had arrived from London in 1862, planning to homestead in Muskoka. Finding his farm there unworkable, he took one a year later at York Mills, just north of Toronto. By 1865 he was living in the village of Yorkville, at that time a northern suburb of the city. He also had a studio on King Street West. James Hoch, the son of a German-Moravian Missionary, and born in the West Indies, had settled in Toronto in 1870, where he taught art at Trinity College and Bishop Strachan School. Charles S. Millard had

been born in Weston, just outside Toronto, but was raised in Wales. He had studied art in London before settling in Toronto early in 1872. Finally, there was J.W. Bridgman, a portrait painter who often worked with photographs, and who also had set up a Toronto studio earlier in the year.

Minutes were kept of this first meeting (now preserved with the papers of the Ontario Society of Artists in the Archives of Ontario, Toronto). Since it had been called by John Fraser he was elected to the chair, and in quick succession proposed three motions: 1/that a society be formed which would be independent of the SCA in Montreal; 2/that this society be entirely conducted by artists; 3/that the society be called "The Ontario Society of Artists" (OSA). All were carried unanimously. Bridgman then proposed that honourary members be admitted from the lay public, and Martin moved that an Art Union be established, and that the President and Treasurer be elected annually from among the Honorary Members, in order to encourage the financial participation of the art-loving public. James Hoch then proposed "that one of the principal objects of the Society be the formation of a Permanent Exhibition or National Gallery." All of these motions were passed, and John Fraser was then asked to draw up a constitution for discussion at a subsequent meeting.

The group met again, this time at C.S. Millard's home, on 2 July 1872. Everyone was there except for Hoch. Also present was a new associate, Herbert Hancock. He had been involved in the earliest exhibitions of the AAM, but had moved to Toronto about 1865. Fraser took the chair again, and read the rather lengthy and detailed constitution he had prepared during the week. Following discussion and some slight amendments, his draft was adopted. Most of it dealt with form, but some points should be singled out for emphasis. One important decision was that while the President and Treasurer should not be drawn from the ranks of the artists, the Vice-President and Secretary, the working officers, should. This was an interesting compromise, an attempt to anticipate, and prevent, the sort of split that had occurred between collectors and artists in Montreal. Article number five carried this idea even further: "while the Society shall be composed of and conducted by Artists solely in so far as the management of business is concerned, a list of Honorary Members or Fellows shall be added to it consisting of those persons who from their love of and liberality in the

cause of Art shall be considered eligible." It was also determined to mount an exhibition of professional, original work annually, and to that end, an annual subscription was to be paid by each member to defray all costs.

Finally, a further (and wordy) commitment was made to the concept of a permanent gallery. "It being one of the principal objects of the Society to obtain the establishment in Toronto of a permanent Public Art Gallery each member of the Society shall pledge himself or herself to donate one or more works executed by him or herself, to form the nucleus of such National Gallery whenever it shall be considered by the Majority that from favorable arrangements on the part of the Government of the Province or Public or private generosity the time has arrived for so doing."

They then proceeded with the election of officers. Fraser was selected as Vice-President and Hancock as Secretary. It was agreed that a certain J.H. Morse, a coal merchant known to a number of the artists, should be approached regarding the position of Treasurer (an unfortunate decision, as matters turned out). Fraser then proposed that D.L. Macpherson, a politician and wealthy businessman be asked to serve as President. As well as being an art collector, Macpherson had also led the group of Ontario capitalists who, in 1871, had bid against Hugh Allan's Montreal-based group for the all-important CPR contract. It was also suggested that W.H. Howland, one of the sons of the Lieutenant-Governor of Ontario, should be approached if Macpherson did not accept. Macpherson did not, and Howland became the first President of the osa. His father was an American Puritan who had immigrated to Upper Canada in 1840, and although Howland himself was only twenty-eight in 1872, he was already the President of the Queen City Insurance Company, which he had just recently organized. He was also an art collector, and a member of the Canada First Party.

Meetings of the osa were held regularly throughout the fall of 1872, and the membership steadily increased. It was decided that a Birket Foster chromolithograph would be purchased in quantity in London, one print to be given to each subscriber to the Art Union lottery, organized along the same lines as the one established in Montreal in 1864 (see Chapter I). Subscribers would also be given the chance to win certain of the members' paintings in the draw and the final date of the exhibition was to be set after some five hundred Art Union tickets

had been sold. Early in January, the membership approached the Notman & Fraser firm to see if the exhibition could be held in a new building they were presently constructing on King Street East.

It was finally determined that the show would open in April, which it did, on Easter Monday, 14 April 1873, in the new Notman & Fraser gallery. There was no conversazione, but instead a private view the first night, open to subscribers, the Press, and members, and the show ran publicly for about three weeks after that (pl. 84).

The osa had been solidly begun. Attendance was heavy, there were numerous sales, and the press reaction was positive. *The Canadian Monthly* probably provides the best reflection of the general attitude.

> Suffise it to say that this First Annual Exhibition of the Ontario Society of Artists has proved in all respects a most creditable success. It has shown that we have a body of artists in our midst who only require adequate remuneration to beget a native School of Canadian Art; and to contribute in many ways to the refinement of taste and the development of education in the highest departments of aesthetic culture (III, June 1873, p. 546).

84
Notman & Fraser Studio
The Ontario Art Union Exhibition, The Gallery, Toronto 1873
Reproduction (probably a Leggotype) in the *Canadian Illustrated News*, VII, 3 May 1873, p. 273

VIII

The Major Landscape Artists to 1873

Frederick A. Verner
Lucius R. O'Brien
John A. Fraser
Fraser and the OSA
O'Brien and the OSA

Three artists were singled out in the reviews and notices of this first exhibition of the Ontario Society of Artists, and for three quite different reasons. John A. Fraser was seen to be the strongest painter of all; Lucius O'Brien was hailed the most promising new native talent; F.A. Verner was the best known and most popular of the exhibitors. These three were the principal painters in Toronto for at least the duration of the decade, and their work set the standard of Canadian landscape painting. Since neither O'Brien nor Verner were involved in the initial meetings in 1872 that established the OSA, we have not as yet been introduced to them. Here is how they came to be landscape painters in Toronto in 1873.

FREDERICK A. VERNER

Frederick Arthur Verner was the younger of the two by three-and-a-half years. In a form he completed for the National Gallery of Canada in June 1930, he stated that he was born 26 February 1836 at the village of Sheridan, in Trafalgar Township near the town of Oakville, which is on Lake Ontario just west of Toronto. Information from his family records has been published by Margaret Annett in the National Gallery of Canada *Journal* (no. 20, 1 November 1976), in connection with an exhibition of Verner's work. We learn that Frederick's father,

Arthur Cole Verner, was born in County Armagh, Ireland, in 1811. Raised in the Channel Islands, he went back to Dublin to attend university, but immediately upon graduation in 1835 returned to the Islands and married Harriet Ayre of Jersey, whereupon the two emigrated to Upper Canada. Arthur Verner found employment running the Trafalgar Township Grammar School, and, not long after they were settled, Frederick Arthur was born – the first of nine children. The family moved to Guelph, Ontario, when Arthur Verner became principal of that town's grammar school, and that is where Frederick was educated (*The Canadian Men and Women of the Time*, Toronto, 1912). Later, the family returned to Trafalgar Township when Arthur Verner became the head-master of the new Halton County Grammar School.

The first hint of young Frederick's active interest in art came in 1852 when he was listed as the winner of a "discretionary prize" in the monochromatic drawing category at the Upper Canada Provincial Exhibition of that year. He was sixteen years old. A descendant owns a small, romantic pen-and-ink drawing of lovers that is dated 1851, that clearly was copied from a wood-engraving in a magazine or book. There are a couple of relatively crude portraits painted in oils on paper now in the collection of the Oakville Historical Society that were probably done a couple of years later, and there is a charming, naïve landscape in a private collection that must also date from about the middle of the decade.

In 1856 his family moved to Windsor, Canada West (his father later served two terms as Mayor of Sandwich, an adjacent town). However young Frederick, then twenty, did not go to Windsor, leaving instead for London, England, to study art. He stayed with his aunt, the Marchioness of Westmeath, who had court connections, and he enrolled in Leigh's School (later Heatherley's) in South Kensington. Very probably in response to a long tradition of military service in the family in April 1858 he enlisted in the Third West York Infantry Regiment of militia, and was promoted to lieutenant in September 1859.

He apparently continued his studies at Leigh's until the end of the 1860 spring term, but then that summer left the militia to join the British Legion. (The Legion was a volunteer force that had been formed to allow Englishmen to take part in Giuseppe Garibaldi's struggle to unify Italy, with which the British government did not officially wish to interfere.) The forces of the British Legion arrived in Naples in October

1860, and Verner saw action at the seige of Capua on the Volturno. In January 1861 he returned to London, although whether back to art classes is not known. He did, however, rejoin his militia regiment.

Early the following year he left London for Canada, settling in Toronto some time before September, when he again exhibited at the Provincial Exhibition. He won a second prize for a pen-and-ink sketch this time, but in the professional list. In 1863 he again won a second prize for pen-and-ink in the professional list. In the Glenbow-Alberta Institute in Calgary are two drawings done on the Don River. The Don, at that time, lay just outside of Toronto to the east. One of the sketches is in pencil, and the other is a watercolour, both indistinctly dated in the eighteen-sixties. Both are competent but stiff, neither of them really much beyond the standard of school-work. They must have been done during these first years in Toronto.

Also in the Glenbow-Alberta Institute is a half-length portrait that is signed and dated 1862. Called *Ta-na-ze-pa* or *Sioux Dandy*, it is inscribed on the back by Verner "Executed at Mankato for participating in the massacre of 1862. F.A. Verner 1862." An unsigned and slightly larger companion-piece, also in the Glenbow-Alberta Institute, is inscribed on the reverse "Ne-Bah-quah-om (Big Dog) – a Chippewa Chief who offered himself and his band of warriors to the Canadian Government to fight the Sioux in their raid in Minnesota 1862. F.A. Verner." Both are dull characterisations, and there is little feeling of real humanity in either face. The former was copied from a photograph taken in 1862 by J.E. Whitney of a Sioux named Dowanea (Singer), a print of which is in the collection of the Minnesota Historical Society. We may expect some day to find the photograph that formed the basis of Verner's portrait of Ne-Bah-quah-om.

Finally, in the Agnes Etherington Art Centre at Queen's University, Kingston, Ontario, is an oil now called simply *Sunset* that is signed and dated 1863. It is Verner's first landscape to include incidents of Indian life. However, it is definitely not based on a photograph. It is modelled on the style of Claude Lorrain, the seventeenth-century Italian-trained Frenchman, who established the canon for idealized landscape. Verner's painting is entirely according to the formula. It is set up like a stage-set, with foreground, wings, and painted back-drop of fiery setting sun. There is a simple force to the work, but the drawing is heavy and obvious, and there is little evidence of formal training in the way the paint has been handled.

No other documents relating to Verner's earliest years in Toronto are presently known. He does not appear in any of the Toronto city directories that survive from the early sixties, although his address is given as Toronto in both the 1862 and 1863 Provincial Exhibition prize lists. And a story has come down to us that probably has its basis in fact. The brash young painter is supposed to have knocked on the door of the famous Paul Kane, only to have been rebuffed. It was in 1859 that Kane's *Wanderings of an Artist Among the Indians of North America* had appeared, the year in which he first became aware that he was going blind. This led him to retire to his home on Wellesley Street, each year withdrawing more and more from social contact. The young Verner, with his Indian portraits and landscape scenes of Indian life, was of course emulating Kane, Toronto's most famous artist.

Verner did not, however, follow Kane's example in travelling west (in the early sixties it would still have been necessary to have had the permission and support of the Hudson's Bay Company, as did Kane). Instead, Verner travelled east again, this time to New York rather than London. In 1865 he showed a painting entitled *On the Madawaska River* at the annual exhibition of that city's National Academy of Design. In all likelihood, it was very similar to the Agnes Etherington's *Sunset*. The following year Verner exhibited there again, and gave a New York address, 724 Broadway (he had given no address the previous year). This time, there were two paintings, *Morning on Detroit River* and *The Road to La Guavia, Venezuela.*

The subjects of these three paintings suggest some far-flung wanderings. Had Verner actually travelled north into Canada West to the Madawaska River? Had he really visited Venezuela? We do not know. We can be sure, however, that he knew the Detroit River at first hand, since Windsor, where his parents were living, is situated on its bank.

By September 1866 Verner was back in Toronto, exhibiting at the Provincial Exhibition, again in the professional lists. He did much better this time, coming second in the watercolour portrait category (originals); best for a photograph portrait finished in oil; second for a photograph portrait finished in India ink; and best for a photograph portrait finished in watercolours. He does not appear in the prize lists for 1867, but does again in 1868: winning best oil landscape of a Canadian subject (originals); third for oil portrait (originals); second for photograph portrait finished in oil; and best for watercolour landscape of a Canadian subject (originals). In

October 1868 he participated in the great loan exhibition at the Mechanics' Institute, standing "pre-eminent, his large drawings of Indian Scenery attracting attention from all passing by" (*Daily Leader*, 18 October 1868). That year, for the first time, he also can be found listed in the Toronto city directory, simply as "artist." Then he drops from sight again.

In March 1871, Verner contributed at least five oils to the third exhibition of the Society of Canadian Artists in Montreal (there is no catalogue extant). The group is described in the *Daily Witness* as "Indian landscape scenes in the Far West.... They are somewhat hard and heavy, yet by no means devoid of merit. Their pervading character is stillness, and their locality gives them a peculiar interest at the present time" (6 March 1871). Another review cites two titles, *Evening on Kanamistiquia River* and *Buffalo Combat*.

The "peculiar interest" these works held was due to the fact that, the year before, Manitoba had become the fifth province of Canada (12 May 1870), and the vast Hudson's Bay Company domain also had been formally annexed to the Dominion (15 July 1870). There had been the "Fenian excitement" in the Eastern Townships early that summer (remember the Vogt sketches in the *Canadian Illustrated News* of June), and there was also the "Red River Expedition," to suppress the first Riel rebellion.

Under the command of Colonel Garnet Wolseley, 1,000 soldiers carried their own supplies over 720 km, travelling by boat and over hundreds of portages from Port Arthur and Fort William (now Thunder Bay), at the head of Lake Superior, to Fort Garry in Manitoba. The reason that this incredible trip had to be made was because a military force could not travel the usual way, by rail, south of Lake Superior through Minnesota; that would have taken them into foreign territory. Wolseley therefore had no choice but to use the old fur-trade canoe route. The soldiers, some of whom were volunteers, managed to make it across a piece of what was certainly the most difficult terrain in the country in just over three months.

William Armstrong, an engineer in Toronto with the Grand Trunk Railway, and also a topographical painter and a photographer, with a special interest in the Northwest, was assigned to the force as Chief Engineer. The *Canadian Illustrated News* published a reproduction of his painting of the first leg of the expedition, *The Algoma Passing Thunder*

Cape (II, 10 July 1870, p. 36). Then from 22 October to 10 December the magazine published eighteen pictures, based on Armstrong sketches, taken in the area of Lake Nipigon and the Nipigon and Black Sturgeon rivers, due north of Thunder Bay. These, however, appear not to have been connected with the Red River Expedition, but to have resulted from an earlier survey trip. (Armstrong had exhibited stereographs of Lake Superior and paintings of the Nipigon River region as early as 1865.)

All this is by way of pointing out that images of the new part of the Dominion were of great public interest, and that Verner was responding to a demand. (Not that his paintings pretended to any of the topographical authority of Armstrong's.) We presently know of two which were very likely shown in Montreal that March of 1871. Identical in size (long and narrow), both are dated 1870. One, *Buffalo in Combat*, is in the National Gallery of Canada. The buffalo are utterly unconvincing. It would seem that Verner had not, at this point, ever actually *seen* a live buffalo. The sky, a sunset of transcendent splendour, dominates the picture, suggesting a vast, almost limitless space.

The other painting is in the Montreal Museum of Fine Arts, and is entitled *Lake, North of Lake Superior* (pl. 85). Again it is the radiant coloured light of a sunset that reigns over all, obscuring the topographical

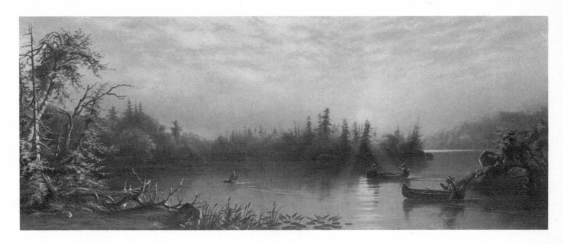

85

F.A. Verner
Lake, North of Lake Superior 1870
Oil on canvas, 50.5 x 127.0 cm
Montreal Museum of Fine Arts, gift of
Miss Isabella McLennan, 1935 (935.652)

shortcomings of Verner's generalized northern landscape, dressed up as it is with stage-set gnarled trees, cheaply-costumed Indians, and a mechanical moose. In spite of the "somewhat hard and heavy" finish (it looks like a chromolithograph), there is indeed a strong "pervading character of stillness." It is also a naïve and romantic view of the new, untouched Canada, opening to the West.

Family tradition has it that Verner, like Armstrong, accompanied the Red River Expedition in 1870. The evidence of his paintings hardly supports such a belief, although one of his sisters, Mrs S.E. Goddard, moved to Winnipeg with her husband that year, and Verner was absent from the Toronto city directory. He was back again the following year, though, listed as "portrait painter, 48 King east," just down the street from James Spooner's tobacco shop and art gallery, and about two blocks from Notman & Fraser.

In April 1872 he showed in Montreal a second time, in the joint exhibition of that year. His contribution was four Indian portraits and three northern landscapes, all oils. One of these latter was *Eagle Rocks, Labrador*, and the other two were of Muskoka. Had he visited Labrador? It seems more likely that his painting was based on a photograph, or on sketches, or the memory of passing through the Straits of Belle-Isle on his return from England in 1862, if that was his route. (He showed two Belle-Isle watercolours in the first OSA exhibition in 1873, and a *Labrador Coast* in 1875.) At least two of the Indian portraits are known, both now in private collections. *Brave of the Sioux Tribe* is dated 1870, and has the look of a studio photograph. *Portrait of a Chippewa Chief* of 1871 is another version of the *Ne-Bah-quah-om*, virtually indistinguishable from the Calgary one. He is supposed to have worked at tinting photographs for Notman & Fraser about this time, and later in 1872 he moved his studio further along King Street to the corner of Church (39 Church Street), where he advertised himself as "artist and photographer" (see pl. 86). By the beginning of 1873 he had for the first time a residence listing: at 213 Seaton.

LUCIUS R. O'BRIEN

Although older than Verner, O'Brien came to consider painting as a true profession some considerable time after the younger man had been established in his Toronto studio. Lucius Richard O'Brien (his

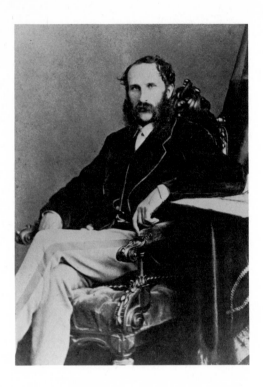

86
Notman & Fraser Studio
Frederick Arthur Verner c. 1870
Albumen print, 10.2 x 6.4 cm
Mr and Mrs L.A. Zeller,
Mississauga, Ontario

family called him "Dick") was born at "The Woods," Shanty Bay, on Lake Simcoe (Kempenfeldt Bay, precisely), adjacent to Barrie, about 85 km north of Toronto. He was the second of six children of Captain Edward George O'Brien and Mary Sophia Gapper, a second son of three. Captain O'Brien was a nephew of the thirteenth Lord Inchiquin, of ancient Irish lineage, and in the family tradition had entered upon a military career.

Part of the programme for the organized settlement of Upper Canada was the establishment of a militia, and British officers were offered half-pay for life if they would settle in strategic areas, assume the responsibility of organizing militia units, and of generally upholding the rule of law. Captain Edward O'Brien was one of these "half-pay officers," and according to family tradition was personally invited by

Sir John Colborne to take a post in the immediate hinterland of Toronto. He and his bride established the village of Shanty Bay in the bush in 1832, and he was appointed district magistrate and colonel of militia. A friend and business associate, Samuel Thompson, later described their home, The Woods, as "a perfect gem of civilization set in the wildest natural surroundings" (*Reminiscences of a Canadian Pioneer*, Toronto, 1884). It was an ideal setting in which to raise a New World aristocrat.

We know the details of Lucius O'Brien's infant years virtually at first hand, as his mother kept a diary, now in the Archives of Ontario (an edited version was published in Toronto in 1968). O'Brien was born after dinner, 15 August 1832, and we know when he first walked, and other stages of his earliest progress. There is also the inevitable initial sign of his future calling, noted by his mother on 12 February 1834:

> I don't say that my boy is a born artist, but he sometimes torments me very inconveniently to supply him with the implements to 'dera, dera.' Sometimes by the same passion I get him off my hands for an hour together. The productions of his pencil as far as I can judge are very much like and quite equal to those of any other young gentleman of a year and a half old. Just now nothing will serve him but a pen and ink which is not quite convenient (p. 223).

The entry continues in the original manuscript (although this was not included in the published version): "He has latterly become very fond of Edward & frets for him when he is away, but one of his most striking characteristics is a fondness for babies and dolls." Although twice married, he would never have children of his own.

Lucius was sent to Toronto in 1844 to attend Upper Canada College (where he would likely have been instructed in drawing by John G. Howard), and the following year his parents moved into Toronto too, although they continued to pass their summers at Shanty Bay. About this time, Edward O'Brien with his brother, a doctor who maintained a practice in Thornhill, bought a newspaper in Toronto. It was called *The Patriot*, and they ran it until their office was burnt out in the great fire of 7 April 1849.

Young Lucius had graduated from Upper Canada College the year before, and entered an architect's office, although he subsequently studied and practised as a civil engineer. (His father, after selling *The Patriot* in 1849, worked as a land agent, and was also secretary of a company formed to construct a railway from Toronto to Lake Huron, thus perhaps influencing his son's choice of career.)

Nonetheless there is some evidence to suggest that, even as early as this, O'Brien was already planning to pursue a career as an artist. In a private collection are three sketch-books, two of which contain dated drawings spaced regularly from 1852 through 1859. They are almost all landscapes done in the immediate area of Shanty Bay, west to Barrie and east to Orillia on Lake Couchiching; although in April 1852 he was sketching in the Eastern Townships around Sherbrooke, and frequently visited the heavy bush on the Severn River, which runs from Lake Couchiching across into Georgian Bay, north of Orillia. The first public trace of his interest in art appears in 1852 when it is noted that he won two prizes in the Provincial Exhibition, in the professional lists, interestingly enough. These were a second in pencil drawing and a first in coloured crayon. He appears in the sampling of those Toronto city directories of the fifties that were published, and have survived, only in 1856, but he is listed then simply as "artist, Spadina Avenue, w.s." (west side).

The earliest of his works to have survived is a monochromatic wash drawing, now in the Metropolitan Toronto Library, done 5 August 1851 at Coteau-Landing on Lake St Francis, which is a widening of the St Lawrence just above Valleyfield. (He was back there again in May 1853, according to one of the sketch-books.) All things considered, it is quite a skilful piece (he was not quite nineteen), in the style of the picturesque illustrations in English travel books of fifty years or more before; the sort of thing he doubtless would have learned at Upper Canada College.

Also in the Metropolitan Toronto Library are examples of two lithographs of the middle of the decade that are based on O'Brien drawings. One is entitled *Government House and Grounds, Toronto, C.W., on the Queen's Birthday, 1854*, and the other, *The Toronto Exchange, Incorporated A.D. 1854*. It is work like this, which drew upon his architectural training and which remained consistent with the draughtsman's skills

required of an engineer, that he was probably exhibiting at the Provincial Exhibition, and that led him to consider himself briefly, in the mid-fifties, as a professional artist.

Family responsibilities, however, caused him to leave Toronto in 1858, and by 29 December of that year he was living in Orillia, managing a stone quarry owned by the family (Henry O'Brien's diary, now in a private collection). He seemed to take to this change of scenery, though, and by 25 January 1859 he had been elected Reeve of Orillia, and by April had announced that he was about to marry "a widow of forty" (Henry O'Brien's diary). As recorded by his brother Henry, his smart-set friends in Toronto greatly disapproved. The marriage went ahead, nonetheless. The bride was Margaret, eldest daughter of Captain Andrew St John of Orillia, and all signs are that Lucius O'Brien was himself extremely pleased with the match.

There are no dated paintings or sketches whatsoever for almost ten years, and the O'Briens continued to live outside Toronto, probably at Orillia and Shanty Bay. There is, however, a sketch dated at Barrie, 2 October 1868, in one of the sketch-books, and five days later one was made at the Rama Bridge on the Severn. Soon after, he was off on a trip to Montpellier in the Languedoc region of southern France, sketching and drawing there from 13 January to 10 February 1869. A drawing done at Bulford places him back at home by 7 April.

The reason for his trip to Southern France is revealed in the 1870 Toronto city directory. He went there on business, because at some point in 1869 he had become associated with Quetton St George & Co., "importers of French, Spanish and German wines, French brandies, salad oils, etc., Mediterranean produce, wholesale & retail, 34 King e." (One of the older merchant and land-owning families in Ontario, and long associated with the moneyed class of Toronto, the Quetton St Georges also maintained vineyards and groves on their estates at Montpellier.)

On his return from Europe, O'Brien settled in Toronto once again, living at 122 Adelaide Street West. The following year, his home is listed at 29 Grenville Street, near Yonge Street. With the founding of the OSA, which he joined 7 January 1873, Lucius O'Brien was, after fifteen years, once again involved in the Toronto art scene, although this time unquestionably as the gentleman-artist.

JOHN A. FRASER

From what little evidence there is, it would seem that John A. Fraser painted the five oils he displayed in the first OSA exhibition only weeks before the opening. He certainly was not a painter who worked to any kind of regular studio routine. We will see – as we already have, to some degree – that he worked in spates, and that besides painting there were many demands upon his time. In the early seventies there was first of all the need to put all possible effort into the establishment of Notman & Fraser in Toronto. That was perhaps not so difficult, as the demand for quality photography was growing. But Fraser, like William Notman, was a man who attended to detail, and the construction of a sumptuous new gallery and studio at 39 King East, and the move there early in 1873, must have occupied most of his waking moments.

He also had four children by then. As in Montreal, he seemed to have needed to move his household every other year. The family stayed on Gould about a year, then late in 1870 moved to 99 Gerrard Street East, one block north. Two years later they moved to 49 Bleeker, just north-east of the horticultural gardens (now Allan Gardens), and later that same year they moved yet again, to a larger house on Wilton Crescent, which was then on the outskirts of town (as virtually was Bleeker).

All of these moves apparently signified increasing material success, and a young diarist, their first daughter, Nannette, recalled from her earliest memories on Bleeker and then Wilton streets that they "were very comfortably off." During 1872, just when the planning of the new Notman & Fraser gallery must have been most involving, Fraser had the added and time-consuming work of organizing the OSA. As Vice-President, the senior executive from among the artists, full responsibility for the success of the first exhibition rested upon him. He also, through the Notman & Fraser firm, arranged to order from England the chromolithographs that were to be given to each of the Art Union subscribers.

All of the paintings but one he exhibited that April of 1873 appear to have been worked up from the sketches he had done in the Eastern Townships and in New Hampshire as much as five or six years before. Robert Gagen in his *Ontario Art Chronicle* of about 1919 recalls that the watercolour (though Gagen remembered more than the one that was

shown), was also "one of his sketches made when living in the Eastern Townships... very clever in handling and color, quite modern...." The critic for *The Canadian Monthly* visited some of the artists' studios before the show, probably in February. His remarks concerning Fraser are interesting. This was less than two months before the opening:

> Mr John A. Fraser (Vice-President), amidst the many calls upon his time, still snatches a quiet hour now and again to portray the beauties of out-door nature. It is likely he will send about six pictures in oil and watercolour. One, a dry bed of a mountain torrent is nearly completed, and is in our opinion, a bit of masterly handling of oil colour in the representation of changeable weather, the cloud shadows falling beautifully across the rugged bed of the stream and contributing to the effect of distance. His other pictures are somewhat unfinished as yet, but an artist of Mr Fraser's versatile powers and ready knowledge, will be certain to shew us good work in all of them (III, March 1873, p. 261).

Fraser did manage to finish the four other oils, so that as well as *Dry Bed of Mountain Stream, Androscoggin*, he showed another of about the same middle-size, *A Smile in the Storm*; a smaller one (the only one not based upon old Montreal field-sketches), *A Shot in the Dawn, Lake Scugog* (Lake Scugog is about 65 km north-east of Toronto); and two considerably larger canvases, *Carrying the Oats, Threatening Weather, Eastern Townships*, and *September Afternoon, Eastern Townships* (pl. 87). This last, along with *A Shot in the Dawn* (pl. 88), are now in the National Gallery of Canada in Ottawa. *Dry Bed of Mountain Stream* was the best received. *The Canadian Monthly* called it "the gem of the exhibition," and then went on, "thoroughly true to nature, even in a certain clearness, if not hardness of distant outline, illustrative of the contrast between the clearness of our Canadian climate, and the hazy, vaporous distances of England's more humid atmosphere" (III, June 1873, p. 546).

Of the six pictures Fraser showed that year, only two are known today, those which are now in the National Gallery. As was noticed at the time, it is the clarity of the atmosphere that is at first striking, a clarity that results in a sharpness of outline and the isolation of discrete objects in space. This may have had something to do with Fraser's perception of the Canadian climate, but it was also derived

87
John A. Fraser
September Afternoon, Eastern Townships
1873
Oil on canvas, 76.5 x 132.1 cm
The National Gallery of Canada, Ottawa,
purchased 1974 (18,159)

88
John A. Fraser
A Shot in the Dawn, Lake Scugog 1873
Oil on canvas, 40.6 x 76.2 cm
The National Gallery of Canada, Ottawa,
purchased 1958 (6938)

from the landscapes of the Pre-Raphaelites and their followers, at that time just passing the peak of their greatest popularity. The matter-of-fact way in which anecdote is handled in both pictures is in the manner of the Pre-Raphaelites, and the close attention to the minute details of things – plants, rocks, and beasts – is the most famous characteristic of those English artists. Finally, Fraser also shared with the Pre-Raphaelite painters the rather complex, untraditional sense of space, and the use of the intense, new coal-tar colours.

But that still does not entirely explain the almost startling sense of newness one feels, particularly in front of the large picture, *September Afternoon, Eastern Townships*. That quality is most probably a direct consequence of Fraser's daily work with photographic images. (The Pre-Raphaelites also knew the camera, a connection that has not as yet been adequately explored.) The space depicted in it is, for example, very different from the easy recession of traditional pictorial space. It is here established as a series of pockets that one's eye passes through, the near limit of each marked by an evident plane: the near bushes of intense autumn hue, the dark island in the centre of the lake, the far shore, and Mount Orford flattened in an early autumn haze. It is the spatial structure of a stereograph, because only by looking through a stereoscope do we experience a momentary disorientation similar to that we feel in establishing the proper scale of those boatmen on the beach. It is like looking from one space through a window into another space. It is bold, and as was remarked at the time, it is strong.

The other elements that relate to a photographic image we can by now identify with ease. Great attention is paid to the details of exact appearance, particularly of texture, and particularly in the foreground. There is the general clarity of atmosphere, and the ease with which optical effects such as reflections are rendered. And there is the tendency to high contrasts of tone, as is evident in the head of the central sheep. This last is also very apparent in the treatment of the island, and is especially beautifully handled where the rocky point enters the water to the left. Of course the vivid, involving colour would, in 1873, have inhibited the association of such characteristics with the photographic image. Fraser painted nothing to approach it for almost five years.

FRASER AND THE OSA

One could almost say he did not try, although circumstances definitely influenced him. The first exhibition of the OSA was received, as we have seen, as a laudable venture, well begun. On 6 May, at the first general meeting of the Society following the exhibition, it was revealed that it had, remarkably, also proven a financial success, with a total realization from Art Union subscriptions, admissions, government and private sales, of $2,312.32. As Notman & Fraser had let their premises without charge, this represented a net profit to the Society.

The only sour note was that the Birket Foster chromos, meant for distribution to Art Union subscribers, had not arrived from London, but no concern is expressed in the minutes of the meeting. For some unknown reason John A. Fraser was not present to hear the praise that would have been his due for having so ably led the Society through its first exhibition. Marmaduke Matthews was in the chair, and the meeting progressed in a business-like fashion. The Secretary was voted an honorarium, as was W.H. Braithwaite, who had acted as curator. It is revealed in the minutes that a separate Art Union display had been set up in space loaned by R. Wilkes, Member of Parliament and prominent businessman. It was agreed to prepare a selection of members' sketches to be presented to him in appreciation.

The new Governor-General, Lord Dufferin, had lent paintings to add interest to this Art Union display. By vote it was decided to thank him formally, and to arrange for J.C. Forbes to repair some of his pictures that had been damaged. Matthews and Charles Millard were directed to travel to London immediately to find a suitable chromolithograph for distribution to the next year's Art Union subscribers, and it was decided that artists who offered small paintings and sketches for the Art Union draw would next time be paid for these works. The last bit of business was a decision to approach Notman & Fraser concerning the possible sale of members' works in their gallery on a continuous basis.

The next general meeting of the OSA was 13 June, convened for the annual election of officers. Fraser was present this time, and again everything seemed to proceed smoothly, the whole executive being returned. The meeting was "followed by a sociable dinner at the

Queen's Hotel." Meetings were held again in July, and twice in Sep-
tember, when routine matters of business were discussed and by-laws
slightly amended. At a meeting on 11 October some concern was
expressed that Millard had not as yet reported back from London,
but at the following meeting, 11 November, Fraser was requested to
write to McQueen & Rowney in London for samples of chromos that
could be ordered in quantity for the Art Union. That evening also
W.L. Fraser, John's brother in Montreal, was elected to membership.

Bad news was the reason for the hurriedly called meeting which
occurred two days later: it had been discovered that the Treasurer, H.J.
Morse, had been using the Society's money to shore up his failing coal
business. The company had finally collapsed, leaving the Society with
unpaid bills totalling $1,023.75. Fraser and the President, W.H. How-
land, had been working behind the scenes in an attempt to satisfy the
creditors with an amount totalling almost exactly one-half the debt.
The decision that night was to charge five per cent on all sales at the
next exhibition, and then to assess each member individually and
equally for whatever balance remained afterwards. Again from the evi-
dence of the minutes, it all seems to have been handled in a reasonable,
objective way. R.F. Gagen, who was there that evening, wrote years
later, however, that

> the failure of Morse, and the consequent assessment was the
> cause of much unpleasantness to Fraser. As Vice-president he
> had to bear the brunt of it.... Fraser was blamed for being too
> autocratic and not consulting the Executive, for which he was
> unfavourably criticized by O'Brien and his friends, and the
> membership divided into two parties (*Ontario Art Chronicle*,
> p. 27).

Be that as it may, the minutes continue to record a series of ord-
erly meetings: in November it was decided to order Birket Foster's *The
Boat Race* for the Art Union, and to engage Mr Braithwaite, who had
curated the first exhibition, to handle the Art Union ticket sales; in
December, Lieutenant-Colonel Casimir Gzowski, a prominent civil
engineer, collector, and socialite, was elected Treasurer to replace
Morse; in January 1874 Sandham and John Hammond of Montreal
were elected to membership and Braithwaite was requested to apply
for security bonding from Citizens' Insurance & Guarantee Co., and

was voted a salary of eighty dollars per month; in February, Braithwaite still had not secured a bond; by March and April there were new membership applications, including Allan Edson, who was accepted; on 14 and 15 April there was discussion about the next OSA exhibition and where and when it should be held; on 5 May the decision was taken to open the exhibition 15 June.

But then, on 18 May, the minutes record an unexpected note of drama. The meeting was apparently particularly well-attended and began, peaceably enough, with some further discussion regarding the date of the forthcoming exhibition. This business having been concluded John Fraser announced his retirement from the chair. He had his letter of resignation with him, so it was clearly a premeditated move. According to the minutes, which continue to maintain their bland tone, this is what transpired next:

> Mr O'Brien was voted in the chair, when the Secretary read a letter from the Vice-president tendering his resignation, after some remarks on the subject it was moved by H. Hancock and seconded by J.T. Lawder and resolved that the Vice-president is requested to withdraw his resignation. After some remarks at length from Mr Fraser upon the question at issue and a fair and friendly discussion on all sides he finally consented to withdraw his resignation and Mr O'Brien vacated the chair. Mr Fraser having resumed his position on the Society, the business of the meeting was proceeded with with evident satisfaction at the amicable adjustment of a little difficulty.

In due course, Gagen was to give a much more revealing account of the true state of affairs in the OSA during that period. He was an employee of Fraser's at the time:

> Fraser, by his impulsive nature (at one meeting he resigned, but was persuaded to withdraw it by all present), played into the hands of 'the O'Brienites.' He refused the use of the Notman Gallery saying it was required for business purposes – for the coming Annual Exhibition, and would not give up the sample engravings (by Landseer, and well known, some sent were only half finished; others, at this time unpublished), which he contended were sent to him personally as a member of a business firm (*Ontario Art Chronicle*, p. 27).

The discreet form of the official minutes hides all of this. The next meeting was again reported dispassionately. It was agreed that the exhibition would be held in the Music Hall of the Mechanics' Institute on Church Street, and two auditors were named for the Art Union draw.

O'BRIEN AND THE OSA

At the meeting following the opening in June, the annual elections were held, and the split became really evident for the first time. The Executive was elected in order. Lucius O'Brien moved, seconded by Millard, that W.H. Howland be re-elected President. This was passed unanimously. It was then moved by F.A. Verner, seconded by Richard Baigent, that Lucius O'Brien be elected Vice-President. R.F. Gagen quickly responded with a motion that John A. Fraser be re-elected, but "there being no seconder" the original motion stood to the vote, and was carried.

Hancock and Gzowski were re-elected. O'Brien, who was prepared for the occasion, then gave notice of the following three motions: that the name of the Society be changed to "Canadian Society of Artists"; that members in cities other than Toronto be encouraged to organize local exhibitions of the Society, subject to its rules; that instead of chromolithographs, photographs of paintings prepared by members be offered as the Art Union subscription prizes.

Fraser, evidently caught by the rapid sequence of events, gave notice of a motion to poll absent members on all important matters of the business of the Society. This was doubtless in realization of the fact that most of his support lay with the inevitably absent Montrealers. He attended the next meeting, on 7 July, but then no more. He had withheld exhibiting in June, and would not show again with the osa for three years. Sandham and John Hammond resigned from the Society in November, Fraser in December, and Gagen (the last of the Notman employees then on the rolls) resigned in response to the still simmering issue in February 1876.

"This might not have been serious had it not caused dissatisfaction amongst the members living in Montreal, who were already jealous that the only society of professional artists should be located in

Toronto." Such was Gagen's opinion when reflecting upon events many years later. "So it resulted in their gradual withdrawal, with the result that the Society finally became a purely Provincial body, and what might have been its destiny was left for the RCA to accomplish." That certainly was not the general feeling in Toronto at the time. There was a flurry following the first three resignations (which coincided with a small scandal concerning the Art Union funds), and *The Nation* reported that the OSA had dissolved (II, 8 January 1875, p. 12). O'Brien responded reassuringly that "the dissolution of the Society has *not* taken place, and there is not the slightest prospect of such a catastrophe. On the contrary, the members were never more harmonious and energetic in prosecuting the objects for which the Society was formed...." (II, 15 January 1875, p. 16).

O'Brien had, indeed, taken firm control. Fraser had been forced to agree to hand over his correspondence concerning the Art Union chromos at the last meeting he attended, and two days later, 9 July 1874, O'Brien had convened a special meeting on the subject of the Art Union. At that time, he presented nine detailed motions. All were unanimously adopted. From then on he ran the OSA ably, and largely as he himself saw fit. When yet another scandal emerged – it was discovered in November 1874 that Mr Braithwaite, responsible for the Art Union ticket sales, had been embezzling the funds – O'Brien wasted no time in dealing with the situation. The membership was informed immediately, and he was empowered to engage legal advice in launching a claim against both Braithwaite and the Citizens' Insurance & Guarantee Co., which apparently had finally bonded him.

O'Brien suffered only one small set-back during these years. In January 1875 he missed a meeting, owing to illness, and it was resolved upon a motion by T. Mower Martin that the name of the Society should not be changed until at least after the next Art Union. It finally never was. On the other hand the plan for the Art Union distribution of photographic reproductions went ahead, and three members T. Mower Martin, Lucius O'Brien, and his friend, F.A. Verner, were chosen to prepare "light and shade drawings...(preferably of Canadian subjects)...." O'Brien had his *Lords of the Forest* ready by 7 November 1874. Martin's *Pines* was finished by 8 December, and Verner's work by 5 January 1875. A grisaille watercolour, *The Sentinel*, which has been on the market for years could have been Verner's contribution. It was last at a

Fraser Brothers' auction in Montreal in February 1976, when it was reproduced in the sale catalogue, lot 268.

That year, O'Brien also got the provincial government to establish a $500 annual purchase grant. (Pictures had been purchased from the first exhibition for the adornment of Government House, but none in 1874.) By June 1876 he had the OSA housed in its own long-lease quarters in the heart of the city, on King Street, just west of Yonge, and as a result of this new, year-round space, had by that fall established, under the Society's auspices, a School of Art. Gagen was re-elected to membership in February 1877, and in April John A. Fraser again appears in the attendance rolls. That May, he even seconded O'Brien's re-election.

The Major Landscape Artists: 1873–1880

Lucius R. O'Brien
Frederick A. Verner
John A. Fraser
Otto Jacobi
further artistic foundations are laid

LUCIUS R. O'BRIEN

By the mid-seventies, Lucius O'Brien was regarded as the best of the painters. Every review of an OSA exhibition singled him out for particular praise. His work, it was felt, showed "a marked individuality ... feeling and genius far above the average" (*The Nation*, I, 25 June 1874, p. 156). He was of "the foremost rank"; there was "an evidence of thought and feeling in his works, which grows on the mind the longer they are studied" (*The Nation*, II, 14 May 1875, p. 226). His watercolours were seen to be "truthful, clear, and harmonious, and... the evident handiwork of a man keenly alive to the beauties of nature, and enthusiastically anxious to do faithful work.... No other painter seems to understand Nature like Mr O'Brien" (*The Canadian Monthly*, II, June 1877, p. 681). None of this praise was misplaced.

Indeed, these qualities of individuality, of thoughtfulness, of clarity and harmony, had been particularly evident in his real Toronto *début* of 1873. I say "real" because he had shown there in the fifties, but this was a new beginning. (In the winter of 1871–1872 he had also shown one work, *At Six-Mile Lake*, in the fifth exhibition of the American Society of Painters in Water Colors in New York. The fact that a relatively large number of Canadians, mainly from Ontario, were included in this particular event had only served to underline the growing need for the OSA.)

In the 1873 osa exhibition O'Brien showed one oil and nine water-colours. The oil, an Indian subject, has disappeared, and he painted no more oils for four years. There was one watercolour of the south of France, *Castle of Murles, Languedoc* (now in a private collection, Shanty Bay). There were a few of indeterminate location, and the rest were of the Eastern Townships. Had he been back there again recently, or were they based on sketches and memories of more than fifteen years before? One of these subjects is in the Agnes Etherington Art Centre at Queen's University in Kingston. Perhaps it is *View from Pinnacle Rock, Eastern Townships*, or it could equally well be *Orford Mountain*, as that great monument hovers on the distant horizon. It is an attractive work, an early example of his sensitive combination of broad composition with fine attention to detail. It is, though, primarily a picture of space, and perhaps a bit empty in feeling.

There is no longer even a hint of such deficiency in some of the paintings he completed later that year, and showed in the second osa exhibition the following June. Dated sketches tell us that O'Brien was on the Ottawa River in May 1873, and in the capital to celebrate Dominion Day. And judging from the works he exhibited the following year, that summer he must also have been all over Southern Ontario, from Owen Sound on Georgian Bay to Port Stanley on Lake Erie, and even across the lake to Cleveland, Ohio. (He was a passionate sailor, evidence of which frequently appears in his paintings.) In the reviews his three largest works were considered the best. Today we know the whereabouts of two of these: *Under the Cliffs, Port Stanley* and *Toronto from the Marsh*. (The name of the one which now appears to be lost was *Ottawa from the Rideau*.)

Under the Cliffs, Port Stanley was the largest of the three paintings and it is now in the collection of Mrs Eigil Simmelhag (pl. 89). It is a wonderfully serene composition, well-arranged and spacious in con-cept. O'Brien's observation and his attention to the natural details of the place are also impressive. He describes with great accuracy the characteristic Lake Erie clouds cresting over the bluffs, the cliff swal-lows and gulls in flight, the beached log half-buried in hard-packed sand. The two fishermen are well drawn, and possess evident individu-ality of character. *The Nation* thought them "perhaps the best figures in the room."

Toronto from the Marsh is in the collection of Mr and Mrs J.A. Grant

89

Lucius O'Brien
Under the Cliffs, Port Stanley 1873
Watercolour, 49.5 x 74.5 cm (sight)
Mrs Eigil Simmelhag

(pl. 90), along with a mate, *Scarborough Bluffs from the Island* (pl. 91).
They are smaller than *Under the Cliffs, Port Stanley*, but every bit as excel-
lent. *Scarborough Bluffs* in particular is so beautifully balanced; the large
expanse of open sky in easy harmony with the busy, small foreground.
The foliage is detailed, but freely handled, and the boats as always are
rendered lovingly. Strong feeling permeates his work.

There was no artist in Toronto whose work could come close to
O'Brien's. His watercolour technique was more developed than that of
any of the others in the exhibition, except perhaps for Daniel Fowler
and Allan Edson, each very different. O'Brien built his picture up with
small dabs of colour, densely packed in some areas, lighter in others,

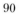

90

91

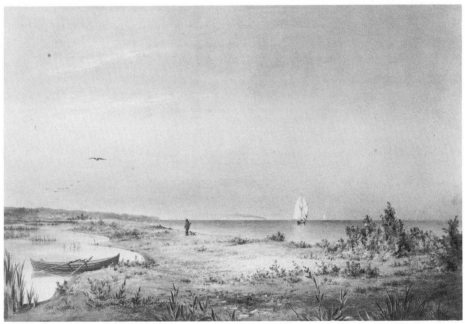

90
Lucius O'Brien
Toronto from the Marsh 1873
Watercolour, 34.3 x 52.0 cm (sight)
Mr and Mrs J.A. Grant, Shanty Bay,
Ontario

91
Lucius O'Brien
Scarborough Bluffs from the Island
1873
Watercolour, 34.3 x 52.0 cm (sight)
Mr and Mrs J.A. Grant, Shanty Bay,
Ontario

and this gives his paintings that striking quality of controlled, changing light. It was a technique used by certain of the Pre-Raphaelites and their followers in England. We can see it in the watercolours of William Holman Hunt, of John Frederick Lewis, and of Birket Foster, for instance.

But for the sense of space, the serene, open quality of the work, one must go for comparison to such American landscape painters of the fifties and sixties as John F. Kensett, Martin Johnson Heade or Fitz Hugh Lane – known collectively as Luminists. They worked almost always in oils, but O'Brien's skies sometimes share their light. Cloud effects are often similar, and particularly at this point in his work, the measured sense of placement of objects is very close.

The German-American, Albert Bierstadt, was another artist whose influence can be felt in O'Brien's work, and his effect on O'Brien's style will be discussed in more detail in later chapters. For the moment, suffice to say that Bierstadt's oil-on-paper paintings of the sixties and seventies have a finely stippled surface that gives a sense, as in O'Brien's watercolours, of sweeping light-changes across the landscape.

An object that seems placed on a perspective line is a device commonly used by Bierstadt, and one that has been related in his paintings to sterographic images. The half-buried log in O'Brien's *Under the Cliffs, Port Stanley* is an example of the same technique. But though O'Brien is sufficiently aware of the camera image to emulate its ability to describe detail and light, these watercolours of his do not relate to the photograph in any other apparent way. They are lean and refined. We are meant to sense a controlling intelligence in their order which is quite beyond that usually sought by the nineteenth-century camera artist.

Indian subjects dominated the 1874 exhibition of the OSA, so much so that *The Nation* devoted a paragraph of complaint to them. O'Brien showed at least one that year, *Indian Summer; a Fishing Party of Rama Indians Outside the Narrows of Lake Simcoe.* It is probably the 1874 watercolour in a Toronto private collection now called simply *Fishing Party Returning Home* (pl. 92). These are the natives of the area of O'Brien's home, families with whom he had had contact since early childhood. (There are many such accounts in his mother's diary.) So they are people at work, fishing, like those men at Port Stanley. Not that O'Brien never indulged in sentimental idealizations of Indians.

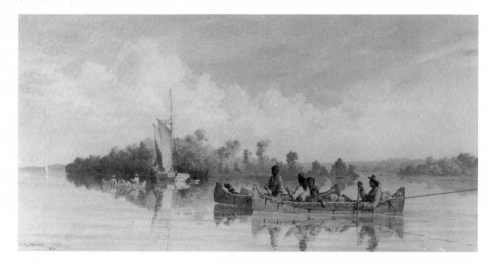

92

Lucius O'Brien
Fishing Party Returning Home 1874
Watercolour, 24.1 x 45.7 cm
Private collection, Toronto

In 1875 the Art Union lottery was again held in conjunction with the May exhibition of the OSA. As was mentioned in Chapter VII, all subscribers to this yearly draw were offered photographs of three works. Small original sketches by members were also available, and seem to have been preferred, since so many of the photographs were left over that it was decided to try again to give them away the following year. (One hundred photos had been printed, although whether of each work, or altogether, is not made clear in the OSA minutes.)

Among the photographs for the 1875 lottery was one taken of O'Brien's *Lords of the Forest*, the original of which he exhibited that year, and which is now in the Art Gallery of Ontario in Toronto (pl. 93). It is somewhat sentimental – one supposes that the "Lords" of the title are the two magnificent trees, as well as the Indian hunter. But once recovered from the touch of maudlin, we can enjoy what is a superb picture. A sparkling, delicate study of light in the deep forest, it is much in the manner – though not the technique – of Allan Edson, who had exhibited in Toronto the previous June. O'Brien made his painting in

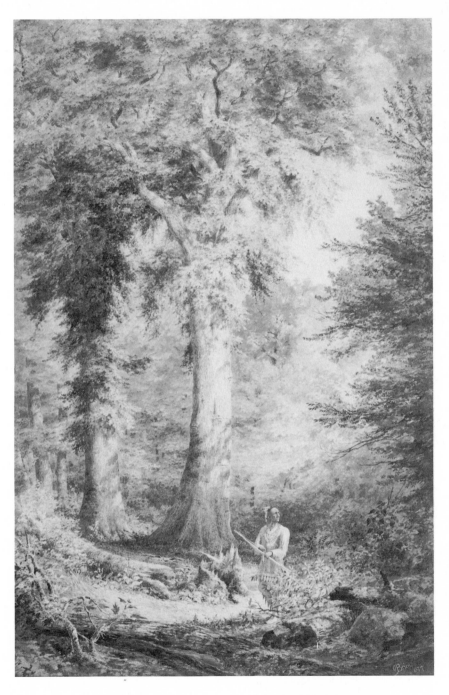

93

Lucius O'Brien
Lords of the Forest 1874
Watercolour, 74.3 x 49.9 cm
Art Gallery of Ontario, Toronto,
gift of the Government of the
Province of Ontario, 1972 (72/19)

October. As effectively as Edson's, it describes a cycle, a fragile balance, a favourite Victorian truth. It is the most blatantly metaphysical work that O'Brien would ever attempt. In fact his subsequent Indian subjects (they are prominent in his work to the end of the seventies), are more matter-of-fact, like his *Indian Summer*.

Doubtless we are meant to understand that these people exist in a delicate balance with the forces of nature; that their presence reinforces the sense of harmonious order which is, at this time, the real subject of O'Brien's art, in a philosophical as well as a formal sense. But no more so, on both counts, than the white sailors in their sporting craft, who are also depicted in many of his paintings of this period.

During the summers of 1874 and 1875, O'Brien again travelled widely about that area which, roughly, encompassed the old United Canadas: as far east as the Eastern Townships, south along Lake Erie, west to Lake Huron, and north, both to Georgian Bay and the Ottawa. In 1875 he took an extended trip along the Ottawa River, and up some distance beyond the capital, following the timber route (although there

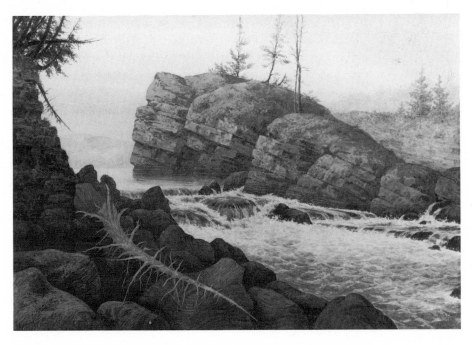

94

Lucius O'Brien
Song of des Érables Rapids,
Upper Ottawa 1876
Watercolour, 36.8 x 53.9 cm
The National Gallery of Canada, Ottawa,
purchased 1978 (23,155)

was little timber running at that time, the Depression having slashed that business by more than half).

Most of the paintings O'Brien exhibited in the June 1876 OSA show resulted from this trip. They depict a land, the Precambrian shield, that is harder than any he had hitherto presented, and in his eyes more primitive. A painting of 1876 called *Song of des Érables Rapids, Upper Ottawa*, now in the National Gallery of Canada, shows a long-dead, bleached cedar, that has been washed up on the rocks like some huge primeval insect (pl. 94).

The summer of 1876 O'Brien visited Ottawa again, as had become virtually a custom with him, and also, either in the spring or summer, went to Philadelphia, to view the International Exhibition. At some point after his return he began to paint in oils, and the following May he exhibited five canvases with the OSA, as well as his usual large number of watercolours (fifteen that year). Two of the oils, by their prices, were small, probably sketch-size. One, *Toronto Harbour, Early Morning*, was a little larger, and another, a *View Down the Ottawa*, was larger still. The location of none of these is presently known, although *Toronto Harbour* briefly surfaced on the market about twenty years ago.

To our great good fortune, the largest oil of this first group, almost twice the size of the next largest, is in a private collection in Toronto. *The Whirlpool at the Chats* is impressive as O'Brien's first major essay in oils (pl. 95). As much as he could, he followed the technique he had developed in watercolour, so that we still have the fine detail, the close observation of texture, the clear, even light that is central to his work. And it is a familiar subject, Indians fishing, engaged in the calm work of waiting, against a backdrop of rushing water. We perceive the circular plane of the pool as though it were the face of a clock, with logs, rocks and canoe marking radiants from its centre. Its merit was understood at the time, and the response O'Brien received must have been encouraging to him. Here is what *The Canadian Monthly* had to say:

> Of Mr O'Brien's works, we can honestly say that his profi-
> ciency in Oils surprises us, while his industry in Water colours
> seems as great as heretofore. His largest Oil – 'The Whirlpool
> on the Chats,' – is admirable. We could stand a little more col-
> our in the distance, but coolness and clearness and realism, in
> a great sense, are the artist's peculiar excellence. The backwa-

ter of the pool is the best part of the picture (II, June 1877, p. 681).

O'Brien contributed paintings to a special OSA benefit auction in December 1877. One of the two oils, *Sunset on the Hudson*, and one of the six watercolours, *Cape Ann, Gloucester Fishing Fleet*, suggest that earlier in the year he had visited New York and New England, although stops at these places could have been part of his trip to Philadelphia in 1876. But certainly, during that summer of 1877, he took the newly-opened Intercolonial Railway to the Bay of Chaleur. Work from that excursion he saved for the May 1878 exhibition of the OSA.

Artists in Montreal had already been involved for four or five years with the Quebec South Shore, and with the North Shore New Brunswick areas, through which the Intercolonial was being built. We have already noted the trips taken by Henderson, Edson and Sandham, but most of the Toronto people waited until the summer after the whole circuit had been opened to make the journey. Many took advantage of this first ready access to federated Canada's eastern regions in that summer of 1877, and the OSA spring exhibition of 1878 reflected this

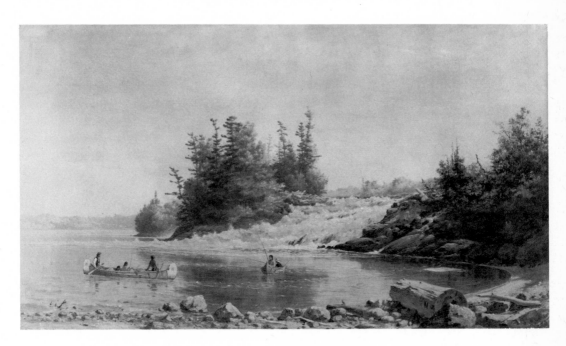

95

Lucius O'Brien
The Whirlpool at the Chats 1877
Oil on canvas, dimensions unknown
Private collection

sudden new broadening of the national horizon. Here is the reaction of *The Globe*:

> One feature of the Exhibition which must have struck almost everyone is the effect which the opening of the Intercolonial, and the access thus afforded to the magnificent scenery of New Brunswick, have had on our landscape painting. A few years ago we had nothing but Lake Superior and Muskoka, now it is the Bay of Chaleur and the Restigouche. The change is really an agreeable one in some respects, after so much sameness as we were threatened with. The new field, with its admirable combinations of mountain, sea, and shore, will furnish abundance of material for years to come, by which time we may have access to the still vaster fields of the magnificent, but, as yet, too inaccessible, scenery of the North-west (21 May 1878).

Four of the seven oils O'Brien exhibited that year – although only a quarter of the watercolours – were of subjects in the region of the Bay of Chaleur. Of the others, enough were of New England to suggest that he might have travelled to the Atlantic *via* the Great Western, then have run north to join the Intercolonial that summer of 1877. None of the oils can presently be located. We might assume they would embody the serene spatial geometry we know in *The Whirlpool at the Chats*. Certainly they were well received at the time, reviewers being divided as to whether *Black Cape, Bay Chaleur, Cod-Fishing off the Bon Ami Rocks*, or *The Mountain in Shadow (Tracadiegash, Bay Chaleur)*, was the best. All were coastal marines: pictures of boats, shore-line, and fog-shrouded cliffs. Although some east-coast scenes dated 1878 are known in watercolour, they cannot be identified with any of the titles listed in the OSA catalogue of that year. They have in common a slightly broader use of the medium than we have seen before in his work, probably a response to two years of painting in oils.

Later that year, O'Brien exhibited in New York for the second time, but this time with the National Academy of Design. He showed two Atlantic coast scenes, both probably watercolours. In December he donated works again to an OSA auction (the second), all of which had been exhibited before (including *Under the Cliffs, Port Stanley*). That summer he had again travelled to the east coast but in this instance to St

Andrews, New Brunswick, and from there to Grand Manan Island in the Bay of Fundy, a popular sketching spot of New England painters.

On the evidence of the works he exhibited the following May, O'Brien went along the old Grand Trunk route through New Hampshire, rather than by the more circuitous Intercolonial, or the Great Western through New York to the south. As with those paintings of the previous year, it has proven impossible to locate any of the oils. The largest was *Northern Head of Grand Manan*, and he showed it again that September at the Toronto Industrial Exhibition (successor to the Provincial Exhibition), and again in 1880, in the first exhibition of the Royal Canadian Academy of Arts. It was by then the property of George Brown, prominent Liberal politician and editor in Toronto of *The Globe*.

But that is getting too far ahead. We at least know the composition of *Northern Head of Grand Manan*, as there is a small monochrome painting done after it, which is now in the Concordia University collection in Montreal. This was probably prepared by O'Brien in 1880 (although it is dated 1878, no doubt following the oil), to be used as a model by a wood-engraver. An engraving of it, crude and differing from the model in many small ways, appeared in the *Canadian Illustrated News*, 17 April 1880 (xxi, p. 248). It is in the same pattern of coastal marines as those canvases of the year before that had been described in reviews: sailing boats before a curved coastline with fog-shrouded cliffs to the left and behind.

In 1879, O'Brien set out on his travels early, leaving in February, when he went to Boston on an official trip to study the facilities of the school of the Museum of Fine Arts. (There is correspondence still in the museum's files.) For the first time he spent part of the summer in the area of Quebec City, staying there from early June into August. From works that survive, we can determine that he went down river as far as Tadoussac at the mouth of the Saguenay, stopping about half way at Baie-St-Paul. But most of his watercolours of this trip are of the immediate region of Quebec, down as far as Cap-Tourmente on the North Shore across from the eastern tip of Île-d'Orléans, and up only to Île-aux-Fleurs, off Cap-Rouge.

One painting that is particularly striking, executed in his new, broader manner, is *Natural Rampart at the Île-aux-Fleurs, Lower St Lawrence*, in the British Columbia Archives, Victoria (pl. 96). By then, he

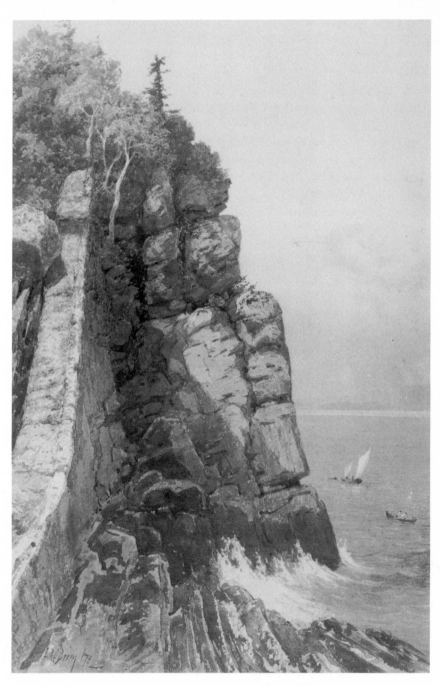

96

Lucius O'Brien
Natural Rampart at the Île-aux-Fleurs,
Lower St Lawrence 1879
Watercolour, 51.4 x 34.3 cm
Provincial Archives of British Columbia,
Victoria, purchased 1960 (pdp 555)

was using more fluid paint, layering it to build up the richness of tone he always desired. It is still very luminous, though the light is perhaps not so steady as in work from earlier in the decade. He was probably now striving for a greater sense of the mass of rocky forms, and of the force of the elements.

It is very likely that in Quebec City he attended the new Governor-General, the Marquis of Lorne, who was there during the earlier part of June. (Lorne inaugurated Dufferin Terrace on 9 June.) O'Brien's perception of Canada was continuing to expand, and was changing in other ways as well. As we shall see, this new point of view that he gained from his visit to the "Ancient Capital," would be the basis for a significant enlargement of O'Brien's ambitions – for himself, for his profession, and for his country.

FREDERICK A. VERNER

Throughout the seventies, Lucius O'Brien retained his connection with the Quetton St George wine-importing firm, and there can be no doubt but that this allowed him independence as a creative artist. F.A. Verner, it is just as certain, was hobbled by the need to devise paintings that would sell. Throughout his career, too large a part of Verner's work is formulary – what would be popularly called "pot-boilers." He remains an artist of interest, however, because he worked a narrow field, was prolific to an extreme, and so periodically produced pieces with real merit.

As we have seen, Verner's art training was minimal. Like O'Brien, he was really a self-taught painter. But whereas O'Brien seemed born with manual facility, which he was almost always able to hone to sincere, personal work, Verner seldom seems entirely at ease with the materials of his craft. His development was slow and halting but, during the seventies at least, he was often engaged with the foremost ideas concerning painting then current in Toronto. As was noted in the reviews of the first exhibition of the OSA in April 1873, he was the most familiar, and in that sense the most popular painter then working in the city. To go back, here is what the *Canadian Illustrated News* had to say:

Mr F.A. Verner, two of whose pictures, which were purchased

by the President [of the OSA, W.H. Howland], are reproduced on another page, is one of the most successful exhibitors, nearly all of his pictures being already disposed of. He appears to hit upon a very popular vein, and will doubtless make a very good thing of this affair (VII, 3 May 1873, p. 275).

The two pictures reproduced were *Shooting the Rapids* and *Deer Hunting in Muskoka* (p. 276). We are presently familiar with the latter, which is in the collection of Mr and Mrs Fred Schaeffer of Toronto. A small canvas in the National Gallery of Canada (the Toronto one is small too) is probably *Encampment, Snake Island*, from that show. And another small oil from the first OSA exhibition, *Portage, St Mary Lake, Muskoka*, was sold in auction at Christie's in Montreal in May 1970 (reproduced in the sale catalogue, lot 73). Virtually all Verner's oils of that year were of Muskoka subjects (Muskoka is just east of the lower part of Georgian Bay, in the Precambrian shield north of Lake Simcoe), as were a good many of his watercolours.

All of these pictures, which we know in various forms, are stiff and awkward in drawing, all evince a lack of formal training in the use of perspective and a general unfamiliarity with the concept of relative scale; the figures in particular are usually poorly proportioned. The over-all impression at this stage of Verner's career is that we are looking at the work of a naïve. However, his paintings are strong in mood, and the compositions are direct and forceful. Although the forms are generalized, rounded and smoothed, on the whole the pictures are not as hard in finish as the chromo-like work of two and three years before.

We have concrete evidence of Verner's travels in the early summer and the fall of 1873. In June he visited Quebec City. There is a group of dated pencil drawings of that city and region in the Montreal Museum of Fine Arts. Charming, they are now somewhat rubbed and worn, although it is likely they were always a little smudged in appearance. Then in the autumn we know for certain that he finally made it to the Northwest, as far as Winnipeg. It has been said that he travelled out to record the ceremonies connected with the signing of the first of the treaties with the Plains tribes, and specifically to make portraits of the twelve principal chiefs involved. It is believed by the Verner family that he was for that purpose on commission from the Dominion Government, although there is no trace of these portraits today. Nor is it clear

what this treaty could have been. It sounds like Treaty Number Four, the Qu'Appelle Treaty, which was signed only in September 1874.

What evidence we do possess of that trip is a group of watercolour field-sketches. These were done in the Rainy River District of north-western Ontario, during the assembly there, in September and October 1873, at the north-west angle of the Lake of the Woods for the signing of Treaty Number Three, with the Saulteaux Nation of the Ojibway. Others, made during the days which followed, are located farther east, along the Rainy River and at Fort Francis, where the river empties into Rainy Lake. These are now all in the National Gallery of Canada in Ottawa. Some have precise inscriptions. On one, which is the most interesting colour study, is written "North west angle of the Lake of the Woods, Time of Treaty, Sept 30 1873 (evening looking east)" (pl. 97). On another is "Camp of Ojibways at Fort Francis, Clear

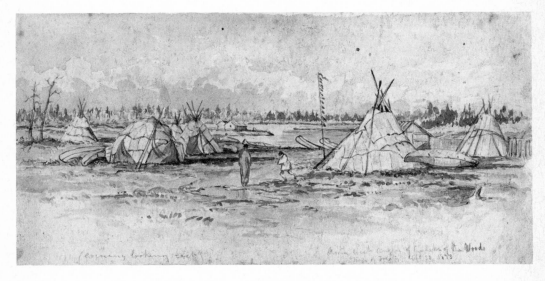

97

F.A. Verner
Lake of the Woods 1873
Watercolour, 13.3 x 30.0 cm
The National Gallery of Canada, Ottawa,
presented through the Canadian High
Commission, London, 1951 (7939)

Afternoon, Oct 6th 1873" (pl. 98). They are not great works. Small in size, they are now rather ragged and soiled. Yet these sketches are lively, and for the very first time we feel an immediacy, an actuality, in Verner's work. They seem natural and authentic; true scenes of native life, rendered in a loose, expressive watercolour style (see pl. 99).

Verner kept them his whole life, making paintings from them until well into the new century. A number of oils and watercolours were made over the years from the watercolour of 30 September: the latest version I have seen is a watercolour painted in 1902 (sold at Christies' in Montreal in May 1970, reproduced in the sale catalogue, lot 47).

The Toronto city directory was compiled twice in 1873, in January and again at the end of the year. It is strange that, having returned from the Northwest with these very painterly sketches, he should have listed himself simply as "photographer." He had moved his studio during the year, to 105 King Street East, across the street and down about half a block from Notman & Fraser's. His home address remained 213 Seaton. Had he taken photographic portraits on this trip, perhaps? We know nothing at present concerning his photo work. Certainly, any association with John A. Fraser ended when Verner nominated O'Brien for the Vice-Presidency of the OSA in June 1874.

He was pressing ahead with his painting. At the June 1874 exhibition of the OSA he showed only oils, but fifteen of them, and all derived from his trip of the previous autumn. Most were small, but they filled a whole screen, placed opposite the entrance, and it was this immediate preponderance of Indian scenes, reinforced throughout the display, that led to the impatient remarks in the reviews that we noted earlier. On entering, the critic for *The Nation* found "Indians in every position that can by any conceivable stretch of imagination be called picturesque" (I, 25 June 1874, p. 155). And perhaps because of this first impression, he was hard on Verner. "There are many good points in each of his pictures, but, taken as a whole, there is a sameness, a baldness, and an amount of crudity about them which is unsatisfactory." *The Canadian Monthly* was even harder:

> The first screen presents a number of Mr Verner's productions, all dealing with native scenery and Indian life, and containing the same defect of hard, unsympathetic treatment, which characterises his works. It is certainly to be regretted

98

F.A. Verner
At Fort Francis 1873
Watercolour, 17.3 x 38.1 cm
The National Gallery of Canada, Ottawa,
presented through the Canadian High
Commission, London, 1951 (7933)

99

F.A. Verner
On Rainy River at Long Sault,
Autumn, October 5 1873
Watercolour, 16.6 x 33.6 cm
The National Gallery of Canada, Ottawa,
presented through the Canadian High
Commission, London, 1951 (7937)

that, with Mr Verner's industry and evident affection for this class of subjects, he should be unable to enter into the poetry of the scenes he paints, or to transfer the sentiment to his canvas (VI, July 1874, p. 86).

The largest of the paintings Verner showed then has been lost. It was called *Pichogen: a Game Played like Lacrosse by the Ojibeway Squaws*. There were two slightly smaller canvases. One we now know is referred to in the original catalogue as *Sioux Encampment on the Assiniboine*, and is probably the painting sold at Christie's in Montreal in May 1969 as *Blackfeet Encampment* (reproduced in the sale catalogue, lot 453). Two others, in an even smaller size, included *Rat Portage, Indians Gambling*, which is now in the Glenbow-Alberta Institute in Calgary, where it is called *Indians Playing Hand Game*. Another of these 1874 canvases, also in the Glenbow-Alberta, would be *Pine Portage, North West*, today known as *Woodland Indians and Canoes at River Portage*.

And finally, a fourth canvas that we can identify was sold at Sotheby's in Toronto, October 1970 (lot 234, reproduced in the sale catalogue). It is probably *Thunder Bay, Evening*, which *The Canadian Monthly* was able to look kindly upon, calling it "a pretty, quiet-toned bit of rock and water in the evening light, treated with considerable tenderness" (VI, July 1874, p. 86). But for the bulk of his pictures that year, such criticisms as "sameness," "crudity," and "hard, unsympathetic treatment," must be accepted as valid.

The Winnipeg Art Gallery has a canvas called *Indian Encampment at Sunset* which is almost the same size as the *Sioux Encampment on the Assiniboine*, and like it, is dated 1873, and so must derive from the same autumn trip (pl. 100). It is not, however, the other second-sized picture shown with the OSA in 1874, as that was called *Deux Rivières (Island Portage)*. It must be admitted that the figures, and particularly the two horses, are clumsy. And the foreground is broadly and even crudely handled. But the sweeping sky is beautiful in colour and movement, and manages to provide the picture with a touch of genuine quality.

Verner's scenes of aboriginal life are still of limited interest, they lack both close observation and fine execution. What a contrast to the Indian scenes O'Brien was exhibiting at the same time! But when Verner manages to get into a picture a feeling of the land, of the mood of a time of day, as he has in *Indian Encampment at Sunset*, we can see that

there is a side to him that is capable of breaking away from the pedestrian.

By March 1874 Verner had moved again, both his studio (to 64 King East), and his home (to 72 Cruickshank, which becomes Crookshank in later listings, a boarding-house run by Mrs Mary Chillcott, a widow). Once again he is describing himself in the city directory as "artist." We have no evidence of travels that summer, and the following May at the osa he showed scenes from Muskoka, the Nipigon River, and Labrador, as well as the Winnipeg and Rainy River areas: all probably taken from his bank of sketches. His most popular piece that year, however, was a *Toronto Bay, 1875*, the largest of four canvases. It has dropped from sight. He also showed sixteen watercolours, as though to make up for their absence the previous year. One or two can today be identified, and they add nothing new to his old formulae of woodland and prairie scenes.

We have an inscribed field-sketch from 1875, in that group now in the National Gallery of Canada, that Verner kept until the end. It is *Por-*

100

F.A. Verner
Indian Encampment at Sunset 1873
Oil on canvas, 51.4 x 91.4 cm
The Winnipeg Art Gallery (G-54-18)

tage to Spider Lake, Aug 1875, and it is stiffer than the sketches of October 1873. There are Spider Lakes in Muskoka, in the Lake Nipigon region, and near Lake of the Woods. The following February he exhibited for the first time with the American Society of Painters in Water Colors in New York, one work, *West Angle, Lake Shebandowan*, a painting that appeared at Sotheby's in Toronto in May 1973 (reproduced in the sale catalogue, lot 101). It depicts two Indians in a canoe, gliding across the still water of a northern lake. Wooded islands and rocky hills on the far shore complete the picture, and in the careful placement of these elements, it achieves a certain quiet force, and suggests that Verner was learning from the superior watercolours of Lucius O'Brien.

The reviewer for *The Nation* preferred Verner's watercolours to his oils in the June 1876 OSA show, and there is evidence that he was indeed improving that branch of his work. *St Clair Flats*, a lovely watercolour he exhibited that year is now in the National Gallery. With its loose, expressive handling, it appears to be a field-sketch, and displays the same sense of immediate responsiveness that we first noticed in the Rainy River sketches of 1873.

Verner must have visited Philadelphia that year – everyone did. A sketch, "Mic Mac Huts near Rivière du Loup, Aug 1876," is in the National Gallery of Canada, and it, with a *Bay of Chaleurs* listed in the OSA show catalogue of the following spring indicates that he also took a trip on the newly-opened Intercolonial Railway – a year before O'Brien and most of the other Toronto artists. He had shown in New York again in February, and perhaps travelled there for the exhibition, as he displayed a New York subject in Toronto in May. His new interest in watercolours still predominated (he showed twenty-one of them at the OSA, and only one oil), and the scenes of Muskoka and the Northwest did too, although, strangely enough, the critic for *The Canadian Monthly* saw things quite differently:

> Mr Verner surprises us this year by the complete alteration of style which a visit to Philadelphia or some other influence has brought about. But, whatever it may have been that has wrought it, we honestly say that we do not regret the change. His eternal devotion to the Red Man was becoming tiresome. Now, besides some exceptionally hazy buffaloes and one sketch of teepees, he eschews the Far West altogether (XI, June 1877, p. 682).

This, I am afraid, was wishful thinking.

But a change was taking place in Verner's work, although it had begun before his visit to Philadelphia. We first noticed it in the water-colour he showed in New York in February 1876. Indeed, it is apparent in a large canvas that he exhibited in the Canadian section of the International Exhibition in Philadelphia, *Hudson Bay Officials Leaving Brûlé Portage, on Rainy Lake (early morning)* (pl. 101). It is now in the Glenbow-Alberta Institute in Calgary. Its mood is very strong – the stillness and freshness – but it is the sense of underlying order in it that sets it apart from Verner's earlier work. As we noted before, it was the close association with O'Brien that was opening up his mind to the many pictorial possibilities of composition, texture and colouring. This painting is also, with its early morning mists, more romantic, and that too was a direction in which O'Brien was leading him, although up to this time only in watercolours.

101

F.A. Verner
Hudson Bay Officials Leaving Brûlé Portage, on Rainy Lake (early morning) 1876
Oil on canvas, 83.8 x 152.4 cm
Glenbow-Alberta Institute, Calgary
(vf.56.27.10)

Verner is listed in a Toronto city directory for the last time in 1877. As mentioned above, he may have visited New York that year. In the summer he was on the Intercolonial again, but seemingly only to run along the South Shore as far east as he could go, and then to travel by ferry across the St Lawrence to the Godbout River. There is a dated sketch of the Godbout (only 1877; no month), in the Glenbow-Alberta Institute. And in the Musée du Québec is a fairly large canvas now called *Fishing in Old Quebec* which shows a salmon pool on the Godbout, and should be identified with a work that was exhibited first in May 1879 (at the OSA, as *Salmon*), and then in the Toronto Industrial Exhibition in September as *Salmon Pool* (pl. 102). Although not as large as *Hudson Bay Officials...* it is even more arresting in mood, and richer in pictorial devices. For the first time he has used light and shade in a broad, sweeping fashion, and this brings a new sense of scale to his work. The figures are still a little clumsy, but they have character, even though they are virtually overwhelmed by the magnificent wilderness scene.

The productions dating from 1877 which we presently know are two views of the Detroit River; a watercolour in the Glenbow-Alberta Institute, *On the Detroit River*, dated simply 1877; and a pencil drawing in the Montreal Museum of Fine Arts inscribed "View near Sandwich, Detroit River, Oct 1877," along with some colour notes. Verner must have visited his parents in Sandwich frequently, but on this occasion he may have been *en route* to New York, since he exhibited with the American Society of Painters in Water Colors, and later at the National Academy of Design – this for the first time in twelve years. (It should be remembered that O'Brien also showed at the NAD that year.) In the exhibition catalogue Verner gave a New York address: 17 Bond Street.

The pictures that Verner exhibited in Toronto the same year were to cover the new range of subjects that *The Canadian Monthly* had commented upon so favourably in 1877. Among the oils were a landscape near Sandwich, a Lake Superior scene, four still-lifes of fruit, and the first version of his Landseer-like buffalo, *Monarch of the Prairie*. His eight watercolours reflected the same variety, although they did not include any still-lifes.

In 1879 he was back in Toronto, as is indicated by a watercolour sketch, *The Lakeshore Road*, in the Metropolitan Toronto Library, which shows that date. He once more exhibited with the watercolour painters

in New York, but not with the National Academy of Design. That May, his works in the OSA exhibition again included the new mix of still-lifes, buffalo pictures, Indian scenes, and eastern landscapes, in a roughly equal balance of oils and watercolours. Some of the paintings had been done in the White Mountains of New Hampshire, which suggests that he may have made yet another visit to the States, via the Grand Trunk Railway.

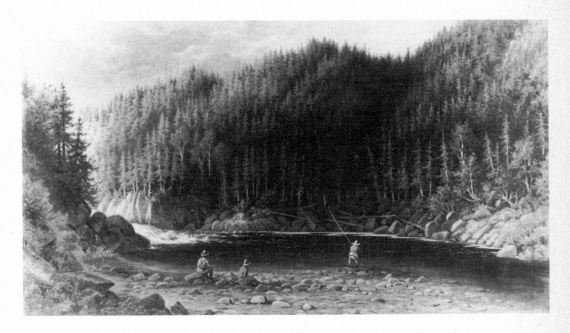

102

F.A. Verner
Fishing in Old Quebec 1877
Oil on canvas, 68.1 x 122.1 cm
Musée du Québec, Québec (A 48 115 P)

JOHN A. FRASER

John A. Fraser's absence from the 1874 OSA exhibition was noted in at least one of that year's reviews (*The Nation*, I, 18 June 1874, p. 142), but the following year it elicited no comment. However in 1876 the critic

for *The Nation* again had something to say: "...this year we presume he [Fraser] has carried all the products of his easel to the galleries of the Centennial at Philadelphia, where he is showing the Americans what Canadian photographers can do" (III, 23 June 1876, p. 292). That by those "products of his easel" the critic meant photographs is unlikely.

Nevertheless, in 1876, photography would have been Fraser's prime concern. As was explained in Chapter VI, this was the year he was Art Superintendent of the Centennial Photographic Co., which was established by William Notman at the International Exhibition in Philadelphia. Notman & Fraser also had a large display of work, which we can assume was somewhat retrospective in nature, and which attracted much attention and some honour.

Since the 1873 opening of the new shop and gallery the Toronto firm had, in spite of the Depression, enjoyed a fine business (see pl. 103). In this period Fraser had R.F. Gagen working for him, as well as young Horatio Walker, who came from the country town of Listowel, in the south-western part of Ontario. Walker was there from 1873 to 1876, and enjoyed both his job and the congenial artistic atmosphere, as did another young artist from the same region, Homer Watson of Doon, who was around the studio in 1874–1875.

There is no record of dated paintings by Fraser between 1874 and 1877, most probably because there were none. All four of his works in the Canadian section at Philadelphia in 1876 had been done earlier, and had been sold. Fraser had not been exhibiting, and so it is likely that, given his temperament, he was not painting. His creativity was doubtless sufficiently engaged by the Notman & Fraser operation. His family also continued to grow. Another girl, Harriet Isabel, was born in the middle of September 1876, but this time, remarkably, the family did not move to larger quarters but remained on Wilton Crescent.

It would seem that this period of non-painting was finally brought to an end through some sort of reconciliation with Lucius O'Brien, which made it possible for Fraser again to become actively involved in Toronto's painting world. It all seems to have been handled in a gentle and civilized fashion. At a meeting of the OSA 7 February 1877, Marmaduke Matthews nominated John A. Fraser for election to membership in the Society. O'Brien then moved the election of R.F. Gagen. Fraser appears in the roll-call of the meeting of 10 April, and he took an active part in the meeting of 11 May, on the eve of the 1877 exhibition. At the

103
Notman & Fraser Studio
John A. Fraser *c.* 1875
Albumen print, 18.2 x 9.4 cm
Archives of Ontario, Toronto
(Ontario Society of Artists papers)

annual meeting, which was held during the exhibition (on 17 May), he even seconded the motion for O'Brien's re-election.

It appears, however, that he was not yet fully prepared to exhibit. He showed only oil paintings: four small sketches, two slightly larger ones, and just one fair-sized picture, *Off in the Morning Mists,* which is presently in a collection in Brooklyn, New York. It was not well received at the time. *The Canadian Monthly* was blunt: " 'Off in the morning mists,' is a mistake, in colour, drawing, and everything: the canoes are obviously going, not only up stream, but up hill too" (II,

June 1877, p. 681). The picture is not really as bad as all that, although Fraser obviously had some trouble coping with the mist effects, and there is overall evidence of haste. The smaller works, none of which has been located, were all Eastern Townships or New Hampshire scenes from along the line of the Grand Trunk. They were probably not new.

In December, Fraser participated in the first OSA benefit auction, contributing one oil and three watercolours. The oil, *Twilight in the Androscoggin*, was probably put up at auction again the following December, when it was called *Twilight in the White Mountains*. Was this a new work, or was it done around 1873, when he painted *Dry Bed of Mountain Stream, Androscoggin*? We cannot today be sure that we even know the picture. The only likely candidate is the large canvas in the National Gallery of Canada, that has been known as *In the Rocky Mountains*, and was consequently once dated to 1886 or after (pl. 104). It

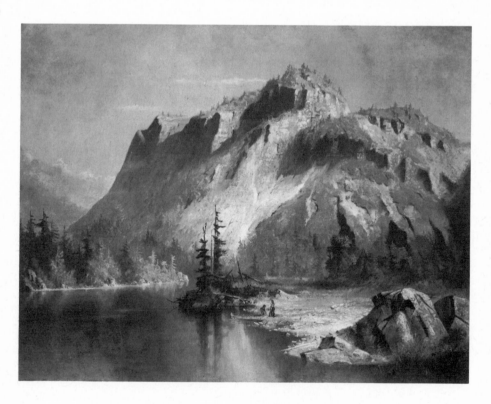

104

John A. Fraser
Unidentified Landscape *c.* 1875
Oil on canvas, 114.3 x 127.0 cm
The National Gallery of Canada, Ottawa,
purchased 1956 (6454)

quite clearly is not a Rocky Mountain scene, however, and it must date before 1880, because the dealer who sold it to the Gallery acquired it from the descendants of George Brown, the well-known Liberal politician and Editor of *The Globe*; they firmly believed it to have been purchased by Brown, who was shot by an employee of *The Globe*, and died 9 May 1880.

The painting does not depict a typical bit of White Mountains landscape, but a worn and eroded hill of some size, rising above a broad stream. It has a certain drama to it, and successfully establishes a particular quality of light that could be best described as twilight. It is a raking, sharp illumination, causing certain rock faces to stand out in bold focus. This highly contrasted effect of shadows against areas of light reminds one of a photograph, and most of the other characteristics of the photograph-related image are here too. (Most noticeable in this case is the lenticular focus pattern.) Nevertheless Fraser's own colour sense is also evident – those intense, high-keyed harmonies that stand out in any room.

The three watercolours in the auction were all sea-coast scenes, and they may have been new. That year Fraser, like O'Brien (could they have been together?), travelled on the new Intercolonial line to the mouth of the Restigouche on the Bay of Chaleur. The following May he made the strongest showing he would ever mount in an OSA exhibition, and all of it (five oils and ten watercolours) was new work arising out of the previous year's trip. Most were small, though the centrepiece was a large canvas – as big as any he had painted – which had already been shown privately in his studio, and sold to Lady Howland, mother of the then-president of the OSA. It was then called *Sea-Side Idyl*, and is now in the collection of the City of Toronto, where it is known as *The Land of Evangeline*. It marked a considerable departure for Fraser, since the figures of fishermen and their families are so prominent that it might be described as a genre scene in an outdoor setting. One is bound to recall Henry Sandham's similar shift in interest at this same time. The landscape, incidental as it is in terms of the composition, is nonetheless strongly present in the picture, primarily due to the subtle force of its colour. The painting was very well received, *The Globe* exclaiming that it was "the gem of the Exhibition, if not the finest landscape, take it for all in all, ever painted in Canada" (22 May 1878). We would hardly find it so deserving of praise to-day.

Only four of the watercolours were of any size, and of those, we presently know only one. Entitled in the catalogue *Study on the Spot (near Dalhousie, N.B.)*, and depicting a scene at low tide near Dalhousie, it is now in the National Gallery of Canada (pl. 105). It is a beautiful watercolour, equal, certainly, to any of O'Brien's. Fraser's technique is similar: the building up of rich tones by means of small dabs, and the layering of slightly larger areas, all with fairly dry paint. Like O'Brien's work, the composition has been carefully considered, but it is more vigorous, and somewhat more muscular in feeling. The light quality is very good, with wonderful plays of silhouettes around Dalhousie's famous natural arches. But it is the colour that is especially fine, and this was noted at the time:

> Mr Fraser's water colours, and Mr O'Brien's also, like the oil paintings of both, take us down the Lower St Lawrence and along the coast of the Bay of Chaleur.... Mr Fraser's colouring [is] much brighter, and the effect he produces more brilliant than the colour and effect in Mr O'Brien's pictures. It would be as invidious as it is gratuitous to say which style is most desirable, for each has its votaries, and *de gustibus non disputandum* (*The Globe*, 29 May 1878).

The Mail found his work to be

> ...daring in treatment, honest and uncompromising as to atmospheric effect, and displaying a command of tint as well as truth, which is truly surprising.... There can be no doubt about his having extraordinary chromatic skill, more probably than any other of our artists.... we cannot leave Mr Fraser without expressing the satisfaction it must give his friends to see him taking up his armour in good earnest. He has made a vaulting leap once more upon the old arena, let us hope that the attentive public will applaud sufficiently to keep him upon it (27 May 1878).

It is clear that Fraser was really intent on getting his painting career underway again. Earlier in 1878, in January, he had once more become involved in the Art Union, when it was decided that a large Notman & Fraser photo of a Gustave Doré engraving of a scene in the life of Christ would be used as the incentive prize (the idea was eventu-

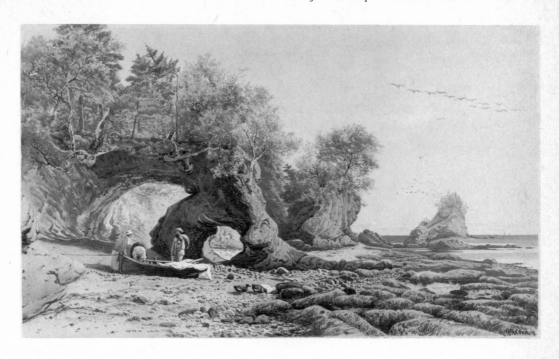

105 John A. Fraser
 Study on the Spot (near Dalhousie, N.B.)
 1877
 Watercolour, 40.0 x 67.2 cm
 The National Gallery of Canada, Ottawa,
 purchased 1975 (18,441)

ally dropped when copyright problems arose). Then in February he showed for the first time with the American Water Color Society (the new name of the American Society of Painters in Water Colors), even though he had been a member since 1868, the year following its foundation. And in December of 1878 he contributed works to the second OSA benefit auction. Then, for some reason, he sent only one watercolour to the seventh OSA exhibition in May 1879. Had there again been a dispute of some kind? The OSA minutes of the period certainly show no sign of friction, and Fraser attended most of the meetings during the year. In September he even lent an O'Brien painting he owned to the Toronto Industrial Exhibition, dispelling any notion that ill-feeling could have again arisen in that quarter.

A more probable explanation is that the pressure of business was limiting his artistic output. Certainly, his life was never to become *less* complicated. At the end of August 1878 a third daughter had been born, bringing the total of children to six, although the eldest son was by then nineteen. They moved again, in anticipation of that last baby, to 255 George Street, south-west of Allan Gardens, and a little closer to the centre of town. But this time there was also growing competition in the photography business. Sometime in 1878 Gagen left Notman & Fraser to set up a rival firm with Fraser's brother, James, who had followed John A. from Montreal, and for years had run a small photography studio on a side street. The new Gagen and Fraser business was set up right in the heart of the city, on the same street as Notman & Fraser, but on the other side of Yonge, at 79 King West. Changes were in the air at the OSA, too, and Fraser always a slightly suspicious man, and with some reason, was becoming wary, even defensive.

OTTO JACOBI

Although he was living at Ardoch, in the bush north of Kingston, Otto Jacobi nonetheless cultivated his city contacts. In the T.R. Lee collection in the Library of the Art Gallery of Ontario is a letter he wrote from Ardoch 30 July 1876 to James Spooner, one of the few dealers then established in Toronto. The letter reveals that Jacobi had recently visited the city, and that while there he had agreed that upon returning to Ardoch he would paint pictures to send to Spooner for sale. He also offers some candid comments on the Toronto art scene in 1876:

> As for Art and Artists in Toronto, I must say I took a very favourable impression with me, and am quite sure, there are only two or three painters of a good sober metal wanted there to make it a very nice circle of artists; it is only a certain *equilibrium* wanting there, as the different parties and interests are rather unsettled, and this hinders the free and easy bearing in their affairs, and I am sure it is only very little wanted, but this little has to be brought in, or they will have hard times. They should by good example be reminded to acknowledge each other good parts and assist each other with real good will, if they wish to be worthy to be Artists, in the sense of the word.

Jacobi has perceived, of course, the consequences of the Fraser-O'Brien split, two separate and antagonistic camps so painfully evident in that small cultural milieu. The tone of his letter suggests that this was Jacobi's first trip to Toronto. If he were going to live in a city again, in the mid-seventies in Canada, Toronto would be the one he would choose. His name appears in a roll of OSA members drawn up 21 December 1875 (with the address, Ardoch, Frontenac County, Ontario), but the minutes later record a motion by Lucius O'Brien the meeting of 3 October 1876 that Jacobi be elected to membership. He was duly admitted, though he did not exhibit with the OSA until May 1878. He was represented in the Canadian section at Philadelphia in 1876 by as many as twelve works. Almost all these came from Montrealers, although Lucius O'Brien also lent one. James Spooner was the official Commissioner of the Canadian display.

Jacobi was first present at an OSA meeting in Toronto 5 September 1877, although it was 1879 before he was listed in the city directory, with a studio in the Grand Opera House at 9 Adelaide Street West, right near King and Yonge, and a house in Trafann, a suburb. Very soon after his arrival he had been engaged as an instructor at the Ontario School of Art, which had been established by the OSA the year before, and which in 1877 was run in conjunction with the Ontario Ministry of Education. He did not last long as a teacher, but it was not for lack of respect, because just as he had been in Montreal the decade before, Jacobi seemed revered by all. Robert Harris, a young portrait painter from Charlottetown, Prince Edward Island, who had just settled in Toronto upon returning from studies in Paris, wrote home about him early in 1880. The letter is in the Confederation Art Gallery and Museum in Charlottetown:

> ...the best there is in landscape; he is a German... an old man between seventy and eighty [he was, in fact, sixty-eight], but as lively as a cricket. He was Court painter to one of the German princes and had a studio with the best men of his time in that country. *He is about the only regularly educated artist here.* Jacobi has been in Canada about twenty years and talks English very well and fluently. He is a very witty, clever old fellow, as full of practical feeling as ever could be. I went to spend last evening with him and his 'old wife' as he calls her. We smoked

like chimneys, he drank 'rye mit vater' and I drank 'lemon mit vater' and Mrs Jacobi looked upon us with complacency.... Jacobi is so full of quaint sayings and sarcastic hits at people that I don't know what to tell of him.... He is as much removed from the commonplace as can be.

The Toronto press was equally taken with him. As already mentioned, he first showed paintings in May 1878, and two of his works, each entitled simply *Upright Landscape*, arrived after the opening and were installed amid a flurry of curious attention. Also during that year he exhibited five small watercolours of idealized landscapes, and a small oil, *The Trapper's Cottage*. Neither the location nor the identity of these is presently known. Spooner had been preparing Toronto's taste for some time, and the reviewers responded with easy familiarity. Here is a typical notice, from *The Globe*:

The two 'Upright Landscapes' ...have arrived and been put in position. They are beautiful landscapes by Jacobi, of large size and exquisite finish. They are peculiarly Jacobian, both in choice of subject and mode of treatment, the effect being such as only he produces. There is no mistaking his style in any of his pictures, and either of those would be pronounced his work at once no matter where it was found. That style is now so well and generally known as to preclude all necessity for description, and the pictures themselves must be seen before any adequate notion of them can be formed. And they should be seen by every one interested in the progress and production of Canadian art, for there is nothing superior to them to be seen in the gallery (25 May 1878).

He even managed to up-stage John Fraser, who had so carefully orchestrated the first public exposure of his major contribution of that year, *Sea-Side Idyl*.

In 1879 Jacobi again carefully planned his contribution to the OSA exhibition, showing a huge oil of *Niagara Falls* and two small figure-pieces of questionable sentiment. We are this time again without benefit of first-hand knowledge of the major picture. With what we know of his style – and it is clear that by this time his style was everything in his work – this notice, again from *The Globe*, provides us with a good impression of the impact the painting had at the time:

Mr O.R. Jacobi contributes three oil-colours which can hardly fail to attract a good deal of attention, not only on account of his reputation as an artist but of their individual merit as well. 'Niagara Falls,' is a large and thoroughly taking picture, which improves upon acquaintance. The view is from a considerable distance, and the scope broad and complete, embracing not only both the Horseshoe and American Falls and a portion of Goat Island, but a large portion of the river and surroundings. The great beauty of this painting is the introduction and exquisite treatment of brilliant colours. Rich and varied autumn tints, water, foam, spray, cloud, clear sky, and sunshine, all have distinctive and pronounced characters, and yet they are all so harmoniously blended, with that rare delicacy of touch for which Mr Jacobi has long been noted, that they make a whole unapproachable in richness and brilliancy (16 May 1879).

This was the only major picture Jacobi painted in Toronto (if, indeed, it was not painted before his arrival), and there are only one or two other known canvases that date from between 1877 and 1880, the

106

Otto Jacobi
Rapids 1878
Watercolour, 15.3 x 26.8 cm (sight)
Mr and Mrs Edgar Andrew Collard

span of his first brief stop-over. They show virtually no change from his work in Montreal ten years before, except that they are perhaps a little looser. There are a few more watercolours known from these years. One of rapids of 1878 in an Ottawa collection has charm, although it is in appearance a touch powdery, it is so open and diffuse an image (see pl. 106).

And three watercolours, dated 1879 (one with some body-colour as well), in the Royal Ontario Museum in Toronto are also fair examples of his work in this period. They are even more suggestive and diffuse than the Ottawa rapids; the forms seem to pull apart before our eyes (see pls 107,108). Jacobi's developed, idiosyncratic style had no appreciable influence on the painters of Toronto, but his flair, his "practical feeling" and ready goodwill, were welcome, and added much to that art scene at a moment when professionalism and broadly-based, anti-parochial aspirations were particularly prized.

FURTHER ARTISTIC FOUNDATIONS ARE LAID

The Toronto art scene had broadened and deepened during the seventies. There were increasingly more professional artists, and their efforts were effectively focused through the efforts of the OSA. As the decade advanced there was an air of steady progress in spite of the great limitations resulting from the Depression. Art in Toronto was no longer parochial in the eyes of its citizens. There was clear evidence in each OSA exhibition of a growing national consciousness:

> We rejoice...at every genuine indication of the growth of a native school of art. Among our Canadian lakes and rivers may be found scenery equal to anything that the old world presents to the eye; and the evidence of the familiar study of nature, and a discernment of the poetry which lurks under its most homely aspects, are the truest evidence of that artistic feeling on which all genuine progress must depend (*The Nation*, ii, 14 May 1875, p. 226).

The move of the OSA into its own rooms on King Street West in 1876 brought to its activities an even greater appearance of permanence, as though it was, in fact, laying the firm foundation for a national school of art (see pl. 109). Every sign was read with optimism:

107
Otto Jacobi
A Woodland Stream 1879
Watercolour, 15.6 x 27.0 cm
Royal Ontario Museum, Toronto, gift of
Brigadier T.G. Gibson (964.211.1)

108
Otto Jacobi
Landscape with Lake 1879
Watercolour, 16.2 x 27.5 cm
Royal Ontario Museum, Toronto, gift of
Brigadier T.G. Gibson (964.211.2)

Mr Howland [the President of the OSA, in his annual address]..., referred to the fact that the work of our artists shows distinct and characteristic features, that in fact we have already developed the germs of a national school. When we reflect that Canadian scenery has its own characteristics, and that the chief merit of our best artists is that they reproduce these with striking fidelity, we must admit that the President is making no unfounded or extravagant claim. And while people lament the absence of great galleries and great pictures as models for our artists, they should weigh against this loss the gain to the painter of being compelled to rely entirely upon nature herself as a study. This, of course, applies specially to landscape painting.... We hope that no worthy people will be suspicious of the Ontario Art Union because it is a thoroughly national institution (*The Nation*, III, 23 June 1876, p. 294).

TORONTO:—THE NEW ROOMS OF THE ONTARIO ARTISTS' SOCIETY, RECENTLY OPENED.—From a Sketch by F. M. Bell Smith.

109

F.M. Bell-Smith
*The New Rooms of the Ontario Artists'
Society, Recently Opened* 1876
Reproduction (probably a Leggotype)
in the *Canadian Illustrated News*, XIV,
15 July 1876, p. 37

That is Ruskinian moralising put to handy advantage! But in spite of such rationalisations the membership of the OSA were still strongly committed to the establishment of a public art gallery and an art school. As their new quarters were rented for the duration of each year, not just for the period of the annual exhibition, they tried during the summer of 1876 and the following fall to maintain some kind of permanent display. But, according to Gagen's report, the members kept removing their pictures for one reason or another, and so no proper display could be maintained (*Ontario Art Chronicle*, p. 30). They got a school properly started, however, in October 1876. Located in the OSA rooms, it was at first under the direction of T. Mower Martin, but in January 1877 it was placed in the hands of an administrative council of seven. It survives today as the Ontario College of Art.

The Depression did cause problems. The 1877 Art Union failed to raise enough money to cover the Society's debts, and these were assumed by the President and the officers. The OSA was finally incorporated that year, however, and the Provincial legislation that accomplished that also established an annual grant of $500, to be spent as the Society deemed appropriate. The Government had periodically spent similar sums before on the purchase of works from the annual exhibition, and it was at first felt that the new grant should be applied in that fashion, as that would best serve the interests of the artists. But as of May 1878 it became clear that there were insufficient funds to cover general expenses, and it was decided to apply the grant to this seemingly ever-present debt. The OSA held its annual exhibition, in spite of these difficulties, and as had become customary, the Toronto press responded with measured enthusiasm and a touch of pride:

> ...there is but little to condemn and much to praise in this the sixth gathering of the Clans of Art in Canada, for though it is found difficult to exercise sufficient influence to draw much contribution or support from Lower Canada, we believe this is the only institution of the kind in the Dominion which has stood the test of years, and at the expiration of so long a term shows a braver and a better front than it did at its first inception and this in the face of very dull and discouraging times (*The Mail*, 24 May 1878).

By the end of the seventies, then, the OSA was seen as much more

than a provincial body. *The Mail* called it "our Academy of Fine Arts" (23 May 1878), and also referred to it as "this young and vigorous society, which takes the place here of the Royal Academy" (15 May 1879). Late in 1878 the Art Union had been, in an attempt to clarify the financial structure of the OSA, established separately from it, to be run by a committee made up, in equal numbers, of OSA members and laymen elected by Art Union subscribers. Reflecting the aspirations of the times, this new organization was called The Art Union of Canada, and just before the 1879 exhibition and lottery it was announced that it had helped swell the resources of the OSA that year to the point where there would be a surplus of $400. It was decided to apply that money once again to the acquisition of works for a permanent collection. An art gallery for Toronto – perhaps even the National Gallery envisaged by the OSA's founders – could not be too far in the future.

1880–1890: The Dominion

X

A
New
National
Forum,
the
Federal
Presence

Montreal on the road to recovery
the AAM *opens its gallery*
promoting a national culture:
the Earl of Dufferin and the Marquis of Lorne
a Royal Canadian Academy of Arts
the first RCA *exhibition*
the National Gallery of Canada is opened
Albert Bierstadt

MONTREAL ON THE ROAD TO RECOVERY

It was in that very month of May 1879 that Montreal saw its new art gallery opened. It was a triumphant moment for that city, since it marked a full recovery from the debilitating consequences of the Depression.

The events which had led up to this prestigious occasion had begun to manifest themselves even during the darkest days of 1876–1877. Building had never stopped entirely during the Depression years, and certain civic projects had been realized, notably the creation of Mount Royal Park. Then in 1876 the decision was taken to form a syndicate to build a luxury hotel – a clear sign that more affluent times were now being anticipated. The hotel was to overlook Dominion Square at Dorchester and Peel streets. William Notman was a member of the syndicate, and when this grand hotel opened early in February 1878, he located a branch of his firm on the ground floor, ready to receive the wealthy and the famous as they alighted in Montreal. The name of the hotel was, of course, the Windsor.

In 1877 another significant event had occurred. The Art Association of Montreal (AAM), which had been moribund since late in 1873, began to stir into life again. At some time during the summer of that year several of those collectors who had last been involved in the AAM's

affairs were informed that Benaiah Gibb, who had been its vice-president ten years earlier, and who had recently died, had left his collection of paintings to the Association. You may remember that Napoléon Bourassa had suggested he should do so as long ago as 1864 (see Chapter I). As well as his collection, he also left a piece of property on Phillips' Square, at St Catherine Street and Union, and $8,000 in cash, all on the condition that the Association commence the construction of a permanent art gallery in no more than three years.

The news of this generous bequest sparked immediate interest, and by the fall the AAM had gathered enough support to convene a meeting for 13 December 1877 to determine a course of action (*Montreal Herald*, 14 December 1877). Funds were obviously the most pressing need, and it was decided to revive the conversazione which had enjoyed such success in earlier years – this one would be the eighth. The popular new Governor-General, Lord Dufferin, would be the perfect individual to open it, and would attract an influential crowd. Someone then suggested that the exhibition be held in the Windsor Hotel. It might well have been William Notman, since he was an active member of the Council of the AAM at that time.

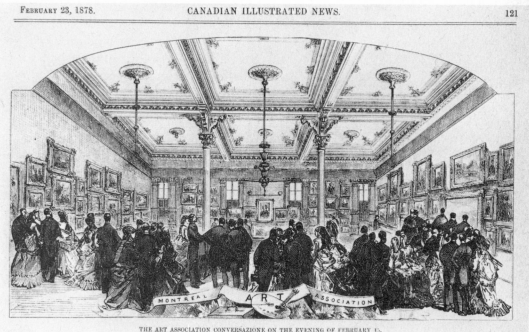

FEBRUARY 23, 1878. CANADIAN ILLUSTRATED NEWS. 121

THE ART ASSOCIATION CONVERSAZIONE ON THE EVENING OF FEBRUARY 15.

110

Unidentified artist
*The Art Association Conversazione
on the Evening of February 15* 1878
Reproduction in the *Canadian Illustrated
News,* XVII, 23 February 1878, p. 121

And so, on the evening of 15 February 1878, in the grand and spacious Billiard Room of the Windsor, this most brilliant affair took place (pl. 110). A military guard-of-honour met Dufferin at the door, establishing the proper vice-regal tone, and adding the weight of moment to the occasion.

The exhibition was almost entirely composed of works lent from Montreal collections, mainly foreign (though a few dealers introduced the work of Sandham, Jacobi, and two or three other Canadians). In his opening address to the members, the President, Sir Francis Hincks, naturally dwelt at length on the Gibb bequest, and the need to raise the balance of the money required for a gallery. But he also stressed the past role of the AAM in encouraging such collections, and introduced Canadian artists only obliquely:

> Some of the portraits on exhibition in this room have been painted by Canadian artists, who, after having imbibed a taste for their art by examining the paintings at the exhibitions of this Association, have prosecuted their studies in Paris, and have obtained the honour of having their works accepted and hung in the Salon (*Montreal Herald*, 16 February 1878).

However, the main purpose of the gathering was to raise money, of which Dufferin was well aware. When it was his turn to speak he kept his remarks short and to the point, and handed over a personal cheque for $500 to Hincks. It was all that was needed to encourage many of the wealthy citizenry of Montreal. Over the next few months enough was raised to begin construction, and ground was broken on Phillips' Square in June 1878.

That summer saw Montreal clear of the effects of the Depression. The Orange Parade was banned because of the killing of the previous summer, and when the Orangemen insisted upon assembling, the civil authorities acted swiftly and decisively, arresting the leaders and dispersing the crowd. Social stability was to return to the "Commercial capital" of the country, along with the promise of prosperity, and the federal election of that summer brought Macdonald and his Conservatives back into power as well, swept along on a rising support for his "National Policy." Montrealers saw clearly the direct benefits that would accrue to them with the resumption of the Canadian Pacific Railway and the opening of the West. The "Pacific Scandal" had been for-

gotten, and all three Montreal ridings returned Conservatives. The wheels of progress were turning once again in the inevitable drive toward improvement; that drive which every Victorian believed in as a basic article of faith.

THE ART ASSOCIATION OF MONTREAL OPENS ITS GALLERY

In the spring of 1879 fliers were circulated in Montreal, in both French and English, announcing that the new building of the AAM (or l'Association des Beaux-Arts de Montréal) would be opened the evening of 27 May 1879 by the new Governor-General, the Marquis of Lorne, and his wife, Queen Victoria's daughter, Princess Louise. It was to mark a coming-of-age for the arts in Montreal, and that it was the consequence of the new prosperity was not lost upon the press (see pl. 111). The connection was given particular emphasis by Toronto's, *The Mail*, which preceded its report of the opening with a description of Lorne's visit to the Redpath sugar refinery on the Lachine Canal. This business, employing 400 men, had only recently resumed production after a shut-down of three years.

That the reporter for *The Mail* fully understood the context and implications of the opening of the gallery is made even more clear in his remarks about the gallery itself:

> The Art Association gallery was inaugurated tonight by his Excellency and her Royal Highness amid a concourse of all that this metropolis contains of wealth, fashion and culture. The building, which is a new one and constructed especially, *ad hoc*, is situated in a framework of foliage in Phillips' Square, one of the most central and charming spots of the city. The ground, which is very valuable, was donated by the late Benaiah Gibb, with a round sum of money, toward erection purposes. There had been a lamentable torpor in art circles prior to that, the old Art Association having fallen very much away in both spirit and money.... Several of the leading citizens loaned the best works in their possession until no less than three hundred pictures were got together that would do credit to any city. Indeed ... it is admitted to be the best of the kind in the Dominion, and on that account the further idea suggests

VIEW OF THE ART ASSOCIATION BUILDING, PHILLIPS' SQUARE, MONTREAL.

111

Unidentified artist
*View of the Art Association Building,
Phillips' Square, Montreal* 1879
Reproduction in the *Canadian Illustrated
News,* XIX, 31 May 1879, p. 337

itself that it be made the nucleus of a National Collection. For decade upon decade to come no one city in any Province of Canada can afford to turn out an exhibition of her own, except of course of local talent. Cooperation is required and centralization in art is orthodox whatever it may be or not be in politics. Montreal too is central, has its own gallery, a fine collection to begin with; and the wealth of its citizens, with the improvement of taste and the gradual manifestation of talent, will prove a lever toward general aesthetic improvement and development. We are all in the national mood just now, barring a few Grits, and it might be worth while to infuse the spirit into our art and literature (27 May 1879).

Lord Lorne also sensed the nature of the occasion, and in his opening speech, praised Canadian accomplishments in many fields. Singling out photography, he then asked, "Why should not we be able to point to a Canadian school of painting?" He seemed, however, also to understand that the characteristics of such a school would differ from one part of the country to another:

Here in this great Province, full of the institutions and churches founded and built by the piety of past centuries, as well as by the men now living, there should be far more encouragement than in poorer countries of old for the decoration of our buildings, whether sacred or educational. The sacred subjects which moved the souls of the Italian, German, Flemish, and Spanish masters are eternal, and certainly have no lesser influence upon the minds and characters of our people.... And in the scenery of your own country, the magnificent wealth of water of its great streams; in the foaming rush of their cascades, overhung by the mighty pines or branching maples, and skirted with the scented cedar copses; in the fertility of your farms, not only here, but throughout Ontario also; or in the sterile and savage rock scenery of the Saguenay – in such subjects there is ample material, and I doubt not that our artists will in due time benefit this country by making her natural resources and the beauty of her landscapes as well known as are the picturesque districts of Europe, and that we

shall have a school here worthy of our dearly loved Dominion.

The relative breadth of such a point of view, encompassing, as it does, the aspirations of a Napoléon Bourassa as well as those of a Lucius O'Brien, could not at that time have been held by many Canadians. And Lorne put forward another suggestion that also could only have come from one who knew the world beyond Canada:

> I think we can show we have good promise, not only of having an excellent local exhibition, but that we may in course of time look forward to the day when there may be a general Art Union in the country; a Royal Academy whose exhibitions may be held each year in one of the capitals of our several Provinces; an academy which may, like that of the old country, be able to insist that each of its members or associates should, on their election, paint for it a diploma picture; an academy which shall be strong and wealthy enough to offer, as a prize to the most successful students of the year, money sufficient to enable them to pass some time in those European capitals where the masterpieces of ancient Art can be seen and studied (*The Mail*, 27 May 1879).

We have heard hopes of a national gallery for their city voiced by Toronto artists, and have seen the similar aspirations of Montreal collectors for their city. And the artists of both cities, when expressing their growing ambitions, would from time to time refer to the "Academy" concept. But Lorne's speech marks the first public occasion when the idea was presented in the form of a proposal, with due attention to the local sensitivities of both major cities, but also suggesting the necessity for the presence of a third, somewhat detached power. That evening Lorne was anticipating, as it turned out, the first federal government involvement in the destiny of Canada's art. Suddenly there had come into existence the promise of a new forum for the pursuit of national aspirations.

PROMOTING A NATIONAL CULTURE: THE EARL OF DUFFERIN

Federal government involvement in Canadian cultural matters has always been problematical. At the beginning, such interference seems not to have been a matter of specific government policy. There was no

ministry of culture. Education, the chief agency of cultural direction in the broadest sense, has always been a provincial prerogative, according to the British North America Act. On the other hand, Lord Dufferin, when he was Governor-General, saw his role as the representative of the Queen in Canada as involving a distinct cultural responsibility.

Frederick Temple Blackwood, Earl of Dufferin, was the Governor-General of Canada from the spring of 1872 until the early fall of 1878 (see pl. 112). A member of the Anglo-Irish aristocracy (as were several of the early governors-general), he was well-educated, imaginative,

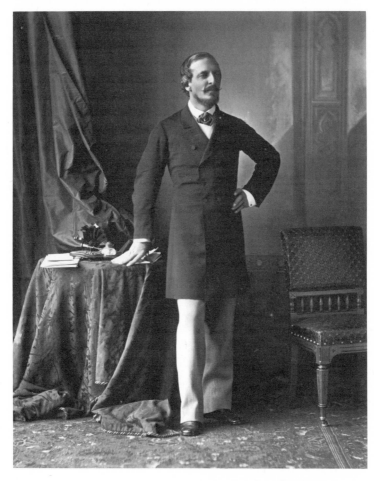

112

Notman & Sandham Studio
Frederick Temple Blackwood,
Earl of Dufferin 1878
Albumen print, 17.5 x 12.8 cm
Notman Photographic Archives,
McCord Museum, Montreal
(48,725-BII)

warm and even romantic in temperament, widely travelled, and a devoted student of the fine arts. The year following his arrival he faced the demoralizing consequences of the Depression, and the awkwardness and disillusionment of the Pacific Scandal. Canada appeared to him fractious, divided, and governed by a dull group of penny-pinching, parochial politicians – at that time Alexander Mackenzie with the Liberals.

Dufferin took his position seriously, nonetheless, perhaps too seriously during the first years of his term. He fancied himself the Chief Executive, and while on a widely publicized trip to the West Coast in 1876, he made reassuring remarks to the angry British Columbians in Victoria who threatened secession if the government did not complete the long-promised building of the CPR. However, upon returning to Ottawa, he was abruptly informed by Mackenzie that he had stepped out of line in encouraging false hopes in Victoria, and that he must remain within the limits of government policy in all of his public utterances. Dufferin was then fifty years old. Frustrated, and perhaps even a touch humiliated, he felt for a while that he had no genuinely responsible role at all.

He was to find one, however, in his travels about the country, during which he actively tried to make Canada's various and varied pockets of population aware of their own and each other's contributions to the national well-being. It is not too much to say that he sought to promote national unity, and this brought him directly to the question of what *was* the Canadian nation. He seems to have perceived it in a largely romantic fashion: as a shared spirit; a commitment to the pursuit of common goals; a veneration of certain symbols.

The Queen was, of course, the chief of these symbols, and he sought – and received – evidence of Canadians' warm feelings towards her upon every occasion. He also actively sought the involvement of French-Canadians in this new national mood, addressing them directly in French on a number of occasions in Montreal, Quebec City, and in Windsor, Ontario. He made an effort to bring special status to Quebec City, the "ancient capital" (which as recently as ten years before had in fact been the capital of Canada). He encouraged the restoration of its city walls; planned the Dufferin Terrace; and established a summer residence for the Governor-General in the Citadel.

This last was, of course, a somewhat ambiguous act. Dufferin

probably meant it to symbolize Quebec's continuation as a kind of national capital, as one of the seats of vice-regal authority. However an underlying implication of the vice-regal presence in that city might have been that the Federal Government had simply replaced the British as an imposed, occupying power. His more romantic intentions were to be realized, however, through the work of the landscape artists of Montreal and Toronto. As we shall see, they turned anew to Quebec City as a symbol, at least in part, of the historical continuity of the Canadian nation.

During his latter years in Canada Dufferin found another means of encouraging and directing the imaginative life of the country. He began to promote the concept of centralized cultural institutions, which simply did not exist at that time. Any institutions that had developed had done so in response to local needs and ambitions, though many had often aspired to some ill-defined national significance. Dufferin never made specific proposals: government support was clearly lacking. But he made at least three suggestions which he hoped would be acted upon either by the federal government or by interested citizens. The first was made in a speech to the Toronto Club, 15 January 1877:

> I believe Toronto is the only city in Canada, perhaps upon this continent, which boasts a School of Art and an annual Exhibition.... I believe the cultivation of art to be a most essential element in our national life. I have no doubt that a fair proportion of the wealth of the higher classes will be applied to its encouragement, and I trust that ere long the Government of the country may see its way to the establishment of a national gallery (William Leggo, *History of the Administration of the Earl of Dufferin in Canada*, Montreal and Toronto, 1878, p. 491).

The second was made in Ottawa. In the *Report of the Librarian of Parliament*, tabled 6 February 1878, we read that Dufferin presented the library with an original composite photograph by W.J. Topley of a fancy-dress ball that took place in Government House in February 1876:

> In making this costly and beautiful gift, Lord Dufferin has expressed a hope that it may 'prove the precursor of many

another artistic donation to the Art Treasures of the Domin-
ion,' and a first step towards the establishment of a 'National
Portrait Gallery.' Your Librarian would venture ... to solicit ...
a small annual grant, to be expended in the purchase of
choice productions by native artists ... a much appreciated
boon, and a stimulus to native talent in this direction.

Dufferin had, since its inception, been an official patron of the OSA,
had often attended its shows, and in 1876 had contributed two water-
colours and in 1878 a drawing for exhibition. During an address at the
opening of the sixth annual exhibition, 21 May 1878, he obliquely
encouraged the national aspirations of that body:

> ...I am happy to know that such a Society as that in whose gal-
> lery we are now assembled should have established itself in
> your midst; and although its beginning may be considered
> modest, it cannot fail to fulfil a prosperous career. After all,
> we must remember that the Academy of Great Britain began
> pretty much like this Society, and now the corresponding cer-
> emony in London to that which we are celebrating to-day is
> considered by everybody in Great Britain as one of the great
> festivals of the year, and the one public dinner in London
> which is always regarded as a source of pleasure to all those
> who are invited, and an invitation to which is coveted beyond
> measure, is the public dinner given by the Royal Academy to
> those distinguished gentlemen in the several lines of politics,
> literature, and art, who are in London during the season. I
> trust the time may not be far distant when this Society will find
> itself sufficiently strong, sufficiently popular, to establish
> something of a similar entertainment in Toronto (Leggo, p.
> 734).

It was Dufferin's successor, though, who took the real step of pro-
posing to do more than aggrandise an existing organization.

PROMOTING A NATIONAL CULTURE: THE MARQUIS OF LORNE

Sir John Douglas Sutherland Campbell, Marquis of Lorne, was the
ideal person to follow Dufferin. He was a poet, he loved drawing, he
was the friend of such famous painters as Landseer and Millais. What

he lacked of the warmth and open enthusiasm of Dufferin, he made up for in gentle thoughtfulness. He represented, in many respects, the noble form of that chivalric mode idealized in High Victorian society (see pl. 113). He was also young (thirty-four when he came to Canada),

113

Notman & Sandham Studio
Sir John Douglas Sutherland Campbell, Marquis of Lorne 1879
Recent print from original negative, 25.4 x 20.4 cm
Notman Photographic Archives, McCord Museum, Montreal (51-076-Misc. II)

vital, and married to Queen Victoria's fourth daughter, Princess Louise. His choice as Governor-General was calculated to flatter Canadians, and arriving, as he did, at a time of improving prosperity, Lorne was able to achieve more than Dufferin, even though his term was shorter. He followed straight upon the older man's steps, however.

Like Dufferin he was concerned with establishing national monuments (he and Louise inaugurated Dufferin Terrace during their first summer in Quebec City, for instance); he travelled as extensively across Canada, actively promoting common goals (the CPR construction was under way again during the latter part of his term, which helped); he paid careful attention to the French language as well as to English (and German, which he spoke on a visit to Berlin, Ontario – now Kitchener); and he soon identified his régime with patronage of the arts. Princess Louise, who was herself a painter of some ability, accompanied him during the opening ceremonies of the new AAM gallery in Montreal in May 1879. It was then, of course, that he proposed a national honourific art body.

In March of that year Lucius O'Brien had approached Lorne and Louise and asked them to open that year's exhibition of the OSA. They consented, and then proceeded to discuss an idea which Lorne intended to raise with the assembled members of the AAM. O'Brien reported this conversation to the OSA membership at its next meeting, 17 March 1879, and was recorded in the OSA minutes. "His Excellency spoke of a scheme he had in view for the formation of a school and Society and on comparison it was found that our own system coincided remarkably with his views."

The apparent evidence that the Governor-General was as supportive of their ambitions as was Lord Dufferin, must have elated O'Brien and his associates, who had been furthur encouraged by allusions to their growing national importance in the Toronto press (see Chapter IX). At that same meeting, William Raphael of Montreal was elected to membership, again reflecting the OSA's desire to genuinely serve the whole nation.

Another meeting was held on 14 August, and Forshaw Day of Kingston, Henry Sandham of Montreal and Eugène Hamel of Quebec City were also elected, providing further proof of the widening scope of the OSA. (Hamel subsequently requested that he be placed on the roll of Honourary Members.) It was at this meeting that O'Brien read a

letter he had received from the Governor-General "giving his views as to the placing of the Society on a more extended footing." Unfortunately, the letter is no longer in existence, but it is clear that O'Brien and the other members of the OSA were becoming increasingly hopeful regarding the approaching fulfilment of their national aspirations.

At the next meeting, on 4 September 1879, John A. Fraser made a motion that "it is very desirable that the name of this society be changed from The Ontario Society of Artists to Canadian Society of Artists." O'Brien must have been silently amused, as he had, immediately upon his election to the vice-presidency in 1874, proposed such a move, but it had been deferred, and then left. It was left again. At this point it would have seemed somewhat precipitous.

A ROYAL CANADIAN ACADEMY OF ARTS

The mounting suspense was allayed a week later, when the Governor-General, while on a visit to Toronto, met with the OSA members to discuss his proposal. The minutes of the meeting (12 September 1879), tell us almost nothing. Everyone probably had stood in awe:

> His Excellency stated in a few words the outline of a scheme he suggested for the formation of a Royal Canadian Academy of Arts and after some discussion it was moved by L.R. O'Brien seconded by J.A. Fraser,
> 'That the members of this Society, having listened to the valuable suggestions of his Excellency in regard to the enlargement of the Society's usefulness by the establishment of a Royal Canadian Academy, to embrace the whole Dominion (leaving all present art organizations intact) desire to express their cordial approval of His Excellency's views, and also that an early meeting of the Society be called for the purpose of taking practical steps in that direction.'

The meeting to discuss Lorne's proposal was convened five days later (17 September). The Governor-General had by then left with O'Brien a draft of a constitution, which he informed him he was also submitting to the AAM. There were seven principal points:

1. 'That a Central Dominion Association be formed to be called the Canadian Academy.' The right to employ the designation 'Royal' would later be sought from the Queen.

2. The initial Academicians were to be selected from the present membership of the AAM and the OSA 'who exhibit pictures for sale.' These two associations were to draw up a list of Academicians, and it was stated 'that in the first instance, the Governor-General be asked by this Society to approve this list, any subsequent cooperation on his part with the Society being a matter for after consideration.'

3. The Academicians were to comprise the governing body of the new Academy, electing members to be Associates, and Honourary Members.

4. Architects and engravers were to be included.

5. All local art associations were to continue to be independent of the Academy.

6. The annual Academy exhibitions were to be held in the national capital and in the capital cities of the various provinces, beginning in Ottawa, followed by Halifax, St John, Montreal, and Toronto. (Note that Montreal was somehow placed over Quebec City as a 'capital.')

7. Eligible works were designated.

Once O'Brien had finished his presentation of the Governor-General's proposal, there "then occurred a very heated discussion." This was reported by Gagen, who was present (*Ontario Art Chronicle*, p. 40). It appears that the main concern of the OSA members at this particular juncture revolved around the all-important question of *who* was to be an Academician, and how these august representatives were to be selected.

It was first moved by Richard Baigent and seconded by J.A. Fraser that nominations be limited to artists at present residing in Canada. Everybody found this acceptable but the next motion was not so well-received. It was proposed by T.M. Martin and seconded by Gagen that each artist member of the OSA submit two "original unsigned pictures"

to a committee of either the British Royal Academy or the American National Academy of Design who would decide which pictures were up to the necessary standard. This choice would then provide the basis for selecting Academicians. The motion received only two supporting votes, and was defeated.

Apparently undaunted, Gagen then put forward a motion (seconded by Shuttleworth) that all artists whose works had hung in OSA exhibitions, and also all Architects, Designers, and Engravers who were already members of the OSA should be nominated. Again defeat. Shuttleworth next proposed (seconded by Verner), that a special meeting be called to consider the knotty question of nomination, and that a notice be sent to all members of the OSA to inform them. This produced yet another defeat. Finally they decided, probably with some degree of desperation, to hold a ballot there and then.

Eight nominees were duly selected: Daniel Fowler, John A. Fraser, Otto Jacobi, L.R. O'Brien, W.N. Cresswell, Henry Sandham, William Raphael, and Henri Perré (a Franco-Prussian from Strasbourg who had arrived in Toronto in 1863 *via* the United States). It was also decided that there should be only twenty-five Academicians at one time, painters, architects and engravers, that only one-half of these should be elected the first year, of which eight should be the already-elected nominees. In a letter dated 20 September 1879, O'Brien informed the AAM of his Society's decisions.

But the matter was a long way from being settled as far as the rest of the OSA membership was concerned. At the next meeting (8 October), it was moved by T.M. Martin (seconded by Shuttleworth) that a general meeting be called to again discuss the actions taken on 17 September. John A. Fraser (seconded by Jacobi) then introduced a contrary motion, insisting that the decisions be sustained. This latter was carried by a vote of eight to five. A special meeting was then called at the request of five members (presumably the dissentors) for the evening of 4 November 1879. Verner, Shuttleworth, Gagen, Michael Hannaford (a New Zealander who emmigrated to Canada in 1875), and T.M. Martin were those who demanded it, but their protest was not very effective. The minutes reveal the discouraging truth: "The five members who had requested the calling of this meeting not being all present and those who were so refusing to sign this book or there being no motion put before the members, the meeting adjourned."

All was then quiet on the issue of the Academy until 12 February 1880 when a special meeting was convened. It had been requested by Jacobi, J.A. Fraser, Verner, Hannaford, Robert Harris, T.M. Martin, and R.C. Windeyer (a Toronto architect), and all but Verner, Martin and Windeyer were present. It is recorded that it was "moved by O.R. Jacobi, seconded by J.A. Fraser, that the Vice-President be requested to inform the meeting whether the Dominion Art Association and the Canadian Academy of Arts were one and the same institution."

They were more confused than they realized. The organization to which they were referring was not called the "Dominion Art Association," but the Art Association of Canada. It had been formed the previous summer by concerned Ottawa citizens as a local exhibiting society, and as the basis of establishing an art school, and to promote the creation in that city of a National Gallery.

The worried Torontonians had somehow come to the conclusion that this new society had *ipso facto* become the Canadian Academy. Their fears had doubtless been strengthened by the fact that many of the officers of this new body were federal politicians, or other influential men at the seat of government.

Unfortunately O'Brien was not present to explain matters. He was very probably in Ottawa himself (*Ottawa Free Press*, 19 February 1880). However Marmaduke Matthews, the Secretary, seemingly well-informed concerning O'Brien's negotiations with Lorne, was able to reassure the OSA members that the two societies were most certainly *not* one and the same.

However, the Art Association of Canada was off to a promising start. Allan Gilmour, Ottawa's principal collector, was one vice-president, and Sandford Fleming another. Lorne had contributed $500 towards a building fund, and Princess Louise had undertaken the task of finding a trained teacher in London. But the OSA had no reason to fear this new society's existence. It really was a local manifestation (it soon changed its name to the Ottawa Art Association), and was also part of a general movement which was taking place across the country.

The Western Art Union had been formed in London, Ontario, two years before, the London artists, at that time, withdrawing *en masse* from the OSA, much to the alarm of the provincial body. The proliferation of these local organizations (there soon would be one in Winnipeg, and a little later, one in St John), justified, in Lorne's mind, the

establishment of a senior, national body. That apparently ended all formal debate within the OSA.

This is not to say that all the OSA proposals submitted to Lorne in September 1879 had been accepted, or that all the OSA membership would remain satisfied with the arrangements. We do not have the minutes of the AAM meetings in which that body deliberated upon Lorne's proposals. They presumably made some changes to the list of nominees. And we know that Lorne had certain requirements, chief of which was that there be at least one Academician from the Maritimes. He himself chose the officers of the Academy, who were to serve by appointment for five years, and then would be elected by the Academy itself each year after.

The President Lorne selected was Lucius O'Brien. It was a natural choice, as O'Brien was the principal executive of the only active artists' society in the country. His social background was also as attractive to Lorne as it had been to Dufferin. The Vice-President was Napoléon Bourassa, at that time the one active French-Canadian artist of prominence. He may have been nominated to membership by the AAM (he had not appeared on the OSA list), or he may have been the means of Lorne's fulfilling the "national" requirements of the body. The Treasurer was James Avon Smith, an architect of Scottish descent who had settled in Toronto in 1851, and who was to represent the interests of the architect-Academicians. And the Secretary was the long-time Secretary of the OSA, Marmaduke Matthews. As a body, the executive of the Academy had all of the appearances of balance and detachment that we have over the years come to expect in federally-appointed committees.

Added to the list of painter-Academicians drawn up by the OSA were, as already noted, Bourassa, and also Allan Edson, from Montreal. Eugène Hamel of Quebec City was added too, as was Forshaw Day, who had just settled in Kingston after having lived for seventeen years in Halifax. He was Lorne's required Maritimer. James Griffiths of London represented the interests of the Western Art Union. And, strangely enough, five additional Toronto painters appeared in the final list of nominees: Robert Harris, Charlotte Schreiber, G.T. Berthon, J.C. Forbes, and T. Mower Martin. Lorne doubtless had his reasons. Harris and Mrs Schreiber stood for the new tendencies in academic figure-painting. Berthon had been for

years the favoured portraitist of the Toronto Establishment. Forbes, of course, was O'Brien's close friend. And there is a story about Martin that reveals much concerning the standards of admission. Newton MacTavish, a critic and collector who knew him in Toronto in his later years, relates that

> ...he used to tell with pride of how the Governor-General and the Princess Louise, who were the sponsors of the Academy, received the proposed list of the first members. 'Why,' they asked, with evident concern, 'where is Mr Martin's name?' And being informed that the name had been left out, this of course because of jealousy, they immediately commanded that it be put in (*Ars Longa*, Toronto 1938, p. 210).

It should be added that one of the requirements of those nominated to the status of Academician was that they deposit in Ottawa a suitable painting as a "Diploma picture." It was intended that these paintings would form the nucleus of a National Gallery, the foundation of which in the national capital had, by 1880, become one of the three chief aims of the Academy. (The other two were the encouragement of industrial art by the promotion of excellence of design, and the support of art schools throughout the country.) Jacobi, Perré, Day, Berthon and Forbes all failed to submit paintings for approval as Diploma pictures that first year, and so had to await proper nomination and election to membership at some later date when they were prepared to comply.

THE FIRST RCA EXHIBITION

The Canadian Academy opened its first exhibition in Ottawa 6 March 1880, in a building that had just been purchased by the federal government, the former Clarendon Hotel at the corner of Sussex and George streets (see pls 114,115). Lorne officiated alone, as Princess Louise had been injured in a sleigh accident the month before. (She would leave Canada in the summer, not to return for more than eighteen months.) The opening was nonetheless suitably gala, and at the first general meeting of the Academy earlier in the day, only cordiality had been expressed.

It was Bourassa (seconded by John A. Fraser), who introduced the vote of thanks to Lord Lorne. Sandham (seconded by Fraser) introduced the first amendment to the constitution, establishing a class of Honorary Non-Resident Academicians. (Sandham was about to leave Canada.) Then Bourassa (seconded by Hamel) introduced an amendment introducing a class of Honorary Retired Academicians, and nominating Antoine Plamondon to its rolls. Next the list of Academicians was put in alphabetical order, and the first twelve were named to the governing council, all to serve subsequently on the basis of annual rotation.

The Council met two days later, and worked out the procedures by which the wishes of the general membership and the Council were to be executed by the President. As matters turned out, Lorne at first had all decisions submitted to him for approval, much in the style of the "Royal assent" he gave to the laws of Canada. But he interfered no more in the decisions of Council than in those of the Parliament of Canada, and after a time such approval was no longer sought.

OTTAWA.—THE CANADIAN ACADEMY OF ARTS BUILDING.

114

Unidentified artist
The Canadian Academy of Arts Building, Ottawa 1880
Reproduction in the *Canadian Illustrated News,* xxi, 20 March 1880, p. 181

115

Unidentified artist
*Opening of the Canadian Academy of Arts
at Ottawa. His Excellency Declaring
the Exhibition Open* 1880
Reproduction in the *Canadian Illustrated
News*, XXI, 20 March 1880, p. 177

The Ottawa exhibition was moved virtually in its entirety to the AAM galleries the following month. It was obviously felt necessary to expose the collection where there were the most collectors. Then, in the subsequent month, the Diploma pictures were shown at the annual OSA exhibition. The second Royal Canadian Academy (RCA) exhibition (it received the appelation "Royal" during the summer, a consequence of Lorne's direct intercession), was held in Halifax, in accordance with Lorne's wish to benefit all parts of the country equally. During the third year, the exhibition was offered to St John, but with certain stipulations concerning a suitable exhibition space, and when these were not met, it was held in Montreal. In 1883 it was in Toronto, combined with the OSA exhibition of that year. And from then on it rotated more-or-less regularly between Ottawa, Montreal, and Toronto, no longer pretending to serve the smaller cities of the country. The exigencies of the market-place, with its attendant self-interested supporters and its facilities, thus proved stronger than any vague policy of equitable national distribution.

THE NATIONAL GALLERY OF CANADA IS OPENED

To complete the picture, it only needs to be added that the National Gallery of Canada, the foundation of which was implicit in the deposit of the Diploma pictures in Ottawa, was opened by Lorne 27 May 1882, thus further expanding the federal role in the Canadian art scene. It was modestly situated in a part of the old Supreme Court building, on Parliament Hill. The first foreign picture had been added to the national collection only the month before when Allan Gilmour donated a large canvas, *The Gulf of Naples*, by the nineteenth-century Danish painter, Vilhelm Melbye.

Before leaving Canada in October 1883, Lorne induced the famous English painter, Frederic Lord Leighton, to give a small oil study of a head of Samson to the fledgling National Gallery of Canada. And later, in England, he encouraged two other well-known artists to make gifts. Sir John Everett Millais donated a *Portrait of the Marquis of Lorne* in 1884, and George Frederick Watts gave a large canvas, *Time, Death, and Judgement*, in 1887. Although all three of these works continue to be of interest as part of the collection of English art in the National Gallery, none can be said to have had much effect on the

course of Canadian art. There was another artist friend of Lorne's and Louise's, however, who did have a considerable impact in Canada. This was the German-born American landscape painter, Albert Bierstadt. Once again it was Lord Dufferin who had laid the foundation.

ALBERT BIERSTADT

Dufferin had first met Bierstadt at a dinner in New York in October 1874, and visited his studio a few days later. He must have been impressed by the paintings he saw, for he went back again to the studio with his wife. In December he wrote from Ottawa to Mrs Bierstadt, thanking her for some photographs she had sent him, and also for having received himself and Lady Dufferin so kindly in New York. (The letter is now in the National Gallery of Canada.) Then, a little more than a year later, in February 1876, the Bierstadts were invited to Ottawa as guests of the Dufferins at Rideau Hall, on the occasion of a grand costume ball. It was an extravagant affair, one of the most elaborate parties ever to take place at the official residence, and the Bierstadts were flattered by the attention of Lord and Lady Dufferin, as well as delighted by the entertainment. Bierstadt painted Lady Dufferin a picture as a memento of the visit (*My Canadian Journal*, London 1891, p. 223). That October Dufferin again saw Bierstadt in New York, and the following spring the Bierstadts seem to have stayed a second time at Rideau Hall (letters in the National Gallery of Canada).

Albert Bierstadt returned to Rideau Hall without his wife in February 1878, but accompanied by a friend, Webb Hayes, son of the President of the United States. The two Americans joined the vice-regal party on an official trip to Montreal a few days later, and so were present for the launching of the building fund of the AAM on 15 February 1878. As swept away by the excitement of the occasion as was his host, Bierstadt offered to donate a painting to the young collection. This munificent gift was announced to the assembled membership, who greeted the news with enthusiasm.

The painting was shipped soon after his return to New York, 21 March, according to a letter he wrote to Dufferin published in *The Dominion Annual Register and Review for 1878* (p. 230), and it arrived in Ottawa early in April. Dufferin displayed it in the Library of Parliament

for a few days, and then sent it on to Montreal. A fairly large oil (82.5 x 123.0 cm), it was called *Sunset in the Sacramento Valley*. The AAM unfortunately sold it in 1945 to a Montreal dealer, who in turn sold it in New York. All trace of it has now been lost, and neither the AAM nor the dealer kept a photograph. (It is not *Sacramento Valley in Spring*, now in the Fine Arts Museum of San Francisco, as has been suggested.)

Bierstadt had shown a picture once before in Montreal, at the third exhibition of the AAM in 1865, interestingly enough, another sunset. Before he met Dufferin, he had on occasion visited Canada at Niagara Falls; a brother was a photographer there, specializing in stereo views. There was a notable instance in 1869 when he probably painted, in oil on paper, a known group of views of the Falls. One of these, taken from the Canadian side, is in the National Gallery of Canada. It reveals in the sharp contrast of its tones, and in its fine attention to detail, Bierstadt's close familiarity with photographic images. An acute perspective line is even marked by a beached log, a device commonly found in stereography. Incidentally, this 1869 visit was completed by a boat trip across Lake Ontario, and down the St Lawrence to Montreal, and then on to the White Mountains of New Hampshire by the Grand Trunk.

In the early eighties, Bierstadt painted in Canada a number of times, mainly at Quebec City and in Ottawa. As on his frequent earlier visits he was a guest of the Governor-General who was, until 1883, Lord Lorne. As was still common with many artists in the middle decades of the nineteenth century, Bierstadt quite openly courted the patronage of royalty and the aristocracy. He had even met Queen Victoria in 1867 and on that same occasion, Lorne's brother. Given also his friendship with Dufferin (which continued for years after Dufferin's return to England), Bierstadt quite naturally found himself on good terms with the new Governor-General.

He perhaps first visited Lorne and Princess Louise in May 1880, but we know for certain that Mr and Mrs Bierstadt were in Montreal in September 1880, and then were in Quebec City, where they visited Lorne at the Citadel. (This information is in a notebook of Mrs Bierstadt's which has been saved by a descendant.) The President of the new RCA, Lucius O'Brien, would have met the German-American artist then. It is probable that at this time Bierstadt prepared studies for *The St Lawrence River from the Citadel, Quebec*, now in the Museum of Fine

Arts, Boston. This work will be discussed later in relation to the pictures of Quebec that O'Brien was then planning to paint for the Queen.

In November Bierstadt travelled to the West, stopping at Vancouver, Tacoma in Washington State, San Francisco, Denver and Chicago. In each city he was entertained by the well-placed and the rich, all prospective purchasers of paintings. As early as the mid-seventies his huge canvases of the American West had fallen from critical favour in the more sophisticated East, but to the railroad barons, politicians, and bankers these grandiose images of an ever-expanding America, a land of vast natural energy and beauty, still held great appeal.

The following year Bierstadt again spent some weeks with Lorne. According to Mrs Bierstadt's notes he was at the Citadel in June. Having perhaps arrived in May, he sailed down to Gaspé with Lorne in June for the salmon fishing. He travelled west again in the fall, to Montana and Yellowstone National Park, but at the end of October he met Lorne at Niagara Falls. The Governor-General had himself just returned from an official tour which took him as far as Calgary. (He had travelled on the growing CPR line to the head of rail, which was by then at Portage-la-Prairie.)

That summer Bierstadt had painted for Lorne a *Montmorency Falls*, and in return, 25 May 1882, Lorne sent to Mrs Bierstadt a hand-written copy of a poem, fourteen verses long, which he had composed, "Memories of Quebec." The copy is now in the National Gallery of Canada. (It was later published in a volume of Lorne's collected verse and speeches, *Memories of Canada and Scotland*, Montreal, 1884.)

Princess Louise returned to Canada in June, after nearly two years absence. Bierstadt met her, most likely for the first time, at the end of September 1882 at Niagara Falls. On the thirtieth they had lunch and dinner together (Mrs Bierstadt's notebook). Lorne and Louise were, at this point, about to leave for British Columbia. They travelled west through the United States to San Francisco, by rail, and then took a Royal Navy vessel to Victoria. Afterward, they spent a long Christmas holiday in Southern California, in Bierstadt country. They returned through Kansas City, to Charleston, South Carolina, where Princess Louise decided she could not face another Canadian winter. She headed for Bermuda while Lorne returned to Ottawa.

In March 1883 Bierstadt visited Lorne for almost a month, staying

at Rideau Hall. Mrs Bierstadt was at Nassau, in the Bahamas, and Prin-
cess Louise was still in Bermuda. Lorne wrote to his father while the
painter was there. "Mr Bierstadt is with me and today he was doing a
pretty oil sketch of tropical vegetation and polar scenery together –
that is as such extremes could be represented by the bananas and roses
of the hot house and the view from among them of the snow-
covered river and spires of the Government buildings" (in W.S. Mac-
Nutt, *Days of Lorne*, Fredericton, N.B., 1955, p. 258).

Probably that same month, Bierstadt painted another view of the
spires of Parliament Hill from Rideau Hall (see pl. 116). It is a vivid,
romantic scene taken on a bright winter day. It, and a similarly-sized
and generally romantic view of Quebec from the St Lawrence, were
mounted in silver to serve as the boards of Mrs Bierstadt's autograph

116

Albert Bierstadt
*View of the Parliament Buildings from
the Grounds of Rideau Hall c.* 1883
Oil on board, 23.5 x 31.9 cm (sight)
The National Gallery of Canada, Ottawa,
purchased 1973 (17,619.3)

117

Albert Bierstadt
The Citadel, Quebec,
from the St Lawrence c. 1883
Oil on board, 23.5 x 32.1 cm (sight)
The National Gallery of Canada, Ottawa,
purchased 1973 (17,619.2)

album (see pl. 117). The album, containing many of the letters from both Dufferin and Lorne cited here, is now in the National Gallery of Canada in Ottawa, a rich reminder of the continuing influence of the American painter upon those British aristocrats who were seeking to guide the cultural development of Canada.

Bierstadt was back at Rideau Hall again in May 1883, and he and Princess Louise often sketched together. It was probably in that month that he painted for her a *View from Government House, Ottawa* that she is known to have owned. Bierstadt and his wife travelled to Europe in June, and that October Lorne and Princess Louise left Canada for good. Bierstadt did not return to Canada again for some years, but he did continue to keep in friendly contact with Kensington Palace. At the Colonial and Indian Exhibition, which was held in London in 1886, Lorne and Louise made sure he was represented in the Canadian section through three pictures they owned of Quebec City and Ottawa.

As far as we know, Bierstadt spent time with only one Canadian artist, Lucius O'Brien, and that only once, during September 1880 at Quebec City. The impact of that short association upon O'Brien's work we shall examine later. Given O'Brien's pre-eminent position in Canadian art circles, Bierstadt's Canadian connections – even though coming relatively late in his career, and well after he had ceased to carry any real weight among painters in the United States – were of considerable importance. And Bierstadt's association with the Dufferins and Lornes is significant too, for it shows that these aristocratic personages were drawn to a certain view of landscape.

As had been suggested before, Bierstadt remained, during his mature years, one of the principal court painters to that relatively large society of millionaires – of European aristocracy and American and European bankers, railroad builders and politicians – who in late Victorian times controlled the destiny of the Western world. Indeed, in that high age of imperialism, they controlled most of the globe. In their heroic canvases, such artists as Bierstadt and Frederick Edwin Church purveyed a sublime view of nature, displayed for the pleasure and instruction of their patrons. It was Art for Imperialists, and none the less so because it appealed so strongly to a broad public in the United States, in Europe and Canada. At that time, everywhere within the European sphere of influence, imperialism seemed to those in command the right and natural order, the chief instrument for progress.

XI

Fraser
and
O'Brien
in
Conflict:
1880–1885

The birth of Picturesque Canada
Fraser to the attack
Fraser versus the Art Publishing Company
Fraser versus O'Brien
Fraser withdraws from the scene
O'Brien continues to prosper
Fraser presses on

THE BIRTH OF *PICTURESQUE CANADA*

Ⓘt was a widely popular point of view in the nineteenth century to see the world as rapidly expanding, as frontiers were pushed back on all sides. The frontiers of knowledge were also advancing as a result of the last great efforts of European exploration; of the implementation of comprehensive theories; of elaborate systems of scientific classification; of commercial exploitation of natural resources on a new vast scale. It was a period of massive European migration into nearly empty lands. Growth, and the inevitable progress of Western civilization, were the great myths of that age of imperialism.

The periodical press, with its colourful prose and dramatic wood-engravings, fed this attitude, supplying images of newly-discovered exotic lands, of hitherto untouched wilderness. And travel books – which had grown from the picturesque books that had first appeared when the aristocratic taste for the Grand Tour began to spread in the late eighteenth century – became increasingly elaborate during the second half of the nineteenth century. In Canada, this form of middle-class art found its finest expression in a large two-volume publication that began to appear in parts, early in 1882. This was *Picturesque Canada,* and it was at the centre of the artistic scene of its time.

Picturesque Canada was the idea of two Americans, the Belden

brothers, and it was based directly upon the highly successful *Picturesque America,* published by Appleton in New York, and issued in parts between 1872 and 1874. There was also a *Picturesque Europe,* that Appleton had brought out in three volumes, between 1875–1879; a *Picturesque Palestine,* and probably many more of the same. It was nothing if not an age of opportunism. Some of the principals involved in *Picturesque Canada* later even went on to Australia where they published *Picturesque Australasia.* So it was a concept based upon a tried and true formula. Its implementation in Canada, however, was to take a special turn.

The Beldens, who had already established themselves in Toronto as the publishers of county atlases, set up a firm, the Art Publishing Company, and attracted enough money to get the project going. The publication was to be produced in parts, and sold only by subscription. By such means, money would start coming in early and the whole massive project would ideally become self-financing in short time. The Beldens never thought small, so the Art Publishing Company was situated in a fairly large building at 58-60 York Street, just two blocks west of Yonge; near King Street. The business offices were on the ground floor at the front, the press-room was at the back. They intended to do their own printing. On the second floor was the art department with the Art Director's studio at the front and space for a large team of wood-engravers at the back. On the third floor were the compositors and others concerned with the letter-press side of the production.

All of this information and more is given in *The Globe* (24 May 1881). The article ends with a stirring summary of the goodness of the cause:

> It is an undertaking such as has never before been attempted in Canada, and its progress will be watched with interest as a striking phase of national progress, and one that cannot fail to have far-reaching results in attracting attention to our material as well as our aesthetic advancement. Every patriotic Canadian will heartily wish it all success.

Although American in its origins, and very possibly American-financed, the project clearly had to have all appearances of being a Canadian venture if it were to succeed. The Beldens recognized that from the first. They sought the services of the best local people they

could find, at every turn stressing their reliance upon Canadian abilities. Lucius O'Brien, the President of the new Canadian Academy was approached to be Art Director. He started working with the Beldens in the spring of 1880 although, until the following year, he also retained his connection with the wine-importers, Quetton St George & Co.

Once O'Brien had officially become Art Director of *Picturesque Canada* it was generally publicized that RCA members would be executing the 500 illustrations. The next step was to find an editor for the literary side of the project. The Beldens were particularly interested in George Monro Grant, who had become Principal of Queen's University in Kingston in 1877. As the author of *Ocean to Ocean,* the exciting record of his 1872 expedition across Canada with Sandford Fleming (see Chapter v), and as a prominent clergyman and scholar, Grant was by now one of the most respected men of letters in Canada. Between May and August of 1880 he contributed a series of articles, "The Dominion of Canada," with illustrations by Henry Sandham, to *Scribner's Monthly* in New York. These articles coincided so closely with the projected model for *Picturesque Canada* that there could have been no doubt in the Beldens' minds that Grant would be the perfect choice. O'Brien was finally brought in to encourage Grant who, late in November 1880, agreed to act as editor of the project and author of some of its parts. (There is correspondence with Henry Belden among the Grant papers in the Public Archives of Canada in Ottawa.)

Since they were intent on seeking the highest level of support, thereby assuring the greatest likelihood of success, the Beldens probably also approached the Governor-General, the Marquis of Lorne, seeking his patronage. He did not lend his name directly to the project, but the paper wrapper of each of the separate numbers is emblazoned with a cameo medallion, in imperial fashion, displaying the profiles of Lorne and the Princess Louise (pl. 118).

O'Brien was in England in the early summer of 1880, but immediately upon his return in mid-August he began sketching in Quebec and the Atlantic region for the *Picturesque Canada* illustrations. He must have been given a retainer as Art Director, and we know that he was paid on a piecemeal basis for drawings. (He kept an account of them in his Studio Journal, which is in the library of the Art Gallery of Ontario.) The same arrangement was made with Grant, who had relatively little difficulty, given the scope of the project, in finding writers willing to

118
Unidentified artist
Part-Wrapper for Picturesque
Canada 1882
The National Gallery of
Canada Library, Ottawa

accept an assignment. (There is an inordinate number of clergymen among the authors.)

O'Brien, however, ran into trouble at an early stage. Preparing a drawing for black-and-white reproduction as a wood-engraving is highly specialized work. (The wood-engraver cuts the block according to the artist's design, but the artist himself must have some knowledge of the limits and possibilities of the medium.) O'Brien caught on quickly, but none of the other members of the RCA really managed to master the new technique. In the end, of the roughly 543 illustrations (some are multiple, so it is difficult to be sure of one's count), O'Brien made seventy-nine of those which are signed, and all the other Canadians together achieved a grand total of ten. William Raphael did three, Robert Harris four, and F.M. Bell-Smith, John A. Fraser, and Henri Julian (a Montreal illustrator), one each. Two of Lord Lorne's drawings were used as well.

All the rest of the illustrations – 452 of them – were drawn by

Americans, especially brought in for the work. One of these, Thomas Moran, contributed some really brilliant drawings (he had trained first as a wood-engraver, and so worked with full knowledge of the range of the medium). One or two other of the Americans also did good work, but the greatest bulk of the illustrations were done by a commercial illustrator who had worked on *Picturesque Europe*, Fred B. Schell. Quite frankly a hack, he completed at least 213 of the drawings. That's almost half. There are eighty-three illustrations of which the authorship is unclear, and it is possible that many of these are also Schell's work. As we will see later, the question of the manner in which the drawings were completed was to become a sore point in certain quarters.

The methods of work had been organized along definite lines. The artists were supposed to fan out across the country, sending their drawings back to waiting engravers in Toronto. (It even turned out that the Beldens eventually brought in American engravers too, and all the early trial blocks were engraved in New York.) But in the end, it is unlikely that very many of the artists saw the regions they were depicting. They did manage to travel through the eastern sections of the country. We know, for example, that Moran visited Quebec City and Niagara Falls, and that O'Brien travelled extensively in the east. But the illustrations that were to accompany articles on the West, even though these were relatively few in number, were probably based on photographs. In fact, the last twenty-two images in Volume II – all of British Columbia – are half-tone photo-engravings, some of them after Notman photographs. *Picturesque Canada* comes at the very end of the era of the wood-engraving. If it had been published even a few years later, it would have been illustrated only with photographic reproductions.

There is much to learn from a study of the two volumes of *Picturesque Canada,* although this is not the place to examine it in real detail. However, there are a few points of particular interest. The great portion of the publication is devoted to the area of the old United Canadas, since in 1880 this region still contained the bulk of the population, and nearly all of the country's wealth. Everywhere else is seen from that point of view, or more specifically from the viewpoint of Toronto. The imperialism it reflects is not that of force and physical oppression, but rather the benign imperialism of appropriation. In a sense, the book can be described as a massive catalogue of the resources, visual and

material, in which the middle-class of Victorian Canada could take pride, no matter how illusory, in calling their own.

The questionable reality of the promise the book holds out is in many cases reflected in the style of the illustrations. Canada is presented as one breathtaking vista after another, all bathed in the golden haze of the High Victorian glow. In spite of all, certain realities break through. In its movement the book at first follows the route of the timber trade into Upper Canada, and from that point west, takes the even older fur routes. The first of these is intentional; the second, seemingly not. A good deal of the prose overflows with a sense of pride, particularly in those portions dealing with the many large towns and small cities which in 1880 were centres of expanding ambition, but which have since been largely by-passed. In the illustrations of almost all of these Victorian cityscapes the railway is much in evidence.

As I have said, Thomas Moran's work for *Picturesque Canada* is exemplary, and the other artist who excelled was Lucius O'Brien. The frontispiece to the first volume is a rich steel-engraving of a view of Quebec City, which he had painted for the Queen. But most of his other illustrations were drawn especially for the publication. A few of the drawings are in the John Ross Robertson Collection at the Metropolitan Toronto Library, among other places. O'Brien completed a highly-finished drawing, usually in washes, although the detail often includes some body-colour. His compositions are always clear and ordered, and they carry over into the line of the wood-engraving extremely well. Painting in monochrome, as he invariably did for this work, he was able to establish a precise tonal balance. There is a lovely roundel of *Voyageurs on the French River* in a private collection in Shanty Bay, in which he has used washes to good effect, achieving a clear range of tones (pl. 119). The engraver had to heighten the contrast, and took other liberties with the composition, but the result is still effectively strong in mood (see pl. 120).

O'Brien naturally introduced images from his oil paintings. The craftsman who made the steel-engraving after his view of Quebec would have himself prepared a sketch from the original painting. The wood-engraver could not work that way, so for each of the reproductions of his paintings that were used O'Brien himself had to prepare a tonal study. We know of two instances of this. One is a sepia wash of striking force after his *Kakabeka Falls* that is now in the collection of Mr

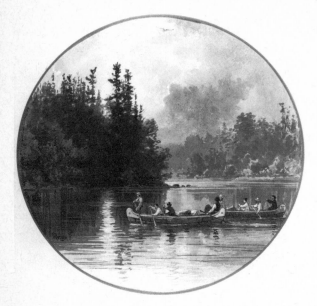

119
Lucius O'Brien
Voyageurs on the French River *c.* 1881
Monochromatic watercolour,
22.9 x 20.3 cm (sight)
Mrs Robert Lockie, Shanty Bay,
Ontario

120
On French River *c.* 1882
Wood-engraving, reproduction in
Picturesque Canada, p. 244

John J. Grant of Vancouver (pl. 121). He has departed from the oil in a
few details, and has been able to introduce more of a rhythm in the
movement of shadow. In sepia, it appears all the more picturesque in
the manner of the early nineteenth century, the tiny figures silhouetted
against the sublime force of the falls. The engraver has translated
O'Brien's generalized areas of dark and light to textures of varying
density (see pl. 122).

Similarly, O'Brien prepared a monochrome study after his *Sunrise
on the Saguenay* (now in the Art Gallery of Ontario, Toronto), that the
engraver has interpreted with texture (see pls 123, 124). The exact
tone is more closely captured, perhaps because this time O'Brien paid
more attention to establishing a textural base, avoiding the flat wash

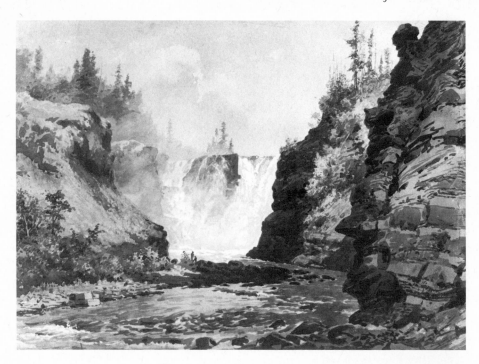

121

122

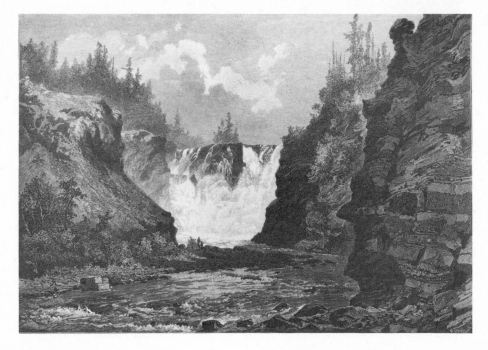

121
Lucius O'Brien
Kakabeka Falls *c.* 1881
Sepia, 24.1 x 33.0 cm (sight)
Mr John J. Grant, Vancouver

122
Kakabeka Falls *c.* 1882
Wood-engraving, reproduction in
Picturesque Canada, p. 270

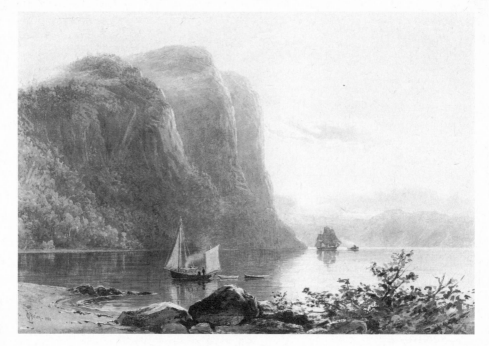

123

124

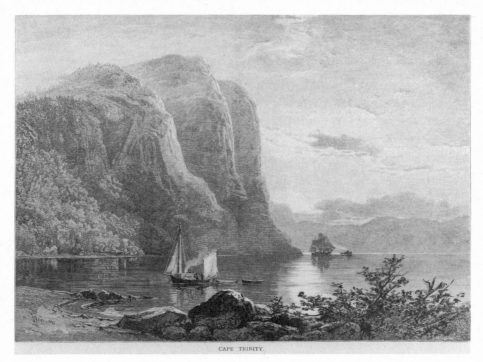

CAPE TRINITY.

123
Lucius O'Brien
Sunrise on the Saguenay 1882
Monochromatic watercolour,
34.3 x 49.9 cm
Art Gallery of Ontario, Toronto,
gift from the McLean Foundation, 1967
(66/27)

124
Cape Trinity *c.* 1883
Wood-engraving, reproduction in
Picturesque Canada, p. 716

areas evident in the *Kakabeka Falls* study. The copy of *Sunrise on the Saguenay* was done quite a bit later, in December 1882, according to his Studio Journal. It is dated 1880, so that the engraving would bear the date of the original oil painting.

Lucius O'Brien handed over the last of his drawings to the Beldens' engravers 4 July 1884 (again, from the Studio Journal). By that time the success of *Picturesque Canada* was assured. From the moment that the first parts started to appear, reviewers seem to have accepted it in the spirit of jingoistic boosterism in which it was presented. In its issue of 6 May 1882, the *Canadian Illustrated News* predicted that *Picturesque Canada* would

> be a credit to the country as a work of art, apart from the interest which its subject matter naturally lends to it.... It is not at all too much to say that no work of the kind, as regards engraving and press work, has been turned out before in Canada. The greatest possible care has evidently been taken to secure only the best work in each department, and the result fully justifies the means which have been taken to secure it.... To [the] plates our Canadian artists have been invited to contribute, and have availed themselves largely of the invitation, the majority of the sketches being by members of the R.C.A., and others, assisted only by one or two well-known American magazine illustrators (xxv, p. 275).

Even after most of the numbers had appeared, reviewers accepted whole the Belden line. Here, in part, is what *The Week* had to say on 10 January 1884:

> We have received numbers twenty-five and twenty-six of this work, which, for magnitude of design and unrivalled execution, stands easily chief among Canadian publications. It argues well for the success of artistic and literary enterprise in Canada that a work of this nature, large and costly, furnishing nothing in the way of illustrations but what comes under the head of pure art, making no concessions, either in letterpress or sketches, to local interests or ambitions should find, as it has, such prompt appreciation in Canada. This proves, what we have long contended, that Canadians are ready enough to

give a cordial reception to any home-production which proves itself equal in merit to what they can procure from abroad. (I, p. 91).

FRASER TO THE ATTACK

One lone voice was raised against what its owner felt to be the Beldens' fraud. He wrote anonymously to *The Week* a few weeks later:

Picturesque Canada

When the above work was first brought out, we had the publisher's positive assurance, in prospectuses, announcements and advertisements, that it was to be a purely Canadian enterprise throughout, 'embellished with engravings of the finest character, from original drawings made expressly for the work, from sketches taken on the spot by Bell Smith, Cresswell, Edson, Fowler, Fraser, Judson, O'Brien, Peel, Perré, Sandham, Watson, and other Canadian artists.' It was further guaranteed to be a 'true delineation of our country,' a 'tribute to native art and native genius,' a 'beautiful specimen of Canadian art and Canadian workmanship,' and much more to the same effect.

But as soon as the publishers had by these promises enlisted the press of the country, and secured a liberal subscription list by their aid and the use of the names of several well-known Canadians who had no real interest involved, they 'dispensed with' all Canadian artists to whom they had promised work, moved their presses, plant and entire establishment secretly to New York, where the senior proprietor permanently resides, and all we have of 'Canadian art' in the entire work (except some half-dozen small and unimportant illustrations) is from the pencil of a single Torontonian – the entire staff of artists, as well as engravers, printers, proprietors, and all others connected with the scheme being New Yorkers...(I, 20 March 1884, p. 250).

The lone voice was, of course, that of John A. Fraser, and this

angry denunciation of both the Beldens and their publication marked his final gesture in a long and acrimonious battle with both the Art Publishing Company and Lucius O'Brien. Its first seeds had actually been sown some ten years earlier, in June 1874, when O'Brien had supplanted Fraser as Vice-President of the OSA (see Chapter VIII). Ever since that day Fraser had observed the other's actions with suspicion and some degree of bitterness.

In 1876 he had even attacked O'Brien's friend, J.C. Forbes, as a means of striking out indirectly at O'Brien. As we have seen, Forbes, like Fraser, often used photographs in putting together his paintings. And as we also know, attitudes concerning this practice were ambivalent. Forbes painted a portrait of Lord Dufferin probably early in 1875, intending to display it in the OSA exhibition that year. He withdrew it at the last minute, and two months later announced that he would show it at the Centennial Exhibition at Philadelphia in 1876 (*The Nation*, II, 9 July 1875, p. 321), which he did. Shortly after the exhibition opened, John Fraser, writing on letterhead of the Centennial Photographic Company, of which he was art superintendent, addressed a complaint to the Canadian Commission for the exhibition.

> As a member of the firm of Notman & Fraser of Toronto it is my painful duty to protest against your hanging or allowing to be hung or publicly exhibited in any way a life-size portrait of His Excellency the Earl of Dufferin painted by J.C. Forbes from a cabinet photograph taken copyrighted and published by us in Toronto. We respectfully submit that painting the picture without our consent and sending it to Phil^a to be exhibited in the fine arts dept., *as a portrait painted from life* is an act unworthy Mr Forbes and must if I am compelled to make the circumstances known through the press vitiate the integrity of the art display from Canada in the eyes of the world and bring contempt on the Ontario Society of Artists more especially. I therefore most respectfully ask you to interfere in the interest first of Canada. Secondly of art which should at least, good or bad be *honest* and thirdly in *our* interest as citizens although of course we have a legal remedy (Public Archives of Canada, Ottawa, Philadelphia Exhibition, 25 April 1876).

So far as we know, nothing was done, and the issue died. By the

following February Fraser had reached some sort of reconciliation with O'Brien, and rejoined the OSA.

For a couple of years all remained more or less peaceful, even though Fraser was one of the members of the OSA most actively concerned with the possible consequences of the foundation of the RCA. He was also probably well aware of how much would accrue to O'Brien, as a result of the organization of this new body. But for the time being he made no further moves, and remained a seemingly contented Academician.

FRASER VERSUS THE ART PUBLISHING COMPANY

But contentment was not a state of mind that Fraser could sustain for long. An obscure entry in the OSA Minute Books for the meeting of 5 October 1880 signals the beginning of his next public battle:

> Moved Shuttleworth (seconded Hannaford), resolved, that Mr. Fraser be allowed to present to the meeting a statement which is affirmed to affect the general interest of the members of this society, upon which Mr. Fraser produced a number of letters purporting to be correspondence between himself and a publishing firm respecting certain disputes as to some illustrative work. The meeting took no action respecting it. Mr Matthews also read a letter from Mr O'Brien bearing on the subject.

As usual, discretion was in order. Fortunately, O'Brien saw fit to retain certain of the documents that throw light on the dispute. They are preserved in his Scrap Book, now with a descendant in London, Ontario.

The earliest item is a printed letter – obviously for general circulation – from the Art Publishing Company, dated 25 September 1880. Of its three pages of closely-set type, the following is the most pertinent passage:

> On account of the false impressions which have arisen on some hands by reason of the misrepresentations of Mr J.A. Fraser, of this city, in regard to our employment of foreign talent on our new work 'Picturesque Canada,' to the exclusion of

Canadian Artists, we feel called upon to set the matter right by a brief explanation of the facts.

When this work was first proposed, the plan was discussed with Mr O'Brien, who laid it before the Canadian Artists at Ottawa, a majority of whom promised to contribute to it; but it being found that at that date all or nearly all of them had already settled upon their several fields for the ensuing summer, it was decided to make no special division or assignment of territory at that time, but to wait till their return from their respective sketching tours – use such of their (*this summer's*) sketches as could be made use of, and they were willing we *should* use, after their return – and get things in shape for a general and vigorous campaign next season. After the canvass was started our Agents all advised us to put out enough *consecutive* work, as soon as practicable, for a few sample numbers, as our having no samples of our own seemed to be an impediment, in many instances, to the success which would attend the production of such finished sample. When we found this was necessary, Mr. Fraser, who was the only Canadian artist then disengaged, proposed going out, and we sent him, while Mr. O'Brien (who from the first had been selected as the Superintendent of the Art Department) was absent in England. Before going out, however, he tried to procure a pledge from us to the effect that *No Canadian Artists but himself and Mr. O'Brien should be employed on the work* – giving as a reason that HE was the ONLY ARTIST fit to do the work, except possibly Sandham, who, he said, had such engagements ahead that he could not contribute. He even had the assurance to tell us that Mr. O'Brien *couldn't do the work*, and we would soon have to drop him.

It goes on like this for another two-and-a-half pages, in which the Beldens set themselves up as the friends of Canadian art, and represent Fraser as a grasping, self-interested individual who had assailed them with demands for territory, listing in detail all of the regions he would illustrate. "We objected to this," say the Beldens, "as it would leave scarcely any work for each of the other Canadian artists whom we expected, and still hope to secure, to assist us." Fraser did go out that

summer, with $100 for expenses. He was gone six weeks, and upon his return, with ill-humour on both sides by then, it seems, he ran into conflict with the Beldens concerning the suitability of his sketches.

Fraser had been contracted, apparently, to draw "on the block"; that is directly upon the end-grain of the wood, the engraver then cutting into the drawing to produce the engraving. The Beldens found his work unsatisfactory for this purpose, and asked him to change his contract, presumably in order to purchase only sketches from him and to make other arrangements for engraving. Fraser became alarmed at this turn of events, and "at once commenced to influence the other artists against us by misrepresentations and falsehoods." He accused them of turning most of the work over to Americans. The Beldens denied this:

> As to work from Canadian Artists, we do not insist that they shall be *drawn on the block;* having made arrangements (specially for the benefit of such as cannot transfer their drawings to wood satisfactorily) with several engravers who make a specialty of cutting from photographs on wood.... Mr. O'Brien has from the first insisted on the employment of Canadian Artists as far as possible, if not altogether. As it is, the only American now employed by us is Mr F.B. Schell, who has been at work thirty days. He is an artist of world-wide reputation, whom we considered would be a very great assistance in starting the work, particularly as we have an arrangement with him whereby he will put upon the block any drawings from Canadian Artists of such subjects as are not susceptible of being properly photographed for engraving – the credit of the same to be given to the artist who makes the original drawing.

The Beldens accompanied the circular with what was purported to be the unsatisfactory engraving they had had cut in New York from Fraser's poor drawing.

FRASER VERSUS O'BRIEN

Fraser reacted first by turning to the OSA, and when that failed to produce results, nine days later, on 16 October 1880, he wrote directly to O'Brien. Again, it was a very lengthy letter, and we quote it only in part:

As the Art director or director of the Art department of the projected work 'Picturesque Canada' you are fairly responsible for the issue of the accompanying cruel and unfair circular and print from a wood block drawn by me for your book.

Why you who occupy the highest public position in Art in this country should so mercilessly and unfairly use your power to crush me I do not know. I can only remonstrate protest and suffer, while I account for the miserable breach of professional etiquette of which you stand convicted in the eyes of all, by your anxiety to inflict on my reputation and professional standing a blow from which I may not soon recover.

Fraser then accused O'Brien of purposefully distributing copies of the unsatisfactory print without ever having discussed the problem with him. And he also accused O'Brien himself of being the one to suggest that the two of them should be solely responsible for all the illustrations in the book. This was supposed to have taken place during a meeting at O'Brien's studio in May:

I indignantly refused to entertain the proposal and insisted on the work being the production of all who were able to do such drawing. You gave me distinctly to understand that you had full control of the Art arrangements and could, if necessary, do all the drawings yourself, and you threatened me with dismissal from the book, adding that if you needed any assistance you would obtain an Artist in England competent to take my place.... Evidently fearing that one day I might divulge it, a charge of a corresponding nature has been trumped up and disseminated in this circular – .

Fraser of course raised the issue of O'Brien using his position as President of the RCA for personal gain, and against the interests of other artists, and he ended the letter with a bitter postscript.

I have just heard that you are complicating matters by sketching for P.C. on the Ottawa River, part of the territory ceded to me.

This then is the solution of the persistent refusal to inspect my sketches or to carry out the contract on the ground that they had not been approved. Is this Canada so small that you

could not allow any other Canadian a chance contracts to the contrary notwithstanding and must yourself and the two Americans Schell and Gibson only be employed on this 'truly national work'?

Fraser had the letter printed, and circulated.

O'Brien, of course, also replied by printed circular. He denied any prior knowledge of the original Art Publishing Company letter:

> Inasmuch as most of your letter is based upon the supposition that I was the author of the circular in question, what I have now said is full and sufficient answer; and I need not notice language used under the excitement caused by that impression.
>
> The only other part which concerns me is your account of a supposed conversation in my studio. In this narrative you have mistaken imagination for memory. No such conversation as you describe ever took place between us, nor did I ever make any proposition to exclude other Artists from the work. All that I have ever said to anyone on the subject was to the contrary effect.
>
> Since receiving your letter, I have seen it in several places in printed form as a circular. This will oblige me to send my reply also to my brother artists; and with this my part in the discussion ends (27 October 1880).

So cool was he in his imperious certainty that he would not have to fight this particular battle. Fraser replied with another circular, no copy of which was kept by O'Brien, and the Art Publishing Company distributed another long printed letter in response, dated 6 November 1880. It was in the form of a summary, and the main intent was to turn the issue to the quality of Fraser's work. From then on – and it went on throughout December, moving into the columns of the *Toronto World* – this was the issue the Beldens kept raising: Fraser's "sketches were not considered by us of sufficient merit to warrant their being used in connection with a work of art" (*Toronto World*, 15 December 1880).

Fraser could only reply that they had never seen his sketches but only the two drawings he did on wood, one of which he felt had been "butchered" by the engraver in New York. Finally, the Beldens con-

trived to impugn his integrity. It all ended just before Christmas of 1880 in a quick succession of bitter recriminations. Fraser feared for his reputation, both personal and professional. The Beldens feared for their investment, which must have been large. And after the end of October O'Brien had managed to keep right out of it, just as he had said he would.

FRASER WITHDRAWS FROM THE SCENE

Another issue touching upon the affair flared up briefly in March 1881. This time we have only one circular letter that was saved by O'Brien. It is from a certain S. Martel Davies, who was selling subscriptions to *Picturesque Canada*, the first parts of which were still a good ten months away. The following is the larger part of Davies' letter.

> In consequence of false reports being circulated to my injury, I am compelled to vindicate myself by publishing the following:
>
> Before I took any active part for the sale of 'Picturesque Canada,' Mr. H. Belden told me that the 'Art Publishing Company' was the outcome of the newly-formed Canadian Academy of Arts, (the members of which would alone contribute the illustrations to the work;) and was composed of Bankers, Merchants, and men of capital, who took a deep interest in the development of art in Canada, but did not want their names made known, *and that they were engaged by the Company as managers*.
>
> From enquiry recently made at the Toronto Registry Office, it appears that the firm of H.R. & R.B. Belden, Atlas Publishers, *alone* constitute the Art Publishing Company....
>
> Both at Ottawa and in Toronto, I found that the controversy between the Art Publishing Company and Mr John A. Fraser, had made a very unfavourable impression against the Company; that Mr. Fraser had a host of friends who considered he had been very unjustly treated; and that in consequence of this, a great number of persons refused to have anything to do with the publication.
>
> On or about the 4th instant, Mr. H. Belden gave me seventeen wood-engravings from sketches, (of those one

was by Fraser, two by Harris, one by Schell of *New York*, and *thirteen* by O'Brien) and the cover of a part, and said, 'There, you have a part of Picturesque Canada, minus the letter-press.'

Surprised at the meagre make-up of the part, after the representations that had been made to me, and which in turn I had made in good faith to the public, I saw the false position in which I had been placed towards my subscribers, and that I could not, consistently with my self-respect, continue my relations with Belden Brothers.

Whether any Canadian artists did withdraw from the project because of the dispute with Fraser, or whether the Beldens always expected to have to fall back upon Americans in the end, we cannot say at this point. It should be pointed out that small as the original Canadian contribution had been, it was to dwindle even more. O'Brien only contributed twenty-one drawings to the second volume, while Schell is represented by at least one-hundred-and-eight.

Fraser left O'Brien alone until April 1882, when he sent a stuffy letter to the General Assembly of the RCA, then meeting in Montreal. He had fallen behind in his dues, and enclosed a note with them; "in paying which I do so, distinctly under protest because I consider that, inasmuch as the Academy is unincorporated, and the diplomas are not issued, I am not bound by Section V Clause 3." O'Brien, Fraser thought, was derelict in his duties in letting these matters ride so long. His anonymous letter to *The Week* in March 1884 was, then, just one last parting shot before Fraser removed himself to Boston – and, as he thought – from the bitter rivalries of the Canadian art world.

O'BRIEN CONTINUES TO PROSPER

O'Brien, of course, found himself in a very different position from Fraser at the beginning of the new decade. As first president of the RCA, engaged with *Picturesque Canada*, and clearly established as the pre-eminent artist of the Dominion, he must have felt himself to be launched on a whole new period of achievement. The scope of his ambition could have never before seemed so vast, the demands upon his energy and his spirit so great. He was naturally confident, self-assured, and charged with that aggressive optimism that then rose so naturally from

the universally-held ideals: Progress, Improvement and Expansion. Canada was the future; its full magnitude still a dim shape, a rough outline, but promising greatness, strength, wealth and, in many minds, even empire. To grasp this future, first to perceive it and then to achieve it, became the Canadian obsession of the eighties, and as much for the artists as for the politicians or railway entrepreneurs.

O'Brien's famous *Sunrise on the Saguenay* (pl. 125), displayed at the first RCA exhibition in Ottawa in March 1880, perfectly established both his own philosophy and the role landscape artists would play in the next decade. And since in 1880 they were still the dominant influence in the exhibitions, they were a force to be reckoned with.

Sunrise, O'Brien's Diploma picture, is tradionally considered to be the first work to enter the collection of the National Gallery of Canada. Much as it can be said to reflect the dawn of a new era in Canada, the

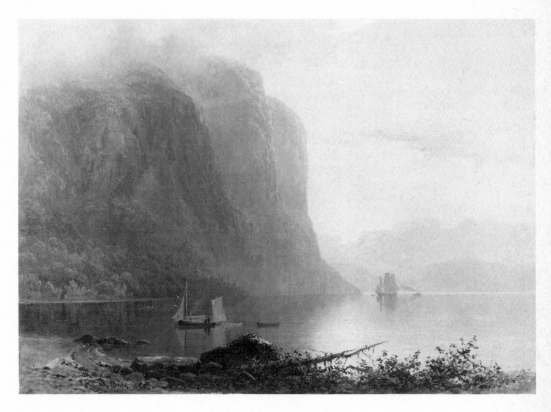

125

Lucius O'Brien
Sunrise on the Saguenay 1880
Oil on canvas, 87.6 x 125.7 cm
The National Gallery of Canada, Ottawa,
RCA Diploma picture, deposited 1880
(113)

beginning of a new national vision that was federal, and so, ostensibly above and beyond the narrow local interests of Toronto or Montreal (how appropriate that it came to rest so soon in Ottawa), it nonetheless marks the culmination and the end of a theme in O'Brien's work. From the time of his trip to the Bay of Chaleur in 1877 he had essayed the coastal marine, quickly devising an image he would repeat frequently over the next two-and-a-half years: a looming bluff or cliff to the left, open sea to the right, a curve of shore from foreground around by the left and a boat or two to establish human interest and relative scale. These bones were then fleshed with atmosphere that was foggy and heavy as in the *Black Cape, Bay Chaleur* of early 1878 or George Brown's large *Northern Head of Grand Manan* of later that year – or light, even sparkling, as in the 1880 watercolour in the National Gallery of Canada of Grand Manan (see pl. 126).

O'Brien never let this become a laboured formula. In *Sunrise on the Saguenay* he pushed it to what was probably its limit of paradoxically sublime scale and delicate, ethereal atmosphere. It was his contact with Albert Bierstadt that encouraged this extension of what had become to O'Brien a familiar theme. The grandiose, almost operatic scale of the picture perhaps still appears reserved in comparison to Bierstadt's huge western pictures of the sixties and seventies, but it is a response to them nonetheless. And the colours – softly glowing pinks, blues, greens, and yellows – appearing here for the first time, he also took from Bierstadt. All this of course gives the proper imperial ring to the image, but it is accomplished with feeling and evident conviction, and it is the integrity of O'Brien's basic pictorial concept that finally shines through.

With the establishment of the RCA there were three major exhibitions a year (although combined showings periodically reduced the number), and with the added responsibilities O'Brien had assumed he had little time for painting. It is clear from the exhibition record that although he was exhibiting more frequently he was showing fewer paintings; certainly in 1880 the same oils, and basically the same watercolours appeared at all three exhibitions. These were works based on his travels of the past three summers, to the Bay of Chaleur, Grand Manan, and from Quebec City to the mouth of the Saguenay. For a native of the country, his view was surprisingly limited to our coastal approaches.

From 1880, as if he was intent upon this very problem of enlarging his horizons, O'Brien's travel patterns broadened dramatically. He spent the early summer in England, stopping in London but then passing some time sketching in Somersetshire. (This is his first recorded trip to England, although it is difficult to imagine that he had not been before.) He was back in Canada by mid-August, and soon was sketching for *Picturesque Canada*. There is a watercolour study of Kingston in a private collection in Vancouver that is dated 26 August 1880. By early September he was in Quebec City. A watercolour in the Public Archives of Canada is dated 7 September 1880. He would have visited with Lorne, who was in Quebec that month, and would then have met Albert Bierstadt. He possibly also visited New Brunswick, for when he was back in Toronto at the end of October, he referred in a letter to having passed his summer and fall in "England and the Lower Provinces."

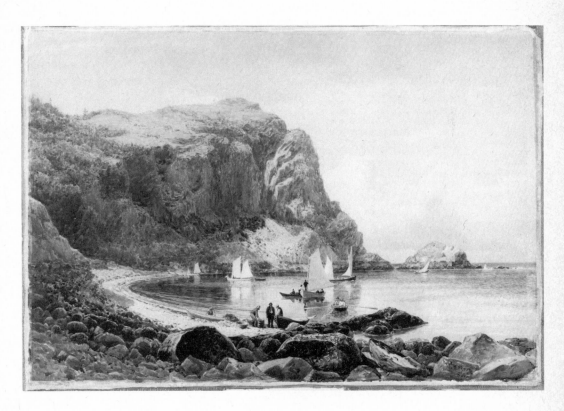

126

Lucius O'Brien
Grand Manan, New Brunswick 1880
Watercolour, 51.8 x 76.5 cm
The National Gallery of Canada, Ottawa,
purchased 1975 (18,534)

Finally, as we noted earlier, the inauguration of the RCA had taken him to Ottawa for a planning meeting in the third week of February (as reported in the *Ottawa Free Press*, 19 February 1880), and again for the opening and the first General Assembly, early in March. He remained listed in the Toronto city directory as an associate of Quetton St George & Co., but also, for the first time in twenty-four years, as "artist." And, as if all of this were not enough, some time that year he engaged his friend, Frank Darling, then one of Toronto's rising architects, to design him a house and studio for a lot he had bought on College Street, at Yonge, just a bit south-east of the university.

The following year was equally hectic. He dropped the designation "artist" from his directory listing. Perhaps Quetton St George was insisting upon a larger share of his time. He was to leave them, at any rate, later in the year. He had had very little time for studio painting the year before, and so was represented in a special all-Canadian exhibition at the AAM in April by watercolours only, two from his English trip, but the rest most likely from 1879 or before. At the end of April, however, it was revealed that he had been working on a commission for the Queen of two views of Quebec. The commission had been given by Lorne and Louise after the closing of the first RCA exhibition. (One can presume that Victoria was in ignorance of the whole affair.)

At least three works by other painters had been purchased from that exhibition for the Royal Collection. The fact that O'Brien was separately commissioned, if indeed it does not reflect his special status, perhaps suggests that *Capes Trinity and Eternity*, the only good-sized canvas available from that show, was not felt to be suitable. The other two were already spoken for: one O'Brien's Diploma picture, the other the property of George Brown.

The special commission certainly carried with it considerable *cachet*, and O'Brien exploited this to the full once he was finally able to turn his attention to the work. He began early in 1881, and the smaller of the two pictures, *Quebec from Point Lévis* (pl. 127), was finished late in April. By the end of that month the larger, *View from the King's Bastion, Quebec* (pl. 128), was far enough advanced for him to hold a special studio viewing on 30 April, to which he invited friends, prospective clients, and the press.

There were a number of notices, the most extensive I have come upon appeared in *The Globe*. The reading of the pictures is close and

literal, and the article is interesting enough to reproduce almost in full:

> The completed picture consists of a very comprehensive view of the city from the south shore of the St Lawrence near the eastern extremity of Point Levis. The time is late in a warm autumn afternoon. Away to the westward on the extreme left, the river (whose smooth surface is just stirred by the faintest of ripples, and dotted with a scattered fleet of vessels) is sleeping in the shadow of the towering south shore which terminates in Cape Diamond, while every outline is softened and faintly coloured by that thin, sub-transparent purple haze that seems to float in every shadow on these bright warm days of early autumn. Farther toward the right and near the centre of the picture rises the abrupt south face of Cape Diamond with the citadel upon its crest just catching upon its topmost peaks and edges the golden sunlight from the opposite side. Then comes the city, with Dufferin Terrace, Laval University, the Grand Battery, and other points of interest presented with extraordinary felicity, but the most striking part of the whole scene is on the right, where the sunlight, bursting out from behind Cape Diamond, falls upon the eastern portion of

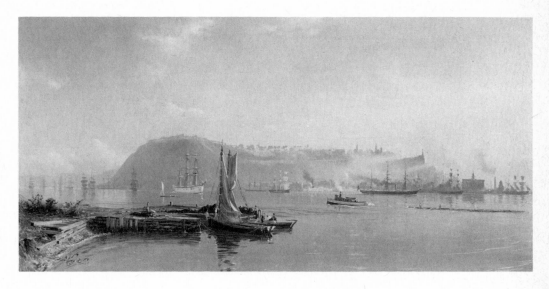

127

Lucius O'Brien
Quebec from Point Lévis 1881
Oil on canvas, 38.1 x 76.2 cm
Power Corporation of Canada, Limited,
Montreal

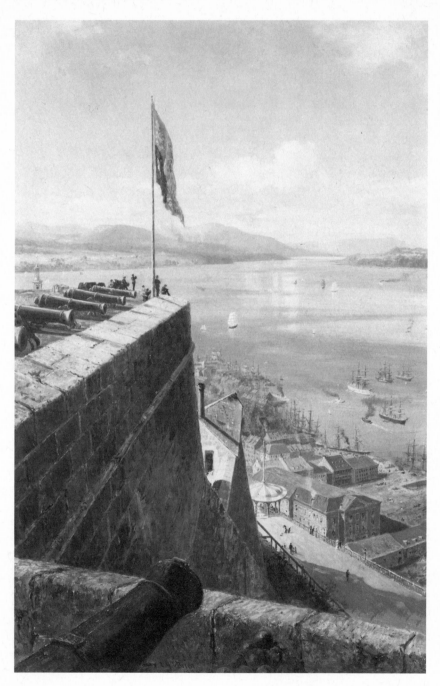

128

Lucius O'Brien
View from the King's Bastion, Quebec
1881
Oil on canvas, 91.4 x 61.0 cm
Her Majesty the Queen

Lower Town, St Roch's, and the harbour. It is a bright blaze of light that completely envelops every object that lies in its path. Sky, clouds, stone walls, tin roofs, and the rippleless waters of the harbour are all ablaze with russet and gold. The contrast which this forms with the rest of the picture, which is only here and there lightened with a golden-edged shadow, is of the most vivid character, but at the same time there is nothing in it that would strike one as exaggerated, harsh, or unpleasing. Indeed, in the blending and harmonizing of colours throughout the whole picture Mr O'Brien has completely surpassed himself.

The unfinished picture is an afternoon view from the King's Bastion looking down the St Lawrence. In this the atmosphere is clear and transparent: each object is boldly drawn and sharply defined. In fact the picture forcibly reminds one of some of the more striking of Mr O'Brien's watercolours. It is as if the scene was dealt with purely upon its merits without anything in the way of idealization. It is quite true that there are few landscapes that can safely be treated in this way, but anyone who has ever looked, either from the King's Bastion or the Grand Battery, down the St Lawrence will readily acknowledge that in that picture no idealizing is necessary (2 May 1881).

O'Brien exhibited the two publicly at the ninth OSA in May, each proudly described in the catalogue as "Painted for Her Majesty." They were his only oils in the exhibition. He showed only one studio watercolour, two decorative panels of *Autumn Foliage*, and two small watercolour sketches. At the second RCA exhibition, which was held in July, in Halifax, he showed the Queen's pictures again, plus *Sunrise on the Saguenay* and a large group of watercolours, almost half of which were small sketches of the Quebec City region and the Atlantic coast, which he had prepared for *Picturesque Canada*.

So the Queen's pictures were his major and virtually his only production of that year. Lorne left for England on home leave in November, and soon after his arrival there he reported to O'Brien that the paintings had been well received. O'Brien informed the press:

Letters have been received both from the Governor-General

and Princess Louise, expressing in the highest terms the satisfaction with which Mr O'Brien's pictures of Quebec, painted for the Queen, have been received. One, the view from the King's Bastion, is at Windsor Castle, and the other, the view of the city from Point Levis, has been taken by her Majesty to her favourite summer residence, Osborne, in the Isle of Wight. Artists are well aware that the removal of the picture from Buckingham Palace to Windsor is evidence of her Majesty's approval, and that it is esteemed by judges to possess a high order of merit. That her Majesty should have ordered one of Mr O'Brien's paintings to be taken to Osborne, where it will be constantly on view and form part of the choice collection belonging to that summer residence, is even a still more gratifying circumstance.... That they faithfully depict the views which they are intended to represent goes without saying, as the artist is an eminently truthful painter, and that their artistic excellence is high is abundantly established by the cordial compliments bestowed on Mr O'Brien by the highest personage in the realm (*The Mail*, 7 January 1882).

View from the King's Bastion, Quebec is still in the Royal Collection at Windsor Castle. *Quebec from Point Lévis*, whose display at Osborn, Victoria's private summer retreat on the Isle of Wight, seemed at the time such a special accolade, was removed at some later date. It was disposed of along with other personal, as opposed to officially Royal, property which had been deemed of little interest, and made its way back to Canada. It is presently in the collection of the Power Corporation of Canada, Limited, in Montreal. Although the smallest, it is the better and more interesting of the two pictures.

The description in *The Globe* perfectly captures its easy relaxed, mood. But what a contemporary reviewer could not see as clearly as can we, is that the picture, in fact both pictures, carried, even at the time, a strong symbolic meaning: Peace, Order, and Prosperity. Thoughtfully composed, *Quebec from Point Lévis* hums in gentle rhythms with the industry of trans-shipment. Quebec is not shown as a barrier, nor as a sentinel but as a great gateway, opening on to continental empire.

The *View from the King's Bastion, Quebec* is even more emphatically

symbolic, and in such an obvious way that in 1882 it would have seemed without need of mention. It too suggests peace, order, and prosperity, but with the emphasis on Order. It is virtually a diagram of the strata of Victorian society: on the lowest level ant-like workers bustle on the docks, at mid-level the bourgeoisie take the air on the new Dufferin Terrace, and on the heights authority, secure in the power of force, surveys it all. The Royal Standard (which could represent the time in 1879 when Princess Louise was at the Citadel) suggests that although unseen, Her Majesty too was there.

O'Brien may have based these pictures on sketches done in the fall of 1880, but it is possible that he had gone back as well to ones made in June 1879. There is a large watercolour of *The Ramparts, Quebec* in a private collection in Guelph, Ontario, that shows a view up to the walls from below. The 1879 sketch for it is in the National Gallery of Canada. We do not at present know of any existing sketches for the Queen's pictures, and thus cannot determine when O'Brien conceived them. But if it was in September 1880, he would then, as already noted, have been with Albert Bierstadt. That this was the case is most likely, as the evidence is all over O'Brien's work.

The colouring of *Quebec from Point Lévis* is particularly close to that used by the American artist. Indeed, Bierstadt's *The St Lawrence River from the Citadel, Quebec* in the Museum of Fine Arts, Boston (see Chapter x), could be a record of the very same day, so close is it in atmosphere to O'Brien's small canvas (pl. 129). It is also linked to O'Brien's other picture, because it is a similar view from the King's Bastion. The Bierstadt painting is horizontal, and he has taken a position to the right, but the idea is the same. There is yet another related view. It is in the form of a reproduction in the English popular magazine, *Good Words* (xxiii, 1882, p. 219), and was based on a drawing by Princess Louise, made during her first visit to the Citadel in June 1879 (see pl. 130). Appropriately, it could have been the inspiration for the other two, although the vantage point of the Citadel has inevitably been chosen by every artistically-inclined visitor to Quebec.

O'Brien's two pictures are, nonetheless, thoroughly integral to his own work. Each is a different variation on his coastal marine theme. In the smaller one he has swung the usual left-hand bluff around to form a free-standing centre-piece, has truncated the curved bay, and scattered the shipping across the whole image. In·the vertical picture the bastion

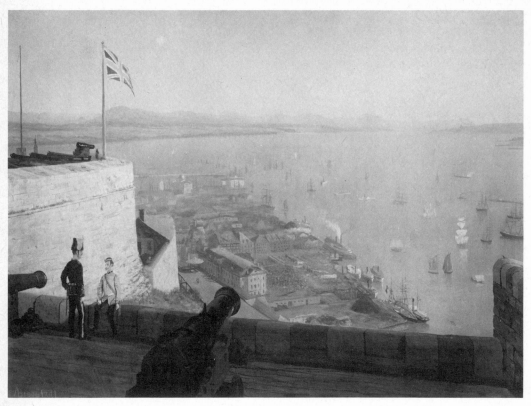

129

is the bluff, and it has been pulled to the foreground and become our point of view, cutting in to the curved bay sharply. We have come some distance from the sombre, natural force of the Bay of Chaleur.

Once the Queen's pictures were out of the way, O'Brien devoted the rest of the year to *Picturesque Canada*, working from his special studio above the Art Publishing Company's offices on York Street. Even before then, he was out in the field. We know from a letter he wrote to Principal George Grant of Queen's University that he was at Collingwood on the south shore of Georgian Bay on 15 March 1881. As we can see from the works he exhibited the following year he also travelled during the summer to the Nipigon River north of Thunder

129
Albert Bierstadt
*The St Lawrence River from
the Citadel, Quebec c.* 1881
Oil on paper on canvas,
55.9 x 77.5 cm
Museum of Fine Arts, Boston,
M. and M. Karolik Collection
(47.1258)

View
from the
Platform
looking down
upon the
Town
and
Harbour.

*Illustration No. 2 is
almost the same view as in
No. 1 (given on a preceding
page), but taken from the
platform and more extensive,
looking down upon the town
and the harbour, with the
King's Bastion overhanging
them.*

130
Princess Louise
*View from the Platform Looking
Down upon the Town and Harbour*
1879
Reproduction in "Quebec,
pictures from my portfolio,"
Good Words, XXIII, 1882,
p. 219

Bay, and then around the lower Great Lakes. This must have been after
his trip to Halifax for the second RCA exhibition and General Assembly
early in July. The sketches he obtained this year pleased him, and in
November he sent two – a sepia of *Lake Ontario from the Heights near
Queenston,* and an India ink of *A Pool on the Nepigon River, Lake Superior,*
both drawn for *Picturesque Canada* – to the fourth Annual Exhibition of
Works of Art in Black and White of the Salmagundi Sketch Club in
New York.

Very late in 1881, or very early in the new year, the first numbers
of *Picturesque Canada* appeared (there were six out by May 1882). The
frontispiece in the initial number was a beautiful steel-engraving of

Lucius O'Brien's *Quebec from Point Lévis*, in the Queen's collection (pl. 131). It was entirely suited to the benign imperialism, the High Victorian sentiment, of the project. It must have been a relief to O'Brien finally to see *Picturesque Canada* appear after almost two years. He had risked his reputation on the venture, and a great deal of effort. He had never publicly shown hesitation or doubt, but now he could hold his head high. That year he listed himself rather grandly in the Toronto city directory as "pres. Royal Canadian Academy."

Nonetheless, the year was to follow the pattern set by the preceding one. It even began with a royal commission, although not for the Queen this time. Lorne ordered a third view of Quebec, as a wedding present for young Prince Leopold. O'Brien again chose an imperial subject, *Quebec on the Queen's Birthday*. Had he been to Quebec City the previous May, or was he employing sketches from his 1879 visit? The painting, unfortunately, has so far proved impossible to trace. O'Brien

131 Arthur Willmore
 Engraving of Lucius O'Brien's Quebec from Point Lévis 1881
 In *Picturesque Canada*, frontispiece

printed invitations to a private viewing of the completed work, held 30 March in his studio above the *Picturesque Canada* offices on York Street. He then prepared to send the painting off to England, just before the opening of the RCA exhibition in Montreal.

The first notice of that show in *The Globe* lamented the fact "that it was impossible to retain 'Quebec,' on account of the necessity for sending it promptly to England," particularly as O'Brien was "not so well represented as usual" (13 April 1882). But Lorne came to the rescue, and consented to delay the picture's departure so that it could be on view at the RCA opening. Beyond this O'Brien showed only two watercolours, and the same two monochromatic drawings for *Picturesque Canada* that he had sent to New York in November. But he also included one other magnificent oil, the *Kakabeka Falls, Kamanistiquia River*, now in the National Gallery of Canada (pl. 132).

It is one of his finest paintings, a great roiling image of the raw

132

Lucius O'Brien
Kakabeka Falls, Kamanistiquia River
1882
Oil on canvas, 82.5 x 121.9 cm
The National Gallery of Canada, Ottawa,
purchased 1935 (4255)

force of nature. He has composed the picture to emphasize the compression where the water crashes through the defile. The large, encroaching shape of the rock-face on the right, most effectively describes the limits of the gorge, bringing us into the heart of the picture and into closer sympathy with the tiny human figures, moving cautiously on the edge of that ominous shadow at the centre, a shadow that is like a black reflection of the brilliant white falls suspended above. Such brutal power, overwhelming in its magnitude, comes as a shock after two years of scenes of controlled order. But it will be good to remember it, for it will be another few years before O'Brien again confronts the sublime so directly. It is also important to note that he would not paint another oil for nearly twelve years.

The RCA opening and General Assembly in Montreal that year was a gala event. Lorne held a grand ball in honour of the Academicians two days later, and it was reported to be, as was inevitable, "the social event of the season." O'Brien almost missed it, having taken ill before the opening, so that Napoléon Bourassa had to take his place in replying to Lorne's speech. His illness was not serious, however, and he went directly back to work in Toronto. The OSA exhibition that year followed immediately after the RCA (which had been combined with the AAM annual spring show), and there must have been barely enough time to ship the works from Montreal. O'Brien showed in Toronto everything that had been in Montreal (except one watercolour), also adding five more watercolours, and five more monochromes prepared for *Picturesque Canada*. Most of these were works based on his trips of the year before around the lakes.

His travels in 1882 began in June when he left for Quebec City, the Saguenay, the lower St Lawrence, and the Gulf. There is a sketch-book from the journey in a private collection, and because O'Brien dated virtually every drawing in it, we can follow his trip in some detail. He was in Quebec City by 19 June and remained there until 24 June, when he travelled down river – it must have been by boat – to St Anne and Les Éboulements on the North Shore, and across the river to Rivière-Ouelle. He stayed overnight, and then returned to Quebec.

Two days later, 27 June, he went down the river again, stopped at Kamouraska, reaching the Saguenay the next day. He travelled up the Saguenay as far as Chicoutimi, where he stayed for a while in order to explore the superb landscape, and after ten days, returned to Tadous-

sac at the mouth of the river. Four days later, on 12 July, he was on the Restigouche opposite Campbellton, and the length of time suggests that he must have still been travelling by boat, which would have taken him around Gaspé.

There are no drawings in the book of this particular region, but he exhibited works the next year that would have been conceived then. He stayed in the Restigouche area for six days, and then caught the Intercolonial at Matapedia, which he took as far as Bic, just up-river from Rimouski on the south shore. Two days later he was at La Malbaie on the north shore, where he stayed for four days before moving on up river to Les Éboulements, and so finally back to Quebec. He had been gone thirty-six days. The rest of the year he probably spent in Toronto, working up drawings for *Picturesque Canada*. At some point that year, he also moved into his new home and studio at 36 College Street. (The number was changed to 20 eight years later.)

In 1883 there were again only two exhibitions, as the OSA and RCA decided to combine that year. O'Brien showed fourteen new watercolours in Montreal, and then again in Toronto, adding five more. They were all of the Saguenay, the lower St Lawrence, or the Gulf. He clearly had spent most of the fall in his studio. His watercolour technique was loosening up considerably, doubtless as a consequence of working under pressure. Relying more on washes, and doing more drawing with his brush instead of building up his tones with small dabs of colour, he could work more quickly. He still painted largely with reference to light and dark, as we can see in the freshly original view, *Percé Rock,* that is in a Vancouver collection (pl. 133). And, if anything, he had become even more sensitive to fine tonal gradations after two years of experience with black-and-white.

O'Brien was planning a trip to England, and this might have been the reason he produced so large a number of works in the fall and winter of 1882–1883. Early in June Lorne and Princess Louise had visited Toronto in order to view the RCA exhibition, which was still hanging. The Princess also visited O'Brien's new studio on College Street (*The Globe,* 2 June 1882). A few days later he began to put things in order. He sold four paintings to Ewing & Co., framers and art dealers in Toronto, and left nine watercolours of the seventies for sale with James Spooner. These transactions are listed in his Studio Journal.

By 15 June the business was complete, and shortly thereafter he

133 Lucius O'Brien
 Percé Rock 1882
 Watercolour, 76.2 x 53.3 cm (sight)
 Mr John J. Grant, Vancouver

left for England. He stayed nearly six months. He immediately con-
tacted a dealer, Mr J. Nathan, of the Burlington Gallery at 27 Old Bond
Street, and left eight watercolours with him. Then he seems to have
spent the rest of the summer and early autumn sketching in the coun-
try, partly around Windsor (did he go to see his painting?) but mainly
in Devonshire. Just before he left, he was included in an exhibition at
Nathan's gallery with Frederick Verner, who was then living in London,
and several other Canadians and Americans who worked in a similar
vein. Verner was the success of the show.

Back home in early December, O'Brien sent eight of his *Picturesque
Canada* black-and-white and sepia drawings to Nathan, who thought he
could sell them. In London, O'Brien had met a popular writer named
Frederick Pollock, perhaps through Nathan, as their names are linked
in the Studio Journal. At any rate, this association eventually bore fruit
early in 1884, and O'Brien was commissioned to illustrate an article for
Pollock on Clovelly, a picturesque fishing town on the North Devon
coast, for *The English Illustrated Magazine* (ten drawings appeared with
the article in the Special Christmas Number, 1884). This project, plus
the last of the *Picturesque Canada* drawings, seem to have occupied
O'Brien well into 1884. He showed only English watercolours that year
(except for a *Cape Trinity* lent by someone else to the RCA in Montreal,
and a Toronto harbour scene with the OSA). His work had changed
noticeably, and this drew instant comment:

> L.R. O'Brien, President of the RCA, has thirteen exhibits in
> water-colour, and all are good. I select those which appear to
> attract most attention, and best indicate his style: dreamy,
> poetical, harmonious, and tender, but not crisp.... Are these
> exhibits equal to his former ones? I prefer 'St Anne' and 'Des
> Eboulements,' and possibly 'Quebec' of a prior exhibition
> (*The Week*, I, 1 May 1884, p. 344).

The last number of *Picturesque Canada* appeared in the early fall of
1884, and O'Brien seemed to slip even further into a kind of retire-
ment. His exhibition record for 1885 differs only by the inclusion of a
few more Canadian scenes, but the English still dominate until Decem-
ber, when O'Brien sent ten watercolours to a special winter exhibition
of the OSA, timed for Christmas sales. Nine of them were of Canadian
subjects. He probably still went on regular summer sketching trips, but

explored no new fields, and none of the work he exhibited from 1883 to 1885 is as exciting as that of the years before. About all of it hung a certain air of staleness.

FRASER PRESSES ON

Did O'Brien need the stimulus of Fraser's constant goading? This is too much to suggest, but it is curious that he seems to have relaxed, even lost ground, just after Fraser quit Toronto. But we are jumping ahead of the story. Fraser himself had seemingly drawn back from the painters' public forums in 1879, but he easily survived the slightly rough period of the establishment of the RCA, and was one of the five Academicians from Toronto included in the first exhibition in Ottawa in March 1880. We have already noted how he never really overcame his suspicion of O'Brien, and fought with him persistently over *Picturesque Canada* and various issues concerning the RCA. This must be constantly kept in mind, as a kind of background to the events which shaped his career during his last years in Toronto (see pl. 134).

KING STREET, THE GREAT THOROUGHFARE OF TOTONRO.

134

Notman & Fraser Studio
*King Street, the Great Thoroughfare
of Toronto* 1880
Reproduction in the *Canadian Illustrated
News*, XXII, 31 July 1880, p. 72

Fraser showed seven oils and five watercolours in Ottawa, and simply in terms of effort, this may be regarded as a turning point for him, much as was the event for O'Brien. It did not herald so much a new point of view as it did with O'Brien, however. In fact Fraser relied entirely upon preliminary sketches made years before. All of the watercolours and the bulk of the oils were based on his trip to the Bay of Chaleur in the fall of 1877. And his major piece that year, the painting he left in Ottawa as his Diploma picture, was derived from a watercolour sketch done in the Eastern Townships, probably as long as thirteen years before. This was his *Laurentian Splendour*, worked up from an earlier watercolour now also in the National Gallery of Canada.

In the oil painting Fraser ended up with a very different image (see pl. 135). A boat and lone sailor have been added to the foreground, and a small sand spit has been set out into the water to accommodate them. A little island has been placed to the left of the bay, and the spikes of dead pines that jut up from it, and from the marshy land farther left, are new too. Although characteristic of the region, they were not recorded in the watercolour sketch. The right-hand side of the

135

John A. Fraser
Laurentian Splendour 1880
Oil on canvas, 48.9 x 95.3 cm
The National Gallery of Canada, Ottawa,
RCA Diploma picture, deposited 1880
(72)

foreground has been filled in to balance the left, and both have been given what is characteristic ground-cover, but that again does not appear in the sketch. Other pines have been added, to the right in the middle-ground, behind the log shanty, as well as another figure, and smoke now drifts from the chimney.

More subtly, but more significantly, the shadows on Mount Orford have been altered, for what can only be interpreted as compositional reasons. The central dark shape in the watercolour has been moved to the left to join the major higher shadow, the combined weight of which now lies directly over the needle-like shaft of the boat's mast. And the water has been rendered in a much better fashion, the sub-surface currents altering reflections in a most naturalistic way. The canvas is, in a word, more finished. It is – without manifesting enough photographic effects to suggest that sort of direct aid – more optically coherent.

At this stage of his career, after twenty years of professional involvement with photographs, John Fraser now doubtless "saw" with the objective absorption of the lens. The mast is so telling: it is depicted not as an object modelled of wood, but as a long cylindrical shape that reflects light in a particular and characteristic way. Coloured light, it must be stressed, because the whole scene is suffused with that incredible flood which on certain days refracts through the atmosphere, just at the moment when the sun dips beneath the horizon. It is indeed a splendid painting, and warmer, and in scale ultimately more human, than the paintings of O'Brien's imperial vision on the Saguenay.

I should add, as a kind of footnote, that *Laurentian Splendour* also reflects Fraser's increasing awareness of American painting (as *Sunrise on the Saguenay* reflects O'Brien's). Particularly with the addition of the small boat and the lone sailor, he relates his picture to the by-then familiar pictorial formula of Martin J. Heade, and some other of the American Luminists. The feeling of quietude is, however, more sensuous, more substantial than their cerebral idealism.

The other oils he showed were all works of the previous two or three years, except for a canvas the same size as *Laurentian Splendour*, entitled *In Breezy October (Bay of Chaleur)*, and also dated 1880, now in the National Gallery of Canada. It is more of a figure-piece, closer to *A Sea-Side Idyll*, though stripped of anecdotal detail. Fraser showed the study for *A Sea-Side Idyll* as well – in the catalogue it is called "Study for

a Large Picture (in possession of Lady Howland).'' The other oils were also smaller. The whole show moved on to Montreal in April (though Fraser dropped two of his watercolours), and there Princess Louise bought one of the small oils, *A Last Ray in the White Mountains (Daily Witness*, 23 April 1880). By the time everything had arrived in Toronto for the OSA annual exhibition in May, he had dropped all but *Laurentian Splendour* and two of the smallest oils.

During the summer Fraser again, as in 1877, travelled east to the Bay of Chaleur. He was under commission to complete drawings for *Picturesque Canada*, and he ventured beyond the Intercolonial line to Gaspé before returning home. This was two years before O'Brien visited that region. Back in Toronto at the end of the summer he received a member of the press in his studio, and a small article appeared in *The Globe*, so full of interest concerning current working methods, and so suggestive of Fraser's ability to capture common interest, that it is repeated here in its entirety:

> The general public who visit the annual Exhibition of the Ontario Society of Artists have probably a very erroneous idea of the methods pursued by the men who paint the pictures. There are, no doubt, artists who complete their landscape on the spot, and with the scene constantly before their eyes; but the average Canadian artist, who is compelled to lay up in the course of his so-called 'vacation' of a few weeks material for a whole year's painting, has to adopt a different course. Selecting some locality, he spends his time while in it making what he calls his 'sketches,' which are really water-colour paintings in varying stages of elaboration. Some of them are, though bearing traces of the necessarily hurried manner in which they are executed, very fine pictures, and there is about a good 'sketch' a breezy, open air look which it is difficult to reproduce in the more elaborate watercolour landscape or still more ambitious oil painting based upon it.
>
> A visit to the Studio of Mr J.A. Fraser, a look at the great number of admirable sketches he has brought home with him as the result of a few weeks work, and a chat over the scenes he has just visited and the difficulties under which he was travelling and working while on his tour, gives one some idea of

the amount of labour an artist goes through in order to prod-
uce the pictures which alone meet the eye of the general pub-
lic. His route this year was down the St Lawrence; across the
peninsula between the St Lawrence and Restigouche, Matape-
dia, and Upsalquitch rivers by canoe and carriage; down the
Quebec side of the Bay of Chaleur; up the Cascapedia, from
which he was driven by black flies; including visits to New
Richmond and other places along the north shore of the great
estuary. Amongst the places visited and sketched were the
junction of the Restigouche and Matapedia rivers, where the
'Salmon Club' of New York millionaires have taken up their
summer quarters, and the scene of the Duke of Beaufort's rus-
tic resort at the junction of the Upsalquitch with the Resti-
gouche. 'Squaw's Cap Mountain,' on the Restigouche, forms a
prominent and striking object in several of the sketches, in
looking over which one comes across old acquaintances like
Cap Rosier, Black Cape, and other points of interest along the
Gulf and River St Lawrence.

But it was at Percee [*sic*] that Mr Fraser found his 'bonanza'
this year. The place is a fishing village at the foot of some high
mountains on the shore of the Bay of Chaleur, and it derives
its name from a long, high, and not very wide rock of singular
formation and striking appearance which stands some little
distance out to sea. There is a large opening through this
rock, worn by the action of the waves and wide enough to
allow fishing boats to pass, and other spots are gradually
being scooped out by the turbulent waters. Still further from
shore lies the Island of Bonaventure, which appears in one of
the sketches, while the Percee rock is figured in various
aspects in half a dozen of them. Both the island, which is a cliff
some 800 feet high for six miles on one side, and the rock are
the home of vast numbers of birds. The finest view of the rock
is one of the shore end, which gives the observer the idea of a
huge irregular cone or trap, surrounded on all sides by deep
water, which reflects the varying hues of the rocky mass. In
more than one of his sketches of this locality Mr Fraser has
dotted the little harbour with the bright red and pure white
sails of the large fish boats of this locality, which impart an

exceedingly picturesque appearance to the scene. From the double impression conveyed by his sketches and his verbal descriptions one may safely conclude that Percee will amply repay the tourist who pays it a visit (16 September 1880).

The watercolour described as "the finest view of the rock" is now in the Montreal Museum of Fine Arts (see pl. 136). It is very good, a

136

John A. Fraser
The Percé Rock 1880
Watercolour, 43.5 x 32.5 cm
Montreal Museum of Fine Arts,
gift of Lord Strathcona and family,
1927 (927.269)

startlingly original point of view, and confidently placed on the sheet, so that the rock balances perfectly with the dark foreground water. The cloud of birds drifting off to the left again precisely counterweights the tilt of the rock. His technique is virtually flawless: open, broad and airy, yet closely descriptive. He had every right to call in the press when he came back with prizes like this.

Fraser must have impressed the reporter, who was the author of a periodical column called "Among the Studios," for he featured the painter again the following April. This time he relates the final step in that creative process which he had described in the opening of his article of the previous September:

> Mr John Fraser will exhibit this year an oil painting which is in some respects the best he has ever produced.... His *pièce de résistance* this time will be a sea and landscape, located at 'Rock Percé,' on the Gaspé shore. A side view of this celebrated rock, with its natural tunnel, constitutes the background of the picture. The rock is some three-quarters of a mile long, nearly 400 feet high and some 300 feet thick, and is from every point of view a most picturesque and interesting object. It loses nothing in the hands of the artist, who has grouped around the details of a busy fishing scene. Immediately in front of the rock stretches a broad, still expanse of sea, dotted over with the red and white sails of fishing boats, and in the foreground is seen the beach, with a crowd of men and women, some of whom are lounging in attitudes as picturesque as their garbs, while most of them are busy getting the fish ashore or cleaning and carrying them off after they have been landed. The immediate foreground of beach is wonderfully realistic in both the appearance of the ground and the truth to locality of the few nets and other appliances scattered carelessly about (30 April 1881).

What the journalist fails to mention is that the picture (see pl. 137) now in the collection of the Metropolitan Toronto Library, is big (the widest Fraser ever painted), and is glorious in its light and colour. It is probably the best oil he ever produced, and was certainly strong enough to support the challenge it so clearly presented to O'Brien, whose two royal views of Quebec were also in that year's exhibitions.

137

John A. Fraser
Morning on the Beach at Percé 1881
Oil on canvas, 63.5 x 152.4 cm
Metropolitan Toronto Library (B 13-155)

Morning on the Beach at Percé might even be seen as a taunt to O'Brien. In it, the rock is placed exactly in the same position as the rock of Quebec in O'Brien's *Quebec from Point Lévis*, and the two forms are similar in shape and proportion, although Fraser's picture is twice the size of O'Brien's. Fraser's has all the stillness of O'Brien's as well, although it is not so austere. And, of course, it is equally a scene of Canadian industry in a dramatic landscape setting, but of a nature markedly different from O'Brien's. And as if to drive all of this home, the article in *The Globe* quoted above appeared on precisely the day O'Brien had set aside for the private viewing of his royal commissions.

Fraser put virtually everything he had into this oil, showing only another smaller one at the OSA exhibition that year, and three of his Gaspé watercolour sketches. In June he arranged for *Morning* to be added to the display in the new AAM galleries in Montreal, along with *A Sea-Side Idyll*, which was borrowed from its owner for the occasion (*Daily Witness*, 15 June 1881). Then in July it was included in the second RCA exhibition, which was held in Halifax. *Laurentian Splendour* and *Breezy October* were sent there too, along with an earlier small oil and

seven Gaspé and Bay of Chaleur watercolours. He did not himself attend the opening or General Assembly. In fact, we do not know whether he travelled anywhere that summer. He had just built a summer house on Toronto Island and perhaps he decided to enjoy its benefits. There is a suggestion in Nanette Fraser's diary that he had established the family on the Island, in a rented house the previous summer, while he was travelling in the east. *Morning on the Beach at Percé* was shown again at the Toronto Industrial Exhibition in September.

He does not seem to have been painting much, although he did send three small oil studies (not field-sketches, it would seem) to the tenth OSA exhibition in May 1882, and seven Gaspé watercolours, three or four of which were probably studio work. We do not at present know any of them. He did not exhibit with the RCA in Montreal that year, but instead sent his cranky letter about fees, diplomas and incorporation – thinly-veiled criticisms of O'Brien's presidency. Although late in the year it is noted in the OSA minutes that he was teaching at the Ontario School of Art, we hear of no painting trips in 1882. He showed for a second time with the American Water Color Society in New York in February 1883 (three Gaspé scenes).

At the AAM spring show he exhibited only one work, although it was a new oil. It was another New Brunswick scene, and has dropped from sight. A slot was left for him in the catalogue of the combined OSA–RCA exhibition that year (no. 94), but he failed to submit anything. There were too many other things on his mind. He had moved his home again in the spring, to 167 Huron Street, just west of the University, and then in June he suddenly bustled the female portion of the family off to Dorchester, Massachusetts, just outside of Boston. Here they were joined by the two Sandham children, whose parents were in Europe (Nanette Fraser's diary). Donald, the youngest Fraser boy, followed them there later in the summer.

With a descendent in California is a small sketch-book that partly explains all these complicated movements. It contains drawings made on a western trip that summer. Fraser was then working out of Chicago, as on the inside cover is written "Return if found, to John A. Fraser, 'Railway Age' Office, Adams St. Chicago US." A number of the drawings are dated, and it appears that there were two separate excursions. One group, dated 26 July to 6 August, were done around Newfield and Lapointe, Wisconsin. Some of these are landscapes (Devils

Lake, Lake Mimetonka), but a number of them are of St Joseph's Church at Lapointe, which was reputedly built in 1640 by Père Marquette. Then there are some views of Calgary, dated 23 August.

Further on into the sketch-book we discover that he was in Brandon 28 August, and then back out to Medicine Hat in September, as though he were riding back and forth on the line of the CPR, which by August had reached just beyond Calgary. There is a pleasant drawing, "At the foot of the Rockies, Calgary, NWT," and a nice double-page one, "Afternoon at Calgary, Looking to the Rockies," but that is as close as he gets to the mountains. The most attractive drawing of all is a double-page panorama of a sparsely-inhabited Medicine Hat, dated "Sept 1883." The paper in the book is a middle-dark grey-brown, and all of the drawings are in pencil, some, including this one, with white body-colour added. The trip ended about the middle of September, and it is noted that he returned from Winnipeg via Rat Portage to Port Arthur, a portion of the CPR line which had been fully opened only the year before.

There is no obvious reason for the journey. He was the first Toronto painter to travel in the northwest by rail, and it may simply have been another summer painting trip. The drawings, particularly those done in Wisconsin, look very much like magazine work, and there is even a kind of rough contract copied out in the back of the book, in which a custodian releases the St Joseph's Church drawings for just that purpose. But no such illustrations have so far turned up in any publication. *Railway Age* was a trade paper, and not illustrated.

On one of the pages of the book it is noted that certain gentlemen ordered pictures. "19th Sept. Mr Eugin gave me order for 3 of my best pictures one of the end (Port Arthur) one of Rat Portage division and one West of Winnipeg. Send them when ready. He will pay (he says he is quite able to pay) I don't doubt it...." A certain McIntyre, who also wants a picture, is mentioned in a note dated 21 September. The only presently-known watercolour related to the trip is *The Ferry at the Mission, Fort William*, which is in a private collection in Toronto. It is skilfully painted, and quite finely finished, obviously in the studio.

We cannot be certain where he had his studio at this point. Those members of the family that were in Dorchester stayed there, while the two oldest boys (men by then), continued to live at 167 Huron Street in Toronto. Sometime in the fall of 1883 Fraser broke off his partnership

with William Notman, whether amicably or not, we do not know. He did not abandon photography, however, as the new firm of Fraser & Sons, appears in the Toronto city directory of 1884. However, Augustine and John Arthur Jr must have run the business on their own, since we know for certain that Fraser moved to Boston in the early summer.

In April he showed for the first time with the Boston Art Club, four east-coast watercolours. He gave Henry Sandham's Boston address (Sandham had moved there two years earlier). Eventually, Fraser settled on Adams Street in Dorchester. He had sent two drawings to the Salmagundi black-and-white exhibition in New York late in 1883, and during that fall of 1884 he worked with Sandham on illustrations for *The Century Magazine*. (We shall see the connection with W.L. Fraser later, for the clan was gathering again.) The illustrations appeared the following year, in April, in an article called "From Puget Sound to the Upper Columbia" (xxix, pp. 832-842), and also in September and October for "The Great River of Alaska" (xxx, pp. 738-751, 819-829). They were renderings of other artists' sketches.

Fraser had not turned wholly to illustration work. It probably took over the role previously played by photography: that is, to make money. He showed with the American Water Color Society again in February 1885 – the Fort William picture which is now in Toronto – and with the Boston Art Club in April. On the latter occasion he exhibited three watercolours: a large one, *On the North Shore of Lake Superior*, and two sketches done in the Boston area. He became a member of the Boston Art Club that year, and with Sandham and other local painters, formed the Boston Water Color Society, which held its first exhibition in December. He showed sketches made that summer at Lake Sunapee, New York, at Nahant, Massachusetts (where the family had vacationed) and other spots around Boston, as well as one Percé scene.

He also continued to work on illustrations, this time based on photographs. These appeared in *The Century Magazine* the following May (xxxii, pp. 137-152). In June 1885 the family had moved into Boston, to the Hoffman, a fairly fashionable apartment building at 120 Berkeley Street. Nanette noted in her diary that they were still "very comfortably off."

XII

Those
Who
Faced
East:
1880–1890

F.A. Verner
Otto Jacobi
Henry Sandham
William Raphael
Allan Edson

F.A. VERNER

The last concrete sign we have of Frederick Verner's presence in Toronto is the appearance of his name in the roll-call of the OSA meeting on 15 May 1880, which was duly recorded in that Society's minutes. He appears to have been very active all through the early part of that year. In February he had once again shown with the American Water Color Society. In March he contributed two oils and a watercolour to the first RCA exhibition in Ottawa, even though he had failed to be chosen as either an Academician or an Associate. Later that spring he had a large selection of both oils and watercolours in the OSA exhibition. He had also gone again to New York, to attend the National Academy of Design exhibition, giving his address as "Toronto." But this was rather misleading since we know that some time during the summer or fall of 1880, he moved to England. He remained, therefore, unaware that no particular attention had been paid to any of the contributions he had made to the various shows.

The following year, in spite of his departure from Canada's shores, he was represented at the AAM special, all-Canadian exhibition of April 1881, albeit by some of his older work, which had probably been left behind in Toronto. However, to the OSA in May he sent over a group of watercolours, three-quarters of which were new scenes of Devon. The only oil was of Mount Desert, in Maine. That year he also made his first

appearance at the Royal Academy, London, with his large Landseer-like oil, *Monarch of the Prairie*, which he had first shown in Toronto in 1878. We see from the catalogue that he was now settled in London at 80 Cambridge Terrace. Again, neither of his efforts in oil elicited much response, although *The Globe*, while reviewing the OSA show, remarked rather dryly that "Mr Verner, who has this year got one of his pictures into the Royal Academy in England, exhibits here only one painting in oil, 'Mount Desert,' which is not a good specimen of his skill" (14 May 1881). At the Toronto Industrial Exhibition in September he was again well represented, by new work he had sent over for the OSA, and by pictures he had left behind in 1880. And, as though in an active attempt to keep the Verner "image" alive, there were also four oils lent by W.H. Howland, including the two purchased from the first OSA exhibition in 1873.

In subsequent years, Verner continued to send work to Canada – his first scenes of Edinburgh arrived for the third RCA exhibition in Montreal in April 1882. He also continued to receive polite but somewhat lukewarm notices. However, a ripple of excitement can be found in the *Dominion Annual Register and Review* for 1883 (p. 242). It appears Verner had scored a success in his joint exhibition with his friend, O'Brien, which was held at J. Nathan's Burlington Gallery in London, November 1883. During that showing Verner sold one picture to the Princess of Wales, and another to Prince Henri de Lichtenstein. Such patronage, as we have seen, counted for much in those royalty-conscious days, and the following year the Canadian art world was suddenly more attentive. In April Verner sent only five works to the RCA: four watercolours of buffalo, and *The Upper Ottawa* (pl. 138), a large, beautiful canvas he had first exhibited at the Royal Academy in London two years before. Here is how the reviewer in *The Week* reacted, driven as it were to the extent of using poetic idiom, in an attempt to describe the remarkable qualities of the painting:

> Mr Verner is well known for his prairies, canoes, and buffaloes, which attract special attention. It is said that he astounds the 'natives' in England who now take an interest in the wonders and inhabitants of the great 'Lone Land' of a past generation. The painting of the 'Upper Ottawa' is not of this class, but is without exception the best work this artist has ever

138

F.A. Verner
The Upper Ottawa 1882
Oil on canvas, 82.6 x 151.8 cm
The National Gallery of Canada, Ottawa,
purchased 1958 (6985)

exhibited here. It is worthy of particular attention as a remark-
ably well painted and pleasing landscape, such as ever charms
and never wearies in the beholding. In early autumn, as the
picture sets forth, when the woods are beginning to mellow,
of a bright sunny day yon bark canoe lightly poised on the
glassy surface of the river losing itself between the rocky
shores separated and still united in their reflections whilst
they claim the companionship of their island aide-de-camps in
waiting. The sky laughs, the water responds in this mirror,
and the reflections dance. The wind must be present, so it
comes in a gently wheeling eddy, and kissing the water marks
the spot. It would be a joy to live ever in converse with such a

scene. This is nature not painting (I, 1 May 1884, pp. 344-345).

And that certainly amounts to high praise. Not that it is misplaced, for *The Upper Ottawa* – which is one of the great Canadian pictures in the National Gallery of Canada – is without question among Verner's finest work. It is a formal painting: the source of its strength lies in its mood of composure. The composition goes back to the watercolour, *West Angle, Lake Shebandowan*, which he first showed with the American Society of Painters in Water Colors in February 1876, and which we have singled out as one of the first instances of Verner's response to the thoughtful composition and dexterous handling to be found in Lucius O'Brien's watercolours. Although *The Upper Ottawa* is more complex visually than are O'Brien's paintings of the seventies, it is still these latter, wonderfully calm works that it reminds us of, capturing as it does both their clarity of atmosphere and breadth of vision.

Verner seems to have sold *The Upper Ottawa* in Montreal, and also one of his buffalo watercolours, for the only pictures sent on to the OSA in Toronto were three watercolours. He continued to send a few works from London each year, usually to the AAM spring show, the RCA and OSA exhibitions, as well as keeping a dealer or two supplied. In October 1882 he had married Mary Chillcott, the woman who had been his landlady for so many years in Toronto, and they settled down at 39 Palace Terrace, Fulham, a fine house that had been left to Verner by that same aunt with whom he had lived, as a young art student and military man, twenty years before. After 1881 he had a studio at 16 Edith Villas, in West Kensington, and submitted work annually to the Royal Academy, which accepted pieces in 1881, 1882, 1885, 1886, 1889 and 1900. He showed with the RSBA in 1882 and 1893, and maintained a lengthy relationship with Nathan at the Burlington Gallery and with one or two other London dealers.

Verner periodically returned to Canada, and seems to have enjoyed some prominence again from late in 1888 until the summer of 1892. He held a large auction sale at M. Hick's rooms in Montreal on 27 October 1888; had a number of works reproduced in *The Dominion Illustrated* from January 1889 to November 1890; and appears to have lived at Sandwich, Ontario, from some time in 1891 until July 1892. (His return to England is noted in *The Week*, IX, 8 July 1892, p. 507.) He

was finally elected Associate of the Royal Canadian Academy in 1893. Yet from about 1880 until his death in May 1928, his life and career were clearly centred in London, where he repeated his Indian and buffalo scenes well into the present century. In any final judgement of his work he can perhaps best be described as a late-Victorian specialty-painter. By definition, that sets him quite firmly apart from those artists he left behind in Canada who were continuing to search for, and find, some expression of developing national aspirations in the landscape of their country.

OTTO JACOBI

A final look should be taken at Otto Jacobi, who had also left Toronto in 1880. He is last listed in the minutes of the OSA at a meeting of 12 February 1880, though he was in Canada long enough to visit the first RCA exhibition in Ottawa in March. He had been chosen as one of the Toronto Academicians, but failed to submit a Diploma picture, or any picture, for that matter. The prominent Ottawa collector, Allan Gilmour, lent one in his possession for the show. When the exhibition moved on to Montreal in April, some works by Jacobi which were already in that city – a few from the collection of the AAM – were included. He was not, however, represented in the OSA annual in May.

He next turns up in an OSA membership list for the summer of 1881 with an address at "Manvel, Dakota." One of his daughters (he had two), his son, and perhaps other members of his family had already settled in the Dakota Territory, and Jacobi had presumably been visiting them, perhaps acting out his dream of homesteading in the West. He did not stay for long, and in fact the address given in the OSA list was already incorrect, for at some time early in 1881 he had settled in Philadelphia. He showed eight of his Canadian watercolours at the annual exhibition of the Pennsylvania Academy of the Fine Arts that May. His address in the catalogue is 1334 Chestnut Street in Philadelphia. He appears in the Philadelphia city directory for 1882, his studio still at Chestnut Street, but his house at 6113 Hoffman Street.

Although friends had lent one work to the RCA exhibition in Halifax the year before, and a goodly selection to the Toronto Industrial Exhibition, Jacobi did not appear in any exhibitions in 1882. By 1883 he had given up his studio, but was still listed on Hoffman Street. Then

in 1884 he does not appear in any listings. Had he gone west again, to the Dakota Territory? That year, in both the RCA exhibition in Montreal and the OSA in Toronto, his lone oil submission was a new figure-piece, called *A Young Pioneer in the North-West*. In 1885 he showed only in Toronto (a joint RCA–OSA exhibition), his submissions all being older works, probably sent in by Spooner. In 1886 he did not exhibit, and in 1887 only thinly, and only in Montreal. By 1887 Jacobi was once again resident in that city, and is recorded in that year's city directory at 60 Beaver Hall Hill. The following summer he was back to Dakota for a brief visit with his children at Ardoch, a village adjacent to Manvel, oddly enough of the same name as his earlier home north of Kingston (*The Dominion Illustrated*, I, 1 September 1888, p. 143).

All of Jacobi's works that have survived from the eighties are in his developed, personal style of idealized landscape. They had become more and more stylized. But Jacobi remained a respected, virtually a venerated, figure on the Canadian scene (see pl. 139). He remained in Montreal, with his studio in the Fraser Institute, until 1891 when he settled in Toronto again, at the rear of 82 Summerhill Avenue.

139

O.R. Jacobi *c.* 1890
Albumen print,
11.2 x 8.0 cm
Notman Photographic
Archives,
McCord Museum,
Montreal (MP 129/78)

Although at first he had seemingly spurned the RCA, he was apparently finally convinced that it was worthy of his attentions, and submitted a Diploma picture in 1883. In 1890, at seventy-eight, he was elected President to replace the retiring O'Brien (who was then only fifty-eight).

Jacobi served three years, but following the conclusion of his term became increasingly withdrawn, owing to rapidly failing eye-sight. His wife died in 1896, and he left Canada for the last time to live with a daughter in North Dakota. (His other daughter was then living in Red Deer, Alberta, and his son in East Grand Forks, Minnesota, on the Dakota border near Ardoch.) He died at Ardoch on 20 February 1901. An old trouper to the end, he offered two last works for sale at the Toronto Industrial Exhibition in September 1900. They were entitled *Evening Glow* and *Last Rays of Day*.

HENRY SANDHAM

When Jacobi moved back to Montreal in 1887, he found hardly any of the painters he had known in the sixties. Robert Ducanson was long gone, having died in Detroit in December 1872, incapacitated, at the end, by the onset of delusions. C.J. Way had left and of course so had John A. Fraser and Henry Sandham.

Sandham in the fall of 1877 had entered into partnership with William Notman. Just as with John Fraser in Toronto, this arrangement seems to have freed him from day-to-day routine, and he was able to devote long stretches of time to painting, and, increasingly, to magazine illustration. Following his experiments with Leggotypes and the more conventional wood-engraving in the early seventies, Sandham had let this interest lapse. Or at least, he had not found many opportunities to pursue it – only two, in fact.

In 1874 he made a drawing of the great *Fête nationale* parade, which was engraved for *L'Opinion Publique* (VI, 2 July 1874, p. 324). Then two months later, a couple of his sketches of Lake Memphremagog – one of the Owl Head and the other of Mount Orford – were quite sensitively cut in wood for the *Canadian Illustrated News* (X, 26 September 1874, pp. 204-205). For him, drawing was more rewarding than cutting, and after his crude attempt at working on the block in 1870 for *A Tale of the Sea* he had plainly made the decision to leave this particular skill to others.

However, drawing illustrations did appeal to him, and early in 1877 he got his first big commercial break when he was commissioned to illustrate an article, "Canadian Sports" by W. George Beers, in the popular New York publication *Scribner's Monthly*. Beers was a Montrealer who can only be described as a dedicated sports enthusiast. He was instrumental in establishing lacrosse as the official national sport, and avidly supported every aspect of the sporting scene in Canada. Undoubtedly, he would have been a close associate of Alfred Sandham, then Secretary of the Montreal YMCA, and it is probably through that connection, if not simply through the agency of the Notman & Sandham sport composites, that he met Henry. His article appeared in the late summer of 1877 with wood-engravings of twenty-four Sandham drawings (XIV, 1877, pp. 506-527). That, by the way, was just prior to the partnership agreement with William Notman.

In 1878 the Sandhams had another daughter, Alice Muriel, which meant they were now supporting three girls and a boy. Early that year they had moved to 447 St Lawrence Street, and Sandham had been represented in the revived AAM exhibition by four oil paintings. One was a *Marine View on the St Lawrence* lent by William Notman. It was probably similar to the river landscape of the mid-seventies, now in the National Gallery of Canada. There was a portrait lent by Notman & Sandham, doubtlessly one of the firm's large photo-based oils; a figure-in-landscape, *Waiting for a Bite*, lent by W.F. Kay, one of the early supporters of the AAM; and finally there was *Return from the Hunt*, lent by Scott & Fraser, a large figure-piece now in the National Gallery. This last appears, to all intent and purpose, to be a very finely finished large photo composite. It served as the basis for one of Sandham's drawings reproduced in the "Canadian Sports" article (it is dated 1877). How perfectly it expresses the way Sandham's growing interests – photography, illustration, painting, and particularly figure-painting – were being brought together, just as both his own, and Montreal's, economic life were taking a sharp turn for the better.

In the summer of 1878 Sandham was visited in Montreal by one of *Scribner's* editors, R.W. Gilder, and out of that visit grew another article, this time by Sandham himself. Did his wife help with the writing? Her father had done some part-time writing, although so had Sandham's brother, Alfred, who had written an illustrated history of Montreal, *Ville-Marie, or, Sketches of Montreal, Past and Present*, published in 1870.

Sandham's piece was called "Chambly Fort, on the Richelieu River," and was illustrated by engravings of twelve of his drawings (xvii, 1879, pp. 129-138). Seven of the original drawings – in most cases marked with the engraver's instructions on the back – are now in the McCord Museum. All are monochrome, rendered in either watercolour, or body-colour and pen-and-ink, or a combination of all three. Some are done on toned paper and all strive for a dramatic composition, and for an effective use of the limited tonal range available in wood-engraving (see pls 140, 141, 142). There is a great play of silhouette and of contrasting forms, which are quite nicely used a number of times, as in the wash-drawing for "Poling Up the Stones for the Gate-Way."

By this time, Sandham was also doing piece-work for *Scribner's* (drawings after other artists, or after photographs, which were inserted in completed articles). He also did the occasional single drawing for reproduction in those American illustrated weeklies which had a larger format. But it was through commissioned groups of drawings that he was to really make his name. His previously mentioned article, "Chambly Fort, on the Richelieu River" appeared early in 1879 (see pl. 143), and by that time he was fully launched upon the biggest project ever given him by *Scribner's*, the illustrating of a series of articles by Principal

140

Henry Sandham
Poling up Stones for the Gateway,
Fort Chambly on the Richelieu River
1878
Monochromatic watercolour,
11.9 x 21.1 cm
McCord Museum, Montreal (M965.109.6)

141

142

143

141
Henry Sandham
*The Ravages of Time, Fort Chambly
by Moonlight* 1878
Monochromatic watercolour,
17.6 x 12.8 cm
McCord Museum, Montreal
(M965.109.12)

142
Henry Sandham
The North-East Bastion, Fort Chambly 1878
Ink and monochromatic watercolour,
22.2 x 10.8 cm
McCord Museum, Montreal (M965.109.8)

143
Scribner's Monthly, XVII, 1879, pp. 132-133

George Grant of Queen's University at Kingston. Entitled "The Dominion of Canada," they came out in four instalments in *Scribner's Monthly* between May and August 1880 (xx, pp. 80-95, 241-256, 433-449, 553-568). The appearance of these articles greatly enhanced Sandham's reputation as an illustrator. As has been mentioned earlier, they were also responsible for bringing Grant to the attention of the publishers of *Picturesque Canada*.

One can follow the quite fascinating step-by-step development of the *Scribner's* project, because the letters to Grant from both the magazine and Sandham have been preserved, and are now in the Public Archives of Canada. The initial approach to Grant was made in 1879, at which point Sandham had already been engaged. The two men began their collaboration in the spring of the same year, and then in the fall *Scribner's* decided to devote more space to Sandham's drawings. This necessitated Grant cutting his articles, which he struggled to do during the subsequent winter. Meanwhile, Sandham was rushing to get his sketches done as quickly as possible, so that they could be sent to Grant while he was writing.

Indeed, it could be said that Grant not only had to cut his articles, he also had to shape his writing to the content of the illustrations. We even find Sandham encouraging him to "handle [his article] in such a way that we will soon come to the Canada of the present day." Sandham had a very sound reason for this request. As he carefully explained to Grant he was "convinced that as far as my work is concerned, it will not be wise for me to give illustrations of any subjects except such as I can secure sketches or photos of, for I find it next to impossible to get any reliable historical drawings to work from. Of course," he went on, "I can compose any number of pictures from imagination, but that is not what we ought to place before the public. So I will confine myself to facts that can be seen, or else as in the case of one or two of the gates I now send you, I shall work from photos" (14 May 1879).

Very few of the drawings are, in fact, based on his own field-sketches, and he undertook no travel at all for the commission. On the other hand, it does not appear that he often directly copied a photograph (although he had literally thousands of Notman photos of Canadian scenery and sites to call upon), but instead used the photograph as a source of detail and local colour, afterwards entirely re-casting the composition to meet the needs of the popular wood-engraving. We have original drawings for a few of the illustrations: one in the McCord, some in the National Gallery of Canada, and some in the Montreal Museum of Fine Arts. Like the drawings for "Chambly Fort...." they

are often striking, appealing work, although a little on the commercially stylish side.

In December 1879, while Grant was busily cutting his text, Sandham suggested that he should drop his whole section on Quebec City. "Since I saw you I went down to Quebec to meet Mr Farnham of Scribner's staff who is writing up that city, and I believe it is their intention to transfer most of the Quebec sketches I sent them to Mr Farnham's article" (5 December 1879). "Cut even more, if you want," he told Grant. "I shall be more than glad to cut down the number of illustrations I have promised, as I am so busy that I can hardly think of them at present let alone try to finish any."

Early in 1879 the Sandhams had been faced with the sudden death of yet another of their children, little Alice, born just the year before. He probably welcomed the demands upon his time made by his numerous activities. In February *Scribner's* had placed two of his drawings in the First Annual Exhibition of Original Black and White Drawings, etc., at the Salmagundi Club in New York. In May he showed two oils at the AAM annual exhibition, including the new, large figure-piece, *Gathering Seaweed, Coast of Nova Scotia*, now in the Montreal Museum of Fine Arts. The rest of the year he devoted to the drawings for the Grant articles, and of course he was still a partner of William Notman, in itself surely a demanding role.

Nonetheless he was also able to prepare for the forthcoming first RCA exhibition, and sent four oils and three watercolours to Ottawa in March 1880. Sandham had been chosen as one of the four Academicians from Montreal, and one of his oils, a moody figure-piece called *Beacon Light, St John Harbour*, was deposited in Ottawa as his Diploma picture. When the exhibition moved on to Montreal in April, he added two portraits to his group. Then in Toronto in May, he stripped it down to four small, saleable items, plus his Diploma picture.

By then, he had probably left Canada. There is a note in the *Daily Witness* of 22 April 1880, to the effect that he is about to leave for England. Also, from numerous references in later biographies, we know that he spent the better part of that year in England and France, studying the masterpieces of European art. By 8 December 1880, he is writing to Principal Grant and informing him that he is "now in Boston and very busy" (see pl. 144). Why Boston? It is hard to say. Perhaps because it was close to New York, but presented less of a daily strain. We know that William L. Fraser, Sandham's brother-in-law, had moved to New York, probably in the early summer of 1879. (He had broken the partnership with William Scott in March 1879, and had returned

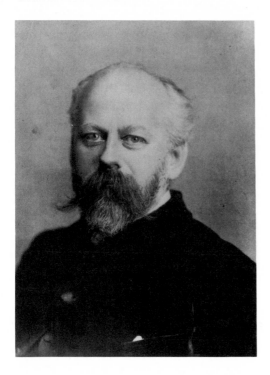

144
Notman Studio, Boston
Henry Sandham *c.* 1882
Albumen print, 18.0 x 12.8 cm
Notman Photographic Archives,
McCord Museum,
Montreal (MP 029/74)

briefly to work with Notman & Sandham. Once in New York, he was to
be for years employed as an art editor with *Scribner's*, which doubtless
had something to do with Sandham's remaining close to that firm.)

In May 1881, Sandham exhibited a large watercolour of an English
subject at the American Water Color Society, giving his address as 4
Park Street, Boston, the location of the Notman branch in that city. He
had also exhibited with the Boston Art Club in February. In April at the
annual exhibition of the Pennsylvania Academy of Fine Arts in Phila-
delphia, he had shown a *Scribner's* drawing. In Canada he had displayed
three English watercolours at the AAM exhibition in April, two of them
again at the OSA show in May, and then his Diploma picture and two
large portraits he had painted from photographs for the Nova Scotia
Government – of Joseph Howe and Judge Strange Johnston – at the
second RCA exhibition in Halifax in July. In September John Fraser lent
three Sandham watercolours of the mid-seventies to the Toronto
Industrial Exhibition.

But by 1881 Sandham was fully installed in Boston even though he remained in partnership with Notman, and visited Montreal periodically and probably for quite lengthy stretches. The family were again hit by tragedy in September when their seven-year-old daughter, Isabella, died.

For the purposes of this study there is no need to do more than summarize Henry Sandham's later career. He ended his partnership with Notman sometime during 1882, the last year in which Notman & Sandham are listed in the Montreal city directory. By then he had settled comfortably into Boston's small art scene. He continued to work for *Scribner's* (or *The Century Magazine* as it became in 1881), at first mainly on Canadian material but, after the middle of the decade, on everything but. He also contributed to *Harper's*, and some other of the American illustrated magazines (notably illustrations for an article by his wife, "A Trip on the Ottawa," in *Harper's New Monthly Magazine*, LXXI, August 1885, pp. 327-342), and doubtless continued to make a good living.

He went on showing paintings in Canada periodically, and even held a large one-man exhibition in Montreal in February 1888, but most of his activity was centred on the Boston Art Club, where he showed regularly until 1901. His portrait painting remained important to him, and in 1889 he was commissioned to paint Sir John A. Macdonald. The picture was presented in Ottawa on 28 February 1890 (*Ottawa Citizen*), and now hangs in the Parliament Buildings. It is Sir John as an aged imperialist.

In this first decade in Boston, Sandham also energetically sought to promote a career as an historical painter. He painted a few huge canvases, some of which were well received at the time. *The Dawn of Liberty* of 1886 is one, a scene of the American Revolution, now with the Lexington Historical Society in Massachusetts. Then there is *March of Time*, showing American Civil War veterans in 1890. It is now in the National Collection of Fine Arts, Washington. In January 1901 he held a large auction at Leonard & Co. in Boston, and shortly afterwards, moved to London, England. For a while he devoted more time to his painting (he was doing little illustration work by then), and to sketching in France, Britain, and the Azores. He developed a rather loose, atmospheric style, well-suited to turn-of-the-century tasks. He died in London on 21 June 1910, as reported in the New York *Times* two days later, and a

large memorial exhibition was staged at the Imperial Institute in London in July of the following year. Canadians had by then forgotten him.

WILLIAM RAPHAEL

By the eighties, of all the landscape painters who had so dominated the Montreal scene in the sixties and seventies, only Raphael and Edson were still there. Both, like Sandham, were chosen as Academicians in 1880 (Napoléon Bourassa being the other Montreal painter selected), and Raphael showed four oils in March at Ottawa. There were two of his *habitant* pictures, a small landscape, *Point au Pic, Murray Bay*, and a larger landscape, *Indian Encampment on the Lower St Lawrence* (pl. 145). Three of these, including the two landscapes, he had first exhibited in Toronto with the OSA in May 1879. The small landscape could perhaps be related to one now in the National Gallery of Canada which is dated 1879. (There are drawings in one of the National Gallery sketch-books made at Murray Bay between 30 July and 8 August 1878, when the sketches for this and one or two other Murray Bay oils of around 1879 –1880 would have been executed.) It is a well-painted picture with strong feeling.

But the larger canvas, *Indian Encampment on the Lower St Lawrence*,

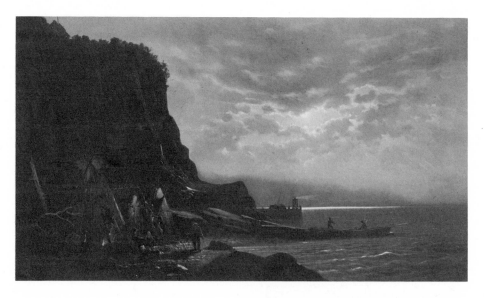

145

William Raphael
Indian Encampment on the Lower St Lawrence 1879
Oil on canvas, 59.1 x 104.8 cm
The National Gallery of Canada, Ottawa,
RCA Diploma picture, deposited 1880
(59)

which was lent to the Ottawa exhibition by William Scott, the Montreal dealer, is much more ambitious. It is twice as big and a dramatic, complex and subtle study of night-light. The bright moon breaking through the clouds and flooding the sky with its intense, reflected radiance at once arrests our attention. It strikes a particularly sharp note where it hits the water of the river, and where it glances off the small waterfall on the face of the cliff. Then we notice the beacon, its lustre made pale and feeble in comparison to the compounded reflection on the water. Next the eye is caught by the light of the flame in the hut, subdued but warm, colouring all that it touches. And finally, we notice the tiny pin-points of illumination radiating from the large house on the brow of the cliff, which is otherwise a dark, lifeless shape against the lightened sky. It is a mysterious painting, and must have seemed particularly so in the company of *Sunrise on the Saguenay* and *Laurention Splendour*. Raphael's most enigmatic genre scene, it is greatly enhanced by the mood of its landscape. He left it in Ottawa as his Diploma picture.

Raphael never again painted anything like it; no picture of his was ever to be so ambitious, so effective, nor so technically accomplished. He continued to paint landscapes periodically, in the German Romantic style he had early adopted as his own. But he never painted very much, and the same oils were shown over and over again at exhibitions

146
Photographer unknown
William Raphael
Copy photograph
The National Gallery of Canada,
Ottawa

of the RCA, the AAM, and occasionally the OSA. When in the winter of 1880–1881 the AAM established a series of art classes for advanced students Raphael was one of the teachers, along with Edson and a certain Mr Van Luppen. This series did not last long, but Raphael always seemed to find teaching posts, his next, for instance was at Villa Maria Convent. And when he could not find employment as a teacher, he established his own class, and advertised for students. This was mainly after he had moved his studio to 2204 St Catharine Street in 1887. (He moved house that year as well, to 39 Victoria Street. Perhaps it was because two more children had been born, Bertha in July 1883, and the ninth and last, Walter, in July 1886.) In the late eighties and early nineties, Raphael's private classes were well-attended, and frequently drew notice in the press. He made an adequate income from them, living out his years as a respected, if somewhat marginal, figure on the art scene (pl. 146). He died in Montreal 15 March 1914.

ALLAN EDSON

Allan Edson re-established himself in Montreal in 1879. He is first listed in the 1880 city directory at 442 Richmond Street, an address close to his mother, who had been widowed the previous year. Although he was one of the four Montreal Academicians, he sent what appear to have been older works to Ottawa in March 1880. His Diploma picture, *Trout Stream in the Forest*, though very fine, was small, and almost five years old. His *White Mountains*, we remember, was painted in 1873. *Old Disused Road in the Forest*, which was as large as *White Mountains*, has been lost sight of. And, surprisingly, there were two paintings on china dishes, as well as two smaller watercolours. No special attention was paid his contributions, though *White Mountains* was purchased for the Royal Collections, and is still at Windsor Castle.

In Montreal in April, however, Edson removed the china, and added four oils and two more watercolours to the showing. (He did not show *White Mountains* there either, though Lorne may have been holding it in Ottawa for shipment to London.) We cannot presently identify any of the new works, except for one, *Mount Orford, E.T.*, which from the brief newspaper descriptions could well be the canvas presently in the Musée du Québec which is known as *The Coming Storm, Lake*

Memphremagog (pl. 147). Dated 1880, it is one of the finest pictures he ever painted.

Although related to his large canvases of Mount Orford of a decade earlier, it seems richer, his experience during the intervening years making him better able to deal with the complex effects of light in foliage. However, it is not a scintillating landscape, as are his forest interiors of the seventies. It is perhaps better described as sonorous, with the light and shade broadly swept in. The brush work is delicate, open and feathery. And the colour! The colour seems a brilliant eruption at the centre of the picture: glory revealed in the flash of an instant. Of all of the pictures we have been examining this is the first that can be described as a frank celebration of the sheer overwhelming beauty of a moment in nature.

The Coming Storm, Lake Memphremagog is important not only because it is such a fine painting, but also because it marks the end of Edson's Canadian work. He taught special art classes for advanced students at the AAM in the winter of 1880–1881, but in the spring he began to make

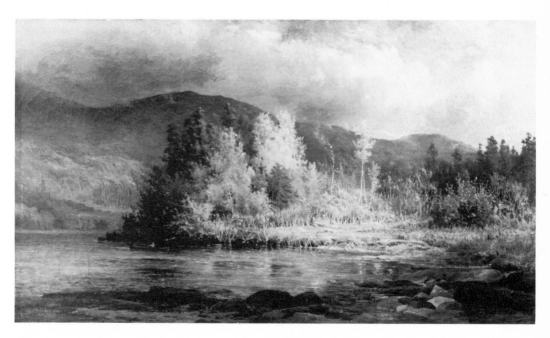

147

Allan Edson
The Coming Storm, Lake Memphremagog
1880
Oil on canvas, 60.6 x 106.7 cm
Musée du Québec, Québec, gift of
the estate of the Honourable Maurice
Duplessis, 1959 (G 59 577 P)

plans to leave, even though a fourth son, Norman, had been born the previous year. His imminent departure was announced in the *Daily Witness* 13 April 1881, and there is a drawing of Quebec City that is dated 7 May 1881 which could have been done on the outward journey (sold at Sotheby's, Toronto, 2 November 1971, lot 157B).

Or he may have stayed the summer. Wood-engravings after some of his pen-and-ink drawings appeared in *Canadian Illustrated News* late in June and early in July (XXIII, 25 June 1881, pp. 403, 412; XXIV, 2 July 1881, pp. 8, 9). At any rate by 4 December 1881 he was in Paris, writing a long letter to his wife. (This has been published in the *Sixth Annual Report of the Missisquoi County Historical Society,* 1960, pp. 47-48.) He had stopped in London on the way, at least long enough to have written her first from there, and from what he says about his living arrangements, he seems to have been in Paris only a week or two. He was at the Hôtel Bisson, 37 Quai des Grands-Augustins, on the Left Bank, across the Seine from the Louvre. Already in April 1882 a French picture, entitled *Up the Seine*, had reached Montreal, and was included in the third exhibition of the RCA.

A descendent has a notebook Edson kept on this trip but has allowed only restricted access to it. I have seen photo-copies of two balance sheets, dated September and December 1882. On the left-hand side of each is a list of pictures sent to William Scott in Montreal, and on the right a record of sales and subsequent deposits in a Montreal account. The final total is converted to francs, and it is noted that a draft for the amount had been received in Paris. Incidental withdrawals in Montreal are also noted: for packing expenses, his RCA dues, and a subscription to the *Montreal Star*.

In the September 1882 list of pictures is a *View of Cernay with Pelouse's Studio*. It is noted in the obituary that appeared in *The Dominion Illustrated* that Edson studied in France with Léon Pelouse, a late Barbizon School painter, now of modest reputation, who lived at Cernay-la-ville, near Paris. Edson had a work accepted in the Salon of the Société des Artistes Français in 1882 (no. 3153 in the catalogue, *Étude de paysage – Canada*); two others in 1883 (no. 884, *En février*, and a pastel, no. 2778, *Une journée brumeuse à Cernay*), and one more in 1884 (no. 275, *Un petit coin aux Vaux, près Cernay-la-ville*). In all three catalogues he is described as a pupil of Pelouse, and his address is given as Cernay-la-ville. He continued to be represented

at home, in both the AAM spring show and the RCA annual exhibition, exclusively by pictures of Cernay. Probably early in 1884 he moved to London, and on 27 March he welcomed his wife and the two youngest boys (there is a mention of this in the notebook). There is also a reference to Joseph Nathan of the Burlington Gallery, where Verner and O'Brien had shown in November of the previous year. Edson stayed in England some months longer, then returned to Montreal (see pl. 148). He is listed in the 1885 city directory as "artist, 251 University," and there is a short piece in the *Montreal Star* for 14 March 1885, describing a visit to his studio on University Street, where the reporter saw sketches of Cernay-la-ville and of the Burnham Beeches.

There was remarkably little reaction to the work Edson sent home, though it appears from the list that Scott was able to sell more than a few hundred dollars' worth. The only other-than-polite notice appeared in *The Week*, in a review of the fifth RCA exhibition: " 'Shooting Path in the Park,' is the best exhibit shown since Edson's residence in Paris, where he is studying under the celebrated Pelouse. It is a close

148
Photographer unknown
Allan Edson c. 1885
Copy negative (19 June 1888),
13.5 x 9.8 cm
Notman Photographic Archives,
McCord Museum, Montreal (86,956-BII)

imitation of the noted master of woodland scenes, and a remarkably good picture, 'after Pelouse,' but I should prefer Edson himself" (I, 1 May 1884, p. 345). That was easy to say, and can hardly be called criticism. The French pictures of the early eighties are very different from the Canadian work, though, and it is clear that he was deliberately emulating Pelouse and other Barbizon painters. There is, for instance, a painting of 1884 in the National Gallery of Canada, that is highly reminiscent of Corot.

Edson did not stay long in Montreal. The *Gazette* noted on 13 April 1885 that he had left for Scotland. He probably took his family with him this time (though again they may have joined him later). There is an inscribed Bible, now with a descendant in Toronto, that was given to the eldest son, Edward, by his maternal grandmother at Teddington-on-Thames at Christmas that year. In due course, the family settled in London, at 39 Clifton Gardens, Maida Vale, and visited the Colonial and Indian Exhibition in 1886, where they saw five of Edson's paintings on display in the Canadian section. These included the Queen's picture (which was then called *Landscape in the Eastern Townships*, to conceal its New Hampshire site), and the *Mount Orford, Morning* which is now in the National Gallery of Canada. In that same year he also had two works accepted by the RA, and two by the RSBA.

Early in 1885, when he was still in Montreal, he had shown Canadian works at the spring exhibition of the AAM (including *A Sketch from Nature*, which is perhaps a lovely small oil study of 1885, of a woodland waterfall in early spring, now in a private Montreal collection). But after his return in 1887 (at some point after 20 April, as he is noted as still being abroad in the minutes of an RCA meeting of that date), he continued to show mainly English work. Edson seems not to have set himself up in Montreal this time, but appears to have worked mainly around Glen Sutton in the Eastern Townships. There in February 1888 he fell ill with pneumonia. He boarded there while his health improved, but went out sketching in the cold again too soon, and died in a relapse on the first of May. He was forty-two. At the end of the month (29 May) an auction sale of his estate pictures was held in Montreal. A catalogue in the library of the Montreal Museum of Fine Arts contains a listing of the prices realized for each item: a surprisingly large total of $5,216.50. Interest in Edson's work would not again be great for more than eighty years.

XIII

Western
Landscape
and
the
CPR

Notman and Henderson: the ever-expanding horizon
the photographers go west:
William McFarlane Notman and Alexander Henderson
Canada on display: the Colonial and Indian Exhibition
Hodgson of the RA on Canadian artists
Fraser attempts the Rockies – at a distance
from ocean to ocean: the CPR
into the mountains at last:
John Fraser and Lucius O'Brien

NOTMAN AND HENDERSON: THE EVER-EXPANDING HORIZON

By the eighties, of that group of Montreal artists who, in the eighteen-sixties, had celebrated Canada's expanding landscape with paint-brush and camera, only William Notman and Alexander Henderson continued to find strength in the national ideal of western expansion. But then expansion, especially to Notman, had become a way of life. To him, continuing growth was the natural, the inevitable thing. It was, indeed, reflected in his own career. Following his success in Philadelphia in 1876 he had opened a number of branches in the United States: at Boston during that year, in Albany, and at Newport, Rhode Island. His photographers worked New England regularly, and offices were soon established at Amherst and Cambridge, Massachusetts, and at New Haven, Connecticut. This American side of the business operated as the Notman Photographic Company.

The Notman & Sandham firm in Canada also branched out, with the establishment of a studio in the Windsor Hotel in Montreal in February 1878, and later that year, an outlet in Ottawa again, listed in the Ottawa city directory at 98 Wellington Street, opposite Parliament Hill.

(This branch remained in operation until 1884, in direct competition with W.J. Topley, who had managed Notman's first business in the Capital, and who had bought that operation from him in 1872.)

Notman's domestic life remained stable, centered round his grand house on Sherbrooke Street. A dark note was the death of his second youngest daughter, Alice Richenda, at the age of seventeen, in February 1881. There had been another loss in the family a year-and-a-half before, when John S. Notman, William's brother and a photographer in his own right, had been killed by a train in the Montreal switching yards.

It was almost symbolic, this death, of how much the railway had become a part of Notman's existence. It could never have been very far from his thoughts. He had supplied a photographer to accompany one of the parties that entered the Rocky Mountains the first year of the Pacific Railway Survey in 1871, and the images which Benjamin Baltzly brought back were a featured part of Notman's landscape business throughout the seventies. They were sometimes reproduced in the form of Leggotypes, and later as photo-engravings. By the eighties, such half-tone engravings of photographs were becoming more common. As mentioned in Chapter XI, the last twenty-two images in *Picturesque Canada*, all of British Columbia, were photo-engravings. At least two of these were made from Notman photographs. This section of the publication appeared in the summer of 1884.

Could these have been made from Baltzly's pictures of thirteen years before? That seems unlikely. There is some evidence in the firm's records that Notman sent an operator to the West for the CPR in the spring of 1884, although it appears that his attempts to take views were for some reason largely unsuccessful. That year, the CPR line from the east finally reached into the mountains, however, and the officers of the company were anxious to obtain visual records of its progress. It is likely that they had, in some way, sponsored John Fraser's run to the end of steel at Calgary the previous summer, and the summer of 1884 they made arrangements for another Notman photographer to travel out.

THE PHOTOGRAPHERS GO WEST: WILLIAM MCFARLANE NOTMAN

This time Notman sent his eldest son (then twenty-six years old), who was also his new partner: William McFarlane Notman. When in 1882 Sandham and Notman dissolved their partnership, William McFarlane joined his father to form William Notman & Son, which is first listed in the Montreal city directory of 1882. By then, William senior had probably not used a camera commercially for some time, and William McFarlane soon became the principal force in the business. He was also a photographer of considerable skill and artistry.

The CPR, according to Russell Harper in the volume on Notman he helped to prepare in 1967, supplied William McFarlane Notman with a private car, specially equipped as a travelling darkroom. It would have had to have been hauled out west through the United States, at least as far as Winnipeg, as rail still had not been laid north of the upper Great Lakes in the summer of 1884. Young Notman perhaps travelled with this special car, but he may also have met it in the West. Whichever way he actually chose to travel, the *Calgary Herald* of 23 July 1884 reports he had left that city the previous day for the mountains. We have no record of how long Notman remained in the Rockies that summer. He brought back a number of views of Kicking Horse Pass, as well as some of the Prairies, and the latter were probably taken on the return journey east.

William McFarlane Notman's 1884 photographs of the Kicking Horse Pass region invite comparison with those taken by Benjamin Baltzly in 1871. Baltzly was in another part of the mountains, farther west and north, and the difference in the terrain is evident. So is the difference in the material circumstances of the two photographers. In Notman's work there is little of that feeling of human struggle against natural forces, so apparent in a number of the Baltzly photographs. And, generally speaking, there is less of that sense of intimacy with the land which permeates the earlier works.

But it must be remembered that at this point in history the younger Notman would be seeing it all with very different eyes. It was now 1884, and the story to be told was of man's conquest of these natural monuments and how easily they could be reached. Notman must have had his headquarters at Laggan, the main construction camp, just east of the divide. From there he could daily make the short run up

over the pass and down into the Kicking Horse Valley. Most of the pho-
tographs he brought back are carefully composed studies of the great
peaks surrounding the pass, particularly Mount Stephen, named after
the President of the CPR, and Cathedral Mountain. Silhouetted against
the sky, these great masses of rock seem as though freshly carved, their
forms are so clean in contrast to the rough forests at their feet (see pl.
149).

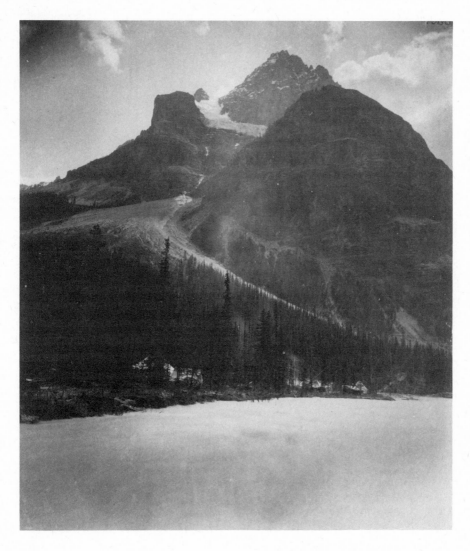

149

William McFarlane Notman
Mount Stephen, East-End Tunnel,
Kicking Horse Valley 1884
Albumen print, 20.0 x 17.5 cm
Notman Photographic Archives,
McCord Museum, Montreal (1360)

The railway line, or aspects of its construction, appear in almost every photograph. But these signs of human industry are invariably dwarfed by the mountains, and it is clear that it was the breathtaking grandeur of the Rockies that caught Notman's interest. That was the real subject of these works. Seldom truly sublime, the mountains no longer posed any immediate threat, real or imagined, to the traveller.

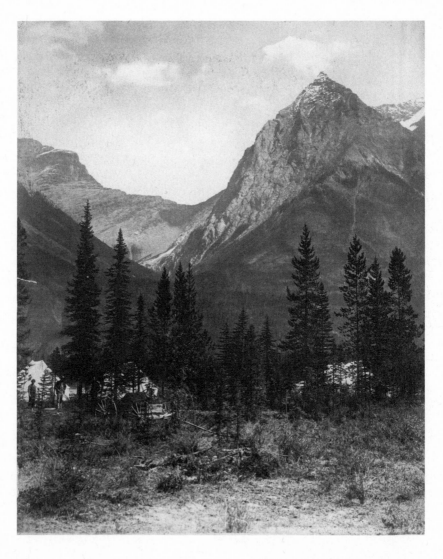

150

William McFarlane Notman
Kicking Horse Pass, Beaver Foot Camp
1884
Albumen print, 22.5 x 18.0 cm
Notman Photographic Archives,
McCord Museum, Montreal (1349)

Nevertheless, they are still enormously impressive, and in every com-
position Notman attempts to enhance their scale. And they are also
photographs in the great Notman tradition. They demand one's total
involvement. Their richness of texture and gravity of tone enobles
every image, and involves us in the most intense consideration of each
new scene (see pls 150,151).

151

William McFarlane Notman
End of Track, Aug 1st 1884
Albumen print, 23.0 x 17.2 cm
Notman Photographic Archives,
McCord Museum, Montreal (1364)

THE PHOTOGRAPHERS GO WEST: ALEXANDER HENDERSON

As a result of his lengthy period of work in eastern Quebec and New Brunswick for the Intercolonial Railway, Alexander Henderson was by way of being something of a specialist in railway work. In the National Gallery of Canada in Ottawa is an *Album of Photographs of Wrought Iron Railroad Bridges Constructed & Erected for the Government of the Dominion of Canada on the Line of the Quebec, Montreal, Ottawa & Occidental Railway, by Clarke, Reeves & Co, Phoenixville Bridge Works – Phoenixville, Penna., U.S. America, 1877–1878,* which must have appeared in 1879. It is a large, lavish volume, and the photographs are clear and straightforward documentations of the bridges. Upon occasion, they are also stirring images. Then in 1885, the year after sending William McFarlane Notman west, the CPR commissioned Henderson to travel as far as the western head of rail, which that summer reached beyond Kicking Horse to Rogers Pass and the summit of the Selkirks.

Only four pictures from this trip have so far been located. After his return to Montreal Henderson supplied the CPR with a number of prints, certainly more than ten, and the company subsequently purchased a group of negatives from him (letter from A. Piers to Alexander Henderson, 22 March 1886, Canadian Pacific Corporate Archives, Montreal). In later years all of these were destroyed. Most unfortunately, Henderson's personal prints and negatives were also destroyed – and this during the present century, as will be explained later. As a result, the four prints now in the Notman Photographic Archives in the McCord Museum in Montreal are virtually the only record we have of his first trip west (see pls 152, 153, 154, 155). All are of scenes in the heart of the Selkirks. Certainly the masses of soaring, lodge-pole pine and the thick, lush undergrowth, were ideal Henderson subjects.

Henderson's four photographs are all larger in size than those young Notman took the year before. And they are better preserved than any of the 1884 Notmans that have so far entered public collections. In printing, Henderson toned to a broader range than did Notman, and though William McFarlane had not the propensity to sharp contrast of mass and tone, so marked in the work of his father, his photos are generally more dramatic in appearance than Henderson's.

Henderson's are gentle yet strong poems to harmony, each an encompassing study of healthy, vigorous landscape, grown to its capacity within the protecting confines of the mountain ranges. In his four

152

Alexander Henderson
In Beaver River Valley
Near 6-Mile Creek, CPR, B.C. 1885
Albumen print, 35.5 x 26.0 cm
Notman Photographic Archives,
McCord Museum, Montreal (MP 141/76)

153

Alexander Henderson
The Hermit Range 1885
Albumen print, 26.9 x 34.4 cm
Notman Photographic Archives,
McCord Museum, Montreal
(MP 120/78)

154

Alexander Henderson
*Hermit Range, Selkirk Mountains,
from* CPR, *Summit,* B.C. 1885
Albumen print, 25.6 x 34.8 cm
Notman Photographic Archives,
McCord Museum, Montreal
(MP 119/78)

photographs he tends to the expression of a broad, generalized view of the nature of the land, rather than composing portraits of the principal isolated peaks, as Notman did. He has accepted whole this rich new land, so long hidden by mountain barriers. And in his sensitive, embracing views even the scars of railway construction appear but momentary surface blemishes, soon to be hidden in growth.

Henderson's western photos are inspired, and it would appear that the CPR people were pleased with them. The following year they sent his prints, rather than Notman's, to an artist who sought information about the landscape surrounding the mountain route. In April 1892, Alexander Henderson became the Manager of the Photography Department of the CPR. This position, Stanley Triggs informs us, required that he spend at least four months annually in the field (*Archiveria*, no. 5, winter 1977–1978, p. 50). Apparently he included a trip to Victoria in his field-work that year, and spoke of returning five years later. There is no evidence that he did so, however, and soon

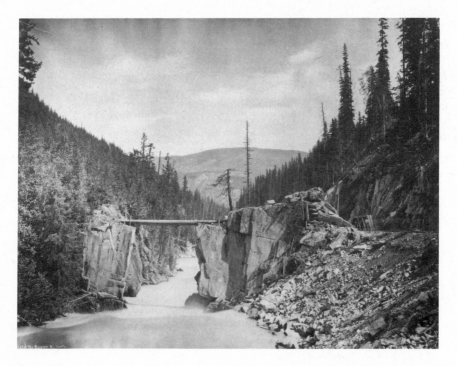

155

Alexander Henderson
Gates of the Beaver River North 1885
Albumen print, 26.0 x 34.0 cm
Notman Photographic Archives,
McCord Museum, Montreal (MP 118/78)

afterwards he retired from the CPR, and from photography (see pl. 156).

There is not a single print known from Henderson's retirement years, and no mention of his photography in the large quantity of letters that survive from this period. Whatever his reasons, he apparently decided to completely set aside the activity that had wholly occupied him for almost forty years. As a consequence, after his death in 1913, his family remembered him as a "man of affairs," to whom photography was purely a hobby. Many years later a grandson put all that remained in family hands of his negatives and personal prints out with the garbage.

156
Photographer unknown
Alexander Henderson c. 1895
Platinum print, 13.4 x 9.6 cm
Notman Photographic Archives,
McCord Museum, Montreal

CANADA ON DISPLAY: THE COLONIAL AND INDIAN EXHIBITION

It had been decided to hold a Colonial and Indian Exhibition in London, in the year preceding Queen Victoria's Golden Jubilee of 1887, in anticipation of the great event to come. The exhibition was to be a vast

display of the civilization and wealth contained in the Queen's domains. As had become the custom in the series of international exhibitions that had punctuated the years from mid-century, the displays were organized into a number of classes.

For the Colonial and Indian Exhibition in 1886 these were grouped into three great, broadly-designated divisions: the Vegetable Kingdom, including agriculture and forests; the Animal Kingdom, made up of birds and terrestial animals, insects and their products, and including fisheries; the Mineral Kingdom, including mineralogy, manufactures and industries. Education and instruction, and the fine arts were added as a final category.

Canada, considering herself the proudest as well as the most senior of the Queen's Dominions, was determined to make the grandest show of all. A commission was established in London to supervise the installation and subsequent promotion of the Canadian display. It was headed by the Marquis of Lorne, the preceding Governor-General. Meanwhile, in Canada, a number of associations and agencies were approached to help assemble the finest Canadian products available for each of the exhibition's numerous classes.

The Royal Canadian Academy was quite naturally asked to assist in the fine arts display. To that end, it was decided to hold the annual RCA exhibition in Ottawa again in 1886. (It would normally have been the turn of another city.) It was also decided to have it earlier than usual, so that a selection could be shipped to London in time. The seventh exhibition of the RCA was thus duly held in February 1886, and from it a number of works were chosen for the forthcoming exhibition.

In spite of these careful preparations, the role of the RCA was essentially ineffective. The published catalogue of the Canadian Section of the Colonial and Indian Exhibition reveals that the fine current examples of Canadian art which had been so carefully chosen, finally constituted only a small part of the total Canadian display. Pride of place in the catalogue falls to Princess Louise, who exhibited a view, *Niagara Falls – Canadian Side,* which had not been included in the Ottawa exhibition. Then comes a certain H.H. Askin, of London, Ontario, who showed *Dead Mallard.* We have no idea who he was, or what connections he possessed which made it possible for him to exhibit in the show.

Next comes the American painter, Albert Bierstadt, who was rep-

resented by two paintings owned by Lorne (*Montmorenci Falls, Quebec* and *Quebec Citadel*), and one owned by Princess Louise (*View from Government House, Ottawa*). Then G.R. Bruenech of Toronto is listed, who had at least taken part in the February RCA show, but with two other works than those exposed in London. Finally, with William Brymner, we have an artist whose seven works in London approximated his display in Ottawa. Even then, one of his works in a section of the Ottawa show which had been devoted to paintings already selected for the Colonial and Indian was, in fact, not included.

In other words, the part played by the RCA was minimal. Inevitably, the main influence was wielded by the powerful businessmen who were close to government and who alone determined what was most in the "national interest," even in matters of the fine arts.

The Canadian display nonetheless included a great many of the prominent artists then active in Canada, with Vogt and Krieghoff represented among the deceased. The only French-Canadian, however, was the sculptor Louis-Phillippe Hébert. Napoléon Bourassa had withdrawn from the Vice-Presidency of the RCA in 1885 on the grounds that he had retired from the pursuit of painting. Eugène Hamel, while resident in Rome from 1880 to 1884, had let his membership lapse. Edson was well represented, as was Raphael, Verner, and even Sandham. O'Brien had the most works: fifteen in all. John Fraser was represented by nine.

The Canadian paintings were well displayed in the east ring-corridor of the Royal Albert Hall. Photographs, included in the Manufactures and Industries class rather than under Fine Arts, were also displayed to advantage. They were mounted on the north wall of the Conservatory, on either side of the south entrance to the Royal Albert Hall. Henderson and Notman were not included here, however. Their work was even more prominently placed in the large Central Gallery, as part of the CPR display, which was the centre-piece of the Canadian Section. Notman even had some of his non-CPR material in this area. Everything was more-or-less in place by 4 May 1886 for the grand opening ceremonies, presided over by Queen Victoria herself.

In general, reaction to the Canadian art was positive. Of particular note is a lengthy, illustrated review by R.A.M. Stevenson in *The Magazine of Art* (IX, 1886, pp. 516-520). Stevenson believed that, on average,

the Canadian work was the best in the whole exhibition. He felt that the main reason for this was that the younger Canadians had, for the past several years, been studying in Paris. Thus, they had been able to take "advantage of European, and more especially of French, sentiments and traditions" (p. 518). In Stevenson's eyes this was a good development, and it was the work of the young Paris-trained figure-painters like William Brymner, Paul Peel, Robert Harris and Percy Woodcock, that he valued most highly. O'Brien received a polite nod, Edson the briefest mixed notice, and Raphael and Fraser mere mentions. In London in 1886, their work quite clearly was considered *dépassé*.

HODGSON OF THE RA ON CANADIAN ARTISTS

Lord Lansdowne, the current Governor-General, while he was in London commissioned a report on the standard of achievement in the Canadian art display. The man he approached was J.E. Hodgson, Professor of Painting and Librarian to the Royal Academy. Lansdowne may well have gone to Hodgson purposely seeking a different view from that of *The Magazine of Art*, since Hodgson's position was the exact opposite of Stevenson's. Obviously an older man, still wholly committed to the Ruskinian concept of "truth to nature," and with a bias toward landscape, he abhorred the French-influenced work of the younger Canadians. In his official report, published in Sir Charles Tupper's general *Report...on the Canadian Section of the Colonial and Indian Exhibition*, which was appended to the *Report of the Minister of Agriculture for 1886* (Ottawa, 1887), Hodgson deemed it morally imperative that Canadian art should grow out of the special local circumstances of Canada, that it be "Canadian to the backbone" (p. 68).

Seen from that position, O'Brien was "a very considerable and accomplished artist" (p. 61). But it was the work of John A. Fraser that really appealed to Hodgson, particularly three watercolours of the Rocky Mountains, and it was for these that he reserved by far his strongest praise:

> He is an artist with whom I venture to express very hearthy sympathy. In several respects he may appropriately be called the pioneer of a new School of Art. He seems to have gone forth into the outer wilderness in search of the picturesque,

and on the evidence of the scenes he represents, in the soli-
tudes of the far West, he must often have startled the eagle
and the 'grizzly' by the unwonted apparition of an easel and
sketching umbrella; he shows the same daring spirit in the
subjects he chooses and the natural effects he tries to repre-
sent.... Mr Fraser's drawings... have, to my mind, more of the
world in them than anything in the Exhibition.... I thoroughly
applaud Mr Fraser, painting in his own country and to the
manner born, in his efforts to grapple with the artistic difficul-
ties of such [a clear] atmosphere; if he is not thoroughly suc-
cessful, and if a certain rawness is observable in his pictures,
time and practice will, I feel certain, bring ultimate triumph. A
more serious indictment to be brought against him, is care-
lessness in the matter of form. The same atmosphere which
would enhance the vividness of colouring, would also bring
the accidents of outline into more prominent relief; and it is a
fact based upon subtle artistic laws, on the effect produced on
the minds by synthesis of effect, that, were the outlines more
clearly defined...and more individualized, the colouring would
appear less harsh and exaggerated (p. 62).

It is a fascinating analysis, and the more so because we know some-
thing that Hodgson did not. Fraser had never, before the opening of
the Colonial and Indian Exhibition in May 1886, set foot in the Rocky
Mountains. His three pictures were painted from photographs. As such
they satisfied, more than anything else in the show, Hodgson's
demands for a close study of natural forms, for attention to detail: in
other words for the whole Ruskin aesthetic. Yet he still sensed some-
thing not quite "true," and although he did not use the term, what he
found unsatisfactory was the focus, which was of course a matter out of
Fraser's hands.

FRASER ATTEMPTS THE ROCKIES — AT A DISTANCE

We can speak with certainty regarding the circumstances under which
John Fraser painted those three watercolours because an extensive cor-
respondence on the subject has been preserved. This correspondence
took place between Fraser and the person who commissioned the

paintings, supplied the photos, and then had the paintings placed in the Colonial and Indian Exhibition. That person was William Van Horne, Vice-President of the Canadian Pacific Railway Company, and the correspondence can be found in the Corporate Archives of the Canadian Pacific in Montreal.

Fraser had met Van Horne most recently in November 1884, presumably in Montreal and perhaps through William Notman, whose son that summer had travelled into the Rockies to photograph for the CPR. (Fraser however, may have known Van Horne since 1883, when he himself travelled west as far as Calgary on the CPR.) At any rate, here is how the correspondence begins. Fraser is writing to William Van Horne from Boston on 12 October 1885:

> Having read several times lately of the completion of the c.p.r. I am reminded of our conversation last Nov. re. your contemplated guide book and I beg to say that I shall be glad to undertake the whole of the illustration work or a part of it. I could prepare many of the drawings and cuts during the coming winter using any photos you have, and arrange for work in the field in the summer....

By this time, as we have noted, Fraser had prepared from photographs numerous drawings for engraving by *The Century Magazine*.

Van Horne's reply, if there was one, has not been found. But that is rather a misleading way of putting it, since he did reply, in a way, three months later by introducing an entirely new subject. He was direct, even emphatic:

> Mr Stephen, our President, is anxious that some large water color views of our mountain scenery should be exhibited at the Colonial Exhibition, which is to be held in London next May. We have a quantity of photographic views here, new ones, which I presume would have to be depended upon for material, as nothing could be done otherwise at this season of the year and Mr Stephen will undertake to buy the pictures himself if no better sale is made before the exhibition closes.
>
> If you would like to take this matter up, you had better come here without delay; but in any case let me know what you decide (6 January 1886).

Fraser must have made the trip to Montreal immediately, and taken the photographs back to Boston with him. He soon ran into problems with the colouring of the scenes, and wrote to Van Horne asking for something to augment the black-and-white image. Van Horne replied on 19 February 1886:

> In reply to your note of the 16th inst about the picture of Summit Lake I give you herewith a letter from Mr Henderson in which he describes the conditions, atmospheric & otherwise, which existed at the time the photograph was taken. Please note what Mr. Henderson says about the wide angle lense lowering the Mountains, and keep it in view as applying to all his views.

Van Horne's assistant, A. Piers, followed this up on 1 March 1886, in reply to an intervening note from the anxious Fraser:

> Referring again to yours of the 20 ulto, which was answered by sending you Henderson's notes, Mr Van Horne wishes me to add that in the case of Mount Hermit the local color of the rock is inclined to purple.
> I hope Henderson's memo was what you required, if not and you will say so, I will try and get some further points.

Unfortunately there is no copy of Henderson's memo, but on 22 March 1886 Piers wrote to him about the purchase of some of the negatives of the photographs he took on his 1885 trip to the Rockies. Piers mentioned that certain of the prints he had supplied would have to be replaced, as they "were sent to an Artist to paint pictures from...." The ten photographs sent to Fraser were listed. There were three large ones: *From Summit of Selkirks, Mouth of Beaver near 6-Mile Creek*, and *Down Stony Creek*. And there were seven smaller, *Mist of Mt Stephen, Devils' Club, On Tote Road – Selkirks, At Bearpaw near Leanchoil, Near Summit, Kicking Horse Pass, Summit Lake – Rockies*, and *After Rain – Mt Stephen*.

It was decided that Fraser should make watercolours after three of these: a *Summit Lake*, a *Mount Stephen*, and a *Mount Hermit*. The first was based on the second-to-last photograph listed above, the second could have been after the *Mist* or the *After Rain*. The third was probably copied from the first large photo. On 24 March 1886 Fraser wrote to Van Horne that the three were now finished. As it turned out, there was not

enough time to get them to London before 4 May and the opening of the Colonial and Indian Exhibition. But that posed no great problem. Van Horne simply had his man in London take them over as soon as they did arrive, and explain what was required to display them. Sir George Stephen, the President of the CPR, had purchased the three of them already, and so everything necessary was done to facilitate their presentation. Van Horne received the following letter, explaining this stage in the operation:

> The watercolours belonging to Sir George Stephen, the President, have arrived in good order and I have seen them carefully delivered at the Canadian Art Gallery of the Exhibition. I saw Sir Charles Tupper [the official Canadian Commissioner] in regard to the hanging of these pictures and went with him through the Gallery. He has instructed Mr Watt, who is in charge, to follow all my wishes as to their position, etc. I am glad to have received your private letter in relation to these pictures and will see that everything is properly done. I am going down tomorrow afternoon to see them hung.... I must say that Sir Charles has taken a personal interest in the matter of these pictures and I do not think there will be any cause for complaint as to their being properly placed (11 May 1886).

Something of the spirit of the venture is revealed in a later section of the letter when the correspondent Alex Begg, the "G.E. Agent C.P.R." in London, mentioned an article published by Lorne, "Our Railway to the Pacific." Beggs explained that he was having it reprinted for the promotion of the line, hoping it would help to do "something practical in working up tourist business this summer and fall."

Of the Fraser Rocky Mountain watercolours we now know, very few are dated, and it is difficult to be sure which of them might have been copied from the Henderson photos for inclusion in the May 1886 Colonial and Indian Exhibition. The largest one of these (66.7 x 91.4 cm) once belonged to George Stephen. It is now in a private collection in Montreal (pl. 157). Entitled *Mount Stephen Near Leanchoil*, it could well be the watercolour exhibited in London in 1886 as *Mount Stephen, Summit of the Rocky Mountains, Near Sencloile*. Sencloile is doubtless a mistaken transcription of "Lenchoile," as it is spelled on the back of the painting. Another watercolour, of Mount Hermit (now called *The Rogers*

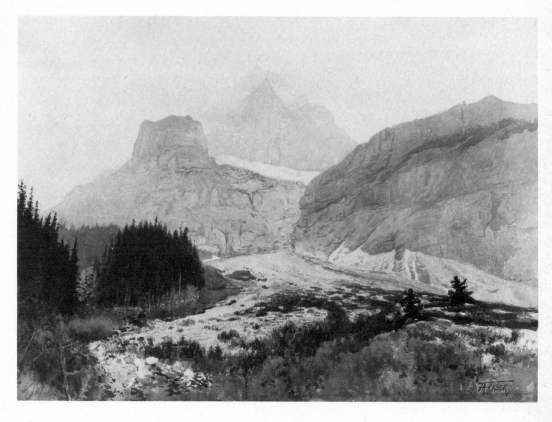

157

John A. Fraser
Mount Stephen Near Leanchoil,
Canadian Pacific Railway 1886
Watercolour, 66.0 x 91.4 cm (sight)
Mr and Mrs G. Douglas Baxter, Montreal

Pass), is in the National Gallery of Canada (pl. 158). It is considerably smaller (38.7 x 66.7 cm), but perhaps should be related to the *Mount Hermit, Summit of the Selkirk Range* shown in 1886.

Nonetheless, the *Mount Stephen near Leanchoil,* perfectly fits Hodgson's criticism of the lack of clearly-defined outlines. If it is based on Henderson's photo, *Mist of Mount Stephen,* that would explain the haziness and the lack of definition. Henderson always revelled in such soft

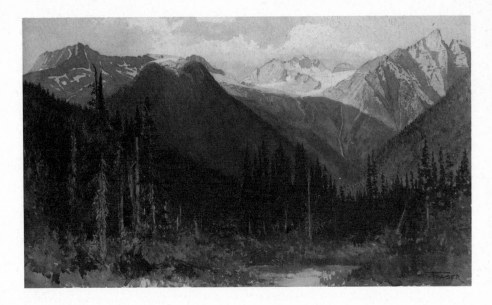

158

John A. Fraser
The Rogers Pass 1886
Watercolour, 38.1 x 66.1 cm
The National Gallery of Canada, Ottawa,
purchased 1964 (14,578)

atmospheric effects. It is a heavy, moist day, and Fraser has captured
the blurring effect of the intervening atmosphere as recorded by the
camera. This is apparent not only in the heights, but also in the gener-
alized treatment of the clumps of evergreens to the left.

FROM OCEAN TO OCEAN: THE CPR

It stood to reason that the CPR would wish to assert as prominent and
as impressive a presence as possible at the Colonial and Indian Exhib-
ition, and that the Canadian Government, long committed to the build-
ing of the railway, would provide every aid to accomplish this end. Sir
Charles Tupper's report even included in its "Concluding Remarks"
the following general statement on the importance of the completion
of the CPR to Canadians:

No time could have been more opportune than the year 1886 for a display of the resources and the achievements of Canada before the British public. The opening of the Colonial and Indian Exhibition by Her Majesty, with all the pomp with which the royalty of England could invest an occasion in which it was profoundly interested, preceded, by a few weeks, that of the Canadian Pacific Railway, the completion of which, from ocean to ocean, had however been virtually accomplished in 1885. The ability of Canada to prosecute this gigantic work to a successful conclusion had, almost to the end, been doubted in very many quarters in England; but when the Canadian Pacific Railway became a realized fact, all remains of the old scepticism of England vanished, and the enterprize, the resources, and the credit of the Dominion were recognized with that generosity with which Englishmen are wont to atone for the tardiness of their appreciation of the capabilities of those whose powers they have regarded as not proven (pp. 69-70).

And it was not only a matter of national pride. You will recall the letter the CPR's London agent wrote to Van Horne, just after the opening of the exhibition. He made it abundantly clear that the company was well aware of the promotional value of the magnificent scenery which the opening of the line had made accessible. Landscape had indeed become one of the principal products the CPR intended to sell. And what more effective means of advertising than the presentation of actual images of the product?

At this point there was indeed in Canada an active interest regarding the new country the railway had opened up. This was particularly true of Montreal, which, even as early as 1885, was enjoying the direct benefits of the steadily-increasing flow of cattle, lumber and grain from the West, brought through by the CPR. Toronto, on the other hand, was a slightly different story. During the Depression years of the mid-seventies the Toronto-based Liberal government had not been enthusiastic about the railway. Even as it neared completion both Torontonians and other south-western Ontarians viewed its probable effect with mixed feelings. Since it would approach the east through the Ottawa valley, Montreal would

derive the benefit and Toronto would be by-passed. (Cartier, of course, had always supported the railway vigorously, knowing what it would do for Montreal.)

But in spite of any reservations the Ontarians may have felt, the construction of the CPR was very much a part of Sir John A. Macdonald's "National Policy." Tied in as it was with protective tariffs, increased immigration, and the systematic settlement of the Northwest, it formed "a Materialistic policy of Bigness" that appealed strongly to the spirit of the age. And by 1886 virtually all Canadians were swept into the adventure, the promise, and the strong sense of national pride which the CPR had engendered. The artists as well.

Thus, when in the spring of that year Van Horne and Sir George Stephen decided to encourage painters to explore the new-found scenic wonders of Canada's – or, as it almost seemed, of the CPR's – Rocky Mountains, they quickly discovered that no real incentives were necessary. As far as can be ascertained, no one, with the exception of the photographers, was commissioned. John Fraser, for example, had, as we have already seen, approached Van Horne first. No correspondence with Lucius O'Brien has yet been found in the Canadian Pacific Corporate Archives, but he too travelled west on the new line that summer. In March 1883 he had supplied estimates for a "proposed C.P.R. illustrated book," based on his *Picturesque Canada* experience, so they knew him, as they did Fraser. (O'Brien's notes are in his Studio Journal.) J.C. Forbes was with O'Brien that summer, but we do not know if he had any previous contact with the company. William Brymner of Montreal also went to the West. Everybody received free passes on the railway, but apparently no other expenses.

INTO THE MOUNTAINS AT LAST: JOHN FRASER

Fraser was the first to go. He was then forty-eight years old, and under considerable pressure, financial and otherwise. His attempt to rely solely upon painting as a means of livelihood had not proved easy, combined as it was with the dissolution of his partnership with Notman and the move to Boston. Early in 1886 he had even broken up the Fraser & Sons business in Toronto, selling the shop and all of the firm's negatives to a certain Millman & Co. (Millman advertisements first

appear in March 1886; they in turn were taken over by Herbert E. Simpson in the fall of 1887.)

Nanette noted in her diary that her father was away in Montreal and Toronto in April. He was doubtless attending the AAM spring exhibition (he showed watercolours painted around Boston), making the final arrangements for the trip, and settling affairs with his sons. (At Toronto in May he showed the same watercolours at the OSA as he had in Montreal the month before.) Back in Boston at the end of April, he had frantic last-minute details to arrange before leaving; for the family had decided to let their apartment go.

Early in June he left for Montreal, and on 8 June, nearly three weeks before the first scheduled run to the Pacific, he set out for the Rockies. That is, according to the text of a talk about his trip he gave to the Canadian Club in New York the following year (published in *Canadian Leaves*, New York, 1887). His family left Boston on 9 June, arriving late the next day in Toronto, where they spent the summer on the Island, just as they had done during the last several years. It seems from Nanette's diary that Fraser was there to meet them, although he soon left for the West, travelling by rail to Owen Sound and from there by CPR steamer to Port Arthur (*Canadian Leaves*, p. 235). Back on the train again, he reached Winnipeg about 15 June, where he and his travelling party were the guests of the Winnipeg Club. Unfortunately some sort of crisis developed there, about which he wrote to Van Horne in Montreal, twice on the same day, 16 June. We only have the second letter, and it is unclear what had happened. He had apparently called off the trip, or at least, changed his plans. But by the time he wrote the second letter his attitude had altered:

> Since writing this afternoon I have reconsidered the matter of which I wrote and think it will be judicious to adhere to my original plan. I shall leave tomorrow morning intending to work back from Vancouver hoping that in the interval you will kindly instruct Mr Gagen (Corporate Archives, Canadian Pacific, Montreal).

Was this R.F. Gagen, formerly Fraser's employee, and at that time working with Fraser's brother, his competitor in Toronto? In the Canadian Club address Fraser notes that there were five artists in the Rockies that summer, although Gagen failed to exhibit any work at all the

following year. Nanette Fraser in her diary gives details of a severe emotional breakdown Mrs Gagen suffered the summer of 1886, which perhaps explains her husband's withdrawal from the exhibitions the next year.

Fraser continued to proceed west, presumably on the morning of 17 June – although he mentioned doing a bit of sight-seeing around Winnipeg in his Canadian Club speech. Once on the train, he was apparently pleased to find himself almost exclusively in the company of Scots. But the trip itself does not sound very pleasant. Perhaps because they were travelling ahead of the scheduled runs, the party kept being moved from one uncomfortable railway-car to another, and seem to always have stopped for meals in canvas-sided "hotels," where they ate poorly.

They crossed the prairies, passed through Calgary, and began to ascend the eastern slopes of the mountains. Through the gap at Canmore they proceeded ever higher, until they reached the crest at the base of Mount Stephen. Then they travelled down the long, steep grade of Kicking Horse Pass into the valley, and up again slowly through Rogers Pass, over the summit of the Selkirks, down and along the Illecillewaet River to Revelstoke. From there they moved up across Eagle Pass, then along the Eagle River to the South Thompson and on to Kamloops, down the Thompson to the Fraser at Lytton, and on to Port Moody, and across the Straits to Victoria.

The whole incredible journey from Winnipeg took only eight days. Fraser spent the rest of the summer travelling back into the mountains to sketch. He was fascinated by the dry belt that begins at Lytton, though some several hundred km^2 of raging forest fires caused smoke so thick that it was impossible to paint. The lushness of the coastal vegetation interested him, and he spent time sketching in the region of the lower Fraser. He seems to have frequently ventured well beyond the railway line.

Back in Toronto, the women moved into town from the Island on 19 August, and settled in a boarding-house with Gus, the middle son, at 239 Sumach Street, in the east end near the Don River. (Gus and his brothers had recently become the Toronto agents of the Boston International Portrait Association.) Early in September Mrs Fraser heard from her husband that he would be away another month. At the beginning of October they moved to Gerrard Street, closer to down town.

Finally, to everyone's relief, Fraser arrived back in Toronto on 19 October 1886. Five days later, however, he was off again, this time to Montreal for the week (to report on his summer's work?) and then a couple of weeks later, on 10–11 November, he held a viewing reception in Toronto at the Queen's Hotel. The pressure was building up tremendously. Nanette confided to her diary the details of a vicious fight between her parents, and the boys too seemed restless and unsure of their futures.

Finally, at the end of November, Fraser, his wife and three daughters left Toronto. Passing through Montreal, they were back in Boston on 27 November, where they took rooms at 87 Appleton, but two days later arranged to board in a large old house at 18 Chester Square: two bedrooms and a studio and their own table in the dining room. That New Year's day, Nanette entered a "prayer for 1887" in her diary. Among her five wishes was one to "make my father a famous artist."

Surprisingly few of Fraser's Rocky Mountain pictures have turned up. There are a number of small watercolour field-sketches that have appeared from time to time on the market. They are not much more than notes, really, though often very fresh and beautiful in colour. There are also about a half-dozen large finished watercolours, and three or four oils. The watercolours are all roughly the same size, painted on sheets of about 45.0 x 65.0 cm. All of them could well have been shown at the Queen's Hotel in Toronto in November, for he exhibited ten at that time, and the showing received an enthusiastic review in *The Globe*:

> Mr Fraser has long held a prominent place among Canadian artists of the foremost rank, but it would seem that this season he has quite surpassed the most brilliant efforts of former years.... The sublime scenery of the Rockies is evidently inspiring, but it has worked no such marvellous change on other artists' work as it has on Mr. Fraser's... he has risen to their sublime plane and depicted their dizzy heights, cavernous depths, dazzling lights and massive shadows, with the same bold firm touch, daring but truthful colour, and the same delicate poetry of treatment that has formerly been so much admired in his charming little pictures of unpretending pastoral scenes (10 November 1886).

The same group of pictures were probably again included in a showing of his work which was mounted at the Canadian Club in New York, at the time of his talk there in early 1887. He commented on them during his talk. "Most of you are aware that all the pictures here exhibited were painted on the spot. I mean by that that they were begun and finished, as far as you see them, out-of-doors and in view of the subjects or objects depicted" (*Canadian Leaves*, pp. 233-234).

I mention this because some of the watercolours that were done that summer, or perhaps in Boston before leaving, evince many signs of the photographic image. One example is the arrestingly naturalistic *The Sun's Last Kiss on the Crest of Mt Stephen, from "Field," Rocky Mountains, B.C.*, now in the Beaverbrook Art Gallery in Fredericton, N.B. (pl. 159). Another is the fine *Fraser River Line of the CPR*, now in the Art Gallery of Hamilton, that once belonged to Van Horne (pl. 160).

Both paintings have an open, snap-shot-like composition with no evident framing devices. In them, the sense of space is determined by the changing light values throughout the scenes, and the contrast

159

John A. Fraser
The Sun's Last Kiss on the Crest of Mt Stephen, from "Field," Rocky Mountains, B.C. 1886
Watercolour, 43.8 x 67.3 cm
Beaverbrook Canadian Foundation,
Beaverbrook Art Gallery, Fredericton,
N.B. (59.70)

between shadow and light is heightened in certain areas to an extreme degree. All these elements add strength to the images, which are direct and natural in feeling. The colour, too, strong and clean, enhances the effect.

One other watercolour of 1886, *The Peak of Sir Donald, in the Selkirk Range, B.C. Taken from the Glacial Stream (near its source) called the Illecille-waet,* now in a private collection in Calgary, is perhaps more of a composed, painter's picture (pl. 161). Again the strongest attraction of the image is the way in which the light is handled, its variations so closely observed, and so carefully and expertly recorded. This is particularly true with regard to the treatment of the stream, and of the distant peaks. Whether based upon photographs, or simply revealing the photographer's eye attuned to perceiving in terms of reflection and refraction, these are bold, fresh images. They capture both the majesty and power of that handful of peaks that would, in a matter of two or three years, supplant Niagara or Montmorency, Percé or, certainly, Lake Memphremagog as natural monuments, emblematic of Canada around the world.

160

John A. Fraser
Fraser River Line of the CPR 1886
Watercolour, 46.3 x 66.8 cm
Art Gallery of Hamilton, gift of
Dora Stock and Wintario, 1978 (78-2)

161

John A. Fraser
*The Peak of Sir Donald, in the Selkirk
Range, B.C., Taken from the Glacial
Stream (Near its Source) Called the
Illecillewaet* 1886
Watercolour, 66.0 x 44.5 cm
Dr Donald A. Grace, Calgary

INTO THE MOUNTAINS AT LAST: LUCIUS O'BRIEN

Although he did not leave quite so early as John Fraser, Lucius O'Brien also headed for the mountains before the first regularly-scheduled train. We have a full record of his trip, because he carried a sketch-book in which he kept – as well as drawings of great delicacy, complete with colour notations – a detailed account of his movements and expenses, and other incidental notes. This sketch-book is now in the British Columbia Archives in Victoria. O'Brien left Toronto with his old friend J.C. Forbes 19 June 1886. They too took the route by steamer from Owen Sound to Port Arthur, and were in Winnipeg by 22 June, where they rested for three days. By 1 July they had reached the summit of the Selkirks, and they set up camp there in the Rogers Pass, hired a cook, and settled down to work.

O'Brien could not have been more delighted with the scenery. On 22 July he wrote a long letter to a friend in Toronto, who sent it to *The Mail* for publication, and it appeared in that paper 29 July. O'Brien found the mountains literally beyond belief, rhapsodizing over their astonishing number, and their close, sentinel-like ranks. He and Forbes intended to move on later to the Pacific Coast, but as he explained in a subsequent letter to this same friend (*The Mail*, 4 September 1886):

> We have been unable to tear ourselves away from these lovely mountains of the Selkirk range. All we have done in the way of moving is to shift our camp three miles west to where the Glacier hotel is being built. The interest of this scenery is inexhaustible, not only from the varied aspects it presents from different points of view, but from the wonderful atmospheric effects. At one moment the mountains seem quite close, masses of rich, strong colour; then they will appear far away, of the faintest pearly grey. At one time every line and form is sharp and distinct; at another, the mountains melt and mix themselves up in the clouds so that earth and sky are almost undistinguishable. Now the mountain sides are of the softest velvet, and presently they look like cast metal. The foregrounds, too, away from the desolation made by the railway cuttings and banks, are rich and luxuriant; large-leaved plants and flowers clothe the slopes. The trees, where the timbermen have not culled out the finest, are most pictureque.

They finally left the Rogers Pass about the middle of September and returned to Toronto.

O'Brien had taken a camera with him, and there are notes in his sketch-book of the conditions under which various photographs were taken, the exposure setting, and so on. But it should be added that apparently not many were taken. And when we look at the paintings of that summer we see that the photography was kept quite separate from the painting. That is certainly the case with *Mountain Lake* (pl. 162), the watercolour in the National Gallery of Canada. As it is dated very precisely on its face, "Aug. 19, 1886," it must have been painted in the field. A larger watercolour of Mount Sir Donald in the Montreal Museum of Fine Arts, called now *Mountain Landscape*, is, if anything, even more painterly (pl. 163).

162

Lucius O'Brien
Mountain Lake 1886
Watercolour, 38.25 x 55.6 cm
The National Gallery of Canada, Ottawa,
purchased 1964 (14,579)

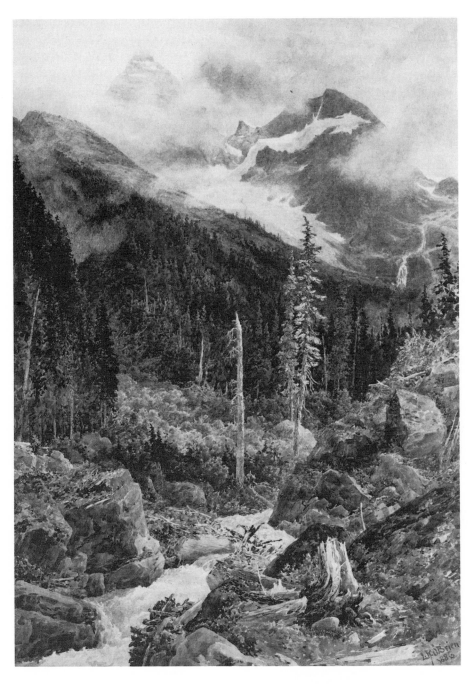

163

Lucius O'Brien
Mountain Landscape 1886
Watercolour, 101.0 x 53.3 cm
Montreal Museum of Fine Arts,
gift of Lord Strathcona and family,
1927 (27.355)

The way its forms are built up in a rich multiple layering of paint, harks back to the technique used in his watercolours of the late seventies. There is a new vigour stirring in this work. The signs of generalization we had noticed previously are gone, and close attention has once again been paid to both general composition and finish. They are perhaps a little too tight. The desire to emphasize the lushness of the scene has led to a too-busy quality in the detail. But this is surely outweighed by the broad movement of light, and the crisp, clean colour.

As with Fraser, there is a dearth of work from the summer of 1886 presently available. There are only the two we have just examined, and another version of the Montreal Mount Sir Donald. This painting appeared at Sotheby's, Toronto, on 15 May 1978 (lot 43), but then was again lost sight of. Called in the auction catalogue *Mountain Stream, Rockies*, it is actually *Cloud-Capped Towers*, which was sold by O'Brien to Edmund Osler in February 1887 (as noted in his Studio Journal). O'Brien's only picture accepted by the Royal Academy in London was one of these products from the summer of 1886. Titled *In the Canadian Rocky Mountains: Footprints of an Avalanche*, it was shown at the Academy in 1887 (no. 1243).

At the RCA exhibition in Montreal late in April of 1887, O'Brien showed eleven watercolours painted as a result of that trip into the heart of the Selkirks the previous summer. All were bought from the exhibition by Sir George Stephen, and we have no idea where any of them are today. And finally, at the OSA in Toronto, he showed three more small ones. Thus his production from that summer was probably not large.

It is also interesting to note that, in the three paintings we do know, the mountains are either set back, so that the intervening atmosphere softens them, or they are swathed in mist or cloud. O'Brien was hesitant to deal with them in a forthright fashion. It is this approach which makes his watercolours of that first year of western exploration so different from Fraser's direct, emphatic portraits of rock-faces.

XIV

The
End
of
an
Era:
1886–1890

The last years:
John A. Fraser and Lucius R. O'Brien
the Notmans again

THE LAST YEARS: JOHN A. FRASER

After the trips of the first year were over, the CPR commissioned visual material that was directly related to their promotional campaign (or perhaps this was understood as the purpose of the original free-pass journeys). John Fraser agreed to produce black-and-white drawings of some of the peaks, which he supplied to Van Horne immediately after resettling in Boston late in 1886. Van Horne was not pleased with the results:

> I have your note of the 3rd instant. The black-and-white sketches will hardly answer our purpose, the mountain not being sufficiently imposing. I made last night a rough sketch in lamp-black which will illustrate my idea: it is made mostly from memory and I have taken a great deal of license but I do not think that any one going to the spot without the picture in hand to compare will ever accuse us of exaggeration. For the great glacier and Syndicate Peak I would like something similar to this. Since the thing has got cold I find the perspective in the glacier not right and the peaks projecting through the glacier are not treated broadly enough to give them their proper distance. You will of course be able to make a great many improvements on my sketch, but I hope you will preserve the size.

402

Please make a sketch of Mount Stephen, treating it in some-thing like the same manner (8 December 1886, Corporate Archives, Canadian Pacific, Montreal).

One can see how Van Horne was used to having things exactly his own way, and how successful he was in achieving this. Fraser, probably concerned with the "license" Van Horne was taking, wrote at the end of the month asking for another photograph to work from. He received a tardy reply from Van Horne's assistant almost two weeks later. "The photograph you asked for, Mr Van Horne did not consider it necessary to send, as his sketch he thought would answer every purpose" (11 December 1886). Fraser delivered the goods just before Christmas, but with ambivalent feelings. It is as though he were aware that this man in Montreal was powerful enough to advance his career, or destroy it, at a whim. On reflection he wrote one last time about the matter, 8 January 1887:

> I fear that in my anxiety to get away the Mt Stephen I mechan-ically & without due thought signed it with my name.
> If so it was a mistake as whatever credit is due, is to you alone, I having merely interpreted your idea for the engraver and would wish you to instruct him if it is not too late to make any alteration in that respect that you choose and upon con-sideration I think that the same holds good in the matter of the Glacier.

We do not at present know how, or even if, the drawings were finally used. A closer study of the early advertising material of the CPR would turn up many more interesting links with the artists of the day.

It was however as a painter, and not as an illustrator, that Fraser wished to make his name. Nevertheless he continued to work occasion-ally for *The Century Magazine,* and one or two other periodicals, doubt-less encouraged by his brother, who had become one of the prominent art directors of the New York illustrated monthlies. He had probably already decided, before returning to Boston, upon the next stage in the advancement of his career.

His domestic life had also changed. The last entry in Nanette's diary is for 4 January 1887, when she was preparing to leave Boston to set up house, it seems, with her two youngest brothers. Was this to be

in Toronto? Gus is still listed in the 1887 Toronto city directory, as agent for the Boston National Portrait Association. Fraser was in New York in March for an exhibition, very likely the one at the Canadian Club. He telegraphed Van Horne when the first review appeared, then wrote to him shortly afterwards, when one of the New York dealers showed an interest in holding an exhibition of his work. There is no evidence of his having a commercial showing in New York at the time, however, and 8 June Fraser wrote to Van Horne from London, enclosing the reviews of an exhibition he was then holding at H. Koekkoek's London Fine Art Gallery at 72 Piccadilly. He had once more left Boston, and with his wife and two youngest daughters was now settled in London. He had not set foot there in thirty years.

There was, before he left, one last public dispute marginally involving O'Brien. Fraser was not included in the eighth annual RCA exhibition held in Montreal at the end of April. A reporter for the *Montreal Herald* was alerted to the omission, and asked the Secretary, Marmaduke Matthews, what had happened. It apparently had to do with a dispute over the receipt of entry forms. When asked if "President O'Brien" were "indisposed to encourage the exhibition of Mr Fraser's paintings," Matthews replied:

> Mr O'Brien has had nothing to do with the matter one way the other. Any supposition that the president or any member of the Academy desired to exclude Mr Fraser from the exhibition is too absurd for comment. Everybody was anxious to have his paintings on exhibition, and it is entirely his own fault that they are not here (18 April 1887).

The journalist concludes his report:

> There is an impression abroad that Mr Fraser is finding a good market for his paintings in New York and that, of course, it will pay him better to exhibit them there than in Montreal. As the scenes are entirely Canadian, and as facilities for accomplishing the work had been supplied in a measure by Canadians, and as the paintings are said to possess superior merit, there will be some disappointment experienced because of their absence from the exhibition; but if the exhibition in New York brings wealthy purchasers to Mr. Fraser and

fame to Canada through him, Montrealers find in such results some compensation for their disappointment.

Whatever market Fraser at the time anticipated in New York could not have materialized. Like O'Brien, Verner and Edson before him, he turned to London.

In writing to Van Horne after his opening there, he made a great deal of two small clippings he enclosed from the *Daily News* (31 May 1887) and the *Times* (2 June 1887). Van Horne, it appears, had sponsored or at least encouraged the exhibition, which consisted entirely of scenes along the CPR:

> I enclose clippings which I ask you kindly to peruse. I am told that to be spoken of so well (and so soon) when so many very large and important exhibitions are going on is a signal mark of appreciation which I hope will please you as it does me. I have made many friends amongst the *swell* artists – Du Maurier and Herkomer are especially kind.
>
> If all goes well I shall be ready for the summer campaign early in July, and I trust that the arrangements re. car etcet. will be completed in time for me (8 June 1887).

Plans were evidently being made to return to the mountains, and in some style. We have no evidence that he did so; but he may have returned to Montreal that year or early the next, for on 16 January 1888 an auction of his paintings was held in A.J. Pell's "Art Rooms," by then relocated on Victoria Square. By his pictures, I mean pictures he owned, for about a third of the sale was of paintings by Daniel Fowler, Verner, Gagen, Edson, and others, including O'Brien. A number of Fraser's Rocky Mountain works were also offered.

There exist a very few Rocky Mountain oils by Fraser, all painted after his return from the West. One, dated on the back October 1886, is in the collection of Hiram Walker & Sons, in Windsor, Ontario. *The Hermit Range at the Summit of the Selkirks on Line of CPR*, it is related closely to the watercolour now in the National Gallery of Canada, *The Rogers Pass*. In the National Gallery there is also another oil version (closer in many ways to the watercolour) which he painted for Sir Edward Watkin, of Rose Hill, Northenden, Cheshire (see pl. 164). Watkin had been President of the Grand Trunk Railway in the early sixties.

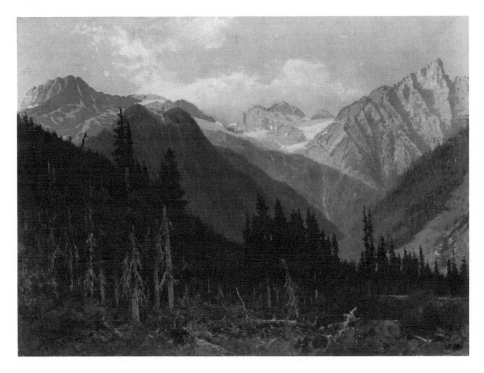

164

John A. Fraser
The Rogers Pass 1886
Oil on canvas, 55.9 x 76.2 cm
The National Gallery of Canada, Ottawa,
purchased 1934 (4227)

He was an Englishman who retained an interest – both financial, and it would seem, sentimental – in Canadian railway ventures.

These two canvases, and another striking studio piece painted in Toronto in November that is now in a private collection in that city, *Mount Baker From Stave River at the Confluence with the Fraser on Line of CPR*, retain, in their naturalistic handling of light, and in their direct, candid compositions something of the immediacy of his watercolours (pl. 165). For someone who had not used oils for five years, they are particularly well-handled. There was at least one other oil, a *Mount Stephen, from Field*, which he tried to sell at Pell's. And another canvas, the largest of the group (94.0 x 122.0 cm), which may have been painted in

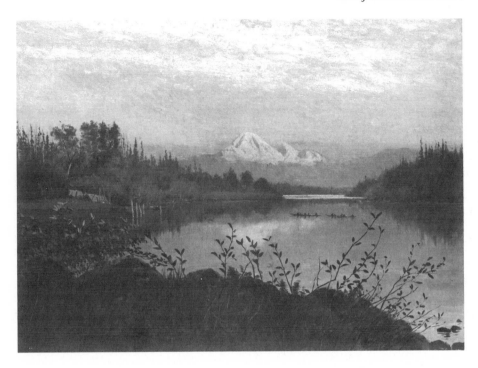

165

John A. Fraser
Mount Baker from Stave River, at the
Confluence with the Fraser on Line of CPR 1886
Oil on canvas, 56.0 x 76.8 cm
Dr G.W. Archibald, Woodbridge, Ontario

England in 1887. It is romantic in atmosphere, more broadly painted, and although sensitive in colour and form, it does not convey the same air of actuality and immediacy as the others. More of a set-piece in the European tradition, it is very likely his last Canadian subject.

Fraser sketched in Kent to the south-east of London and, at some time in 1888 or early 1889, he visited Scotland. Perhaps his imagination had been stirred by the numerous Gaelic names he had encountered in the Canadian Selkirks. Works exist of the Highlands at Loch Achray and Loch Katrine near Loch Lomond (in Perthshire, north-west of Glasgow), and of the area round the Pass of Brander, which runs between Loch Awe and Loch Etive in Argyll, farther to the west. One of

these was accepted by the Royal Academy in 1889. His London address was then 3, St John's Wood Studios. However, his out-of-door sketching proved costly to his health, and by late summer 1889 he was back in the United States, living in New York (*The Week*, VI, 23 August 1889, p. 604).

There is little more to add concerning Fraser's life and career. He exhibited once more with the OSA, in 1890, with the RCA that year, and again in 1891, 1893 and 1894. But he had really finished with Canada by then, and his last years were centred on the world of the New York watercolour painters and illustrators. He had a one-man exhibition of his Kentish and Highland watercolours at Boussod Valadon on Fifth Avenue in March 1890, and showed regularly with the American Water Color Society, the National Academy of Design in the early nineties, and occasionally with the Boston Water Color Society and the New York Water Color Society.

He, and another artist with Canadian connections, the sculptor A. Phimister Proctor, were elected to the Board of Control of the latter organization in 1892. Fraser was then living at 114 West 18th Street. The following year his wife died, and Nanette took over the running of the household, which he relocated further uptown at 157 East 47th Street. He occasionally sent work to international exhibitions (he was included in the Canadian section of the World's Columbian Exposition in Chicago in 1893) but on 14 October 1897 he held another large auction, this time in Toronto. That marks the end of his career. He died of a heart-attack in New York on 1 January 1898. He was just about to turn sixty.

Fraser's family, particularly his daughter Nanette, worked hard to keep his memory alive, and through their efforts, exhibitions of his estate were held at the Kit Kat Club in New York in April 1901, and at the Detroit Museum of Art in January 1903. A small exhibition was held at the Art Gallery of Toronto in January and February 1916, but after that Fraser, like his brother-in-law Sandham, was pretty well forgotten.

THE LAST YEARS: LUCIUS O'BRIEN

John A. Fraser had thrown himself wholly into the CPR project, wagering his career as a painter on the outcome. When the first great effort

failed to pay the dividends he expected, he dropped the whole idea and turned to something else. That was always his way. His mountain paintings consequently are more emphatic than those of O'Brien of 1886. There is, simply, more agressive force behind them. Fraser, it will be recalled, travelled the whole line that summer. O'Brien, on the other hand, got as far as the Rogers Pass, was overwhelmed, and set up camp. But, as we will see, over the following two or three years, he slowly but surely managed to crown his career with the success his western pictures eventually won (see pl. 166).

O'Brien probably did very little work in the months following his return from the West in 1886. His wife, to whom he had been married twenty-seven years, died on 10 November. Like Fraser he had received a commission from the CPR to prepare black-and-white drawings for advertising use. Unlike Fraser, he did not seem in any great rush to begin, probably because of the death of his wife. Also, though we have no correspondence, there is no evidence that he experienced any of the difficulties with Van Horne that Fraser had faced. There is simply a list

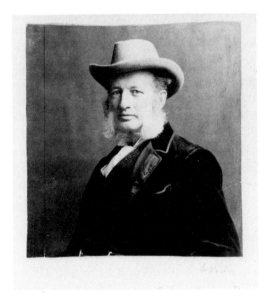

166
Photographer unknown
Lucius R. O'Brien c. 1885
Albumen print, 10.0 x 9.5 cm
Archives of Ontario, Toronto
(Ontario Society of Artists papers)

of the six drawings in O'Brien's Studio Journal, with the remark, "sent to Van Horne March 18th 1887," and a later note, "paid for by cheque $240."

Back in 1885 O'Brien had begun holding Saturday afternoon studio receptions, and in a note in *The Week*, 3 February 1887 (IV, p. 159) we see that he revived the practice in order to introduce his mountain pictures of the previous summer. Fraser, too, had held an exhibition at a hotel in November, commencing on the very day on which O'Brien's wife died, and had subsequently left Toronto. O'Brien obviously waited a suitable time after the funeral before proceeding with his campaign in February in his usual measured and deliberate way. The reporter for *The Week* approved of O'Brien's Selkirk Range watercolours, finding them more "pleasing" than he had thought he would.

They were first displayed publicly at the RCA exhibition in Montreal in April 1887 and, as already noted, all eleven of the works shown were bought by Sir George Stephen. The sale netted more than $2,000, a very considerable sum of money in those days. O'Brien's new work was mentioned in all the reviews (Fraser was not even in the exhibition), and the same was the case with the OSA exhibition the following month. Then in June the inclusion of one of his Rocky Mountain pictures at the Royal Academy was noted in *The Week* (IV, 2 June 1887, p. 436). And when the offer of free passes was renewed that summer, O'Brien did not hesitate. He left earlier than the year before, stayed longer, and this time travelled right through to Victoria.

Not at first. He never rushed. He took the same sketch-book with him which he had carried the previous year, so that again we may follow his movements closely. He left Toronto on 8 June, this time accompanied by his younger sister Lucy (Loo) who was unmarried, and must have been keeping house for him after the death of his wife. A certain "Johnny" also travelled with them. It was not John C. Forbes, because this Johnny had to pay for his railway ticket. (Loo, like Lucius, was given a pass).

They landed by steamer at Port Arthur on 10 June, and three days later were in the village of Banff, on the Bow River below Kicking Horse Pass. Hot mineral springs had been discovered at Banff, and in order to preserve these from private speculation the immediate area, some 16 km wide by 40 km long, had been declared a National Park,

with development under government supervision. Already two hotels had been built, and the CPR was constructing another large one. But O'Brien and his party as in the year before, had brought tents. Again he had also brought along a camera. Unfortunately none of his photographs are known to have survived.

Also as in the previous summer he wrote long letters to a friend in Toronto, which were published this time in *The Globe*. Here is his initial reaction to Banff:

> This place seems designed by nature for the purpose for which the country, with one consent, has appropriated it. The aspect and sentiment of the scenery is as different from the stern majesty of the Selkirks as it is possible to conceive. The mountains are as high, but the valley is wider, and they stand off to be admired instead of towering over one's head. There is no want of grandeur, but one is filled with a sense of beauty rather than of awe. Among the Selkirks and in the desolate wilderness at the summit of the Rockies, the tourist is an intruder and an offence. Here the pleasure seekers and the invalids who come to the healing waters for relief for their maladies, are welcome guests, and add the kindly human interest which is appropriate to the place (15 July 1887).

This explains much about the work he had done in the Selkirks the year before. He had been overawed. The Banff pictures, on the contrary, show an expansiveness. The mountains stand farther back, and the artist does not hesitate to encompass them all. Although there is still a sense of atmosphere, clouds seldom obscure the mountain forms. And every one of the Banff and Kicking Horse Pass paintings has "human interest" in the form of people or trains. O'Brien was clearly more comfortable with this majestic landscape, and this is reflected in the easy breadth of the 1887 work.

We also know a larger number of watercolours from this summer. There are two big ones of the Banff area in the Public Archives of Canada, both now called simply *View of the Rockies*, the slightly smaller of which is dated 21 June 1887 (pls 167, 168). The mountains, so broad across the horizontal format, have a tendency to flatten, suggesting that he may have sought the aid of photographs. But it is not the compositions that are of so much interest here (they are in fact a little

167

Lucius O'Brien
View of the Rockies 1887
Watercolour, 47.8 x 70.4 cm
Public Archives of Canada, Ottawa,
bequest of William Molson MacPherson,
Quebec City, 1933

pedestrian), it is the richness of colour, and particularly the extremely varied tones within the hues. The colours of early summer had deeply affected him:

> Last September I saw Banff in all the glory of Autumn; the mountains were purple and gold, and the valleys were filled with a golden haze. Now in the verdure of early Summer it is scarcely less beautiful; a pearly shimmering green has replaced the gold, and the combinations and gradations of delicate grey, soft blue and the richest purple and green are lovely, both in their wonderful variety and perpetual changes (*The Globe*, 15 July 1887).

168

Lucius O'Brien
View of the Rockies 1887
Watercolour, 54.0 x 75.3 cm
Public Archives of Canada, Ottawa,
bequest of William Molson MacPherson,
Quebec City, 1933

By the beginning of August, O'Brien's small party had moved camp up to Laggan at the head of Kicking Horse Pass. He wrote back home again, and at the end of the month this latest report on the wonders of the mountains appeared in *The Globe*:

> This is a very different place from Banff. There the mountains beam a welcome to the visitor and the valley looks pleasant and festive. Here we are on the crest of the great range, 5,000 feet above the sea, up upon the shoulders of the mountains, which are entrenched behind scraggy and bristling foothills, above which from the railway track little is visible but the tops of the peaks glistening with caps of perpetual ice and snow.

Thus they look low at first sight, and in passing by the railway, but they are solemn and grim (27 August 1887).

Close by was the beautiful Lake Louise (named after the Princess), accessible only by "an hour and a half of rough walking and climbing," and O'Brien believed, doomed to obscurity by the abandonment of the construction town of Laggan. Also close at hand was the Kicking Horse Pass:

> We have stayed longer at Laggan than we anticipated on account of its convenience of position at the head of the passes. Six miles to the west begins the descent of the Kicking Horse Pass. At the divide, which is also the boundary between the Northwest and British Columbia, the water runs east to the Atlantic and west to the Pacific Ocean. The western slopes of the mountains are much steeper than the eastern. The Kicking Horse River rises in a mountain lake and rushes westerly down a precipitous gorge in a foaming torrent. The railway has to follow its descent as best it can, clinging to the slopes in a serpentine path which often overhangs the stream, flashing white through the tree-tops hundreds of feet below. The sides of the pass are dominated by the highest mountains on the line, Mount Stephen and Cathedral Mountain being seven thousand feet above the track. The grade of the railway is extraordinarily steep, making the bare possibility of a runaway train or carriage frightful to contemplate. But every possible precaution is taken and one feels that the risks are controlled and the line is practically safe; still enough is left for pleasing excitement and a stirring of the nerves....
>
> If, by special favor, one is permitted to go on the front of the foreward engine, the grandeur of the pass and the forces of nature overcome and controlled by the hand of man, are fully realised. There can be but a few things in the way of locomotion to compare with the sensation of a spin down the Kicking Horse on the front of the engine (*The Globe*, 27 August 1887).

This is somewhat like the famous story of the great English lands-

capist, Turner, sticking his head out of the window of a moving train during a storm, in order to gain the full visual impact of his journey. But O'Brien would not have attempted to paint his sensations, as much as he enjoyed his experience of them. Instead, he got as far back from the railway line as the narrow pass would allow, to paint a scene of two engines straining to pull a train up the steep gradient, the mighty river crashing below, and the sublime, cloud-capped peaks pressing in above. This testament to human resolve proved popular enough for O'Brien to have painted at least two versions of it, the one recently sold by Kennedy Galleries in New York, the other, slightly larger, now in a private collection in Toronto (see pl. 169).

169
Lucius O'Brien
Through the Rocky Mountains,
a Pass on the
Canadian Highway
1887
Watercolour,
103.0 x 69.2 cm
(sight)
Mr and Mrs
F. Schaeffer,
Toronto

Just before the middle of August O'Brien and his companions began to move west. There are drawings in the sketch-book made at Quilchena and Nicola Lake, in the interior south of Kamloops. And there are numerous watercolours from along the Fraser River, a region that had interested John Fraser the year before. *Wagon Road on the Fraser*, in the National Gallery of Canada is one of O'Brien's (pl. 170). It is

170

Lucius O'Brien
Wagon Road on the Fraser
1887
Watercolour, 51.3 x 35.9 cm
The National Gallery of
Canada, Ottawa,
purchased 1964 (14,580)

in every detail much more romantic than Fraser's paintings of the region. O'Brien plays contrasts of light against dark, loose against tight, close texture, in a manner that is only incidentally naturalistic. His placing of two riders exactly in the gap of the canyon is typical of the way he thinks through every aspect of a picture to wring from it its fullest dramatic value. He is also as much in love as ever with the mists.

As the summer advanced they worked their way farther west, finally arriving in Victoria probably in the third week of September. (It may have, however, been earlier, as the letter that was published in Toronto at the end of August was reprinted in the Victoria *British Colonist*, 11 September). He made a sale there, on 25 September, to a British naval officer, a certain Captain Acland. And passing through Vancouver he had sold another watercolour, this time to another visiting Englishman, the Earl of Lathorn. These he duly entered in his Studio Journal on his return to Toronto, with the note that they were to be sent when finished.

This gives some insight into his working methods. Presumably the larger watercolours were roughed in, and then with the aid of his pencil sketches and their colour notes finished in the studio. But they must have been fairly well advanced in the field, or at least some of them, or he would not have been able to interest buyers. The Earl and the Captain were finally sent their works – a *Kicking Horse Pass* for the former, and a *Kicking Horse Pass* and a *Mount Sir Donald* for the latter – on 27 December 1887.

O'Brien also painted in and around Vancouver and Victoria. The most memorable from the latter location is a view of Mount Baker which is now in the Glenbow-Alberta Institute in Calgary (see pl. 171). It has all of the loose naturalness of a field-sketch and, with the brilliant crest of Mount Baker floating on the horizon, a startling sense of immediacy as well. It must have marked the high point of an exhilarating summer. But this was not the end. Although they had apparently stopped in the Rogers Pass on their way out (as O'Brien had a *Mount Sir Donald* to sell), they did so again, according to the notebook, 8 October. They were probably back in Toronto within the week. In that summer of 1887 O'Brien had spent four-and-a-half months in the West.

In the first three days of March 1888 he held an exhibition of his Rocky Mountain and Pacific coast work in the galleries of the AAM. Was

171

Lucius O'Brien
Puget Sound 1887
Watercolour, 24.5 x 41.9 cm
Glenbow-Alberta Institute, Calgary

this by Van Horne's or Sir George Stephen's arrangement? He shared the space with F.M. Bell-Smith, who, it will be remembered, had lived in Montreal in the late sixties with his father, John Bell-Smith, first President of the SCA. In 1887 Bell-Smith was a teacher in London, Ontario, but had been one of a larger group of artists who were given passes the second summer of the CPR. He was also one of the best in the new group. O'Brien, however, received the lion's share of the notice. The writer of "Montreal Letter" in *The Week* gives us an idea of how his paintings of the "new West" were perceived:

> If literature and politics have so far failed to awaken in Canadians any lively national spirit, surely the pictures of all that glorious land, a veritable promised land, that is ours, must send the blood tingling through our veins with wild enthusiasm and wilder hopes. Patriotism in all its depth and beauty and passion, Canadians may not feel, alas! but gazing on these

'everlasting hills,' a sentiment closely akin to it must thrill even the coldest of us (v, 8 March 1888, p. 233).

O'Brien sold seven works from the showing; two of them to Sir George Stephen, and one to Van Horne.

He showed eight paintings from his previous summer's campaign at the AAM annual spring exhibition in April, selling three of them (two again to Stephen); and at the RCA exhibition that May, which was combined with the OSA in Toronto, he showed fifteen western scenes, again selling three.

Although commercially speaking, "on to a good thing," O'Brien had had enough of the mountains. In the summer of 1888, he and his sister Loo rode on their CPR passes directly to Vancouver. He had decided to spend the summer largely on the water (he loved sailing) in the general area of Howe Sound, just up the coast from Vancouver. He took along his western sketch-book once again but not his camera. Partway through the summer he wrote to Toronto, and the letter, as had become the custom, was published, this time in *The Mail*:

> Ever since my first visit to the mountains I have had an increasing desire to see something of the fiords and inlets of the Pacific coast. So this summer, resisting all the fascinations of unexplored places by the way, we came straight through to Vancouver by rail, and engaging a Chinook canoe and two Indians went up the coast wherever sail or paddle might take us. They might easily have taken us much further than we have gone, but as my object is to paint, and subjects of interest abound, we find ourselves lingering weeks instead of days at each successive camping ground (16 August 1888).

He enthused over the climate, found the Cascade Range of mountains, which everywhere ran right down into the sea, more beautiful than the Rockies or the Selkirks, and believed the British Columbian rain forests to be something approaching heaven on earth. Even Vancouver, the city the CPR had created to be its western terminus, seemed exciting, as it doubtless was. "It must have nearly doubled since I was here last summer," he wrote, "and building is proceeding rapidly. I paid a visit to the town yesterday, and found that during my absence of two months hundreds of buildings had gone up." Not only would the

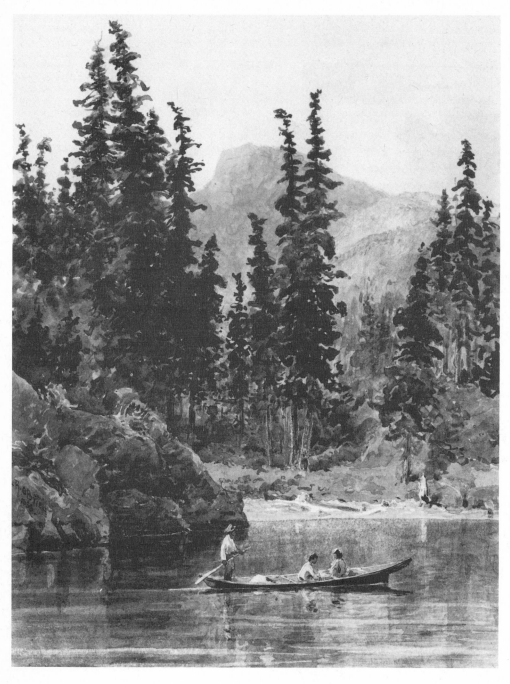

172

Lucius O'Brien
A Nook on the West Coast,
Howe Sound, B.C. 1888
Watercolour, 27.9 x 22.9 cm
Provincial Archives of British Columbia,
Victoria, gift, 1956 (pdp 2154)

CPR have been pleased with his report – he included a paragraph in praise of their new Hotel Vancouver – but so were the business interests of the city. The whole letter was reprinted in the Vancouver *News Advertiser*, on 1 January 1889. O'Brien did not stay so long in the West that summer. He returned to Toronto early in September.

He brought back a goodly number of works. As in the year before, some were smaller, freer wash drawings of great delicacy; others were larger, richer and more finished paintings. A good example of the former is a quiet painting now in the British Columbia Archives in Victoria, *A Nook on the West Coast, Howe Sound* (pl. 172). Its stillness and its sense of harmony recall his canoe scenes of the seventies.

The most impressive painting of that summer, however, is one in the National Gallery of Canada called *A British Columbian Forest* (pl. 173). It shows a giant cedar in Stanley Park at Vancouver, a famous

173

Lucius O'Brien
A British Columbian Forest　1888
Watercolour, 54.1 x 76.4 cm
The National Gallery of Canada, Ottawa,
purchased 1889 (159)

tree, often photographed and almost as frequently painted. It is diffi-
cult to say just how big it was on the basis of O'Brien's picture, because
it is unclear how close the two men in front are to its base, and how
close is the third man just passing behind it, to the right. But its scale is
not so important. O'Brien was not, in this instance, concerned with
sublime effects. It was the incredible richness of the forest that
attracted his interest, and he has bent every effort of his talent to the
description of its living form. It is a new Eden, with the promise of new
beginnings, even though itself as old as time. An enticing, exotic land-
scape, supportive of life, a symbol of potential, of faith in the future, it
evokes a much stronger response than the mountains. Crammed with
myriad shapes and textures, with shifting light and shade playing
across it, it must have appealed particularly to the Victorian mind.

It is believed by his second wife's family that before he married his
first wife, Margaret St John, Lucius O'Brien had been betrothed to
Katherine Jane Brough, daughter of the Venerable Archdeacon C.C.
Brough of London, Ontario, but that her father had forbidden the mar-
riage. She subsequently married a certain Parker. He died after they
had had one son. In mid-November 1888, after his return from Howe
Sound, O'Brien married Katherine Brough Parker in St James Cathe-
dral in Toronto. The ceremony was performed by her brother-in-law,
Canon John Philip DuMoulin.

In February 1889, as in the year before, he showed a group of his
new western pictures at the AAM. This time it was as part of a special
small selection of Canadian artists, gathered for the occasion of the
Montreal Winter Carnival. Of his twenty-one works all but two were of
the Howe Sound region. A number were left with William Scott after
the showing, and by the end of March, five of these had been sold. All
are recorded in his Studio Journal. From that point on he seems always
to have had something at Scott's, usually CPR pictures.

Clearly, Montreal had developed, once more, into the principal art
market of Canada. And just as clearly it was a market, like any other,
with definite tastes and preferences. In Canadian work the prevelent
fancy was for pictures of the West, the "CPR country." This hunger for
images of the new land, or at least the artists' anticipation of such a
demand, reached its peak in the 1888 spring exhibition of the AAM,
more than a third of which consisted of images of the Rocky Mountains
or the West Coast.

In November 1888 O'Brien's Royal Academy watercolour of the year before, *In the Canadian Rocky Mountains: Footprints of an Avalanche*, was accepted for exhibition at the Royal Society of British Artists, London, and in 1889 he returned to the seat of empire for the first time in six years. He may have been encouraged by the RSBA's acceptance of his painting, or perhaps he was under pressure from the CPR's promotional interests. Whatever the reasons for his decision, his show opened in June of that year. As on the previous occasion he was to stay for six months, and it was a commercial showing that proved the highlight of the trip. It was a one-man exhibition this time, though, at McLean's Gallery, Haymarket. Consisting of twenty-seven views of the Rockies and the West Coast, it opened on 22 June. He sold a number of works from the show, including two to the Colonial Secretary, Lord Knutsford, and at the end of the exhibition left twelve of them with his London agents, R. Dolman & Sons.

Certainly he received no greater critical attention in London than had John A. Fraser two years before. But back in Canada, somewhat more notice was taken. A short piece appeared in the Montreal *Daily Witness* on 13 August 1889. A longer, more detailed review in the Vancouver *Daily World* on 27 August 1889 was treated as an item of local interest in Vancouver, because of the subject-matter of the pictures.

O'Brien stayed in England until November, sketching in Kent and Sussex in the east, and Cornwall and (as in 1883) North Devon in the west. He seems not to have been tempted, as were so many other Canadian artists of the time, to remain in England with its large art market. At the same time he also took the decision to withdraw somewhat from public life in Canada. Remarkably, he had not participated in the seventeenth annual exhibition of the OSA late in May 1889, though he had contributed to the AAM spring show and, of course, to the RCA exhibition, which had been held in Ottawa in March.

Earlier in 1889, in January to be precise, O'Brien had become involved in a project which had long been dear to his heart. In March of 1888 the OSA had once again found itself in financial trouble, and had been forced to give up its King Street quarters for lack of funds. The crisis was the direct consequence of yet another embezzlement, this time perpetrated by the Secretary, J. Jardine.

For a number of years O'Brien had been encouraging the idea of establishing a building fund to eventually provide permanent Academy

quarters in Toronto. The present OSA crisis seemed the perfect occasion to establish an Art Association of the City of Toronto, which would undertake the building of permanent RCA quarters, including a proper art galley that would house the annual exhibitions of the OSA, the periodic appearance of the RCA, and a permanent collection. It would also include space for and assume the administration of the Ontario School of Art, thus wresting it from the control of the Ontario Department of Education, yet another pet project of O'Brien's.

But alas, this whole comprehensive scheme was destined to be abandoned the following November, shortly before O'Brien returned from England. The OSA rejected the idea of a cooperative building effort along the lines of the proposed Art Association, and again determined to establish its own gallery. In immediate reaction the RCA decided to sell the Toronto property it had already purchased, and to apply its building fund to other purposes.

This turn of events must have greatly disappointed O'Brien, dashing his hopes for the firm establishment of artistic support in Toronto. He was also feeling pressure from other quarters. For some years, young painters had been travelling to Paris for training, and they brought back with them a radically new view of art, based almost entirely on the study of the human figure. The reviews of the late eighties show a rather dramatic turn toward the large figure-paintings of these new men, and away from the landscape work that had dominated the exhibitions for almost three decades. At the General Assembly of the RCA in Montreal at the end of April 1890, George Reid and Paul Peel, two of the Paris-trained figure painters, were elected to RCA membership. O'Brien had, after ten years of service, decided not to stand for re-election to the presidency. Robert Harris, another Paris student, was elected but, declined, and Otto Jacobi was chosen in his stead. In either case it meant that the President would reside in Montreal.

O'Brien now began to settle into a kind of active retirement in Toronto. He showed only English works in 1890, putting a definite end to his CPR connections. A painting had again been accepted by the RSBA in the winter of 1888–1889, and he continued to send work to Dolman, who continued to sell the occasional painting. He was in Quebec City in June 1890, and back again in the late summer to sketch along the lower St Lawrence. In December he held his first one-man show in Toronto, at Matthews Brothers on Yonge Street.

He tried, in his usual way, to establish a precise routine. He held annual showings at Matthews every December until 1894. In March 1892 he had an exhibition at Scott's in Montreal, and in April of that year arranged for a New York agent, Boussod Valadon & Company – where Fraser had shown two years earlier – and they sold several for him over the following two or three years. He showed regularly at the AAM spring exhibition, and with the RCA, though in 1892 he resigned from the OSA in protest over the inclusion of too many of the new painters, whose broad oil technique led him to call them "the eliminators." He subsequently formed his own exhibiting group, the Palette Club, which held its first show in his studio in February 1893, its second at Matthews' in April of that year, its third in January 1894 at the Roberts Gallery on King Street West, and its fourth and final one there in November.

Also in that year, after a lapse of some twelve years, he began to paint in oils again, with a broader handling and tendency to generalization which, in fact, brought him closer to the technique he had criticized in "the eliminators." He allowed himself to stand for re-election to the OSA in May 1896, and in February 1896 his last illustration work had appeared: six drawings for an article, "The British Navy of Today," in *Massey's Magazine* (I, pp. 67-75).

His watercolours of these last years also tended towards an increased broadness of handling. There was no marked diminution of his powers, only a kind of levelling off. From the mid-eighties onward he had usually avoided putting a singular effort into any one work. His western pictures in particular are notable in this respect, as though we were not meant so much to attach importance to individual pieces, but to consider the artist's total effort, perceiving each watercolour as only a part of the whole. This tendency increased greatly in the nineties, with the result that there are not, really, any individual works to single out. Although the quality remained reasonably high he was generally working, in both subjects or themes, within a long-established pattern. That they were "O'Briens" seemed more important than anything else.

O'Brien had held formal classes in his studio as early as February 1890, and in February 1893 he revived these, and continued them in the spring and fall, at least until 1895. The summers were thus left free for field-sketching trips, which he usually took in the Atlantic Provinces. Among his students, in 1894, were C.T. Currelly, who would

become the first director of the Royal Ontario Museum, and Edmund Walker, a man who was to be, after the turn of the century, probably the most prominent patron of the arts in Toronto, and an important force in the proper establishment of both the Art Gallery of Toronto (now the Art Gallery of Ontario) and of the National Gallery of Canada.

Walker remained close to the older man during his final years. O'Brien became ill in February 1899. On 10 May, he held a large auction sale of his work at the Toronto firm of C.J. Townsend & Company. One of the purposes of the sale, according to the numerous newspaper notices, was to enable Mrs O'Brien to take him south and in the summer to revisit the West Coast. It is unlikely that they made it. All evidence is that he continued to fade gradually through the year, and he finally died on 13 December 1899.

Edmund Walker arranged an exhibition and sale of the pictures in his estate at Matthews, in February 1900, and another, smaller sale in Ottawa at James Wilson & Company in October. O'Brien, unlike most of the other artists of his period, has never been completely forgotten. His ten years as president of the Royal Canadian Academy have kept him in all the history books. One or two of his paintings, particularly his Diploma picture, *Sunrise on the Saguenay*, have also kept some concept of his work before us over the years. But what we did lose sight of was the extent of his contribution, its quality, and its value to our country's history. Above all, we had forgotten that for almost two decades he was the central figure in Canadian art.

THE NOTMANS AGAIN

Even though the CPR did much to encourage painters to travel to the Rocky Mountains, it also continued to support the production of photographic images. The photographers had been there first, of course, and had set the initial standards against which the painters found it necessary to judge their own accomplishments. William McFarlane Notman, in the work he produced on two subsequent trips to the West in the later eighties, continued to build up the original range of images he had established in 1884. Notman again went west in the summer of 1887 (as mentioned in an article on F.M. Bell-Smith in the *Winnipeg Free Press*, 18 October 1887), accompanied by his youngest brother,

Charles, then sixteen. Then, two years later, he and Charles spent another season in the West, working from a CPR private car. On both occasions, they travelled right through to Victoria, producing scenes of the coast, of Indian life, and of the growing towns and cities. The railway appeared in some form in most of the pictures, and the mountains still provided the most dramatic subjects.

The 1887 and 1889 mountain pictures are not significantly different from those of 1884. The same grand peaks are photographed from the valleys for maximum scale. Mount Stephen is treated with all of the reverence that then seemed due to its majesty (see pl. 174). Isolated, detached from its surroundings, and with its massive forms revealed clearly in broad sweeps of light and shadow, it is as full of imposing character as is any Notman subject. In others of his photographs, however, William McFarlane Notman reveals a quieter side that brings him

174

William McFarlane Notman
Mount Stephen 1889
Albumen print, 19.2 x 23.5 cm
The National Gallery of Canada, Ottawa,
purchased 1973 (P73:041)

close to Alexander Henderson, and a concern for atmosphere and intimate mood.

175

William McFarlane Notman
*Looking Across the Valley from First
Trestle of Loop on the Canadian Pacific*
1887
Albumen print, 23.0 x 18.0 cm
David Mirvish Gallery, Toronto

Looking Across the Valley from First Trestle of Loop on the Canadian Pacific, showing a second trestle among the trees, and a small work-camp nestled in the bottom of the valley, is one of the most evocative images that Notman brought from the Selkirks (pl. 175). It was taken in Glacier Park. The smoke from one camp fire rises straight up; that of another is drawn by a gentle breeze into the leaves of a large deciduous tree, mingling with the morning mists, and low clouds that hang lightly in the air. An awareness of the vast scale of the landscape arises in the viewer with a similar slow inevitability, to the point of overwhelming awe.

In 1887, and again in 1889, the two Notman brothers took with them a much larger camera than they had ever used before. In the Banff region they took a series of photographs that are almost double the size of the usual Notman landscape print. Such "mammoth plate" cameras, as they were called, had been used extensively by photographers in the western United States in the seventies. Although the Notman records mention that forty-two of these mammoth views were taken in 1887, and another forty-seven in 1889, only three are presently known, and no negatives have survived (they were then still of glass). These three scenes are certainly among the best of Notman's mountain pictures. The large plate takes so much in that even though the composition is based, in the usual Notman fashion, upon the balanced play of large forms, and the dramatic contrast of areas of dark with light, there is an overall sense of place, of the rich, complex harmony of a closed system. It can truly be said to approach the achievement of Alexander Henderson in 1885. The presence of man is incidental. He exists as a perfectly integrated small element. In *Bow Valley from Upper Hot Springs, Banff*, the shadow of the huge camera-box and its operator represents no more of a flaw in the image than does the heap of rubbish to the left seem a blemish on the landscape (pl. 176). Both are so insignificant before the mighty scene that fills our view, that they fall naturally into place, small human reminders in the presence of the vast space articulated by such forms.

Yet in these mammoth prints, in which there is every possibility of inducing that mixture of fear, awe and fascination which makes up the sublime, Notman very clearly diverts the effect (see pls 177, 178). In these panoramas, the mountains balance one another. There is no

176

William McFarlane Notman
*Bow Valley from Upper Hot Springs,
Banff* 1887
Albumen mammoth print, 42.0 x 52.7 cm
The National Gallery of Canada, Ottawa,
purchased 1972 (P72:077)

177

William McFarlane Notman
Looking Down Bow Valley
from CPR Hotel, Banff 1887
Albumen mammoth print, 43.0 x 52.8 cm
The National Gallery of Canada, Ottawa,
purchased 1973 (P73:039)

178

William McFarlane Notman
Mountains at Canmore 1889
Albumen mammoth print, 44.2 x 54.8 cm
The National Gallery of Canada, Ottawa,
purchased 1973 (P73: 038)

dominance. Space flows easily. There is no containment, no sense of compression or force. These are open, expanding views of wilderness splendour. Such are the changes that have been wrought since William Notman Senior first sent a photographer into the mountains in the summer of 1871.

There is one final image I would like to introduce. It is a photograph by William McFarlane Notman, taken in 1889 in Stanley Park, Vancouver, of the same famous tree that Lucius O'Brien had painted the year before (see pl. 179). Notman's photograph evokes everything we find in the O'Brien watercolour. Festooned with ferns, thick with moss and fungi, the tree is itself a landscape, a living symbol of the never-ending cycle. Even though the image is framed by trunks and branches, it is open and expanding. This giant tree does not inspire in us feelings of the sublime. It promises comfort and support; it stirs hope. It is the rich Victorian prize at the end of the long road.

179

William McFarlane Notman
Spruce Tree, 44 Feet in Circumference,
Vancouver 1889
Recent print from the original negative,
20.4 x 25.4 cm
Notman Photographic Archives, McCord
Museum, Montreal (2150)

The end was near for those landscape artists who had first essayed the discovery of their country in the eighteen-sixties. Some were already dead, and most of the others were either retired from active life, or preparing to do so. William Notman died at his home in Montreal on 25 November 1891, and although the studio system he worked within assured that his values and ideals were in a particular sense to continue, his death marked the passing of an artistic era in Canada.

Epilogue

It did not suddenly end. Successive waves of "CPR artists" were, during the late eighties, to follow in the lead of those painters who had travelled west in that first summer of through rail in 1886. On the evidence provided by the exhibition records, O'Brien and Notman were joined, during the second season, by F.M. Bell-Smith, T. Mower Martin, Marmaduke Matthews and Forshaw Day.

The next year Bell-Smith and T. Mower Martin returned, and in 1889 Bell-Smith, Mower Martin and Matthews were all sent out again by the CPR, as well as the familiar American, Albert Bierstadt, who produced a number of large and rather stiff canvases of the company's inevitable mountain sights. The best he produced that year is a smaller painting, *Sunset with Railroad (Rogers Pass)*, commissioned by Sir George Stephen, and now in the collection of the Mount Stephen Club, located in that gentleman's palatial former residence in Montreal.

Even after the advent of the nineties, the CPR interests, by this time chiefly represented by W.C. Van Horne, continued to encourage artists to visit the mountains. John Hammond – who had as a young man in 1871 accompanied the photographer Benjamin Baltzly out west – was commissioned on more than one occasion. G. Horne Russell and R.F. Gagen also visited the Rockies a number of times in the late nineteenth and earlier twentieth century. Bell-Smith returned frequently after 1898 (he had made the trip every year between 1887 and 1890), and such was the success of his mountain pictures that he was able to give up teaching. Indeed, his career as a mature artist is centered on these paintings. Mower Martin returned as many as ten times, also basing the latter part of his career on the work resulting from these trips. Like O'Brien, he wrote at some length of his experiences, and five such reports entitled "An Artist's Letters from the Rockies," were published in *The Week* between 30 August and 11 October 1889 (VI, pp. 617, 648-649, 682, 699-700, 713-714).

William Brymner of Montreal, one of the first group to enjoy a CPR pass in the summer of 1886 – he painted Indian subjects – was sent to the far west again in 1892. After this trip, he executed large landscapes, as was the fashion among the painters of the second wave. They tended to paint on a more ambitious scale than had O'Brien and Fraser, and in oils rather than watercolour. These later works – usually painted on commission – were modelled on the huge "machines" that had enjoyed such favour in the United States thirty or forty years previously. In the nineties and the first decades of this century, they must have seemed to most of the informed art audience to have been almost comically bombastic. Had they not been commissioned by the CPR, they would not have been painted at all.

Nevertheless, such railway commissions continued to put bread on artists' tables at least until the First World War. Early in the summer of 1914 three Toronto painters were hired by the Canadian Northern Railway to make scenes of its new line being built through the Yellowhead Pass. These were C.W. Jefferys, J.W. Beatty, and a future member of the Group of Seven, A.Y. Jackson. Jackson returned again ten years later with Lawren Harris; and to this day, numerous artists have continued to feel themselves inspired, or perhaps simply challenged, by the grandeur of the Rocky Mountains.

But, as we already know, the great early public interest in images of the West continued to decline rapidly after 1888. In Montreal, with Toronto following not far behind, the new goals and values of a younger generation of Canadian artists was steadily superseding the aging painters of the national landscape. Not that the public turned its back on the still-vital aspirations of these men overnight. *The Globe*, in reviewing the joint exhibition of the RCA and OSA held in Toronto in 1888, remained enthusiastic, echoing themes heard first twenty years before:

> This...collection is one of the strongest exhibitions of Canadian work yet seen in the Queen City. It augurs well for Canadian art, and is especially strong in water color landscape.... The result of focusing so much attention on the beauties of Canadian scenery cannot but have a salutary effect on both home and foreign markets – to put it commercially; to encourage native painters, enabling young Canada to form *a school of*

her own that shall not be ashamed to compete with that of older civilisations. The only drawback at this juncture is that perhaps there is somewhat too much Rocky Mountain. Excellent as most of it is, it wants scattering by purchase (9 May 1888).

This last remark perhaps masks greater impatience with pictures of mountains than the author thought commensurate with current patriotism. The reviewer for *The Week* (v, 24 May 1888, p. 417), felt no such hesitation:

> In the water colour section the mountaineers monopolize the wall. The admissibility of mountains as a pictorial element, is associated with art in its infancy. New York has outgrown Bierstadt, as Paris has long since outgrown Calame [see Chapter II]. The pictures before us, however "striking" the scenic effects may be, have all the faults of mountain pictures. They contain too much and insist on the most maplike composition. There are over fifty pictures of mountains, and, excepting that Mr. Bell-Smith displays the most facility and does by far the better work in the scenic line, they are all pretty much alike, the same rocky formation, the same trees, and all possessing the peculiarity of that 'mounting' described by Artemus Ward 'the highest part of it is the top' as Sam Weller's pieman, to suit the taste of his customers, could convert a 'weal' into a 'am' or a 'am' into a kidney or all into a mutton, when really they were all cats. There is as much variety in the peaks and gorges of the Rocky Mountains named and designated to suit the inordinate vanity of the directors and projectors of the C.P.R.

The heydey of the mountains was past, and with it the exuberant years of pursuit of an ever-expanding landscape. For a considerable period of time the Canadian art scene would continue to be dominated by a somewhat self-conscious orientation toward European art and European-trained artists. The next concerted attempt to express the "national" landscape would not come until the *début* of the Group of Seven, when landscape and, yes, mountains would once again be adventurously explored.

Index
of Artists

439

Index
of
Works of Art

Index
of Institutional
References

DESIGN:

Frank Newfeld

PRINTING:

Southam Murray